Ingres

*In Pursuit of Perfection:
The Art of J.-A.-D. Ingres*

*By Patricia Condon with
Marjorie B. Cohn and
Agnes Mongan*

Edited by Debra Edelstein

*The J.B. Speed Art Museum
Louisville, Kentucky
December 6, 1983 to January 29, 1984*

*The Kimbell Art Museum
Fort Worth, Texas
March 3, 1984 to May 6, 1984*

*Under the High Patronage
of His Excellency
Bernard Vernier-Palliez,
Ambassador of France
to the United States*

*Published by
The J.B. Speed Art Museum
in association with
Indiana University Press*

Designed by Images, Julius Friedman
Production by Barbara Cunningham Shillito
Typography by Adpro
Printed by Pinaire Lithographing
Distributed by Indiana University Press
Tenth & Morton Streets
Bloomington, Indiana 47405

This exhibition is supported by an indemnity from
the Federal Council on the Arts and Humanities
and by a grant from the National Endowment for
the Arts, a Federal Agency.

ISBN: 0-9612276-0-5
Library of Congress Catalog Card Number: 83-81727

Contents

Preface

A more than passing interest in nineteenth-century French art has been demonstrated by this Museum in a series of exhibitions and in acquisitions made for the permanent collection. Our first major move in this field was the organization in 1971 of the pioneer exhibition *Nineteenth-Century French Sculpture: Monuments for the Middle Class*. It is with deep satisfaction that on this occasion we extend our interest to the work of the most significant academician of that protean century.

This exhibition was organized to inaugurate a new Museum. New construction and renovations have substantially changed the appearance and operation of the J. B. Speed Art Museum. From this point a richer life begins for the Museum and the community it serves.

Although the twentieth century occupies a primary position in our thoughts and plans, the great and enduring traditions of art have a warm and permanent place in our hearts. Even in our new building the predisposition is towards the classic ideal. What artist more appropriate than Ingres would come to mind for such a celebration as this?

We have fortunately been able to place the organization of this exhibition in the hands of perceptive scholars, representing both an established, elder generation and a venturesome, youthful approach. On behalf of all of us who have worked towards the realization of our new Museum and this inaugural exhibition, I want to express our appreciation to our guest curator Patricia Condon, who planned the exhibition, selected the works in it, and is responsible for its catalogue, and to Marjorie Cohn and Agnes Mongan of the Fogg Art Museum, who have supported this enterprise throughout.

Addison Franklin Page
Director

Acknowledgements

My thanks must first go to Addison Franklin Page, Director of the J. B. Speed Art Museum, for the support he has offered from the moment we first took on this exhibition in the Fall of 1982. It would never have been possible to do so much in this short period of time had his confidence in the project ever waivered. I also am grateful to the Board of Governors of the museum for their enthusiasm for the type of exhibition we wanted to do and for their unquestioning response to our needs as the dream became a reality.

Instrumental in my preparation for this project was the museum training I received as part of the graduate program at Brown University. My thanks to Professor Catherine Wilkinson-Zerner, who was the advisor to the exhibition I worked on there, and to Professors Kermit Champa, Michael Driskel, and Anne Markham Schulz for the high standards of scholarship they set. At the University of Louisville, I owe much to the Art History and Modern Language faculty.

My interest in this subject grew from a report for a seminar on Ingres taught by Agnes Mongan, Director Emeritus of the Fogg Art Museum, at the University of Louisville in 1976. She has graciously extended her help at every stage since then. Her belief that Louisville might one day host an Ingres exhibition was instrumental to its realization. Her knowledge of Ingres collections and her experienced eye were invaluable in the early months of organizing the show.

Marjorie B. Cohn, Associate Conservator at the Fogg Art Museum, has been involved with the project as one of my dissertation advisors since 1980. It is most appropriate that she should write the introduction to the catalogue, since the idea of a study of Ingres' attitude toward the replica was hers before it was mine. It was her advice that my dissertation on Ingres' watercolors should have as its primary objective the clarification of their position within his lifelong replica process. Doing this meant opening up the research to a study of every version of each of Ingres' historical subjects. From that study emerged the raw material for this exhibition; it is my hope that it stands as a suitable tribute to the original idea.

A Dissertation Research Travel Grant from the Samuel H. Kress Foundation for 1981-82 made possible the investigations that evolved into this exhibition.

Without the support of the French museums, an undertaking such as this would be impossible. Pierre Barousse of the Musée Ingres welcomed me warmly in Montauban and has been unfailing in his support of what this show is doing. Jill and Robert Portal's hospitality made my stay in Montauban immeasurably more pleasant; I owe much of the success of my travel in France to them. In Montpellier, Xavier Dejean and Martine Feneyrou of the Musée Fabre have been especially kind.

At each of the museums in which I worked over many months of travel in France, Belgium, and England, curators and directors extended their help. I wish to acknowledge: Annie Adriaens-Pannier, François-Xavier Amprimoz, Marie Christine Boucher, Denis Coutagne, Genevieve Creuset, Vincent Ducourau, Monique Geiger, John Kinney, Catherine Legrand, Jean Milhau, Alain Mousseigne, Hervé Oursel, Pierre Rosenberg, Annie Scottez, and Maurice Sérullaz.

All three authors own an immense debt to the scholarship of Hans Naef and Daniel Ternois. Their work has laid the foundation for modern scholarship. I thank Professors Naef and Ternois for their assistance in locating several works. I also wish to thank Héléne Toussaint for her help.

Art dealers both in the United States and abroad were helpful in locating works in private collections. My appreciation to John Baskett, Lillian Browse, Christopher Burge, Elisabeth M. Drey, Joseph Faulkner, Richard Feigen, Shaunagh Fitzgerald, Lucien Goldschmidt, Derek Johns, Elizabeth Llewellyn, Marianne Roland Michel, Martin Reymert, Alexandre Rosenberg, Frederick G. Schaub, Robert Schmit, Eric Stiebel, and Gerard Stora. Eugene V. Thaw and Clyde Newhouse worked with us in preparing the original estimate of the insurance costs for the National Indemnity.

Alice Martin, Museum Program/ Indemnity Administrator at the National Endowment for the Arts could not have been more generous with her guidance. Our thanks to C. Ross Albright, Jr., J. Thornton Eiler, Philippe J. Gaudin, and Louise Welch for their advice with our transportation arrangements.

Several others have gone out of their way to offer timely assistance: B. de Boisseson, Mimi Cazort, Albert Ferlin, Brigitte Genta, Gail Gilbert, Robert Guicharnaud, Mrs. John Loeb, Kathleen Moore, Pat Morrissey, Mackie Nichols, Elizabeth Owen, Janet Rabinowitch, Jenni Rodda, M. Tourniol, and Nancy Versaci.

The staff of the J. B. Speed Art Museum could not have been more helpful. My thanks especially to Linda Wright, Secretary to the Director and to this exhibition, whose kindness could always be depended on, and to Melanie Préjean, Assistant Registrar in charge of the loan arrangements for the exhibition, who handled the immense work load so professionally. Many others shared in the preparations for this show: Jean Battoe, Mary Jane Benedict, Allis Bennett, Mary Carver, Kathleen Elgin, Pam Hessel, Mary Ann Hyland-Murr, William Kruetzman, Carolyn Ledford, Inez Pryor, Kelly Scott Reed, Gerri Samples, Albert Sperath, Mary Taylor, Louise Thomas, and Alberta Thompson. My special thanks to Martha Nichols for volunteering to be my assistant.

Robert Geddes, the architect of the new museum addition, not only designed a beautiful space for special exhibitions, but also assisted in the design of the exhibition installation.

At the Kimbell Art Museum, Edmund P. Pillsbury, Director, and Michael Mezzatesta, Curator of European Art, made several inspired suggestions in the planning of this project. We wish to acknowledge Foster Clayton, the Kimbell's Registrar, for her time and assistance.

To my catalogue crew my debt is immense. Their effort and expertise exceeded all expectations. Jim Patus found the right computer and software for me and programed the research files into a usable data base. Mindy Griffin manipulated the programing on a daily basis and typed the entire catalogue manuscript. Her conscientiousness and unfailing good spirits were a pleasure. Debra Edelstein's editorial skills taught me what an editor should be. My immeasurable gratitude to her for the text as it now stands. I stand in awe of her skills.

The book owes its beauty to the design talents of Julius Friedman. My trust in the end result was implicit from my knowledge of his posters. From my concept of what the catalogue needed to be, and his of how it should look, he wove a reflection of our vision. I am grateful to him for this gift. My appreciation to Barbara Cunningham Shillito for her attentive eye and extraordinary care in the production.

My deepest thanks to my family for enduring and for understanding.

Patricia Condon
Guest Curator/ Project Director

Introduction:
In Pursuit of Perfection

by Marjorie B. Cohn

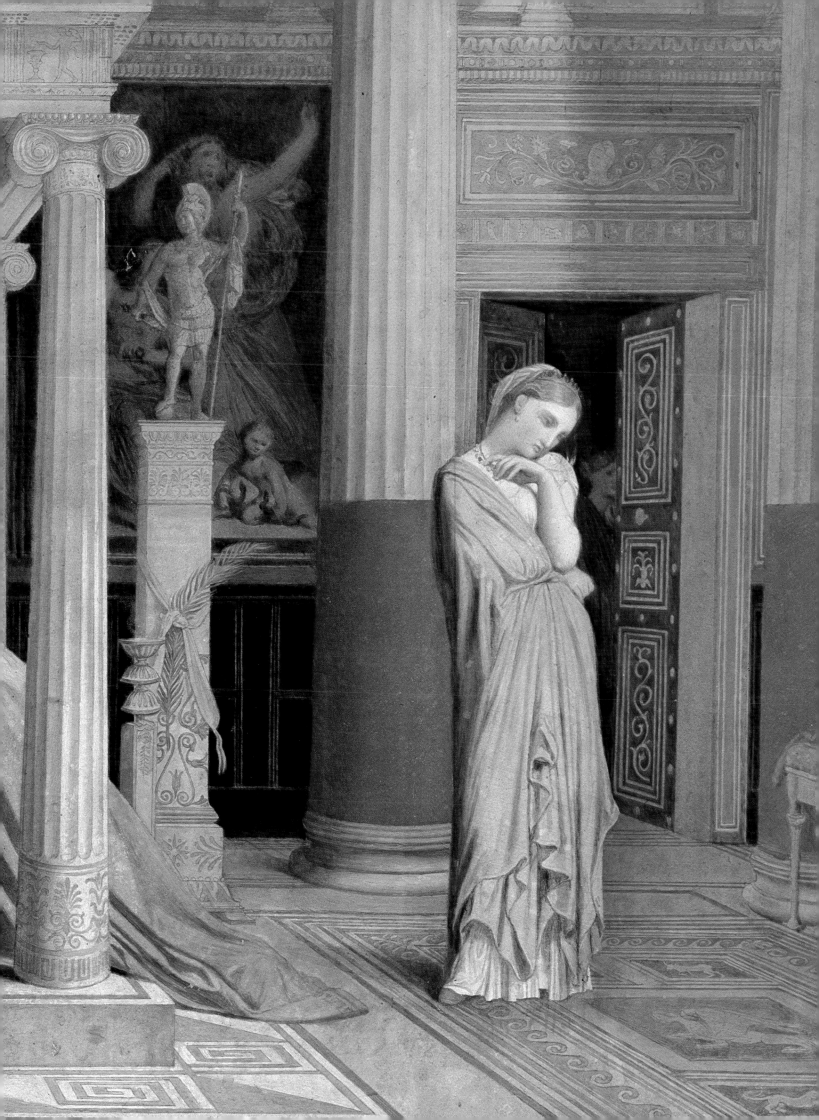

In the present age, . . . today no less than yesterday, the strong and vigorous divide between them the various territories of art, each according to his tastes and temperament. . . . Some gather an easy and abundant harvest in the golden, autumnal vineyards of colour; others toil patiently and laboriously to drive the deep furrow of drawing.
—Charles Baudelaire, 1846[1]

Most of us have never read this subtle propoganda against Ingres' reiterated lines—bare, plowed dirt. Still, we have been seduced by the great poet and art critic's image of a luminous harvest of wine, with the implicit potential for luxurious revelry. Baudelaire and his fellow enthusiasts for Delacroix and the Romantic movement gave us the modern definition, our definition, of the artist as "by nature essentially and intimately . . . a spontaneous creator."[2] Human nature loves the grasshopper, not the ant; and over the last hundred and more years, the critics' redefinition of creative genius in the age of Gericault and Delacroix has obliterated any earlier definition.

In 1845 Baudelaire declared Delacroix "the most original painter of ancient or modern times . . . a genius who is ceaselessly in search of the new."[3] The next year Thoré extolled Gericault's "lively and fecund" imagination.[4] This esteem for "the new" and these adjectives—"lively," "fecund," and especially "original"— attained their particular positive values for art at this moment, though not without a struggle.[5] Baudelaire's designation of Delacroix as the most original artist of *all* times, including the ancient world, indicates the opposition against whom Romantic art's champions were ranged.

In 1846 Jean-Auguste-Dominique Ingres flourished the Classical standards at his first retrospective exhibition.[6] Nine years later, in his next retrospective, his works were hung under government auspices "like the flags of French art,"[7] in the words of Théophile Silvestre, another advocate of the Romantics habitually hostile to Ingres. Silvestre characterized "these forty-odd paintings" as evidence of the "sterility" of the leader of the French school, especially as compared to "the abundance of the old masters!" He further declared: "M. Ingres has passed his life as much in repeating the same forms . . . as in insidiously combining the most famous traditional types with the living models. . . . And how unscrupulously he pillages statues,

reliefs, engraved gems, antique cameos, frescos, vases, antique implements, paintings, prints, mosaics, and Italian tombs!"[8]

Indeed, Ingres' critics did believe that he was a robber of the graves of the past, for they required genius to find ever new expressive forms within itself. Silvestre's specific criticism of Ingres as a plagiarizer of himself and of all earlier art was the expression of Romantic dogma. It was also true. Ingres made copies, many copies, of practically every one of his major compositions; and all these compositions, even in their first, "original" manifestations, are demonstrably derived from prototypes. The facts and the Romantic prejudice have combined in such strength that today many of Ingres' works are neglected and misunderstood.

In particular, the replicas Ingres made of his own compositions, which he made obsessively throughout his career, which he made in a great variety of techniques, which he sometimes valued above his first realization of a motif, which are often changed, greatly or subtly, from their prototypes—these replicas, because they are *not the originals*, have been given short shrift. Even the great Ingres centenary exhibition organized by the French National Museums in 1967 consciously excluded the "late, very finished drawings, and also repetitions realized at the end of the artist's life after earlier paintings," by disparaging them as "works of essentially documentary interest."[9]

Yet such willful omissions have done more than simply deprive us of the enjoyment of works of beauty and interest. They have also allowed misconceptions of Ingres' essential accomplishment to continue. The emphasis of the present exhibition on replica in its explication of Ingres' creative process requires us to omit, perhaps, some of his greatest oil paintings. Our compensation is the sight of many fine watercolors and drawings and the sense, gained through an understanding of their development, of an alternative to the extemporaneous creations of the Romantics.

Born in 1780, Ingres was by 1810 fully educated within the French art establishment in his profession as a "history painter," a specific rank of artist and the highest within the academic hierarchy. Ingres' explicit methods of creation were shaped by academic rules that would be modified, then overthrown, only by later generations. The Academy did,

Sketch for Frontispiece of the Sacre Album of Charles X
Montauban, Musée Ingres, 867.2654. Pen and black ink on paper, 10.3 x 6.5 cm, 1828.

however, allow for initial creative inspiration. The general scheme for the creation of an art work had two stages in academic theory. As one historian of the French institution notes: "[There was] . . . the 'generative' phase and the 'executive' phase. The generative phase designated the *première pensée* of artistic inspiration—self-expression without self-consciousness. . . . The spontaneity and freedom of the generative phase were gradually refined out as the work assumed a finished appearance. Throughout the history of the Academy, the generative phase was associated with idiosyncratic genius and originality."[10]

Although Ingres had his generative phase, it is not visible in the finished work in any idiosyncratic or original way. But those adjectives *can* describe Ingres' prolonged, obsessive executive phase, which by means of replicas he extended far beyond what is normally considered the definitive execution of a work of art. This exhibition's primary concern is Ingres' pursuit of perfection in his executive phase, resulting in a long overdue recognition of its importance.

Ironically, it was the generative phase that Ingres, early in his career, described as "the longest work" for the artist. According to his repeated testimony, with him that phase was mental and manifested itself only in the briefest of pen-scribbles. He conceived a composition in his head, sometimes only moments after the stimulus of a commission for a specific subject, as in the case of the *Apotheosis of Homer*.[11] The shorthand style of the first record of his idea (cat. 42) is typical, and its brief inelegance demonstrates the necessity for the manipulations of the executive phase to bring the picture to final form.

In an 1814 letter to Marcotte that could well be a prescription for a Romantic painter's method, Ingres described his conception of the making of a work of art: "When you really know your business and are really ready to imitate nature, the longest thing for a good painter is to think through your painting, to have it, so to speak, all in your head, and then to get it done hot, all at a stroke. Then, I think, everything will seem to be felt as a whole, and there's real mastery. And that's what should make you dream, night and day, of your art. . . . A moment comes when a man of genius feels like he's caught by his own powers and daily makes things that he doesn't know how to make."[12]

Unfortunately, as his career developed or, rather, was thwarted in its early development by constant, harsh criticisms, Ingres found himself less and less able to "get it done hot, all at a stroke." The standard routines of the academic executive phase were prolonged and repeated to the point that, as Ingres himself recognized, progress toward the finished picture could falter. In the maze of tracings from reproductive prints, life drawings, historical studies, composite manipulations, and painted sketches,[13] the artist could lose the thread laid down from his inspiration. Reconsiderations and reworkings often obliterated the real achievements of each stage of work. In January 1823, more than a year after receiving the commission for *The Vow of Louis XIII* (cf. cat. 54), the altarpiece which would be his great chance to escape a sixteen-year impoverished exile in Italy, Ingres again wrote to Marcotte: "It's true I often scrape out [my work] and begin again, that's true . . . but I cannot, really, do otherwise. . . . in the grand manner that I have adopted, how can I avoid doing so . . . I'd rather make one [painting] well than ten mediocrities. Then there'll be a reward for all the late nights and sacrifices . . . but sometimes you're stopped, like a ship on the high seas, with anchors set."[14] We must ask, then, confronted with the replicas: are these the recourse of an artist at sea, incapable of creating a new work, falling back on the old?

In the same letter, Ingres confided, "Lucky for me, I have never become tired of a work and, blessed with a quite fine technique (if I may say so), the part that I've done over sixty times is never labored or stale."[15] This single sentence carries two essential clues to the artist's lifelong willingness to rework an image again and again, whether on the same canvas or in new formats.

Ingres' student Amaury-Duval suspected half the truth. Having commented upon Ingres' fabulous painting technique, he observed about the leader of the Classical school, perhaps to counter Romantic claims for prodigal creativity as a criterion of genius and *fa presto* technique as its province: "With this facility of execution, one has trouble explaining why Ingres' oeuvre is not still larger, but he scraped out [his work] frequently, never being satisfied . . . and perhaps this facility itself made him rework whatever dissatisfied him, certain that he had the power to repair the fault, and quickly, too."[16] Ingres himself gives us the other, more substantial explanation in his counter

to critics who "observed . . . and perhaps with justice, that I reproduce my own compositions too often."[17] He explained: "Here is my reason: most of these works, which I love because of their subjects, seem to me worth the trouble to make them better, in repeating or retouching them . . . Should an artist hope to leave a name to posterity, then he could never do enough to render his works more beautiful or less imperfect."[18]

Ingres wrote the above in 1859, when he was fully engaged in the construction of his glorified status as the savior of French art; his dicta from his last years must always be read as justifications, not confessions. But many years earlier we hear him, less sanctimonious, more eager, striking the same note. In 1824, unable to borrow back for exhibition *Virgil Reading the Aeneid* (cat. 14), he was cheered by the prospect the setback offered: "It's really lucky that he has not accommodated me because it allows me to reproduce the picture, better than I made it, and with more profit: its subject is so beautiful!"[19]

A canvas might be completed, but the picture never was. Again it is Ingres speaking, this time in 1820 about *Christ Giving the Keys to St. Peter* (cf. cat. 53), just delivered to the church in Rome for which it had been commissioned: "Finished, but never sufficiently according to the ideas I have for a certain perfection."[20] For this canvas and for all his others, the pursuit of perfection meant that a chosen subject could always surpass its present realization, that the artist in his dreams "night and day" could always imagine it anew, renewed.

On the other hand, Ingres seems never to have doubted that his first realization of a subject was valid, if not perfect. In a curious way, his own compositions, once created, acquired for him the authority that the images from the antique and the old masters also had. We must ask then, if his replicas were no different from the traced copies that he took from art works of every era and that in his labyrinthine executive phase transformed the scribbles of a *première pensée* into paint.

His much-loved subjects, whether self-generated or commissioned, were particular to Ingres. At a time when battle scenes and, more generally, physical suffering and psychic melodrama were all the rage, Ingres selected in almost every instance moments of revelation or intimate decision manifested by meeting or

confrontation, but never by violence. Even in his first important painting, *The Envoys of Agamemnon*, which in 1801 won for him the *Prix de Rome*, he managed to distort the topic to reflect his own predilections. The assigned subject was a procession of warriors, which presumably would have been filled with movement and intimations of battle. Ingres instead painted the event toward which the procession marched, the meeting of Greek envoys with Achilles in his tent. It was the personal confrontation and choice (for this was Achilles' moment of decision), not the action, that attracted Ingres.

The subjects that Ingres chose for himself, particularly those for his small historical genre paintings, are especially revealing, as the psychological import often had a connection with the crises of his own career. Who can doubt that the painter, scorned by French critics and living, in his own words, "from picture to picture"[21] in Italy, invested all his embittered fantasies in the motif of Leonardo dying in the arms of a French king (cat. 28-32) or of Tintoretto playfully taking the measure of his critic with a pistol? Even Ingres' *Bathers* (cat. 48,49) and *Odalisques* (cat. 50,51), who seem so withdrawn into themselves, participate in an emotional drama with the unseen spectator, whether their sultan or ourselves, charged with passion by their beauty.[22] The tremendous appeal of Ingres' portraits, both painted and drawn (e.g. cat. 62,63,65,66,76), results from yet another aspect of the concentration on encounter. In them personality is revealed through character, not narrative, but the emotional acuity rendered in a moment of perfect poise is the same as in the historical works.

Even in Ingres' few subjects where action is represented, it is frozen to heighten our realization that the crucial moment is at hand. In *Paolo and Francesca* (cat. 19-24), for example, Ingres chose the moment when Paolo stretches forward to kiss his brother's wife and she drops the suggestive volume of chivalrous tales. Having the book improbably suspended in mid-air only intensifies the sense of time stopped, frozen at the instant before the sword of the vengeful husband is plunged into the flesh of wife and brother. The visual device by which Ingres realized the psychological climax of the subject was refined through the many—at least eighteen paintings, drawings, and prints— versions of the subject.

Ingres' limiting his subjects to only a few favorite themes and their

The Ambassadors of Agamemnon
Paris, Ecole des Beaux-Arts. Oil on canvas, 110 x 155 cm, 1801, reworked c. 1825. (W. 7)

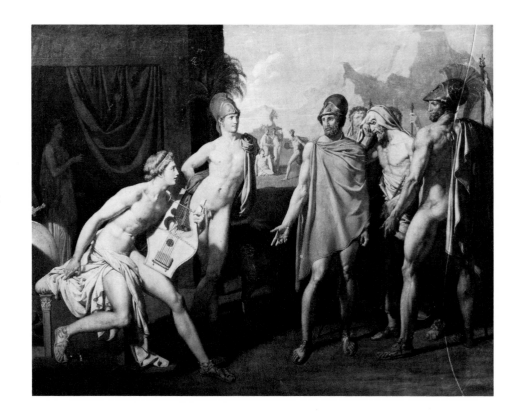

repetition through his entire life's work is comparable to his choice of reading material. The latter was notoriously restricted to "the classics"—Homer, Virgil, Plutarch, other ancients, Dante, histories, the lives of the artists— which he read and reread. It was the same with his picture subjects, as if the telling of a tale could only gain by repetition, much as the best bedtime story is the one the child wants and hears every evening.

Ingres' first version (1814) of *Paolo and Francesca* (Chantilly, Musée Condé) smacks of its prototype, a painting exhibited in the 1812 Salon by Coupin de Couperie and known to Ingres through an engraving; but the replicas increasingly display Ingres' unique conception of the relation between the silhouettes of the illicit lovers. Paolo's throat, swollen with desire, is indeed a copy from Raphael, as has been observed;[23] but as the motif is developed in later replicas, its engorged contour nestles exactly against—without overlapping—the hollow of Francesca's clavicle. Paolo's profile is perfectly flat, so that it is tangent to the curve of Francesca's cheek. The fingers of his left hand pass unseen beneath her hand, and his thumb barely touches her wrist. His right hand rests on the back of her neck and does not dare curl around its curve. In sum, all has been pictorially contrived to present the moment when contact is made but no mingling of forms achieved, the very instant of consummation, with the sin implicit but as yet unsensed.

Paolo and Francesca can be read in other contexts besides that of the subject and its interpretation. It is a perfect example of Ingres' use of, even dependence upon, a specific prototype for subject and general composition, in this case a painting by a contemporary. It also demonstrates his "pillaging without scruple" art of the past, here a Renaissance painting,[24] for the architectural setting of at least some of the replicas. Most important, the general style, insofar as Ingres was a knowledgeable interpreter, was derived from early Italian works. And at the beginning of the nineteenth century, before the development of the modern concept of artistic originality, Ingres was not harshly criticized for poaching from a contemporary; instead, he was criticized for his originality in copying unanticipated prototypes.[25]

At the time, art history as a scholarly enquiry was brand new. Artists and critics outdid each other in their attempts to identify, interpret, and

exploit what they were just beginning to perceive as historical stylistic developments. It was as if only the generation come of age at the French Revolution, which had begun time anew with "L'An I," had the capacity to regard all previous eras as historical, as if it were the first who could recognize in the images of the past the logic of transformations over time.

During the first years that Ingres exhibited his works, critics were preternaturally alert to plagiarisms of style. It was not plagiarism itself, but the particular style selected as well as originality as such, that offended. A reviewer of the 1819 Salon, echoing critics of Ingres' earlier Salon presentations, said of *The Grand Odalisque* (cf. cat. 50,51) and *Roger and Angelica* (cf. cat. 33): "A man whose talent should make him commendable, has, pursued by the mania for originality, sought new paths: he has got himself lost, and the result is the ridiculous extremes before our eyes. M. Ingres has thought that the painting of the 12th and 13th centuries is still fashionable today, or that it could be rediscovered."[26] *Paolo and Francesca* also appeared in the 1819 Salon, but was hung too late to be tarred with this same brush.

Despite Ingres' astonishment and anger at the epithet "gothic" with which "the fools" damned his pictures of "authentic character,"[27] it was an accurate criticism and was predictable given the self-consciously historical frame of reference of the early nineteenth-century artist and critic alike. Even Ingres' earliest pictures prove him a student of the art of all ages, assiduous in his search for historical stylistic prototypes. He insisted that he had painted *Paolo and Francesca* "in its authentic character, and not at all *à la française*"[28]; that is, that he painted it in the manner appropriate to its subject's time, not his own.

Had Ingres been accused of mere compositional plagiarism in copying Coupin de Couperie, he could have pointed to his unique perception of the true style of the subject as his original, creative achievement. In fact, of course, Ingres would never have so responded; for as his pupil Amaury-Duval ruefully observed, "Discussion was, unfortunately, not possible with M. Ingres."[29] But Ingres did grumble into his notebooks: "A skillful painter, who does not run the risk of being corrupted by imperfect models, will know how to take advantage of them. He will extract something from even the worst mediocrity, which in passing

Paolo and Francesca
Angers, Musée Turpin de Crissé. Oil on canvas, 48 x 39 cm, 1819. (W. 121)

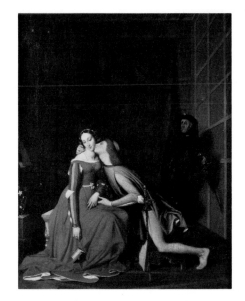

through his hands will be perfected, & he will find in the crude attempts of art before its renaissance original ideas, thoughtful compositions, & what is more, sublime inventions."[30]

As time passed and criticism took its toll, Ingres' choice of sources became less eclectic. Eventually, within his increasingly restrictive dogmatic position, the only tolerated exemplars were the Greeks and Raphael. In 1821, with a characteristically elastic sense of chronology, he declared: "For a long time, my works have recognized no other discipline than that of the old masters, that is to say, the great masters which flourished in that century of glorious memory when Raphael set the eternal and incontestable bounds of the sublime in art . . . I am thus a *conservator* of good doctrine, and not an *innovator*, nor am I as my detractors pretend, a servile imitator of the schools of the 12th and 13th century, even though I know enough to take advantage of more of the fruits than they know how to see."[31] So committed were contemporary critics to art historical interpretations that an admirer of Ingres (who called the painter the new Raphael) found his earlier passage through a "pre-Raphaelite" phase only a necessary stage in his evolution toward artistic maturity.[32]

After 1824 and the success of the Raphaelesque *Vow of Louis XIII*, Ingres rarely executed *new* Byzantine, Medieval, or Oriental subjects. Yet he did complete, or make replicas of, works for which he had undertaken historical research decades earlier. In any case, by the 1840s his portfolios were filled with tracings after reproductive engravings of art works, for this was the particular method by which he commonly digested objects as disparate in scale, shape, and color as Greek sculpture and vases, Early Christian mosaics, Byzantine ivories, and Medieval manuscripts, as well as paintings.

An artist who came to maturity before the invention of photography, Ingres had been visually educated by means of engravings. When as a teacher he had his students copy prints as their initiation into drawing, he was only following the centuries' old academic procedure by which his own juvenile hand and eye had been trained. But engravings were for him more than simply an expedient conduit of historical forms and styles. Ingres asserted: "It is through prints that one judges paintings and their merits. Because the former are more

conveniently and commonly at hand than the latter, you can more readily grasp weaknesses of composition or style, or appreciate more easily and acutely every intention."[33] Prints were purifying agents that reduced, condensed, and distilled all the miscellany of the world of historical art to a tabletop format and a black-and-white, drawn dictionary. Their definitions were exact, and their reductive simplifications, which necessarily omitted every richness and subtlety of the original works, allowed Ingres the liberty to impose his own creative amplifications on his prototypes.

The intellectual necessity for reduction to essence was characteristic of Ingres in every aspect. As much a devotee of music as of painting and equally a man of the pre-recording as of the pre-photographic age, he said, referring to the reduction of orchestral compositions into more accessible piano scores, "I have sublime extracts and, no small thing, I can hear them over again 23 times if I wish, and in truth I believe that it's at the piano that you really come to know a masterpiece."[34] Again and again, whether with Beethoven symphonies at the keyboard, with tracings from engravings, or with replicas of his own works, we find the same need for compression of data and the same esteem for repetition as a means to understanding or to perfection.

The process of tracing is the technical epitome of Ingres' method.

In addition to his tracings from engravings, Ingres took traced copies directly from Greek vases.[35] He felt that from Greek vase painting "one can get an idea of the perfection of Greek painters in drawing," and added, "imagine the greater masters, when you see that men reduced to laboring in [potters'] workshops would have been worthy of comparison to Raphael."[36] Today we can hardly imagine the fascination that lost masterpieces of Greek antiquity held for the late eighteenth and early nineteenth centuries and the intensity with which even the least relics were scrutinized as the key not only to the art of the past, but also to creations of the present. Wincklemann, a theoretician for the Classical school, set the proper note of passionate yearning: "Just as a lover standing on the shore of the sea who follows her departed loved one with tear-filled eyes . . . and even in the distant sail thinks she can see the image of her beloved; we, like lovers, have only a shadowy outline of the object of our desires. But this awakens in us an

The Vow of Louis XIII
Montauban, Cathedral. Oil on canvas, 421 x 262 cm, 1824. (W. 155)

even greater longing for what we have lost, and we contemplate the copies of the originals with greater attention than we would if we were in full possession of them."[37] If one accepted the primacy of the Classical example and if one believed that "mankind itself has its infancy and its youth, and that with the species as well as the individual, when the season of the imagination is gone by, it can return no more,"[38] then, like Ingres, one could legitimately ransack vase painting for inspiration and images.

No doubt the austerity of the vase painters' outline style validated for him the dry and uninflected contours of his tracings, which seem to us such impoverished productions compared to his life studies and portrait drawings. The sheer mass of accumulated tracings in the Musée Ingres proves their importance to him, as do the repeated testimonies of his pupils. Over and over again we read of Ingres taking tracings of their works or keeping tracings that they had done for him.[39]

The "antique" purity of the traced line was not the only stimulating aspect of the technique. Ingres' tracings were typically executed on a translucent paper, *papier calque,* and he seems to have been tempted by this into manipulations and additions to his compositions which could not easily have been done with opaque paper. The expression of two alternate poses is common: a tracing of *Paolo and Francesca* (Montauban, Musée Ingres, 867.1399) for example, records both the profile and front-view arrangements of Paolo's legs that are alternately selected for the various replicas of the subject (cat. 20,21).

Further, we find in Ingres' compositions a consistent willingness to reverse elements or the entire scene, as if he had studied his tracings from their reverse side. His last painted *Stratonice* (cat. 16) is his first seen backward. Paolo (whose profile is patterned on a *reversed* copy of a Raphael prototype) kisses the right or left cheek of Francesca (cat. 20,21). In his painted and drawn versions of *Jupiter and Thetis*, the nymph fondles the god's chin with either hand (Montauban, Musée Ingres, 867.1795, 867.1796).[40] This temptation toward reversal provided by his medium is of a piece with Ingres' use of the counter-proof as a transfer technique (cat. 25), his indifference to the effect of reversal in his own prints,[41] and his exploitation of the many hexagonal mirrors in his studio, which, in the words of a model for *The Turkish Bath*, "permit[ted] him, with a single model, to draw the same

Detail of an Untitled Study after Antique Pottery
Montauban, Musée Ingres, 867.3538. Graphite and watercolor on tracing paper, 19 x 19 cm, n.d.

combination of a Christian martyr and the accoutrements of the Roman empire with the evocation of Michelangelo. *St. Symphorien* was hung beneath "four or five life-sized cows returning to their stable by the setting sun, which were redder and more dazzling than the star itself."[53]

Doubtless the critics who disparaged Ingres' altarpiece were more offensive to him than the gaudy red cows; but it was probably the cows that caused him from that Salon onward to refuse ever again to have his pictures hung with those of any other artist. In fact, after the 1834 Salon, where he was critically bested by Delacroix's and Delaroche's large-scale figure pieces of less than the most elevated subjects, Ingres vowed, in the words of a pupil, "to renounce all work for the government [with the implicit rejection of large-scale commissions], Salons, to work only on little canvases for his friends."[54]

For Ingres, proud of his professional rank, *"peintre d'histoire,"* at the apex of the academic hierarchy, this meant compromise. Henceforth all of his canvases would be life size or less, with the two exceptions of a ceiling painting commissioned by the city of Paris in 1853 and a wall painting commissioned privately in 1839. Neither survives intact: the one, though completed, was burned in the fires of the Commune; the other was left incomplete and is today in a partial, ruinous state. Ironically, only miniature versions present these monumental works to posterity, by accident with the watercolor of the destroyed *Apotheosis of Napoleon*, but by choice with the reduced oil replica of *The Golden Age*, defiantly signed by Ingres "aetatis LXXXII"[55] twenty-three years after his receipt of the original commission.

The contraction of Ingres' format generally went unnoticed among his critics, probably because most of his subjects were set in their definitive scale in oil painting early in his career and because most of his later career was spent in completing these paintings or making replicas and variants of them. These, as they were *not the originals*, were not usually selected for exhibition in his retrospectives. His inclusion of three small drawings by his favored engraver Calamatta in his 1846 retrospective was easily accepted, as they were clearly just substitutes for larger, unavailable paintings and were in any case hung in the entrance rotunda, apart from the main gallery.[56] Yet their presence demonstrates not only Ingres' validation of the reduced format and of reproductive engraving,

but also his commitment to his subject and composition, not to a particular version, and his esteem for the replica as an art form.

Critics who continued to favor Ingres even at the end of his career, when he finally permitted an exhibition of his drawings, made a virtue of the watercolor replicas, whose small scale was appropriate among portrait drawings and life studies. Charles Blanc, referring to versions of *Ossian*, *Romulus*, *Virgil*, *The Betrothal of Raphael*, and *The Tomb of Lady Jane Montague*, remarked, "In a very restricted space and with the adoption of the techniques of miniature, the pencil of M. Ingres knows how to act with as much authority as if it had vaster resources at its command."[57]

Blanc's comment does, however, contain a subtle apology for Ingres' choice of technique as well for his reduced format. Watercolors, drawings, and prints occupied in the academic hierarchy the same lowly position relative to oil paintings as small scale did to large. And just as the hierarchy of scale had been overturned by the middle of the nineteenth century primarily by painters who can loosely be described as Romantic or Realist, so too the technical revolution had been accomplished by artists very far from Ingres in ideological stance. While in the first years of the century, when Ingres still participated in the Salons, drawings (including watercolors, miniatures, and gouaches) were very occasionally exhibited, they were always in the lesser subject genres— portrait, landscape, and still life. Only in the 1830s and 1840s, with the exhibition of monumental drawings of ancient and biblical subjects by the preeminent Romantic Decamps, did critics applaud the potential of the lesser technical genres for serious statements; and by mid-century ten to fifteen percent of the works in the painting section of the Salon were in fact drawings.

Ingres had received his original technical training from his father, a provincial artist whose odd-job talents included miniature painting. Even before the Romantic promotion of watercolor, Ingres had been attracted to it and to wash drawing as a means for reproducing his own composi-tions.[58] Especially in the years when he was isolated in Rome from his few French admirers and also from pictures that he had sent off for display or to clients, he made replicas to show off his conceptions to influential friends in Italy and France. These were often very small, perhaps for ease of shipping: the

The Martyrdom of St. Symphorien
Autun, Cathedral. Oil on canvas, 407 x 339 cm,
1834. (W. 212)

Betrothal of Raphael
Cambridge, Mass., Fogg Art Museum, 1943.374.
Graphite, watercolor, white gouache on tracing
paper, 19.9 x 16 cm, 1864.

The Golden Age
Cambridge, Mass., Fogg Art Museum, 1943.247.
Oil, graphite on paper laid down on panel, 47.8 x
62 cm, 1862. (W. 301)

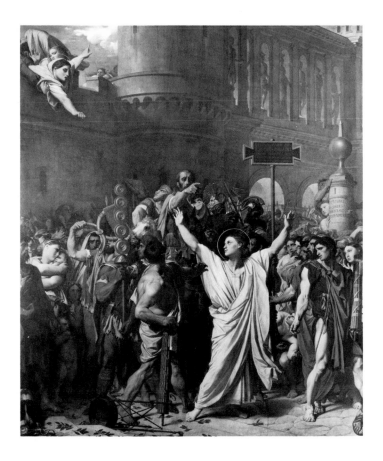

acclaimed exhibition of the royal heir's commission *Antiochus and Stratonice* and the welcome of the painter back from Rome with a formal banquet attended by the whole Parisian art establishment (except Delacroix, whose presence surely would have spoiled Ingres' supper). But the end of the decade saw Ingres' most prestigious commission, the wall painting of *The Golden Age*, in shambles. The royal family, who had favored him with private patronage, had been overthrown by revolution in the streets, and—most crucial for the painter's soul—his beloved wife Madeleine was dead. Ingres' friends solaced him as best they could, but he seems truly to have believed, at age seventy, that his creative life was over. Perhaps to distract the self-absorbed widower, a pupil, Albert Magimel, who was a nephew by marriage of the great French publishing family Firman-Didot, suggested issuing a compilation of Ingres' works.

Although Ambroise Firman-Didot was one of the great connoisseurs of old-master prints of his day, Magimel, Ingres, and the publishing house chose to translate Ingres' compositions into tiny, crude outlines. This style of reproductive print had been introduced at the beginning of the century, when the *Annales* of Salon exhibitions and then the holdings of public and private collections began to be illustrated for popular distribution. The style derived from the fashionable, exquisite outline prints after Flaxman drawings, which were ultimately inspired, like Ingres' traced line, by Greek vase painting and which had a tremendous influence upon Ingres (the Musée Ingres still holds Ingres' collection of prints after Flaxman, which includes rare first editions). The popular reproductive engravings, however, rendered only a barren condensation of the paintings, most of which were not at all flattered by their toneless compression into an octavo page.

Ingres was the last champion of the outline engraving. By mid-century there had been enormous "progress in the arts of reproduction," and the "outline engraving, insufficient and inexact, was, except for the *Annales du Musée,* practically completely abandoned."[64] Ingres, who had been thwarted in his early hopes to see his own paintings reproduced in Salon *Annales,* who over the years had assimilated into his own creations outlines traced from these ready-made dictionaries of artistic prototypes, and who by 1850 was vigilant in his defense

Raphael and the Fornarina
Réveil, 1851, pl. 20.

Raphael and the Fornarina
Réveil, 1851, pl. 99.

of every vestige of the dying Classical school, deliberately chose the archaic medium.

Charles Blanc gave a positive interpretation to Ingres' preference: "In the fear that his design would be suffocated under crosshatching, he often preferred a simple outline to a finished print, and when Magimel, his pupil and friend, had the idea to publish the *Works of Ingres*, the master contented himself with a simple outline engraving."[65] But presumably Magimel and Firman-Didot knew all about the years, even decades, of collaborative revisions that Ingres had imposed upon engravers of his major compositions, such as *The Vow* and *Virgil*. They must have hoped that the tracings and record drawings which filled Ingres' portfolios could be converted in short order into line engravings without awakening the artist's perfectionism.

The book was produced within the year, not, however, with engravings, but with etchings on steel, a relatively new process that was much quicker than engraving. They were executed by Achille Réveil, an aged veteran of outline engraving who had produced volumes after Flaxman (which Ingres owned) and Canova, had illustrated many *Annales*, and had even made in 1828 an outline engraving of *The Grand Odalisque*.[66] It was this version, the same as the Sudré lithograph with the still life, that was etched in 1851; and throughout the plates by Réveil one sees revisions, some subtle, some extreme, of the pictures they purport to reproduce.

Magimel's scheme worked. One letter demonstrates the incredible revival of the mourning, unmotivated painter, now inspired to perfect all at once his entire life's work. Ingres had, apparently, stopped by his editor's house to leave off a tracing and found Magimel not at home: "But where've you been, dear friend, I arrived just this morning to bring you two drawings which I hustled along yesterday and I've come back expressly to see you about others. I waited around for you but left to get back to it, because I am really working to get them even better . . . What do you say? Still *grousing*? . . . Have you made a proof of the [*Duc d'Orléans*]? It seems to me that we're set on the figure; I'm leaving you this tomb of Florence [cf. cat. 36] to guide M. Réveil in its details. And if you still aren't happy, I don't know what I'll do; because it's been found charming. . . . So I took away the *Mars* and the little *Bather*, of which I am going to make *two*. I also want to ask you for *Le Sueur,* which I want to *do over*."[67] Réveil died

the same year, perhaps exhausted by his collaborator; but Ingres found new life. His friend Magimel may have been more perceptive than we know in realizing that the sight of all those past creations—by the painter's definition never perfected—would get Ingres' juices flowing.

When the volume was published, critics habitually favorable to the artist greeted it warmly. In view of the impoverished expressiveness of the prints, their praise strikes modern ears like courtiers' appreciation of the emperor's new clothes; yet Ingres, describing the reviewers Janin and Delécluze as "two divine hymners,"[68] burbled to Magimel, "We're going on under full sail, and it's for you dear friend that I am so happy, for you will finally be rewarded for so much work and so many troubles and cares, all for me, for my poor little glory."[69]

The prints themselves do little for Ingres' "poor little glory," but the many replicas worked up from tracings produced for Réveil's use add significantly to Ingres' perfected oeuvre, and the impulse given by the project seems to have inspired the artist to devote to it the remaining sixteen years of his life. With the exception of the ceiling painting *The Apotheosis of Napoleon I*, several fabulous portraits of society women, portraits of himself and his wife, and a few small archaeological evocations of the antique, Ingres invented no new compositions. All his efforts were turned toward the achievements of his own past. He finished a few canvases begun earlier, but mostly he made replicas and variants of the pictures catalogued by Magimel.

Ingres had been making replicas all along, of course, from the years of his first Roman sojourn onward. As has been indicated, the earlier replicas, both works from the artist's own hands and reproductive prints, had served to inform his friends and a larger public of his accomplishments. And, especially in the case of oil paintings, they had also been made to make money.

The manufacture of replicas of successful compositions by an artist, often with the collaboration of students, was an accepted practice in the early nineteenth century. Ingres' master had set an example: "*Bonaparte at Mont Saint-Bernard* was repeated four or five times by David, and each repetition paid 25,000 francs."[70] Under analogous circumstances forty years later, Ingres and his studio cranked out an estimated nineteen versions of the *Duc d'Orléans* (cat. 67),[71] and the painter regretted

that he had not been able to capitalize further on the unexpected death of the royal heir by the immediate publication of a print of his portrait. He lamented, "I'm sure I'd have had a deal that would have earned a hundred thousand francs."[72]

This mercenary urge by no means minimized Ingres' genuine grief at the death of a patron who, despite his rank, had shown the artist a deferent and affectionate understanding. Typically, Ingres expressed his bitter sense of loss in a wish that his representation of his subject had been more perfect: "Only one thing consoles me, that I was fortunate enough to trace his features; but how I would have wanted to do still better!"[73] Perhaps his unprecedented willingness to copy the portrait so many times was motivated as much by perfectionism as profit.

Even when it was not a matter of a state portrait, a successful composition could engender orders for more. Gérard had painted and sold at least four versions of his *Ossian* over a period of thirty years, and Granet, Ingres' fellow student and friend, had achieved such success at the 1819 Salon with his *Choir of the Capuchins* (to Ingres' intense jealousy) that he painted at least six replicas and sold them all over Europe, mostly to kings and queens.

Developments in the intervening years of the nineteenth century had, however, promoted the concept of artistic originality expressed by unique works. Certainly one factor was Romantic revulsion against the depersonalizations of the Industrial Revolution. The nineteenth-century critic who reported David's profitable trade in copying his *Napoleon* went on to disparage the propagation of the image "a thousand times in bronze and plaster, on clock pendulums and chimney pieces, by graver and chalk, on wallpapers and fabrics, everywhere."[74] By extension, Ingres' repetitive creations were a contradiction in Romantic terms, although even a Romantic artist's replication of his work, such as Decamp's production for a patron of reduced copies after his widely admired drawings of the life of Moses, escaped censure. The following episode, however, indicates the changing temper of the time: "In the summer of 1848, a cousin of [the painter Ary] Scheffer . . . became interested in two paintings by Ingres: *Aretino at the House of Tintoretto* and *Aretino and the Envoy of Charles V*. He had seen them in Paris. . . . Once back home in Rotterdam, he received a letter from Scheffer, who wrote: 'As for the

two paintings by M. Ingres about which I spoke to you, I am not at all interested in them further. M. Ingres has repeated these paintings three times and at this moment he is making them again, for the fourth time. As I know what they think in Holland of these repetitions, I have taken another tack and have asked Ingres to let me know the first time that he has a little original painting to sell.' "[75]

Ingres' manufacture of a state portrait for state purposes was more acceptable, of course, and his trade in oil replicas, especially of his smaller religious and historical genre compositions, seems to have been profitable. They were certainly less costly for the artist to produce, as the life models had already been paid and the time for historical research spent for the first version.[76]

At the end of Ingres' life, his motivation for making replicas was no longer money; there is no doubt that even if changing fashion had made them utterly unsaleable, he would have continued to produce them. In 1860, for example, when he undertook yet another *Raphael and the Fornarina* (his fourth oil version; there are also drawings and tracings), he wrote a friend, "I am taking up again the picture of *Raphael and the Fornarina*, my last edition of this subject, which will, I hope, cause the others to be forgotten."[77]

The mania of his last years to perfect his subjects through replicas began with his work for Magimel in 1850, slackened off briefly as he applied himself to *The Apotheosis of Napoleon I* and several portrait commissions, and then resumed in earnest in the mid 1850s, after his triumph at the 1855 *Exposition universelle*, where a view of almost all his important paintings seems to have reinforced the impulse given by Magimel to "resee and redraw."[78] With his usual paranoid sensibility, Ingres believed he had been humiliated by the decision of the exposition's jury to award gold medals to other artists in addition to himself, including one to Delacroix, "the apostle of ugly."[79] The episode provided Ingres with a rationalization, if one was needed, for withdrawing into the world of his own compositions: "Now, at this moment, they're meeting in all sorts of commissions to sanction these iniquities. I really don't know what I should do. All I do know is that if I don't like what they're doing with me, I'll leave that world, my position, any sort of participation in the art scene, and shut myself up at home to lead

Raphael and the Fornarina
Cambridge, Mass., Fogg Art Museum, 1943.252. Oil on canvas, 68 x 55 cm, 1814. (W. 88)

Raphael and the Fornarina
Norfolk, Virginia, Chrysler Museum. Oil on canvas, 70 x 54 cm, c. 1850-65. (W. 297)

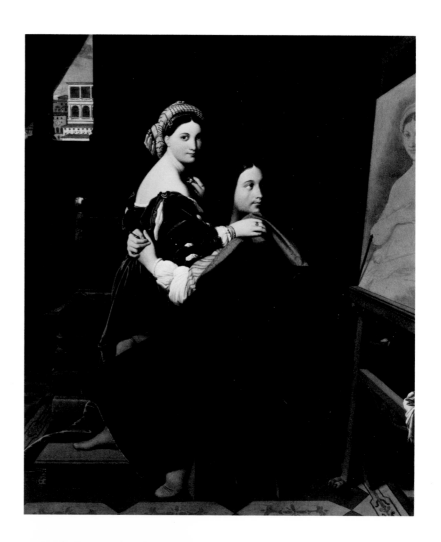

finally a life which, anyhow, I like, retired, calm, entirely disinterested, my last moments given over to the love of art, . . . in living in lazy labors."[80]

What did Ingres mean by lazy labors? Like his master David [81] and his rival Delacroix,[82] he felt an ever more urgent pleasure in "this devil painting whose rage seizes me more than ever at the end of my life."[83] In 1856 he wrote, "I am absorbed by my work, which I have never loved so much as now. The more I age, the more it becomes for me an irresistible need."[84] But work did not mean new work. Ingres described his life at his summer home in the country: "To fill all the empty moments, I work four, five, six hours sometimes, a day; I greatly amuse myself in making drawings after my own works. I have made St. Symphorien, Romulus, a colored one of Charles X in coronation robes [cat. 68], and others."[85] Lazy labors, then, were "drawings after my own works."

And in another reference to this country retreat, Ingres let slip the ultimate clue to his lifelong pursuit of perfection through copying, tracing, and replication. Though the rambling words of a very old man, whose original masterpieces (in the sense of their first representations) had been generated a half century earlier, they illumine his whole life in retrospect. Ingres was giving a view of his prospects for the next few months to his friend Calamatta: "I see myself, then, in my studio free before Jesus [*Jesus Among the Doctors*] and then in perspective in the country [with] *The Homer.* I look forward to it for [there] they leave me alone and I'll be beyond [reach] of the dread of new work."[86]

"The dread of new work." Hans Naef, the cataloguer of Ingres' portrait drawings, has perceived Ingres' dread in the context of his confrontation with the sitter: "Ingres was of such a sensibility that all of his perceptions forced him with the not inconsiderable strength of his whole being into a practically physical constraint. In initiating his artistic exactions from the real, he found anew in each encounter a liability for virtual imprisonment, which time after time was only overcome when the subject was subsumed into his own being, man and artist. The process was comparable to . . . the photographic development of a plate from exposure to image, only in Ingres the transformation proceeded in his most delicate and sensitive nerves. And their restoration to a viable state required the development in full form of a masterpiece."[87]

Odalisque with the Slave
Paris, Musée du Louvre, RF 4622. Graphite, white gouache, grey wash, pen and brown ink on tracing paper, 34.5 x 47.5 cm, 1858. (Del. 228)

The Marytrdom of St. Symphorien
Cambridge, Mass., Fogg Art Museum, 1943.845. Graphite, white gouache, grey wash on laid paper, 47.9 x 40.5 cm, 1858. (Del. 171)

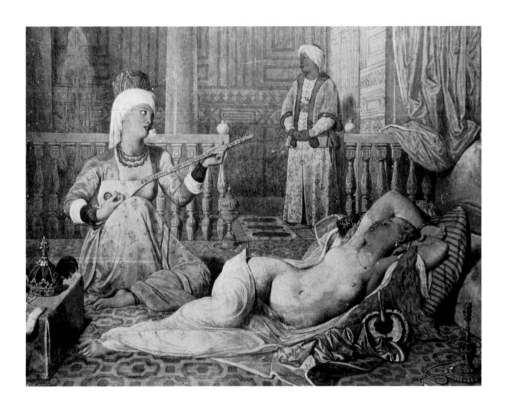

Many authors have seen in Ingres' convoluted drawn preparations for painting and in his practically mythic struggles with his compositions the agony of a man not really suited to his art of history painting. Naef's conception is of Ingres "as a painter of historical, mythological, and religious themes . . . forced to draw upon a capacity that in largest part is utterly innate: imagination, that faculty with which Ingres had been but scantily endowed. He was forced to torture it, and so went to work with an intensity peculiarly his own."[88]

Yet, while some have found Ingres' method "laborious to the point of pedantry,"[89] and "a time-consuming and practically futile battle against the deficiencies of his imagination,"[90] others have seen past it to the ultimately productive arousal of his personal genius. Siegfried has astutely observed that his "research was not the dry and deadening process assumed in almost all interpretations of the artist's historicism; it was instead his personal initiation into a dream."[91] Yet few since Beulé, in his formal eulogy for Ingres in 1867, have conceded the vitalizing potential for Ingres of the working and reworking of given images: "For the masters of the sixteenth century, imitation was . . . not a goal, it was a point of departure. Ingres imitated with the same freedom. . . . The school of history has paralyzed many spirits, it has weakened even the most powerful. Ingres himself would have been more free had he lived in a less learned culture. Yet no one but he has known how to dominate the documents, to make them express what he felt, to vivify them by his own emotion: by the strength of caressing an archaeological detail, he found what he sought."[92] What Beulé does not add is that once Ingres had composed in the first thirty years of his career practically all his repertoire of subjects, this increasingly became his archaeologic source. He dug into his portfolios of record drawings and caressed his own creations, so that they spawned generations of descendants. Perhaps it was easier for the old man than facing "artistic exactions from the real."

Perhaps, too, a law of diminishing returns always threatened to reduce the gain from each subsequent repetition to the point of imperceptibility. But the last years of Ingres' life do seem to have brought him close to the final perfections he sought. And by the simple act of dating them with the correct year of their production, he finally brought himself to admit to the replicas' existence as works of art in their own right.

A curious fact about many, indeed most, of the repetitions of subjects from Ingres' middle age is his subtle refusal to acknowledge them. He did not itemize many in his notebook lists of his productions; of his ten *Virgins*, for example, he catalogued only three. But it is his bizarre system in his middle years of predating his drawn replicas that is most revealing. Self-conscious of the Romantics' criticism perhaps, and of the replicas' reduced format and lesser technical means, he signed them not with their actual dates of execution but with the dates—almost—of his first realization of the motifs.

The dates on these copies, it should be noted, are always preceded by some version of "pinxit" (painted) or "invenit" (invented). "Delineavit" (drawn), when written, seems to have been consistently followed by the correct date of completion of that particular art object. Thus, assuming a knowledge of artists' Latin nomen-clature, Ingres could never have been accused of attempting to pass off the replicas themselves as his first conceptions of the subjects. Furthermore, he and his students were very literal in their Latin: Ingres signed a drawing after Holbein "Ingres copia," and a version of Ingres' figure of *Stratonice* by a pupil was inscribed "Ingres direxit"!

The bulk of the dates on Ingres' replicas of his middle age are, however, predated to one, two, three, even four years prior to the earliest possible date of his original commission. These dates, false in any interpretation, have generated the erroneous idea of Ingres as a more spontaneous inventor of his subjects than he really was and the notion of him imposing them onto his patrons. Ingres scholarship has come to acknowledge the pattern of inconsistency only gradually, although instances had been noted by his earliest cataloguers.[93] Ternois began to correct the misperception by unraveling the chronological skein of all the drawn versions of *Ossian*;[94] Siegfried has proposed a more general structure for the phenomenon.[95]

These misdatings are only one aspect of Ingres' idiosyncratic chronological sense. For example, his *Apotheosis of Napoleon I*, though completed in 1854, is dated "1821," the year of the death of Bonaparte and, to believers, his apotheosis. And the portrait of *Amedée-David, Marquis de Pastoret* (cat. 66), dated "1826," gives the sitter's age as "Aetat. 32." In fact, he was thirty-two in 1823, when Ingres had made his first studies for the painting.

We can only guess at Ingres' motives in predating his replicas. He was probably not simply absent-minded about the actual dates of his earlier life; and in his misdatings, he was careful to maintain the correct relative chronology of his commissions, insofar as this can be deduced from sets of copies done in the 1820s and 1830s and then in 1850 for Magimel.[96] Significantly, most of the misdatings are on replicas of paintings that had been abroad, lost from view, for years. Perhaps in their absence, in his concentration on their images in his dreams "night and day," he had genuinely come to believe that he *had* been possessed by them for more years than the calendar permitted. Perhaps the replicas seemed in his middle age, when the poverty and rejection of his youth had become literally legendary, like resurrections of buried artifacts, to be dated according to their antiquity.

But in Ingres' last years, the replicas, not the originals, received the authentication of their actual dates; and there is no doubt that Ingres believed them all to be his ultimate statement of his subjects. Philippe de Chennevière's inimitably terse, and untranslatable, description of the Bonnat Collection *Bather*, dated "1864" by Ingres, captures their character: "*Dessin d'arrière-saison, un peu froid de pinceau, mais très caressé.*"[97] Again, it is the caressing touch of the artist that his contemporaries could not resist; it characterizes perfectly not only the infinite pains the aged Ingres took with his late replicas, but also the emotion he invested in them.

His friends were disappointed at his concentration on copying. Calamatta wrote Marcotte, who had commissioned several masterpieces from Ingres, beginning with his own portrait (cat. 63) a half century earlier: "M. Ingres writes me that he's at work redoing in small a portion of his works. It would be preferable if he did new compositions, but when you think of his age, he's really allowed to do what he pleases. He is the most dissatisfied of artists, but that's his nature, he has to grumble, it's a good sign: he's in good shape."[98] His friends trivialized Ingres' perfectionism into grumbling, but the artist was proud of his last small replicas. He denigrated the earlier versions: in the face of his drawing *Homer Deified*, he remembered the great 1827 ceiling painting of *The Apotheosis of Homer* as "a *première pensée* vividly expressed but only half rendered."[99] The drawing had been begun a quarter-century earlier as a

copy of the painting for Calamatta to engrave. By the time Ingres finally completed it, "reseen and redrawn," new technology permitted its reproduction as a huge photographic print, which he distributed in a limited edition to a selected band of friends and acolytes.

Continuing a method begun decades earlier, when he had extracted the bust-length *Virgin with the Blue Veil* (cat. 55) from a first version of his monumental, multi-figure *Vow of Louis XIII*, Ingres in his last years sometimes worked up "new" works from fragments of earlier compositions. A head of *Eros* (cat. 18) is a bit of the *Venus Anadyomene*, with which, along with a *Jupiter* (cat. 5) from *Jupiter and Thetis* and several new portraits of gods and goddesses, he decorated a friend's living room. Also, fragments of different compositions could be merged: in *Homer and His Guide* (cat. 47) the blind protagonist of the *Apotheosis of Homer* is led by a boy from *The Martyrdom of St. Symphorien* who, in the altarpiece, had been throwing stones at the saint.

In these cases and others, it is often unclear whether new paintings were made or whether Ingres reworked as finished and self-sufficient pictures sketches of single figures made in preparation for the earlier, larger compositions. Certainly the canvas on which he was working at his death, *Jesus Among the Doctors*, a condensation of the painting finished in 1862, is simply a collage of oil studies for the earlier work, with Jesus' head, two hands, and two feet on individually applied scraps of cloth connected by a lattice of tremulous chalk lines. No work speaks more eloquently of Ingres' rummaging through the debris of his glory in his last days, hoping always to "add to my artistic package of farewell from this world, where every day I am amazed to be with faculties for execution, head and hands, which amaze me myself."[100] If he could have completed it and retained the standard of its present state, the last *Jesus* would have far surpassed in force of effect the tediously elaborated "definitive" version.

As for the late drawn replicas, many seem to be tracings that had earlier served for Réveil's reproductions and were now mounted and colored as little, finished pictures. Others, like the *Turkish Bath* (cat. 49) and the late oil of *Virgil* (cat. 15), were painted directly over actual impressions of reproductive prints of earlier compositions. All the replicas, both oils and watercolors, are quite small; the

Homer Deified
Paris, Musée du Louvre, RF 5273. Graphite, white gouache, grey wash on laid paper, 76 x 85.5 cm, 1865. (Del. 180)

Jesus Among the Doctors
Montauban, Musée Ingres, 867.71. Oil on canvas, 265 x 320 cm, c. 1842-62. (W. 302)

old man was husbanding his strength, to perfect as he pleased as many of his compositions as possible. Dating, media, format—all prove that at the end of his life he was ready "to pack" that "bag" of compositions, which he envisioned "as big and as beautiful as possible, wanting to live in the memory of men."[101] The aged Ingres committed himself to himself, in a grand disregard of the conventional expectations of the "original" artist.

As there is little doubt that his capacities and motivation for original composition were gone by the last years of his life, the question of the value of his replicas is, in a sense, moot. They exist because he could paint nothing else. Moreover, they are not necessary to demonstrate the nature of Ingres' creative impulses; all the earlier manifestations of his urges toward perfectionism—the voluntary restriction of his subjects, the repeated tracings, the many replicas, the subversive transformations of purportedly reproductive images— suffice for that. Yet in the end we must ask, was the chase worth the quarry? Are the last works perfected?

Given that none of Ingres' last productions, for better or worse, can detract from the accomplishments of his earlier years, the example of only one perfected final version is sufficient to answer both questions in the affirmative. We find that perfection in Ingres' last *Virgil Reading the Aeneid to Augustus* (cat. 15). In fact, a completed, definitive version of *Virgil* is not conventionally recognized;[102] we must now be original and seek it in his last copy.

None of Ingres' compositions had a more mysterious origin and convoluted history than *Virgil*. Robert Mesuret cogently summarizes the subject's evolution: "Constantly reworked and constantly neglected, a work of love and work of bitterness, the prodigal child of a too-steadfast god, this piecemeal product of a search of incomparable constancy charmed and crushed the master by turns."[103] The two large oil versions that exist were apparently begun as early as 1811, although their relationship to each other remains uncertain. It appears that the canvas in Brussels (cat. 10) is probably only a fragment.[104] In its present state, the canvas in Toulouse (cat. 14) represents Ingres' work scraped out and overlaid with repaintings by Raymond Balze under Ingres' direction. After Ingres' death, those repaintings were in turn completed with overpaintings by Pierre-Auguste Pinchon guided by

Virgil Reading the Aeneid
Brussels, Musées Royaux, cat. 14.

28

Virgil Reading the Aeneid
Philadelphia, La Salle College Art Museum, cat. 15.

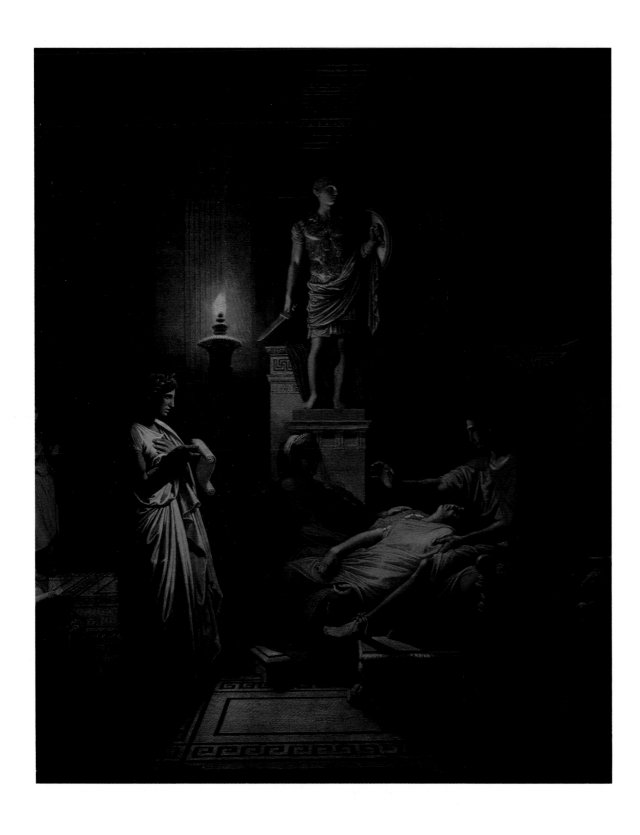

Charles Pradier's reproductive engraving.[105]

These convolutions hint at the complexity of the motif's development through new versions, which survive from every decade of the artist's career and which were perhaps motivated by the production of engravings of the definitive oil painting that did not exist. For example, the penultimate replica, the watercolor in the Fogg Museum, is based on a tracing of a drawing in the Louvre. The tracing was certainly made for the 1832 engraving by Pradier; a contemporary of Ingres noted that the tracing was "taken up again and completed"[106] in 1850, implying its earlier origin. The top layers of the Fogg watercolor, a *papier calque* collage, incorporate changes Ingres drew on a proof of the Pradier engraving (cat. 13). These in turn were adopted by Réveil; the completion of the Fogg watercolor may have been inspired by Ingres' need to formulate yet another perfected version of the composition for the Magimel publication of 1851.

Finally, in 1864, the year in which the eighty-four-year-old artist, still burning with "the fire of thirty years,"[107] made versions in oil, watercolor, and drawing of many of his major subjects, Ingres painted a new *Virgil* directly over Pradier's engraving and transformed the softly melancholic nocturne of the Fogg watercolor into a hallucinatory melodrama. The fastidiously archaeological interior, which had undergone innumerable transformations—statue or no statue, doorway or wall, draped screen or curtain—was finally subordinated to the figures. The figures themselves finally asserted the significance of the subject in a whole representation; the dramatic confrontation of the Brussels version is an artifact of its fragmentary condition. Doubtless the monumental Brussels canvas is to modern connoisseurs the most attractive of all Ingres' *Virgils*; but for those able to overcome traditional prejudices of scale, technique, and originality, the 1864 replica, though small and based on a print, remains the perfect realization of Ingres' idea.

Indeed on the grounds of one definition of originality alone, the late replicas are to be preferred over their definitive "original" versions. Ingres' first major versions of his subjects were frequently executed or reworked with the aid of assistants. As early as 1807 he proposed to enlist a fellow student, an architect at the Villa Medici, to draw the background of his first *Antiochus and Stratonice*.[108] A collaboration also produced the "definitive" Chantilly *Stratonice*. Ingres concentrated on the concept, while his students, conforming to the old masters' studio practices and to those of Ingres' master David, laid out the material work of art. Ingres' pupil Raymond Balze described their roles: "The emotion of Ingres was extreme. He wept from it. He recounted the subject many times while we worked on it, my brother and I. It was I who made the furnishings and the lyre, a number of times repositioned. My brother Paul had for this picture and for the Patron the most extraordinary patience. At first, before the present columns, the background was composed of the *Battle of Arbellus*, after the Pompeiian mosaic, then of the Labors of Hercules, of which practically nothing remains, and finally the columns and all the architecture."[109]

But the last years' productions were the works of Ingres alone. The available prototypes (his own previous versions), the reduced formats and restricted technical means, and the urgent demands of "this devil painting" precluded collaboration. In the little replicas, in every detail caressed to a new, compressed perfection, Ingres finally resolved for himself his lifelong struggle. Not every picture of the 1860s succeeds: surely, for example, the *Philémon and Baucis* (cat. 1) from his middle age is more effective than the last version (cat. 2). But the earlier drawing is itself a replica, and it is definitely superior to the first version. In fact, among the historical compositions, practically all of the subjects gained by repetition.

One can argue about the best version, about the moment when the surge of concentration upon the motif forced contours and details into perfect focus, before a relaxation of technique, sporadically seen in Ingres' later works, blurred the vision. What is indisputable is the value of these replicas as a whole to the understanding of Ingres' ambitions and achievement. And if even one, like the 1864 *Virgil* (cat. 15) or the 1866 *Stratonice* (cat. 16), excels all its earlier versions, then the artist, the plowman driving deep his furrows of drawing, finally gathered his harvest in the ripeness of his old age.

Antiochus and Stratonice
Montpellier, Musée Fabre, cat. 16.

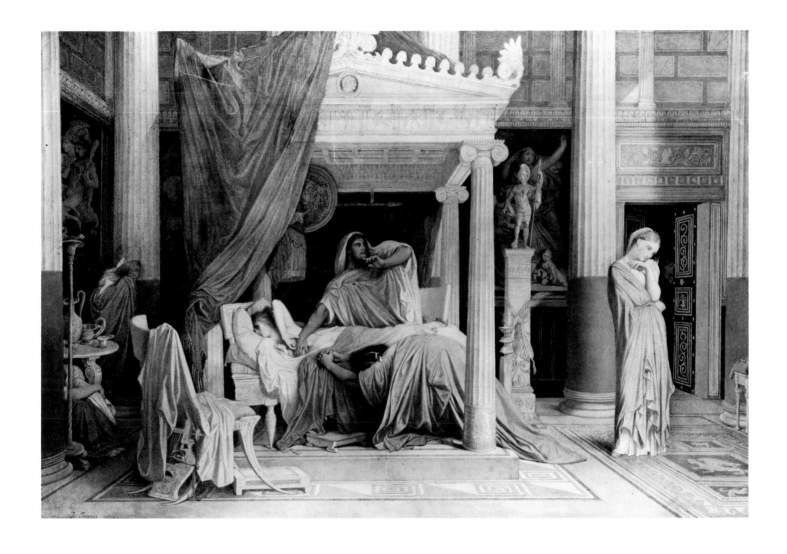

J.-A.-D. Ingres, "Peintre d'Histoire"
Ancient Subjects

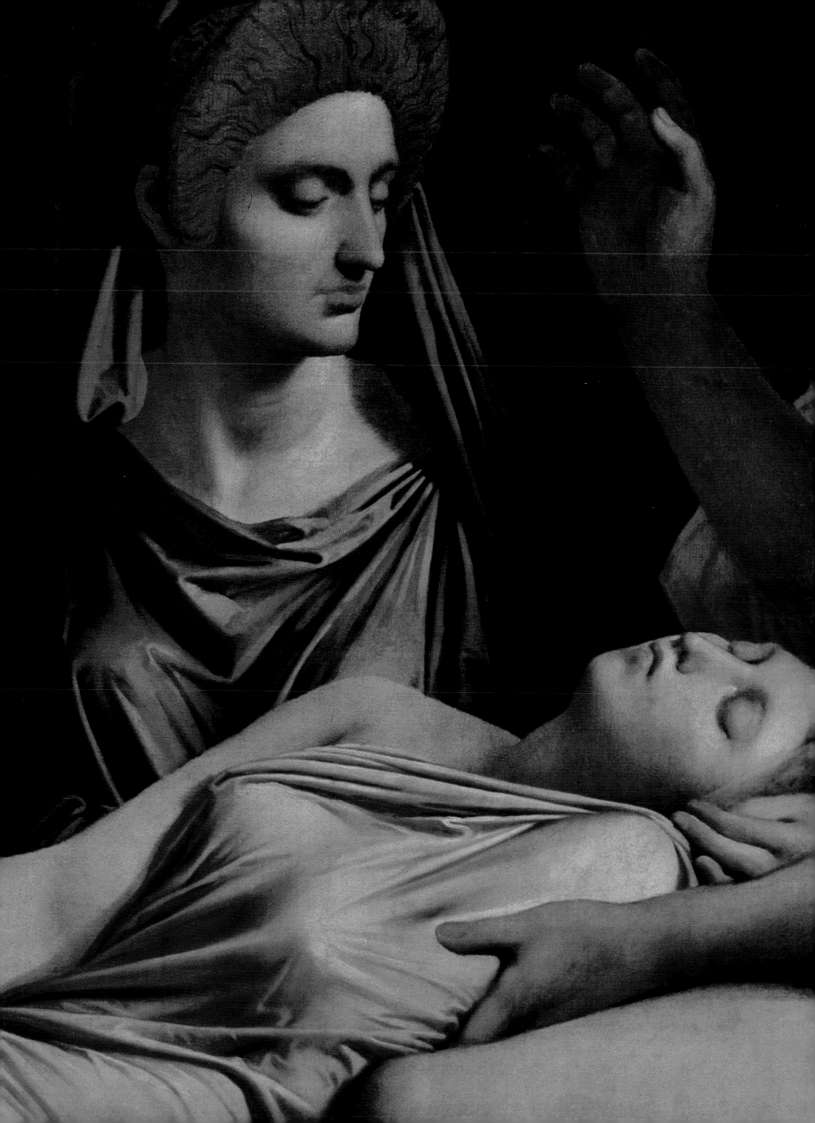

Philémon and Baucis

The first version of Philémon and Baucis is usually dated 1801. As one of the few drawings without a painted version featured in the 1851 *Oeuvre*, it was honored by Ingres as the equal of his monumental compositions. When Ingres gave the drawing to the Société d'Agriculture of LePuy in 1833, he undoubtedly introduced the changes now evident (fig. 1, cat. 1). Ingres masked with a grey wash a water pitcher on the floor to the right of the couple, which is in all other versions. He revised contours of figures and furnishings with brown pen lines. Those additions appear in the 1851 print (fig. 3), suggesting that Ingres kept a tracing done after the revisions. Working from it, he introduced several changes in detail, the most radical of which was the extension of the composition on the right, a format retained in 1856.

The watercolor Ingres gave to Mme. Hennet in 1851 (Del. 183) may have been done over the tracing that had been Réveil's model. Or it was perhaps the print itself, colored by Ingres.

The 1856 Bayonne drawing (fig. 2) is identical in scale to the LePuy drawing, but the details of the scene differ. Mercury, who began with wings on his feet but lost them in the Réveil print, has wings once more and carries his caduceus. Jupiter's head, which at first had the look of chiseled stone, now has the delicacy of the Jupiter in the 1856 *Birth of the Muses* watercolor (Paris, Musée du Louvre, RF12.295). His chair has the curve of a Gothic stool; a slab of stone replaces broken crockery as support for the broken table leg. The distant landscape, previously illuminated by a lightning bolt, is now immersed in dark storm. A tracing in Montauban (MI867.2773) records these changes.

Ingres took up the subject once more in 1864 (fig. 4, cat. 2). Here he broke with the earlier versions by introducing a nearly square format. The work is the most anecdotal of the series. For the first time, Mercury is seated. Jupiter almost grasps the bird's neck. Philémon has the knife ready. His astonished wife has her hands raised and her hood up over her head. The door opens to a vista that only hints of the storm, while inside the deep shadows of the earliest drawing give way to the radiance that surrounds Jupiter.

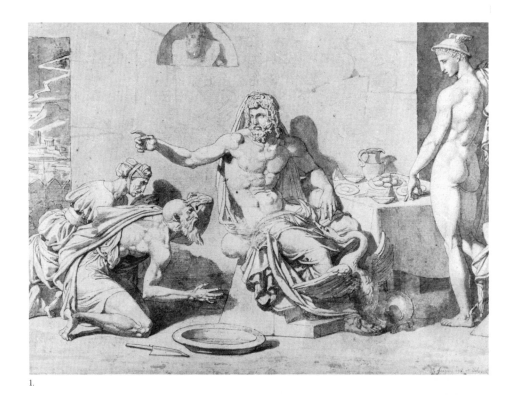

1.

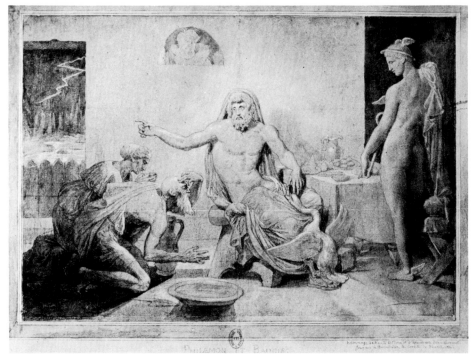

2.

36

1. LePuy, Musée Crozatier, cat. 1.

2. Bayonne, Musée Bonnat, NI 998. Graphite, pen and black ink, grey wash, heightened in white gouache with changes in brown ink, lightly squared for transfer, on wove paper, 29.4 × 44.3 cm. Inscribed l.r.: Hommage de haute estime et d'affectueux dévouement./ Ingres à M. le comte de Nieuwerkerke. Août, 1856. (Del. 184)

3. Réveil, 1851.

4. New York City, Collection of Mrs. Althea Schlenoff, cat. 2.

3.

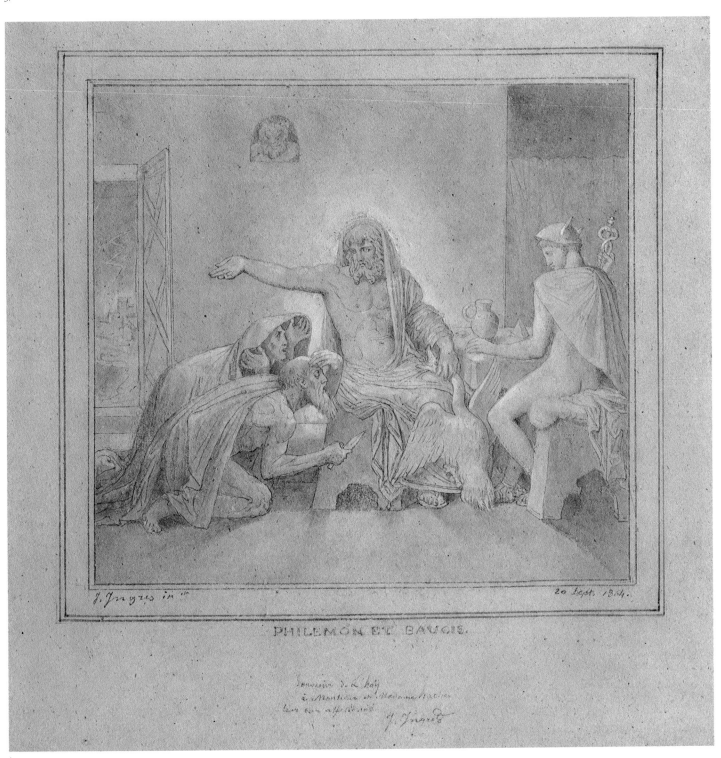

PHILEMON ET BAUGIS.

4.

Oedipus and the Sphinx

In 1808, for the annual envoy a student was obliged to send back to Paris, Ingres settled on two compositions focusing on his expertise with the nude. The first was a female bather viewed full length from the back (the celebrated *Valpinçon Bather*). The second was the earliest version of *Oedipus and the Sphinx*. The handsome "Figure of Oedipus," as the artist referred to it in his Notebook IX (Lapauze, 1901, p. 235), was posed on the foreground of what became the central portion of the Louvre canvas (fig. 1). The face of the Sphinx was an almost unnoticeable detail on the left. The story was merely an excuse for the selected pose.

On his return to Paris in the 1820s, Ingres again took up both compositions. As the *Bather* had been sold long before, the artist had to begin anew. With *Oedipus and the Sphinx*, he indulged in a freely worked oil sketch that was almost a miniature (fig. 2) and then plunged into major changes on the surface of the original envoy.

Ingres changed the "Figure of Oedipus" into a life-size oil to send it to the Salon of 1827. To expand the landscape and to more dramatically treat both the Sphinx and her victims, the artist added 20 cm to the left side of the original canvas, 31 cm above, and 31 cm to the right. New lighting accentuated the disparity between the dark, craggy lair of the Sphinx and the city of Thebes, now bathed in sunlight in the distance. Ingres introduced into the middle ground a fleeing man derived from Poussin. The 1851 Réveil print (fig. 3) must have been made directly from the Louvre painting, as its only change is an additional foot on the victim at the left.

In 1864 the artist completed what he felt was the definitive rendition of the subject (fig. 4, cat. 3). The work may have been started in the early 1830s. His listing of works from that time records a "Petit Oedipe, demi-nature, non fini" (Lapauze, 1901, p. 249). The canvas is the reverse of all other versions. It is also the first to really *show* the Sphinx, as she draws back in horror at the consequences of Oedipus' wisdom. Ingres also substituted two spectators in the left background for the earlier fleeing figure.

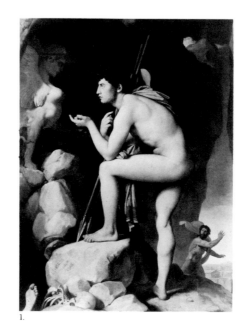

2.

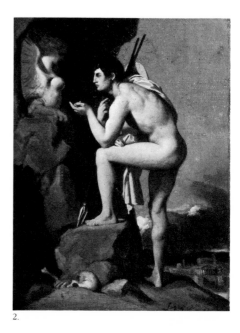

1.

3.

1. Paris, Musée du Louvre, RF 218. Oil on canvas, 189 × 144 cm. Inscribed l.l.: I. INGRES PINGEBAT 1808. (W. 60)

2. London, National Gallery of Art, 3290FS. Oil on canvas, 17.8 × 13.7 cm. Inscribed l.r.: Ingres. (W. 61)

3. Réveil, 1851.

4. Baltimore, The Walters Art Gallery, cat. 4.

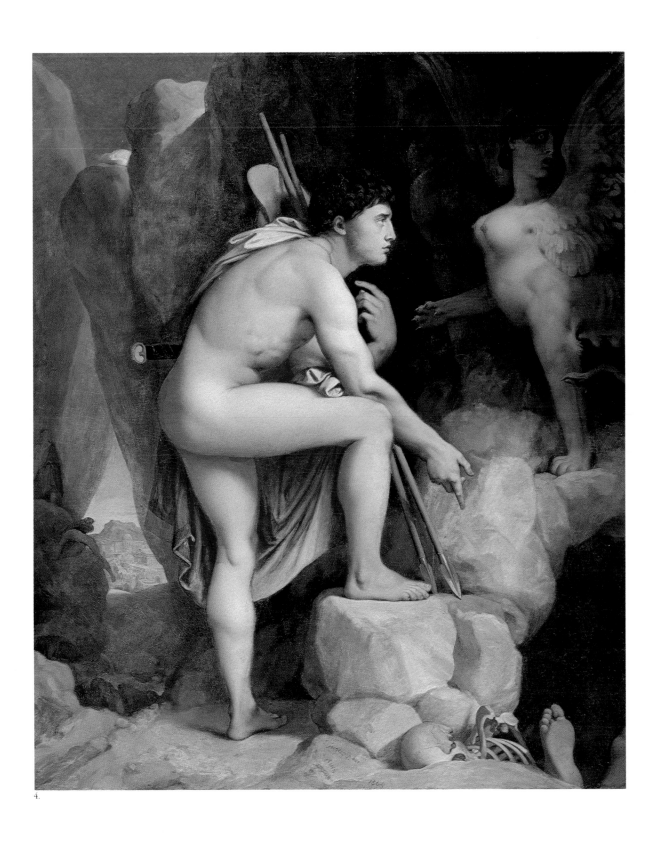

4.

Jupiter and Thetis

Ingres first considered doing a *Thetis Imploring Jupiter* as a possible envoy. In a December 25, 1806 letter to Forestier, Ingres described the work he said was all but composed in his head. In the "divine painting" he envisioned, he hoped one could sense the "ambrosia" of the place and see the full beauty of the divine expressions and forms. Even "mad dogs," he wrote, would be touched by that beauty.

It was 1811 before the painting was completed (fig. 4). The work met with a cold reception and was not purchased until 1834. To modern eyes, it has all the beauty and force Ingres anticipated. The Jupiter that dominates the canvas is an image of male power that is unrivaled. The sensuous curves and pliant posture of Thetis articulately render the sensual intimacy between the two immortals implied in Homer's text. At the upper left, an almost resigned Juno regards the scene, leaning with crossed arms on a cloud. The pose seems strangely tranquil for one of literature's most jealous wives.

An early drawing of the scene (fig. 1) reveals that Ingres' first conception was decidedly less serene. In it a raging Juno enters from the lower left and violently grabs Thetis' drapery. The drawing recalls Flaxman's illustrations to *The Iliad,* which Ingres admired.

The major revision introduced by the artist as he prepared the model (fig. 2) for Réveil (fig. 3) was a change in the position of Jupiter's free arm. Here Ingres cut away the original upper portion so that he could have the god pensively rest his forehead in his right hand. Ingres mounted the two pieces on another sheet of wove paper and drew in the lines between the two parts.

Another tracing from Montauban has nearly identical inner dimensions (MI867.1797). It may be by a student and records a stage between the 1848 wash and the 1851 tracing. Another sketch of the composition was recently sold (Hôtel Drouot, June 2, 1981).

Jupiter's head fascinated Ingres. Two early oil profiles bear traces of both his own *Oedipus* (cat. 3) and Flaxman's *Jupiter.* Two others are replicas finished in the 1860s: the first was one of six medallions for a ceiling decoration (W. 74; USA, Private Collection), the second was an early sketch reworked and enlarged in 1866 prior to its sale (cat. 5).

1.

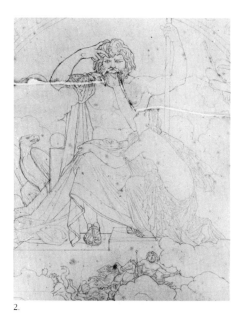

2.

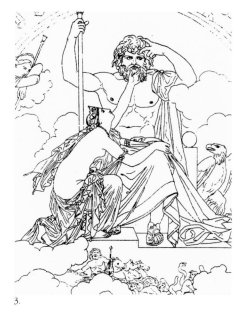

3.

1. Montauban, Musée Ingres, 867.1796. Graphite on tracing paper, 32.5 × 24.2 cm, c. 1807.

2. Montauban, Musée Ingres, 867.1795. Graphite on tracing paper, 40.2 × 30, c. 1857.

3. Réveil, 1851.

4. Aix-en-Provence, Musée Granet, 835.1.1. Oil on canvas, 327 × 260 cm. Signed and dated l.r.: Ingres Rome 1811. (W. 72)

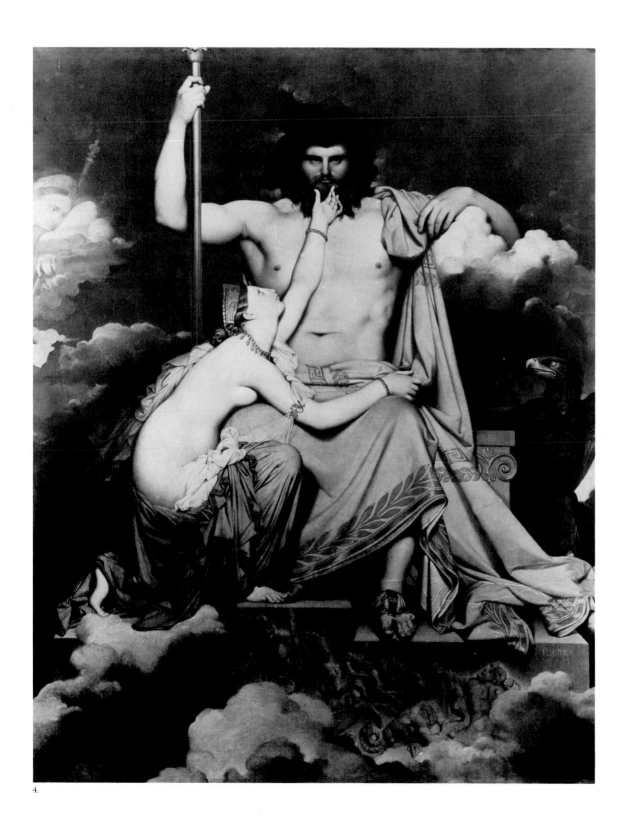

4.

Romulus Conqueror of Acron

Ingres' drawings for *Romulus* reveal that his overall conception of the form and the narrative varied little from the first extant version (fig. 1, cat. 6) to the last (fig. 7). In this sequence, he seemed content to modify minor details of the figures and accessories. He introduced only two major changes: an expanded landscape in the foreground and background and the reversed direction of the charging horse at the center.

The first work, a wash drawing Ingres gave to his dealer Haro, has a single plane of densely packed figures arranged in a manner suggestive of the triumphal processions of antique sculptural friezes. Romulus is poised in the center, with the vanquished Acron lying dead at his feet. One of the soldiers lunges forward to restrain Acron's charging horse. On the left, the Roman soldiers and Romulus' young servants prepare for the procession. On the right, the captured followers of Acron await their fate. One among them bends down to tend the body of the fallen leader.

A second drawing (fig. 2) presents two phases of the evolution of the theme. Under the surface of the present watercolor is an earlier pen, brown ink, and brown wash drawing that linked the Haro wash drawing and the painting (fig. 3). Ingres apparently altered the original of the Coutan drawing to test his changing conceptions for the painting. He gave Romulus a beard and revised the drapery of both Romulus and his servant. The small variations in costume design could have mattered only to an artist whose library was filled with books recording the decor and attire of the past. Ingres also repositioned the foot of the servant to the left of Romulus and the feet of the young soldier with his back to the viewer. He shifted the legs of the front soldier to the right of Acron, and there is a trace of an earlier leg positioned in front of Acron's leg. The drawing has additional details in the foreground, and the developed background shows the city burning and the tumult of the continuing battle. The watercolor washes were added in the 1820s, probably when Ingres was preparing the drawing for Coutan.

The 1851 Réveil print (fig. 6) is predominantly the composition of the Ecole des Beaux-Arts painting (fig. 3). However, it also includes details from the Haro wash as well as new features. Salvaged from the Haro drawing are the position of the feet of the young soldier

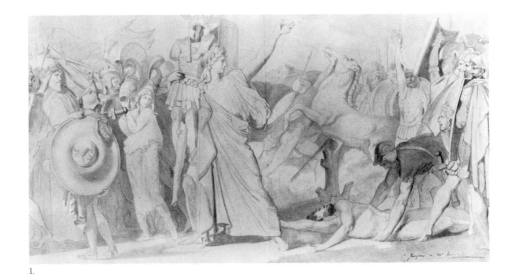

1.

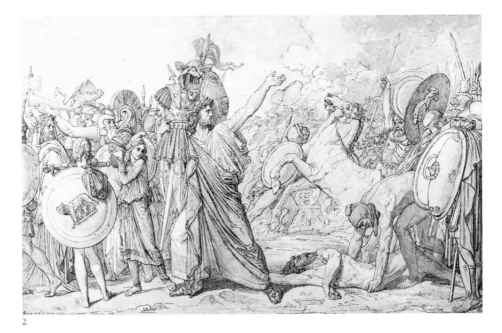

2.

1. USA, Private Collection, cat. 6.

2. Paris, Musée du Louvre, RF 1441. Pen and brown ink, watercolor over traces of graphite on cream laid paper, 31 × 50.7 cm. Inscribed l.l.: Ingres, inv. et pinx., Roma, in Edibus Monte Cavallo a tempera, 1810. (Del. 191)

3. Paris, Ecole des Beaux-Arts. Tempera on canvas, 276 × 530 cm. Inscribed l.r.: Ingres, Rome, 1812. (W. 82)

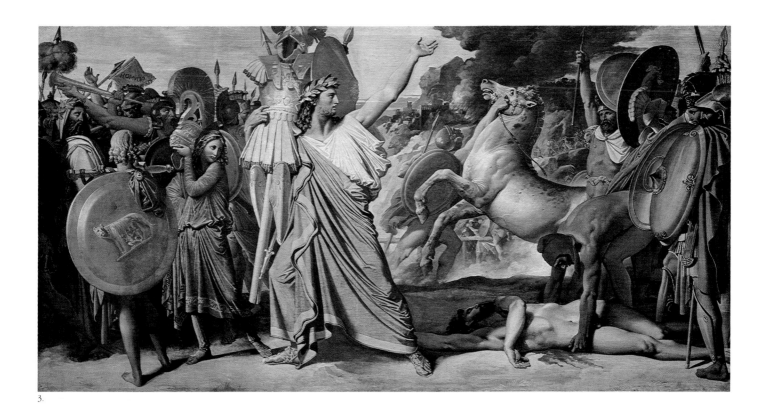

3.

with the shield on the left, the feet of the servant carrying the helmet to the left of Romulus, and the position of the legs of the second soldier on the right. The print introduces several interesting changes. Ingres reversed the direction of the charging horse for no apparent compositional reason and added the figure wrapping Acron's body. The man on the right rallying Acron's troops has moved into a more prominent position. The battle scene behind is given more detailed attention. Ingres has added a bird in flight, symbolic of the victory.

It was probably as he considered the changes for the Réveil print that Ingres contemplated one major compositional revision that he never fully executed. A Montauban drawing (fig. 5) shows the horse charging to the right as in the Réveil print, but Romulus has been moved to the far left of the scene. Another drawing (cat. 7) details this change. Even in the sketched form, the revision completely alters the feel of the composition by shifting the action to one side and leaving a void at the center.

Of the late replica drawings, the "Grand dessin" of *Romulus* that was formerly in the collection of Galichon (fig. 7) is one of the most exquisite. Under the surface of the present wash is a tracing that may have served first as Réveil's model. In the late 1850s, Ingres picked up the drawing once more and added the minutiae he loved in the late years. He "decorated" the battlefield with greenery reminiscent of the 1856 watercolor *Birth of the Muses* (Paris, Musée du Louvre, RF12.295). Below the raised arm of the hero, he carefully stippled in three soldiers' faces, and other new faces appear in the crowd. Acron's right hand is shifted into an awkward position near the figure wrapping his body. This figure is now given more attention as well. Ingres fusses again with the costumes of Romulus and the servant and shifts once more the right foot of the young soldier with his back to us. The version Ingres colored in the summer of 1858 (Lapauze, 1911, p. 502) may be the wash or watercolor drawing photographed by Marville (fig. 4), which was in the Gatteaux collection in the 1860s.

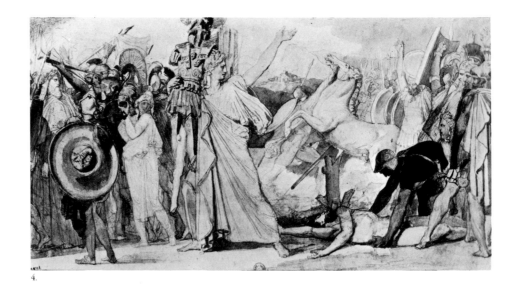

4.

5.

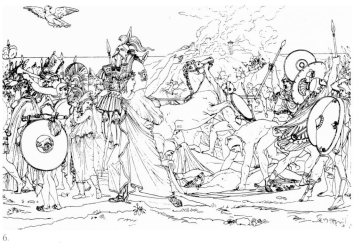

4. Paris, Bibliothèque Nationale. Marville photograph of a pen and black ink, grey wash and graphite drawing, location, size, and date unknown (presumed destroyed by fire in 1871). Signed in ink l.l.: Ingres. (Del. 189)

5. Montauban, Musée Ingres, 867.2130. Graphite on wove paper, squared for transfer, 34.5 × 52 cm, n.d.

6. Réveil, 1851.

7. Paris, Musée du Louvre, RF 4623. Graphite, pen and black ink, grey wash heightened with white gouache on tracing paper, 33.5 × 53 cm. Inscribed in graphite l.l.: J. Ingres in. Pit Roma 1808. (Del. 192)

6.

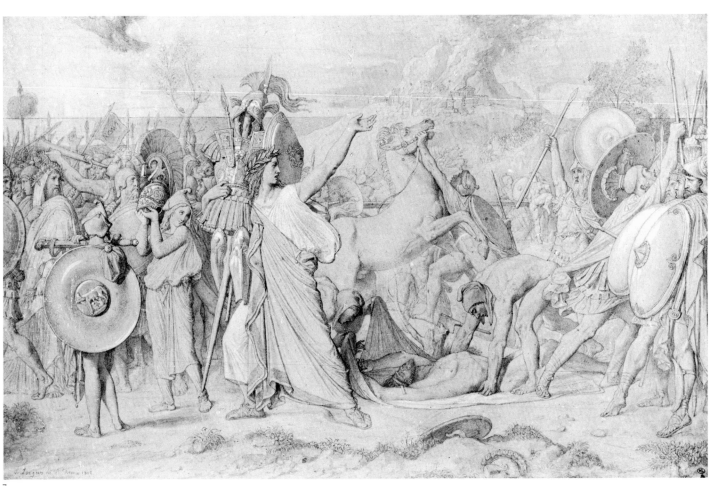

7.

Dream of Ossian

One of the most complicated of the compositional cycles is the *Dream of Ossian*. The huge oil was executed in 1813 as an oval ceiling decoration for what was intended to be Napoleon's bedroom in the Palace of Monte Cavallo. Today it is hard to tell just what the painting was like at the time Ingres finished the commission. In 1835 when he returned to Rome as Director of the Academy, Ingres managed to purchase the painting. With the assistance of a student, Raymond Balze, he began a major reworking of it, eliminating the oval format. The canvas was in his studio at his death, and the intended changes were left as grisaille shadows sketched in and abandoned around the central core (fig. 1). It is impossible to say just how much had already been changed in the central portion. What it was once, and what Ingres intended to make it, we can only surmise from the nine drawings of the whole that exist today.

The first of these (fig. 2, cat. 8) is a watercolor so simple and direct in its approach to the details of the fairy-tale land (twinkling stars, crescent-shaped sailboats, and howling hounds) that it undercuts the awesomeness of the nocturnal dream world of ghosts and death. The work could date from Ingres' student days, when he first confronted similar subjects in the Salons. It is doubtful that the presence of this work in his portfolio in 1813 had much to do with his receipt of the commission for the oil.

There are three drawings that were certainly done near the time of the commission; two are in Montauban (figs. 3,4) and one is in a private collection in France (fig. 5). The first is larger than any of the other drawings of *Ossian*. It maintains the upward-turned face of the sleeping Ossian from the early version, while the line of warriors added to the upper right in later versions is absent. Several elements that will appear throughout the later works are introduced here. The most significant is the transformation of the female figure on the right from one of the harpists into the pensive poetess who will later guide Ossian into the shadow world of death and dreams. Behind her, one warrior with a round shield has moved forward into a more prominent position. The overall shift is away from a planear composition, emphasized in the early watercolor by the horizontal band of warriors standing behind the Snow King, to one of deeper recession accentuated by the converging lines of soldiers.

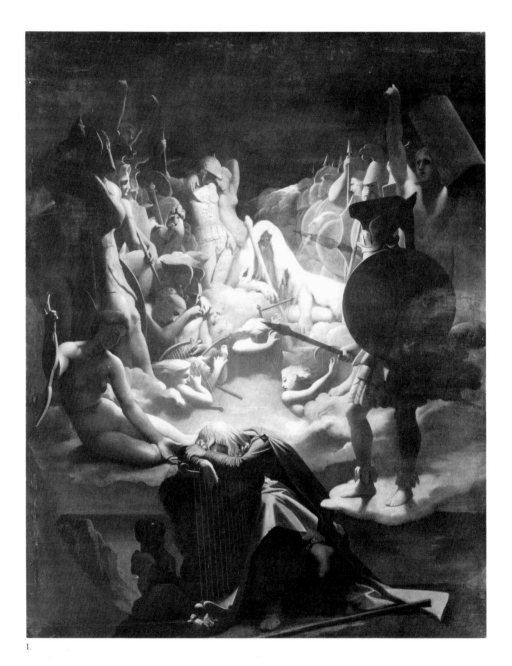

1.

1. Montauban, Musée Ingres, 867.70. Oil on canvas, 348 × 275 cm, c. 1812-13, reworked after 1835. (W. 87)

2. Montauban, Private Collection, cat. 8.

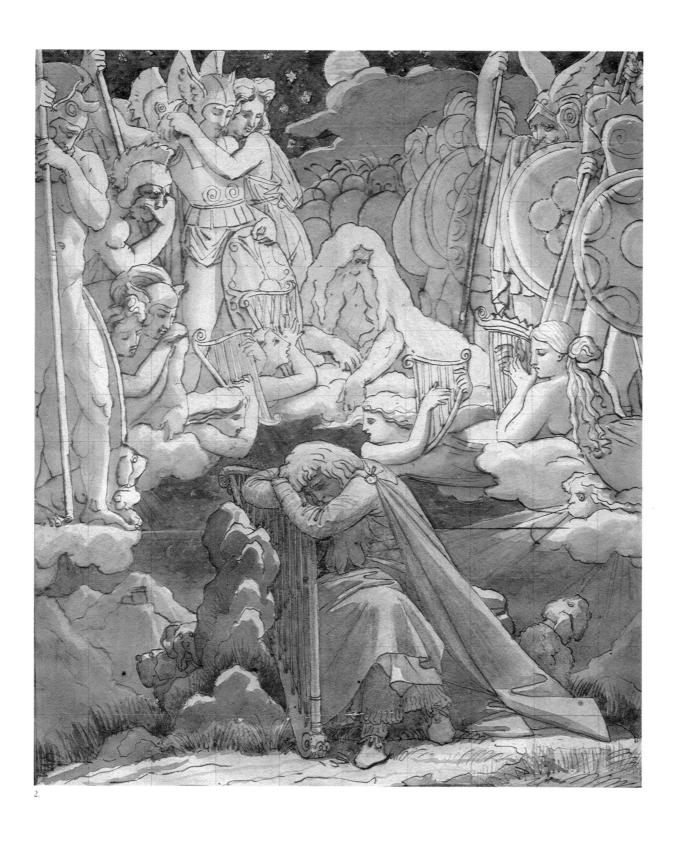

2.

Of the lesser details that will persist through the 1851 Réveil version (fig. 8), the majority are already in place with this trio of drawings. Ossian's harp has a swan at the base; the front soldier on the left is shown full figure with his shield leaning against his leg; two new soldiers have been added to the line; the "Michelangesque" figure (Fingal) has put aside his helmet and is resting a weary old head on his crossed arms; and both pairs of lovers are now entwined in more sensuous poses.

The second Montauban work (fig. 4), which is on tracing paper, was presumably traced from the wash drawing (fig. 5). In both, Ingres has turned Ossian's head to hide his face. And almost as an afterthought, in the tracing the artist has Malvina touch Ossian's arm, a gesture that will characterize the composition in its maturity.

In the late 1820s or early 1830s, Ingres did two related watercolors of the subject. The Louvre work (fig. 6), was traced from the Fogg drawing (fig. 7), as a replica to be given to Madame Coutan prior to Ingres' departure for Rome. That alone may have been reason to take up the composition again. He may also have thought in terms of an engraved version of the subject by Pradier (Fogg, 1980, no. 35), or he may have been readying his thoughts in preparation for the reworking of the canvas itself.

In these watercolors, the drama is more clearly focused than in previous works. To the left, the beloved daughter-in-law Malvina reaches down with a loving touch to guide the old bard into the shadow world. To his right, his son Oscar stands waiting. Minor changes in the landscape and decorative details between the two works suggest that Ingres took up the Fogg drawing again at a later date. Its closeness to the 1851 Réveil print (fig. 8) might offer that as a possible completion date for the Fogg watercolor. Another drawing (Switzerland, Private Collection. Graphite and white chalk on blue paper, 25.5 × 20 cm. Signed: Ingres pinx Rome 1811, Songe d'Ossian, à son ami et cher confrère Hippolyte Lebas) is also close compositionally to the Réveil print.

One can generalize to some extent about the changes Ingres made. In all of the versions from the 1820s on, Malvina has a harp at her side rather than a bow. The single exception is the reworked painting. In all later versions, the soldiers above her and to the left have rectangular shields. The outlines visible on the unfinished canvas suggest

3.

4.

3. Montauban, Musée Ingres, 867.2174. Graphite on tracing paper, squared for transfer, 42.5 × 29.2 cm, c. 1813.

4. Montauban, Musée Ingres, 867.2173. Graphite on tracing paper, squared for transfer, 24.5 × 18 cm, c. 1813.

5. France, Private Collection. Pen and black ink, grey wash on wove paper, 24.2 × 18.9 cm. Inscribed l.r.: Ingres inv(t) et Del(it) 1813, Rome. (Del. 201)

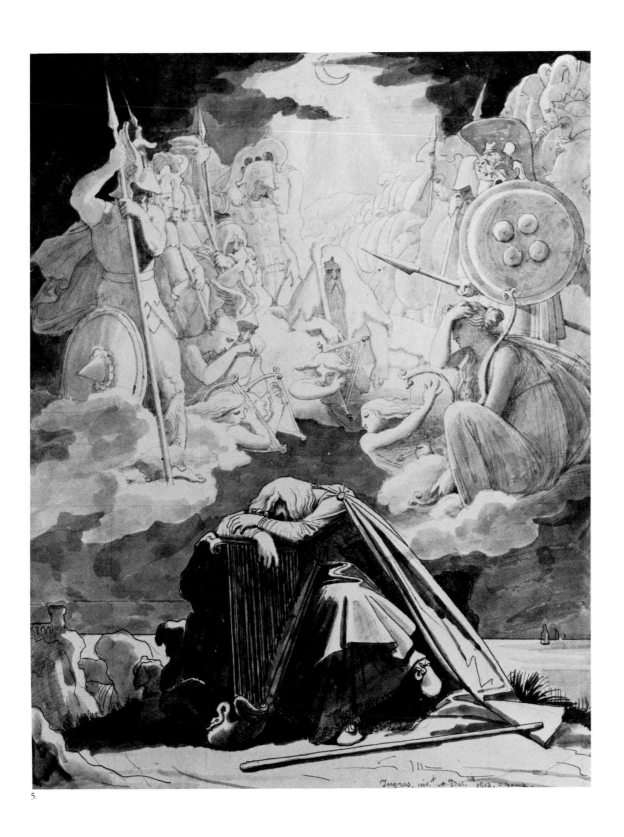

5.

that they may have been intended additions to the painting as well. Ingres repeatedly shifts the position of the dogs within the rocky landscape. He alternates in his handling of Malvina's hair, which either loosely flows on her shoulders or is wound up in a ribbon that trails onto the nape of her neck. The only version in which Malvina is not at least partially clothed is the painting. In all post-1820 drawings and in the 1851 print, the size of Ossian's harp has been reduced and Ossian leans on the rock behind it. In the painting, the harp is full sized.

The final drawing (fig. 9), dated 1866, is on tracing paper squared for transfer. The dimensions are within a centimeter of the Montauban tracing, the 1813 wash, the Louvre and Fogg watercolors (figs. 4-7), and the drawing in Switzerland. As is so often the case, this may well be the drawing prepared for Réveil, which was later altered. The 1866 drawing originally had a border identical to that of the 1851 print. Ingres added a narrow band of paper at both the right and top to make the drawing closer in size to the final painting.

True to his habits, Ingres introduced several elements adding drama to the scene. Replacing Ossian's harp is a female figure who crouches against the dark rock like a creature from the nether world. In the upper right, the first of the soldiers has been turned forward. His arms are raised as he cries out. The repositioning of the soldier occurs in only one other place, the revised painting. Finally, as if he embodied the cycle of Ingres' revisions, the dog which was at the feet of the soldier on the left in the earliest watercolor has come to rest beside Oscar on the right.

The partially reworked painting includes elements from all phases of the compositional cycle. It is therefore likely that its haunted forms are exactly the fusion of spirit and flesh Ingres sought.

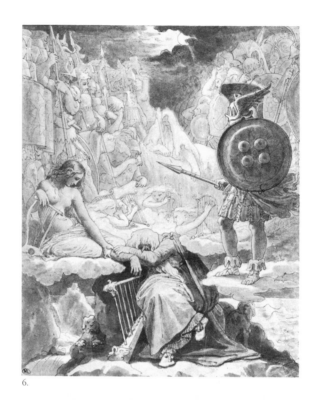

6.

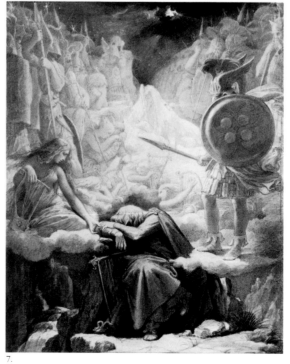

7.

50

8.

6. Paris, Musée du Louvre, RF 1446. Graphite, pen and black ink, grey wash heightened with watercolor and white gouache on tracing paper, 26 × 21.3 cm., Inscribed l.l.: Ingres inv. et pinx Roma in Edibus Monte cavel. 1812. (Del. 199)

7. Cambridge, Mass., Fogg Art Museum, 1943.376. Watercolor, white gouache, and brown ink over graphite and partial stylus outlining on white wove paper, 24.7 × 18.7 cm. Inscribed l.r.: Ingres in E. Pinx Roma 1809.

8. Réveil, 1851.

9. Montauban, Musée Ingres, Deposit from the Musée du Louvre, D.54.2.1. Graphite, pen and black ink, grey wash, brown wash heightened in white gouache on tracing paper, 25.6 × 20.3 cm. Inscribed l.r.: J. Ingres inv. et pinxit 1866. (Del. 202)

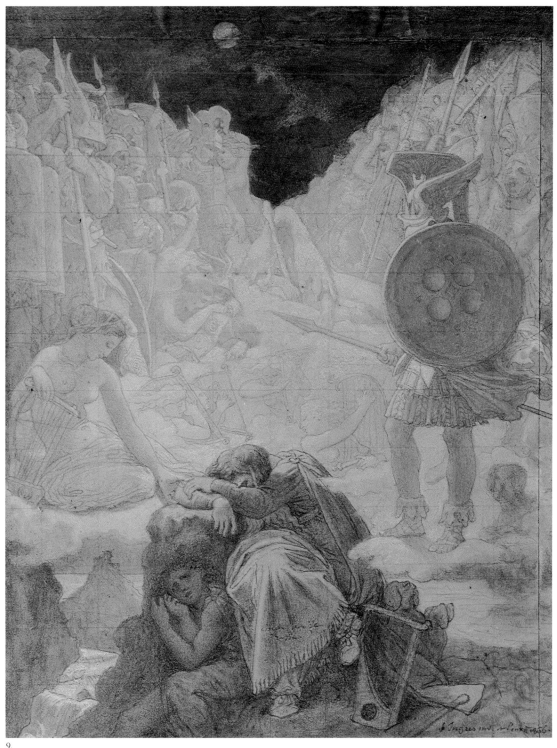

9.

Virgil Reading the Aeneid

The paintings usually considered Ingres' major statement of this subject are actually the least help in understanding what the artist achieved through a constant reworking of the theme. The Brussels canvas (fig. 5, cat. 10), for instance, is only a fragment cut from an unknown composition. The work that could have been the primary statement, that in Toulouse (fig. 11, cat. 14), was, like the *Ossian,* purchased and reworked by Ingres sometime after 1835 and left unfinished at his death. Its present appearance gives no indication of what the original canvas was like. Most of what is now on the canvas is the result of compositional turns the artist took in the handling of the subject during the 1820s.

Ingres developed various components of the composition from approximately 1812 to 1832, when the "definitive" version of the subject — the Pradier engraving (fig. 9) — was completed. The complex evolution of the subject from one version to the next has two major aspects. Through increasing sophistication in the use of pose and gesture, Ingres enhanced the story-telling capabilities of each version. Changes in the presentation of the protagonists allowed Ingres to show an exact moment in the story and the specific relationship of each figure to it. Parallel to this fine tuning of the figures is the manipulation of the architectural background and the lighting, which become progressively important conveyors of the narrative line.

The earliest sketch of the whole composition (fig. 1) depicts Octavia mid-faint with Livia and Augustus reaching out to catch her. In another early sketch (fig. 4, cat. 9), Livia feigns concern for her sister-in-law's plight. The grouping clearly has roots (conscious or not) in a Mannerist *Descent from the Cross.*

At the time Ingres did the Fogg drawing (fig. 2) and the drawing given to Alexander Hesse in 1815 (fig. 3), he had the major elements of the composition in place: the group of three figures on the right, Virgil on the left, and a doorway and candelabra in the center. Unique in this phase is the placement of Livia to the right of the doorway, close to Augustus. The cramped space of this format restricts Augustus' signal to a raised right hand. The Fogg drawing is undated; it could well be the original layout of the Toulouse painting.

Over the years, Ingres made subtle changes in the main figures, and each

1.

2.

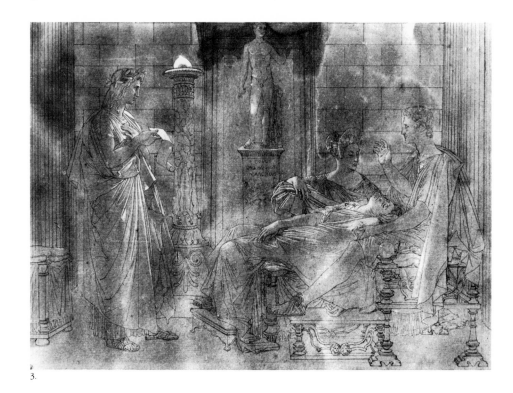

3.

1. Montauban, Musée Ingres, 867.2398. Graphite on paper, 14.8 × 20.2 cm, c. 1812.

2. Cambridge, Mass., Fogg Art Museum, 1965.299. Graphite and grey wash on wove paper, 29.1 × 42.2 cm, c. 1812-15.

3. Bayonne, Musée Bonnat, Inv. 2232 NI972. Pen lightly washed with bistre on paper. Inscribed on verso: à Rome 1815. J. Ingres fec.

4. Ottawa, National Gallery of Art, cat. 9.

5. Brussels, Musées Royaux, cat. 10.

4.

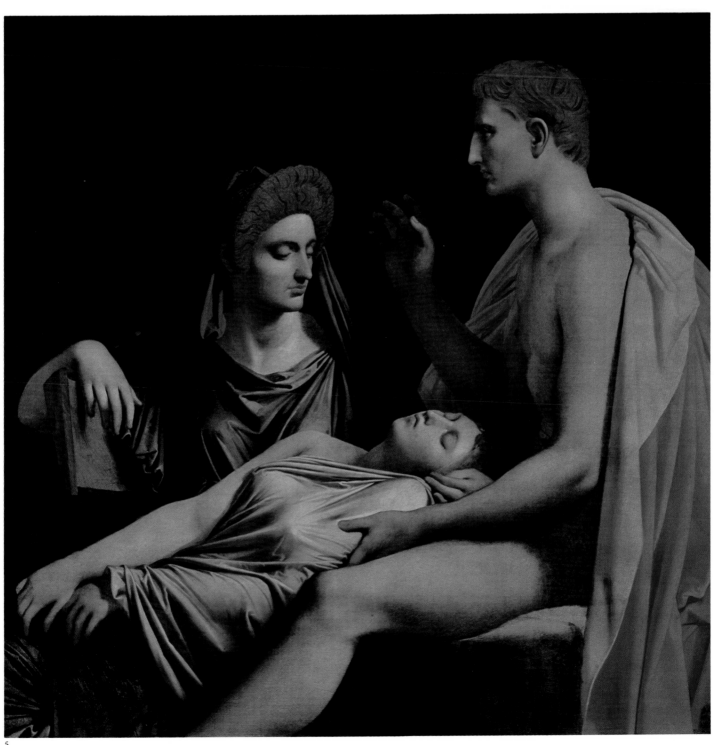

5.

change quietly shifted the emphasis in the story. Virgil is the least changed. In the earliest stage, he is still reading; his eyes are directed down and his feet are flat under him (fig. 2; see also Paris, Musée du Louvre, RF1444). Here he is unaware of both Augustus' gesture and Octavia's fall. The next works depict the following moment, when he becomes aware of Augustus' signal and looks up from his reading (fig. 3). Finally, he starts forward (the raised heel, figs. 6,9,16) and looks down at Octavia (figs. 6,8,9,16).

Augustus originally looks directly at Virgil and has his right hand raised. He is next shown with his eyes directed down to Octavia and his head tipped forward (fig. 7 and cat. 11). His gesture expands to an extended arm as Livia's position shifts to the left (fig. 8). With the Pradier (figs. 8,9) and later the Réveil (fig. 15) prints, Ingres settled on a compromise: Augustus has his head bent down toward Octavia, but his eyes are meeting Virgil's.

Octavia's position, once set, never varied. She is shown fallen limp into the lap of her brother; the only changes are in how limp Ingres made her right arm and where he had it fall.

Ingres decided very early that Livia's function in the story was her indifference. She originally sat close to Augustus with one hand under Octavia (figs. 2,3), but that gesture suggested too much involvement in the action. At first Livia looked very much like the sculpture on which Ingres based her form (fig. 5, cat. 10). The drawing Ingres gave to Marcotte in 1822 (Del. 196; location unknown; repr. Schlenoff, 1956, pl. XII), the first done in a vertical rather than a horizontal format, made Livia's face and attire softer and more feminine. She was still positioned to the right of the doorway. As Ingres elaborated the vertical format, he gradually moved Livia further to the left (cf. figs. 7,8), where she ceased to participate in the event and merely functioned as a necessary compositional weight in the center section.

Ingres' introduction of additional figures makes the scene even more theatrical. The emblematic sculpture of Marcellus appeared in the 1815 Bayonne drawing. Centrally placed, he both presides over the scene and crystalizes the meaning of the death about which Virgil is reading. At first Marcellus is an undeveloped youth. Later the sculpture's stance and physique are those of a heroic young man. By he 1832 print, Ingres had added a sword and a shield, completing the image of the warrior cut down by Livia's treachery. Finally, in the 1865 oil

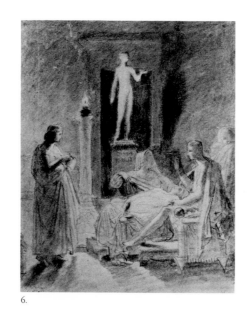

6.

7.

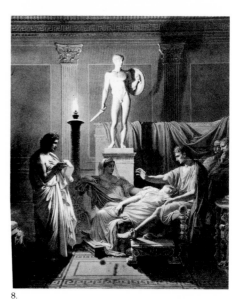

8.

6. Montauban, Musée Ingres, 867.2453. Black chalk on wove paper, 26.1 × 21.3 cm, c. 1825. Inscribed in ink l.l.: Ingres; inscribed with notes for the engraver; c. 1825.

7. Montauban, Musée Ingres, 867.2469. Graphite and brown wash on tracing paper, 49.7 × 44.7 cm, c. 1825.

8. Paris, Bibliothèque Nationale, cat. 13.

9. Pradier, 1832.

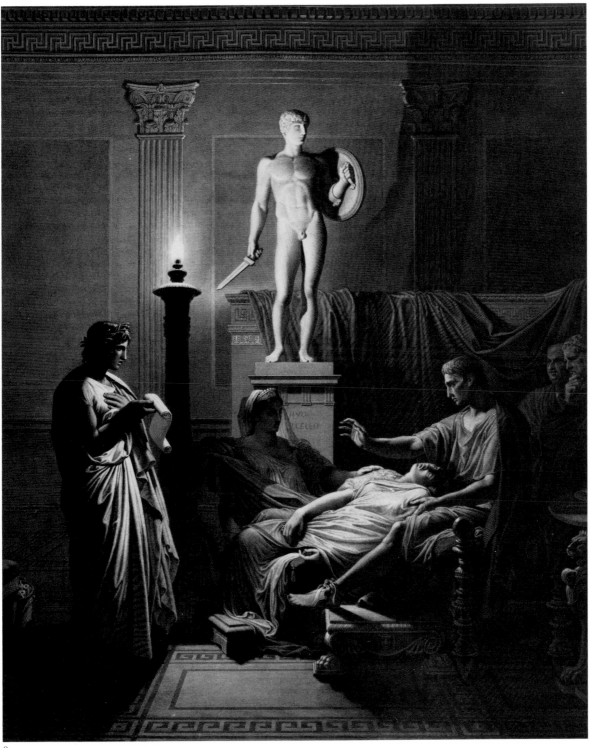

9.

he painted over a print of the Pradier engraving (fig. 12, cat. 15), Ingres covered the nude with a tunic (cf. fig. 14) to please his rather prudish second wife, for whom the work was done.

The number of figures became seven in the 1822 Marcotte drawing with the introduction on the far right of Agrippa and Mécène, two members of Augustus' court. Ingres seems at first to consider them accessories, of no more significance than additional furnishings. He later realized they could have narrative importance if their actions commented on the scene they witness. Instead of two profiles looking toward the center (cf. cat. 11 and fig. 10), Ingres turns Agrippa toward the viewer but leaves his eyes on Octavia and Livia, as if Mécène were about to speak to him (fig. 16). Their reaction confirms for the viewer the court's suspicions of Livia's guilt.

The final figure added is the servant girl peeking from behind a curtain on the left in the 1865 LaSalle College oil (fig. 12, cat. 15; cf. fig. 13).

Ingres also modified the architectural setting. He began with a simple horizontal space barely large enough to contain the figures. In the Fogg drawing (fig. 2), he further defined the doorway with moldings and brackets and hinted at pilasters on each side. The Bayonne drawing has a more elaborate doorway framing the sculpture. Here Ingres also gives texture to the wall surface and begins to define three-dimensional space by extending columns toward the viewer.

In the early 1820s, Ingres realized that if he wanted to introduce additional figures he needed a larger stage. The horizontal format had little to offer the artist after the addition of the figure of Marcellus, so he abandoned it to gain height. The only exception to this after 1822 is the reworked Toulouse painting, to which Ingres had tried to add considerable height but had cut it back again in frustration (E. Gatteaux, letter to the Mayor of Toulouse, April 17, 1867, Musée des Augustins).

To heighten the dramatic effect, Ingres began emphasizing both focused light from a single source — the candle — and the shadows created by it. He executed a chalk drawing (fig. 6) as a study for his engraver of the effects of the single-source lighting. The most impressive effect here is the shadow of the youth looming ominously over the scene.

In other studies Ingres focuses on the fine details of his setting. There is a study (fig. 7) for the elaborate doorway later incorporated in the Toulouse

10.

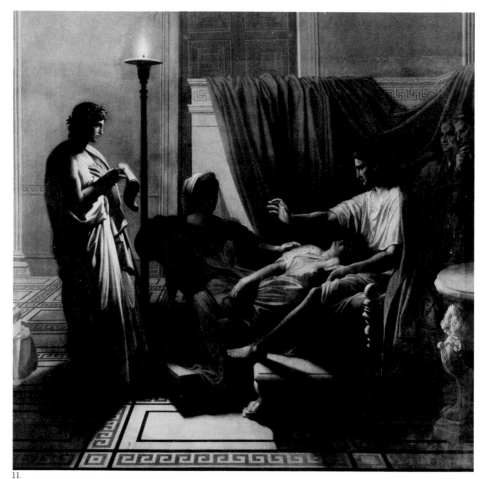

11.

10. Montauban, Musée Ingres, 867.2480 (detail). Graphite, pen and brown ink on tracing paper mounted on cream wove paper, 20.1 × 13.2 cm, c. 1825.

11. Toulouse, Musée des Augustins, cat. 14.

12. Philadelphia, La Salle College Art Museum, cat. 15.

13. Montauban, Musée Ingres, 867.2461 (detail). Graphite on tracing paper, 29 x 18.4 cm, c. 1825.

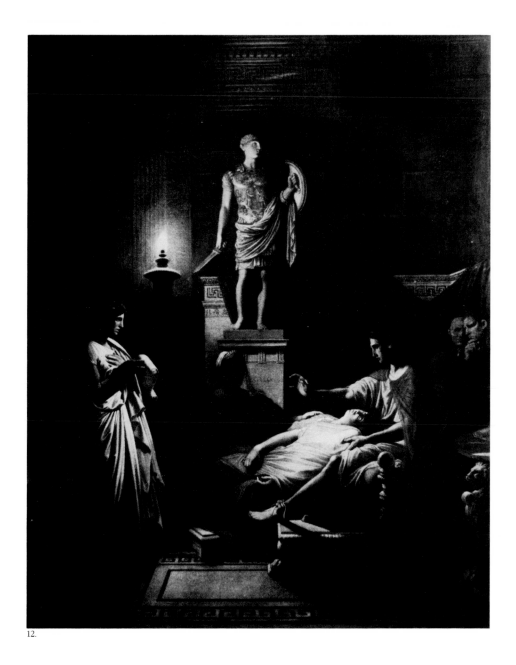

12.

13.

Antiochus and Stratonice

The development of this sequence parallels the evolution of *Virgil Reading the Aeneid*. Both began as simple formats in a limited spatial plane containing sparse furnishings and minimal characters, and both were expanded over the next six decades.

In style and composition, the Boulogne drawing (fig. 2) resembles other wash drawings done by Ingres while in David's studio. Both the figures and the setting recall David's *Oath of the Horatii* and *The Death of Socrates*. The Boulogne work is the only version in which Stratonice is seated and the only one to place a figure of her servant so prominently at her side. On the reverse is a scene from the *Iliad's* story of Achilles, suggesting a date of 1801.

The Louvre drawing (fig. 3) has a decidedly archaic look but a more sophisticated handling of the subject. An aloof Stratonice stands at the foot of the bed, turned away from the drama of which she is the object. The doctor, Erastratus, is seated on the bed with one hand on the chest of Antiochus and his eyes on Stratonice. Antiochus has one arm thrown back over the pillows and one foot dangling off the bed. His father is bent over with grief against the back wall and hides his face. A doorway breaks up the expanse of the rear wall. The design is flat, the execution labored and precise. A tracing in Montauban (fig. 1) repeats this composition with a line quality that suggests the hand of the artist at a much later date.

In 1834 the Duc d'Orléans commissioned from Ingres a *Stratonice* as a pendant to Delaroche's painting *The Death of the Duke of Guise*. An unfinished oil sketch of the subject now in Cleveland (fig. 4) may have been executed with this commission in mind. The work introduced the distinctive Stratonice pose (cf. cat. 17). The most striking feature of this painting is the odd column to the right of the heroine, which seems to float in mid-air because of the way she is positioned beside it. The doctor has been moved into his final position and stands behind the bed with his arms and body theatrically posed. The lover now exhibits an anguish that contrasts with the limp acquiescence of the Louvre drawing. The father has been moved to the foot of the bed, where he is slumped over in despair. The extension of the foreground by way of the patterned floor and the open door behind Stratonice adds a three-dimensionality that was absent in the earlier drawings.

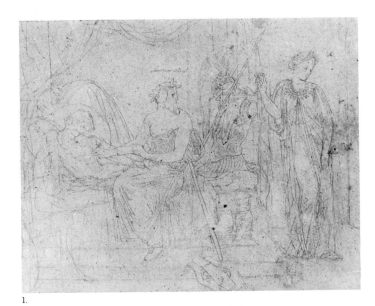

1.

2.

60

1. Montauban, Musée Ingres, 867.2193. Graphite on tracing paper, 22.1 × 31.3 cm, c. 1856. Inscribed: La tete eu arrière.

2. Boulogne-sur-Mer, Musée des Beaux-Arts. Graphite, grey wash, pen and black ink on paper, 32 × 40 cm, c. 1801. Inscribed in ink l.c.: Stratonice debout sur la meme place.

3. Paris, Musée du Louvre, RF 1440. Graphite and brown wash on wove paper, 29 × 40 cm, c. 1807. (Del. 188)

4. Cleveland, The Cleveland Museum of Art, Mr. and Mrs. William H. Marlatt Fund, CMA 66.13. Oil on canvas, 47.4 × 63.5 cm, c. 1834. (W. 224)

5. Chantilly, Musée Condé. Oil on canvas, 57 × 98 cm. Inscribed: J. Ingres F(at) Rome, 1840. (W. 232)

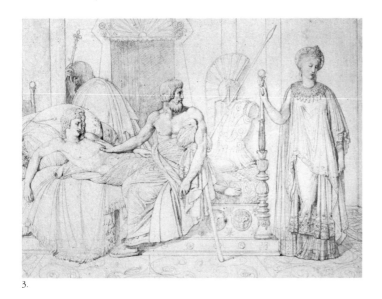

3.

4.

5.

The painting done for the Duc d'Orléans (fig. 5), which Ingres did not complete until 1840, includes a full cast of characters set into a room whose splendor recalls Pompeii. The architecture owes much to the designs of Ingres' friend Victor Baltard and to Ingres' able students Raymond and Paul Balze. Required to extend the width of the composition to match the pendant in the Orléans collection, Ingres added an impressive array of new characters. At the far left, a servant is attending to the perfume. At the far right, a distressed friend leans against the column, while the nurse huddles under the table. A servant peeks through the door behind Stratonice. The four main figures are posed as in the smaller painting (fig. 4). The 1851 Réveil print (fig. 8) is faithful to the Chantilly painting.

Ingres painted a reduced version of the subject with a reworked composition in 1858-60 (fig. 6). The work returns to the less flamboyant setting of the Cleveland oil. Ingres kept a tracing of it (fig. 7). The most striking aspect of these two works is the inclusion of a pair of handsome dogs. The tortured pose of Antiochus in the painting is unbelievably strained, whereas the drawing has a simpler pose for the figure. Stratonice wears a crown for the first time, and Seleucus' long sceptre is propped against the column. Only one servant remains; with her hands on the door, she looks as if she is about to enter the room.

Ingres did a reversed version of *Stratonice* (fig. 9), which is narrower than the Chantilly version. It seems likely that this was the "calque colorie de *Stratonice*" (Lapauze, 1901, p. 249) Ingres listed in Notebook X as having been done at Dampierre (1843-1849). He mounted this watercolor and reworked it in oil at about the same time he reworked the Pradier engraving of *Virgil* (cat. 15) for Madame Ingres' collection. Ingres called this his "second painting of *Stratonice*" (Lapauze, 1901, p. 249). The colors are exquisite, and the artist clearly used the washes to divert the eye from his esitations in the form: ie., the duplication of the servant's arm against the column on the left and the change in the form of the drapery on the temple.

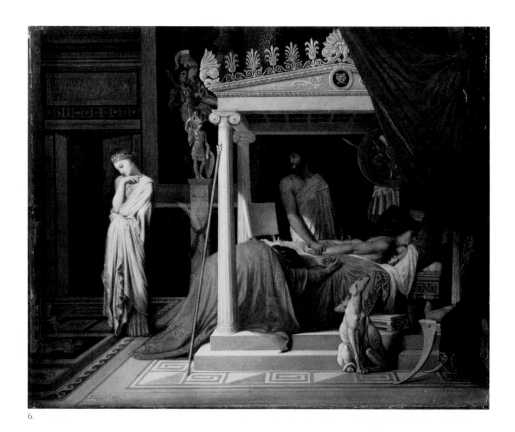

6.

7.

62

6. Philadelphia, Collection of R. de Schauensee. Oil on paper affixed to canvas, 35 × 46 cm. Inscribed: J. Ingres pxit 1860. (W. 295)

7. Montauban, Musée Ingres, 867.2194. Graphite on tracing paper, 33 × 40 cm, c. 1860.

8. Réveil, 1851.

9. Montpellier, Musée Fabre, cat. 16.

8.

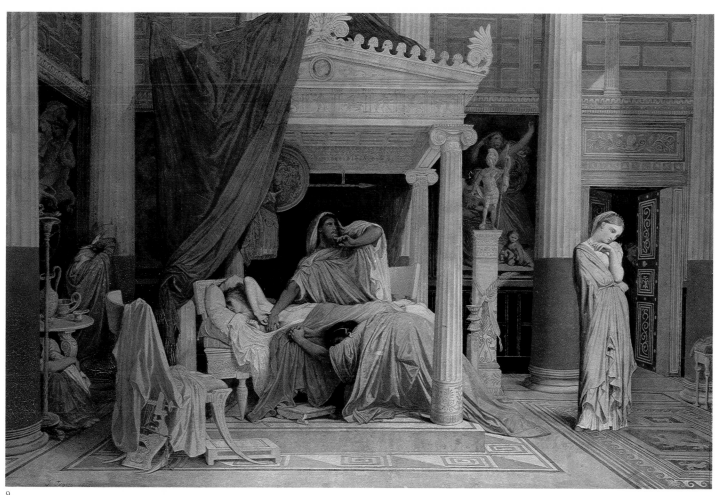

9.

Venus Anadyomene

One of Ingres' compositions with the
slowest gestation was the *Venus
Anadyomene* or the *Birth of Venus* (fig.
4). It was begun in 1807 and left
unfinished until 1848. Despite this
extraordinarily prolonged executive
phase, the first and final conception are
remarkably of a piece.

An early sketch (Montauban,
Musée Ingres, 867.2301) shows that
Ingres first thought of Venus in the
classic *Venus Pudica* pose, in which,
just becoming aware of her nudity, she
modestly covers herself with her hands.
Another sketch (fig. 2) leaves little
doubt that Ingres' artistic source was
the celebrated Botticelli painting of the
same theme. Surrounded by a host of
zephyrs, Venus rises from the sea. Her
hands are chastely placed, her head is
in profile to the right, and her right foot
rests on a shell. The purity of the
contours and the successful resolution
of figure and ground make one wonder
why it took Ingres forty more years to
finish the painting.

The reason is that he almost
immediately abandoned this treatment
of the subject to work on a more
difficult one. He changed the moment
depicted in the scene and had some
difficulty realizing the new concept. A
drawing similar in dimensions and
media to the preceding one shows
Venus at an earlier, more innocent
moment, still unaware of her nudity
(fig.1). The placement of her hands
below her breasts emphasizes her
awakening sense of her own form. In
what was the genesis of the final pose,
Ingres has also sketched her with her
arms over her head. The artist
substituted for the bodiless, winged
zephyrs flitting above the water in the
earlier sketch the marvelous pudgy
cupids paying court to the young
goddess. The early oil cited by Ingres in
Notebook IX from the Roman period
(Lapauze, 1901, p. 235) may have
reached about this point when Ingres,
unable to decide on the correct
position of Venus' arms, abandoned it.

While working on the *Venus,*
Ingres began a painting of a water
nymph known as *The Source.* She too
had a slow birth; conceived about 1820,
it was 1856 before Ingres finished the
work (fig. 8). An early Montauban
drawing (fig. 7) demonstrates the
affinity between the figures of *Venus*
and *The Source.* Within the multiple
contours suggested for the arms, hands,
legs, and feet are the final poses of both
figures. The beauty of the final form of
each work justifies the long wait (figs. 4,
8). Ingres finished the *Venus* while in

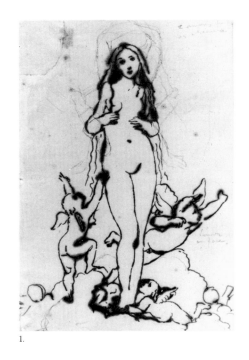

1.

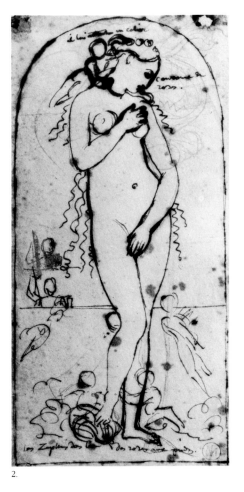

2.

1. Montauban, Musée Ingres, 867.2303.
Graphite, pen and brown ink on paper, 18 x 12.3
cm, c. 1807. Inscribed u.r.: 2 amours lui. . .ses
cheveux. Inscribed below: l'amour en face.

2. Montauban, Musée Ingres, 867.2302.
Graphite, pen and brown ink on paper, 19 x 9.4
cm, c. 1807. Inscribed in ink l.c.: les Zéphirs dans
l'eau/des roses aux pieds. Inscribed in ink above:
il lui attache un collier/couronne de roses.

3. New York City, Ian Woodner Family
Collection, cat. 18.

4. Chantilly, Musée Condé. Oil on canvas, 163 x
92 cm. Inscribed: J. Ingres Faciebat 1808 et 1848.
(W. 257)

3.

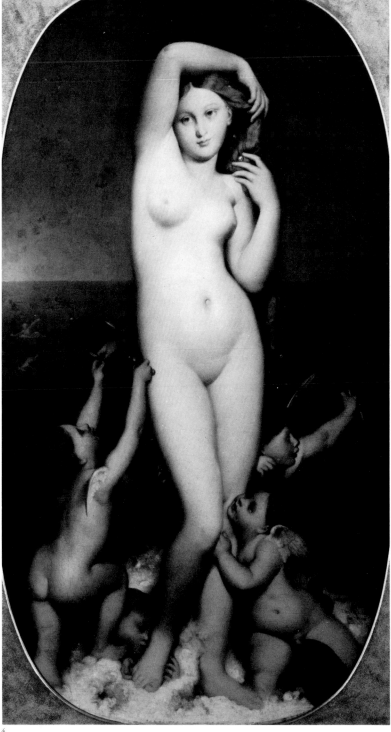

4.

safe retreat in his studio prior to the worst of the June 1848 revolution. As a symbol of innocence, beauty, sensuality, and grace, Ingres' youthful goddess can hold her own against those of the Italian masters, whose perfect forms had no doubt intimidated Ingres until, in his maturity, his vision equalled theirs. In the final plan for the *Venus* (fig. 4), the cupids become more important. On the left, one holds out a mirror, which symbolizes the moment when the goddess will become aware of her nudity. To her right is Cupid (Eros), the god of love, who is Venus' son and her constant companion. This Eros pleased Ingres so much that in 1864 he used the figure as one of the medallions of gods and goddesses done in oil for the architect Hittorf (fig. 3, cat. 18). A lovely tondo of Venus (W. 258; location unknown) was part of the same commission.

There are several other versions of the *Venus.* The 1851 Réveil print (fig. 5) is identical to the Chantilly painting (fig. 4) except that Venus' face is now more rounded. A tracing from the Vieillard Collection (Réunion des Musées Nationaux photo 78EN975) is almost identical to the print. Wildenstein (1954, pl. 78) reproduced a watercolor version of this subject without giving the location, size, inscription, etc. It appears to be one of the loveliest of the late watercolor replicas, done over a tracing in thin veils of layered colors. In the late 1850s, Ingres did a small version of the Venus for Marcotte-Genlis (fig. 6). He also did a reduced version of *The Source* for him (W. 286). Both recall the diminutive versions of the *Grand Odalisque* Ingres did for his friends in the 1820s.

Although according to Amaury-Duval (1878, p. 58) it was sketched in oil on canvas in the 1820s, the definitive work on *The Source* (fig. 8) did not begin until 1855. Ingres was assisted by his students Paul Balze and Alexandre Desgoffe. To modern eyes *The Source* seems a bit cold and artificial beside the warm sensuality of her sister; but in Ingres' lifetime, it was universally admired.

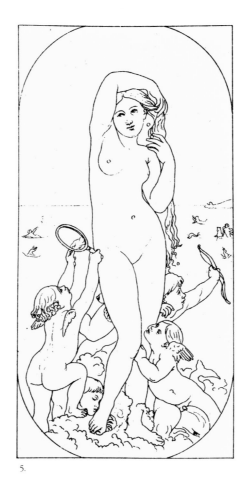

5.

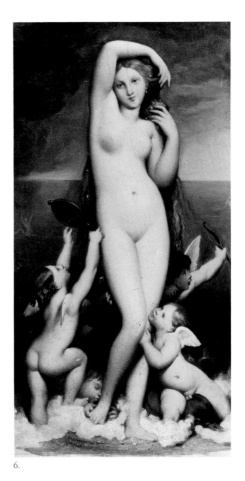

6.

5. Réveil, 1851.

6. Paris, Musée du Louvre. Oil on paper, 31.5 x 20 cm. Inscribed: Ingres. (W. 259)

7. Montauban, Musée Ingres, 867.2305. Black crayon on laid paper, 38.3 x 28.5 cm, c. 1820. Inscribed: Cadre ou encadre(ment) antique de cou(leur?) Pompey hercu(lanum).

8. Paris, Musée du Louvre, RF 219. Oil on canvas, 164 x 82 cm. Inscribed: J. Ingres 1856. (W. 279)

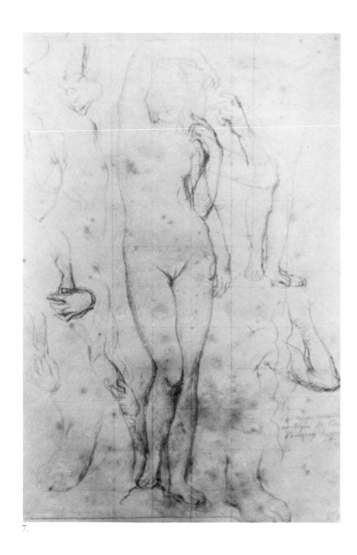

7.

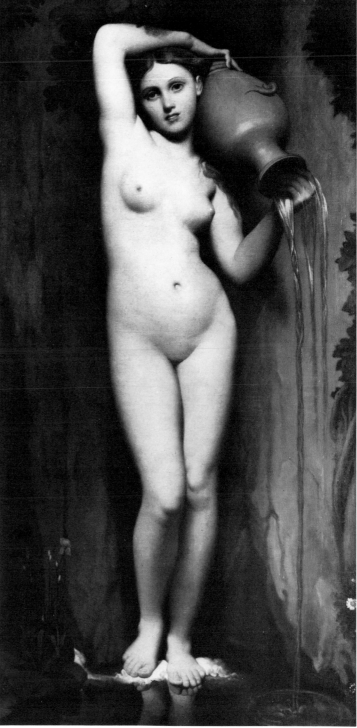

8.

J.-A.-D. Ingres, "Peintre d'Histoire"
Modern Subjects

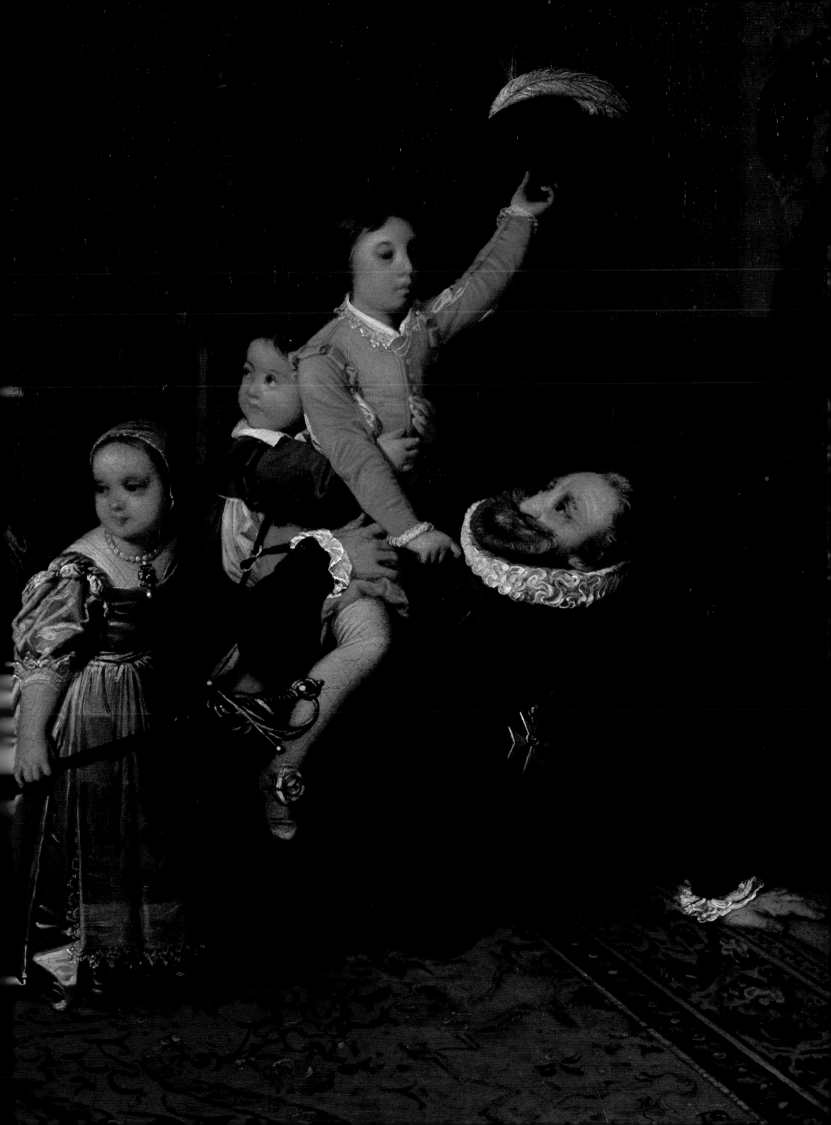

Paolo and Francesca

In his ninth notebook, Ingres outlined an ambitious plan for a cycle of paintings dealing with the tragic story of Paolo and Francesca. The first work would depict the instant of their "innocent love." The second would show the remorseful husband standing over the bodies of his two victims. The third (in the manner of Granet's paintings) would have the two bodies in the palace chapel receiving the Office for the Dead from a Franciscan friar. The final painting in the cycle would present the souls of the unhappy couple, as Dante described them, entwined in the whirlwind of the Inferno's Second Circle.

Despite this wealth of ideas, Ingres treated only the first subject. His interest in compositional possibilities outweighed his concern for narrative, so he completed seven paintings and eleven drawings of the innocent moment. He responded the same way to his anticipated series of scenes from the life of Raphael, of which only two— *Raphael and the Fornarina* and the *Betrothal of Raphael* —were ever completed.

As was often true with Ingres, the earliest work in the series (fig. 1) stays the closest to the literary and artistic sources. In this instance, Ingres has carefully written the appropriate lines from Dante in the lower margin of the drawing, as if it were a book illustration. In the awkward composition, Ingres indicates the figures, the space, the furnishings, and the curtained opening with an archaic touch similar to that of the Italian Primitive painters contemporary with the story itself. Ingres' reading of the story at this point also lacks maturity: Paolo is barely out of boyhood, hardly old enough for the sort of carnal lust that lands him in Hell for eternity. Francesca looks surprised by his kiss and not like a complicit partner.

Ingres' first oil version (fig. 3) was commissioned by Caroline Murat, Queen of Naples, who had also received the first painting of *The Bethrothal of Raphael*. The work disappeared with the fall of the empire in 1815 and did not reappear until the 1850s. The engraver Coraboeuf owned a copy of it (fig. 4, cat. 19) done to the exact measurements of the original, which is rather unusual among the painted replicas, especially as no changes were introduced. It is possible that Ingres did Coraboeuf's copy from a tracing in his portfolio when he thought the original was lost.

The painting retains the look of the

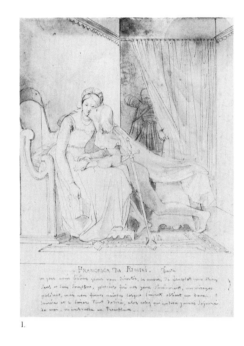

1.

2.

1. Paris, Musée du Louvre, RF 23.328. Graphite and brown wash on wove paper, 25 x 18.7 cm.

2. Location unknown. Graphite, pen and wash(?) Inscribed: Ingres inv. et Del. à Monsieur Artaud. Secretaire d' Ambassade./Roma. 1816. (Del. 206)

3. Chantilly, Musée Condé. Oil on panel, 35 x 28 cm, c. 1814. Inscribed: Ingres P. (W. 100)

4. Birmingham, England, Barber Institute, cat.19.

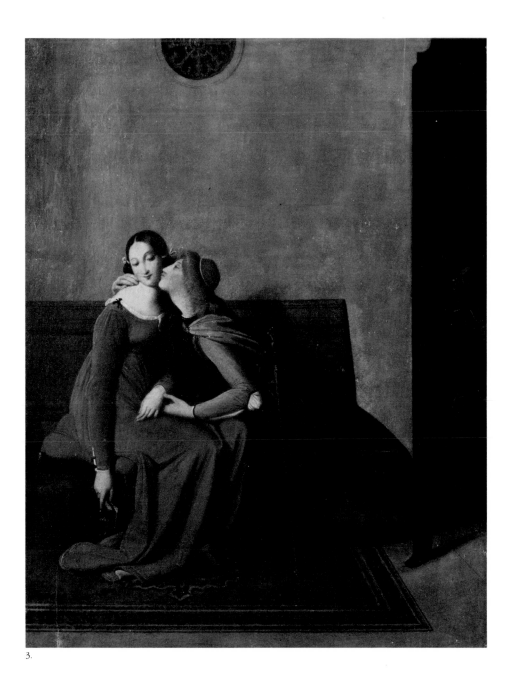

3.

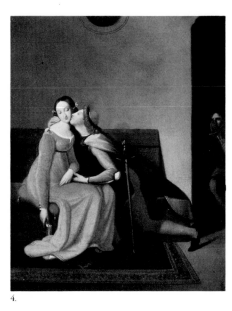

4.

Quattrocento masters in the sparse planes of its format and the linearity of its figures. The awareness of the shared sin is evident. The furious husband is reduced to an apparitional face and a hand on the hilt of the sword. All attention is focused on the pyramidal form of the two lovers.

In 1816 Ingres gave away two drawings of this subject: the first to Artaud de Montor (fig. 2), the French translator of the *Divine Comedy* and Secretary to the Ambassador in Rome, and the second to the musician Cherubini (Location unknown; H. Naef, "Zum Problem der Schöpferischen nachahmung bei Ingres," *Zeitschrift für Kunstwissenschaft*, X, 1-2, 1956, p. 104). The Artaud de Montor drawing shows a lovely Francesca seated on a stool identical to that used by Paolo (a shift away from the bench of earlier works). Paolo's position remains unchanged. More attention is given to the husband. The wall behind the lovers is decorated with an elaborately patterned tapestry and displays the family coat of arms. The lovers look perfectly matched, which renders the moment more poignant. The Cherubini drawing introduces a new pose for Paolo. He had been kneeling to the right of Francesca, but now Ingres has him seated with his legs spread. The new pose was probably suggested by Coupin de Couperie's 1812 Salon painting of the subject, which was available to Ingres through the engravings of the Salon Livre. The pose does not appear again until the 1850s.

The Angers painting (fig. 6), dated 1819, was done for the Société des Arts for 500 francs. Their committee was not pleased with the work and traded it to the painter Turpin de Crissé for one of his paintings. For this canvas, Ingres reversed his pattern of reducing the size of his later versions and even indicated the change in his Notebook X, where he listed the second oil as "plus grande" (Lapauze, 1901, p. 248). The larger format of the canvas gave Ingres room to do a gridded wall around the figures (derived from a Masolino fresco in the Church of San Clemente in Rome; see Naef, 1956, p. 105). Ingres' interest in the architectural details recurs in a drawing of identical dimensions in Montauban (fig. 7), in which the artist experiments with the addition of classical columns and overhangs. The painting (fig. 6) combined his earlier tapestries and curtains into one heavy drape, from behind which a full-length figure of the jealous husband jumps out. The small table with a vase of flowers that completes the scene is a reminder of

5.

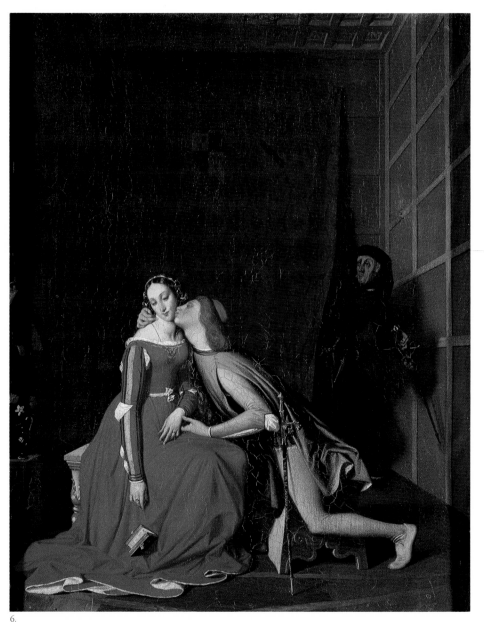

6.

5. Indianapolis, Indianapolis Museum of Art, Gift of Mrs. William Thompson, 47.19. Graphite on tracing paper, 50.6 x 40 cm.

6. Angers, Musée Turpin de Crissé. Oil on canvas, 48 x 39 cm. Inscribed: Ingres. Rom. 1819. (W. 121)

7. Montauban, Musée Ingres, 867.1391. Graphite on wove paper, 50 x 39.5 cm, c. 1819.

8. Montauban, Private Collection. Graphite on laid paper, 17.2 x 13 cm. Inscribed: Ingres inv. et fec. (Del. 204)

9. Amsterdam, Amsterdams Historisch Museum, cat. 20.

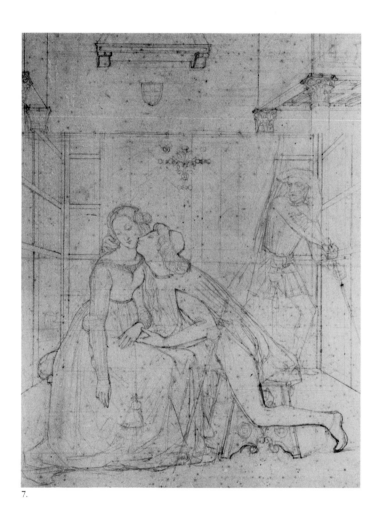

7.

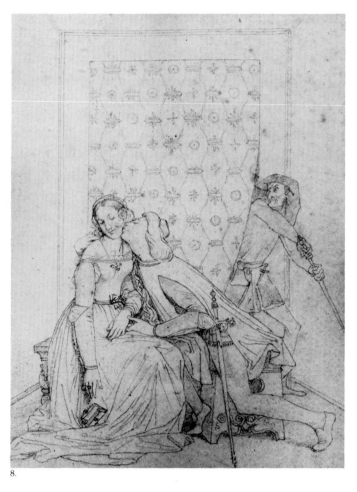

8.

9.

the artist's admiration for the early Flemish painters.

At this stage, Ingres adds frills to Francesca's dress and coiffure which appear in later versions. Most important, he makes the moment in the story a second or two later, indicated by the fact that the book has left Francesca's hand and her husband has advanced into the room. As he so often did, Ingres made a tracing of this painting as a record (fig. 5).

In 1820 Ingres gave a scaled down version of the subject (fig. 9, cat. 20) to Madame Taurel, the wife of a friend. For the first time he shifts Paolo to the left side. Giovanni is still behind him and is depicted with a deformed leg that adds pathos to the narrative. The considerably simplified setting focuses attention on the three participants in the drama. To his friend Gilibert Ingres gave the original from which the reversed drawing had been made (fig. 8).

Three drawings (figs. 10,11,14) and a painting (fig. 13) are related to the Réveil print (fig. 12). All four are nearly identical in size, and the details of the scene vary little. All show Paolo seated on the right on a four-legged stool with his legs in the position adopted in fig. 10. Giovanni's leg is not as deformed as in the earlier pair of drawings (figs. 8,9). In the Bayonne drawing (fig. 14) is a tall table covered with a cloth, which occurs in no other version. The Bayonne painting (fig. 13) is the only work in the series to use two strong light sources, one from behind the curtain and one from the left corner. This dramatic touch suggests a date for the work from the last years of Ingres' career.

In 1834 Aubrey Lecomte did a lithograph of this subject (fig. 15) which was a reversal of the Angers painting (fig. 6). He focused the attention entirely on the pair of lovers by dropping out all the details of the room. It was probably this print that prompted Ingres to do a variant of the painting with a similar emphasis (fig. 17, cat. 22). The painting reflects as well a general trend in depictions of the subject. Ingres' contemporaries were shifting from an emphasis on the narrative to an interest in Paolo and Francesca as symbols of innocent love (M.-C. Chaudonneret, "Ingres: Paolo and Francesca," Galerie d'Essai, Musée Bonnat, n.d.). Given its restricted format, this work is probably the "Petite Francesca da Rimini" done after the cartoon for the Chapelle of Dreux (ie., after the mid 1840s) listed in Notebook X (Lapauze, 1901, p. 249).

There are two other late versions

10.

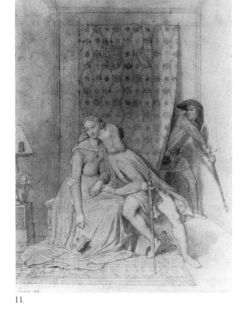

11.

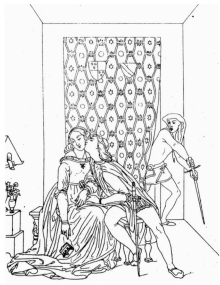

12.

10. Montauban, Musée Ingres, cat. 79.

11. Switzerland, Private Collection, cat. 21.

12. Réveil, 1851.

13. Bayonne, Musée Bonnat, NI 87. Oil on
canvas, 22.8 x 15.8 cm. Inscribed: Ingres P. Ro.

14. Bayonne, Musée Bonnat, Inv. 2234 NI 974.
Graphite on paper, 23.5 x 17.4 cm.

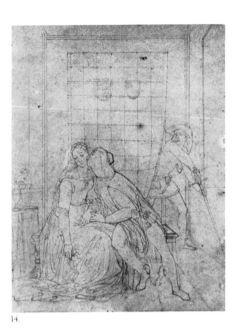

14.

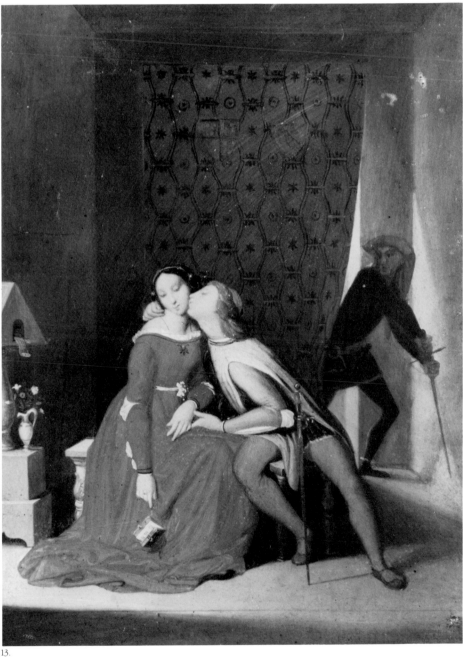

13.

of the subject (fig. 16, cat. 23, and cat. 24). Both are approximately the same size as the Hyde Collection painting. Each abandons the oval emphasis for a nearly square format. The London painting (cat. 24) focuses on the lovers without any additional decorative details. It adds to the composition of the Hyde Collection work the bodiless face of the charging husband in the upper right behind the couple. The artist combined the early and late schemas in the New York painting (fig. 16, cat. 23) by including the full figure of Giovanni entering from behind a curtain on the left and by bringing back the still life of the table and vase of flowers on the right. Nevertheless, the primary focus remains the couple themselves. Like the Lecomte lithograph, this entire group of works shows Paolo positioned on the left.

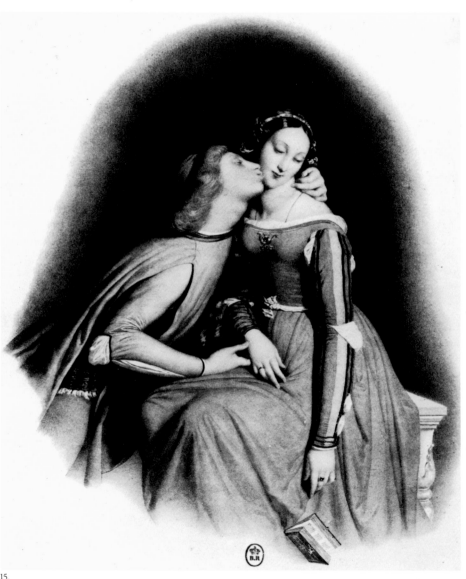

15.

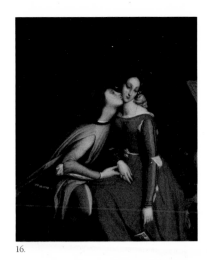

15. Aubrey Lecomte, Lithograph, 1834.

16. New York City, Private Collection, cat. 23.

17. Glens Falls, New York, Hyde Collection, cat. 22.

16.

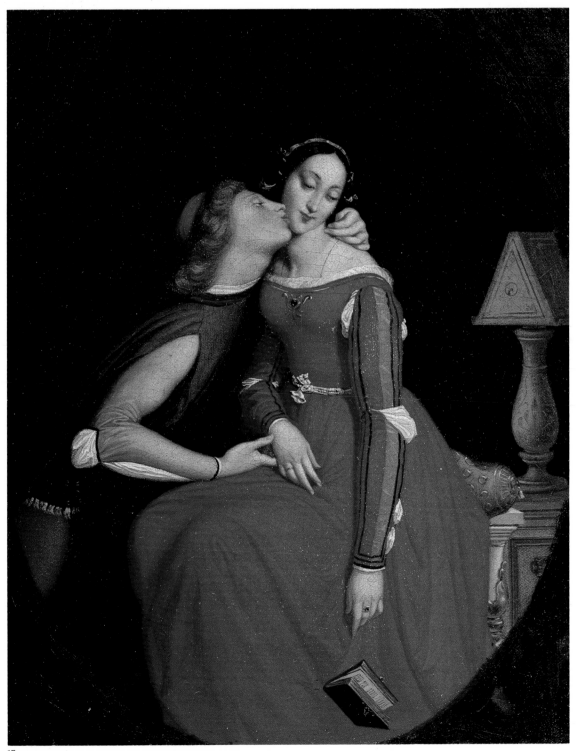

17.

Don Pedro of Toledo Kissing the Sword of Henri IV

Ingres sent his first version of *Don Pedro* to the Salon of 1814. This work was thought lost (Wildenstein, 1954, no. 101; Ternois and Camesasca, 1971, no. 82a), and the only apparent record of it is the first of two Réveil plates of the subject (fig. 1). Shortly after Ingres' death, Delaborde catalogued the painting as identical to one in the collection of M. Graves of Montauban (1870, p. 232, no. 67). The Réveil text (no. 29) also states that the work he engraved as Ingres' first version was then in a Montauban collection. Ingres' notebook references to the cycle support Delaborde, as do his habitual practices with his replicas. There should be only one Wildenstein entry for this painting: the two works (W. 101, W. 141) are the same canvas. The artist, disappointed and angered by the work's cool reception even among his friends (letter to Marcotte, May 26, 1814; cited Delaborde, 1870, p. 233), must have had the painting sent back to him in Italy. Ingres held it until his move to Florence in 1820, when he redid it (Lapauze, 1901, p. 235).

The version he completed in 1819 for the painter Alaux (W. 129; location unknown. Oil on canvas, 45 x 37 cm) is probably close to the first version. The scene is the Salle des Caryatides of the Palais du Louvre. Two of the caryatids are included on the left. Don Pedro kneels to kiss the sword of Henri IV, which is held by a young page. Behind them stands a guard. The back of a third figure is sketched on the right.

The reworked original canvas (W. 141; location unknown. Oil on panel, 48 x 40 cm) moves Don Pedro and the page of Henri IV to the right and includes in place of the guard on the left two figures from the court, the Duc d'Epernon and Gabrielle d'Estrées. Four caryatids are shown in a striking spatial recession. To the far right is a doorway, which the artist includes in all later versions. The guard is placed under the porch in the shadows behind the two main figures.

An early drawing of the subject reflects Ingres' general tendency toward narrative and spatial elaboration. The drawing (Location unknown; sold Charpentier, March 20, 1959, no. 4, repr. Graphite and brown wash, 26.5 x 19.5 cm. Inscribed: Ingres inv. et pinxit, Rome) shows simply the two main figures before a wall patterned with delicate fleur-de-lis.

In 1821 Ingres executed another drawing of the subject (Florence, Uffizi, Cabinet des designo, 118555. Graphite

1.

1. Réveil, 1851.
2. Montauban, Musée Ingres, cat. 25.

2.

on paper, 13.2 x 18.2 cm. Inscribed below, with five lines of the story: J. Ingres, inv. e pinx. 1821). It is the only version of the scene done in reverse and places Don Pedro on the right of the page. A counter-proof (fig. 2, cat. 25) returns Don Pedro to his customary position. On the recto are revisions in brown ink that introduce several steps on the right. Ingres also considered placing the page's left foot on the lowest step. The drawing and counter-proof abandon the elaborate caryatids for a view of the figures in front of a massive doorway.

In 1825 Ingres did a drawing of this subject for an album containing the work of several of his friends (Sale, Hôtel Drouot, June 19, 1968, no. 25, repr.). Ingres liked what he had done so much that in his Notebook IX he called it "Petite Epée de Henri IV."

Ingres did a smaller version of the subject in 1832 for S. Davilliers (fig. 5). Here he switched the setting to the Stairway of Henri II in the Louvre. Ingres also significantly increased the cast, adding the poet Malherbe, the Cardinal Duperron, and an anonymous figure who looks like the artist himself as a young man. A study for this version (fig. 3) has only two figures in the group on the near left and shows only the cloak of a figure exiting to the right.

Ingres apparently felt that the differences between his first and later conceptions of the subject warranted two prints. The only other compositions to receive that distinction were his *Bather* and *Raphael and the Fornarina*. The first *Don Pedro* print (fig. 1) is identical to the 1825 drawing. It contains an elaborate doorway and two columns behind the page that do not appear in either the reworked or Alaux canvases. The upper left corner is also tightly cropped.

The second of the Réveil prints (fig. 4) is identical to the Louvre painting (fig. 5). The files at the Louvre contain a photograph of a tracing (Réunion des Musées Nationaux 78EN973) from the Viellard collection which may have been Réveil's model.

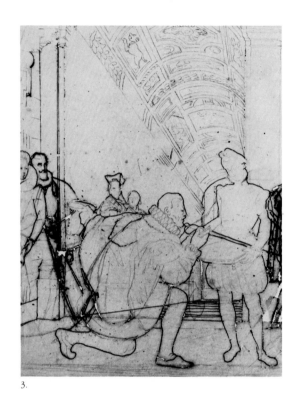

3.

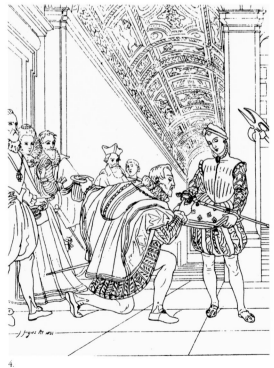

4.

3. Montauban, Musée Ingres, 867.1386.
Graphite, pen and brown ink on tracing paper, 35
x 26 cm, c. 1832.

4. Réveil, 1851.

5. Paris, Musée du Louvre, RF 1981-56. Oil on
canvas, 32 x 30 cm, c. 1832. Inscribed: J. Ingres
P(it) 183_ (W. 207)

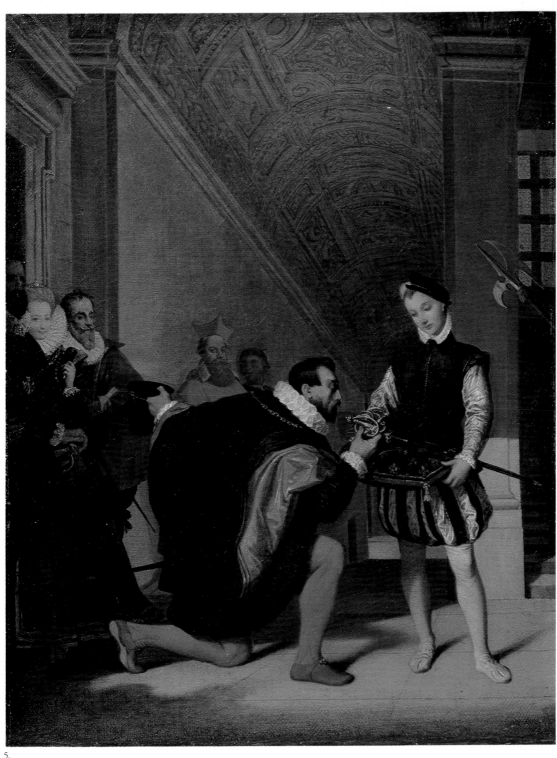

5.

Philip V and the Marshal of Berwick

One of Ingres' favorite compositional ploys was to match the style of his work to the subject matter. For the *Francesca*, he had chosen the linearity and spareness he associated with the purity of early Renaissance Italy. For the subjects from antiquity, he looked to classical sculpture and vase painting for his models. For *Philip V and the Marshal of Berwick*, set in the early years of the eighteenth century, Ingres raided the Gobelins tapestry series *l'Histoire du Roi* for his prototypes (Paris, 1967-68, no. 101). Everything seems diminutive by comparison with Ingres' other work. Subordinated to the props of the scene, the figures are reduced to actors dressed in the correct period costumes and playing their assigned roles. The commitment evident in works of such personal significance as *Ossian*, *Stratonice*, or *Roger and Angelica* is absent here. The client gave him a subject which could be anecdotal at best. No secret motives, no strong passions, no tragedies lurk in the shadows. What you see is it: the young Spanish king rewards his soldier for a job well done. The subject did appeal to one of Ingres' primary interests, as it gave him the chance to experiment with the period's furnishings and with the pomp and regalia which always fascinated him.

His first version of the subject (fig. 1), a drawing erroneously dated 1813, is much less elaborate than the final painting (fig. 2). The original cast had eleven characters. At a later date Ingres lightly sketched seven other figures in the grey wash of the background. In fact, the drawing has different sections pieced together almost like a jigsaw puzzle. The space to the left of Philip V is composed of nine separate pieces. The area containing Philip V and the space just above his head is one piece. The Marshal of Berwick is another. The monk and the page to his right are each separate pieces. The three observers behind them are another unit. The male figure standing at the fore of the group at the far right side is one piece. Those posed behind him are another piece, and the banister below is yet another.

The changes begun in the revised drawing continue in the painting. As a result of his research, Ingres reclothed virtually every figure and corrected the details of the flags. The cast of characters in the painting grew to twenty-seven with the addition of aristocratic witnesses and servants. None of these "improvements" served

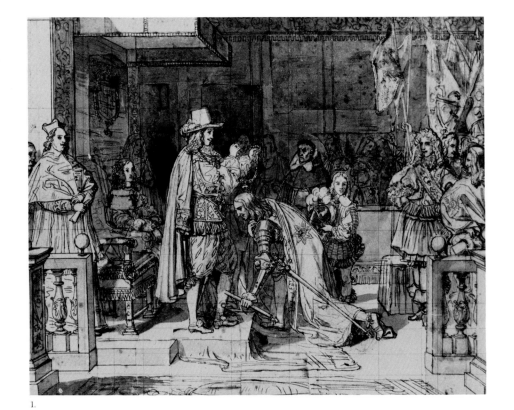

1.

1. Bayonne, Musée Bonnat, Inv. 248 NI 941.
Graphite, grey wash, pen and brown ink on
paper, 38.9 x 50 cm, c. 1816-17. Inscribed: J.
Ingres inv. et pinxit, Roma, 1813.

2. Madrid, Collection of the Duchess of Alba. Oil
on canvas, 88 x 109 cm. Inscribed: Ingres Fat. an.
1818. Rom. (W. 120)

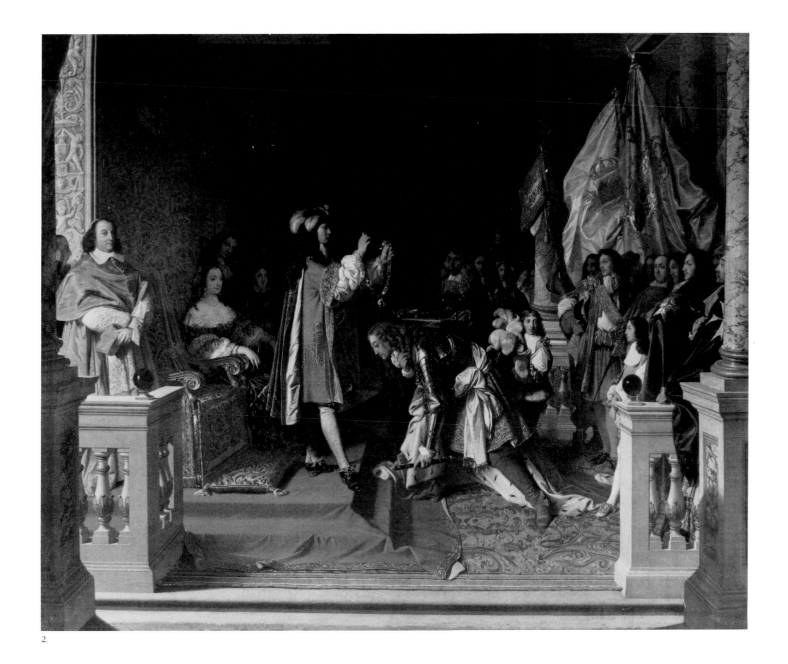

2.

Ingres very well when he braved the Salon critics in 1819. The painting was severely criticized on several counts, including the "arbitrariness" of its color scheme (Ternois and Camesasca, 1971, p. 99, no. 98).

An 1817 drawing of this subject dedicated to Poublon has recently surfaced in the Alba Collection (fig. 3). The work, which is identical to the painting, has the polished look of a replica drawing. The date and the dedication to Poublon, however, suggest that, like the drawing for the *Duke of Alba at St. Gudule* (cat. 26), this may have been a final model for the painting.

The 1851 Réveil engraving (fig. 4) differs from the painting and the Poublon drawing only in the simplification of some details of the setting. A watercolor Ingres completed for his wife in 1864 (fig. 5) was, in its original traced form, probably his 1851 model. Both the print and the watercolor delete the marbling of the columns, the brocade of the walls and furnishings, and the patterning in the carpets. Suppressing unnecessary ornamentation allowed the artist to focus more attention on the figures. To make the scene more vital, Ingres made subtle changes in the positions of the onlookers' heads and in their expressions. Each of these modifications was done through layering and stippling of grey wash and watercolor. The artist first worked the tracing with a modeling in grisaille and then reworked it with thin glazes of vibrant colors. As is often true of the late watercolors, magnification reveals that Ingres has used the miniaturist technique of dabbing touches of red and blue to accent the facial features. One of his final flourishes was the addition on the right of a French tri-color flag; the outlines of the former flag are still visible.

3.

4.

3. Madrid, Alba Collection. Graphite, pen and wash with white gouache on wove paper, 47 x 57 cm. Inscribed l.l.: Ingres. . .Roma, 1817. Inscribed l.c.: Après la victoire d'Almansa reimportée par le Maréchal de Berwick, le Roi Philippe le fait Duc, Grand d'Espagne de première classe et le décore de l'ordre de la Toison d'or. en l'année 1707. Inscribed l.r.: hommage à Monsieur le Chevalier de Poublon, par son très dévoué Serviteur Ingres.

4. Réveil, 1851.

5. Paris, Petit Palais, cat. 77.

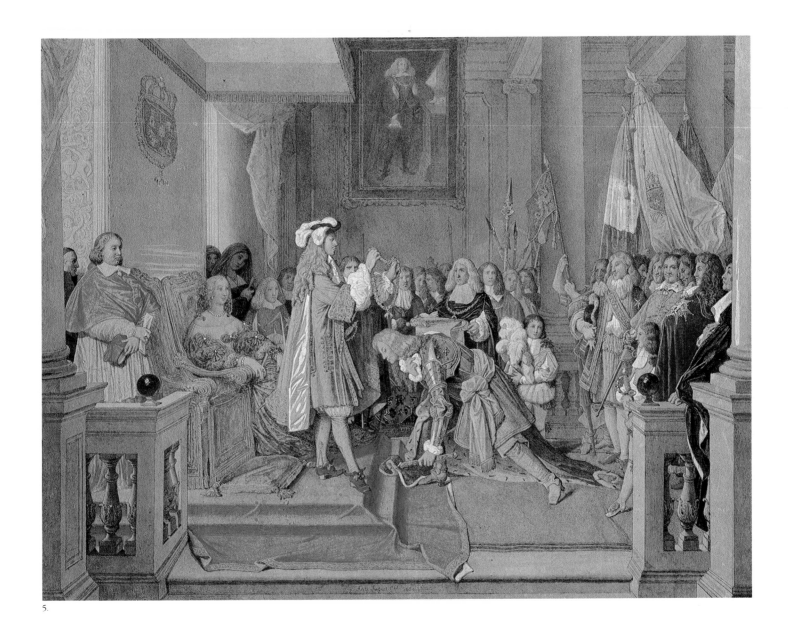

5.

Henri IV Playing with His Children

The 1817 Petit Palais painting of *Henri IV Playing with His Children* (fig. 5) is a classic of the troubadour mode. The interior has a preciousness that recalls the small Dutch genre paintings of Dou, Metsu, and Teniers. Rendered in jewel-like colors with luminous surface reflections, the scene has an intimacy enhanced by the small scale.

The Spanish Ambassador enters from the left. In the center are the queen, a small child, and a dog. Three children cluster around their father. The eldest son is riding on his father's back and flourishes his father's fancy hat. Observing the scene is Ingres' ever-present servant figure. The room has brocade walls, Royal fleur-de-lis over a canopied throne, and a small Raphael tondo of the Virgin and Child. The Réveil print (fig. 4) derives from the 1817 painting.

Ingres repeated the subject in a wash drawing given to the Alba family around 1817 (Location unknown; sold Hôtel Drouot, February 13, 1939, no. 44, repr. Graphite with sepia wash, 23 x 17.5 cm). It reverses the original composition, as does a drawing Ingres gave to Thévenin in 1819 (fig. 2, cat. 27). In both the 1817 painting and the 1819 drawing, the child riding on Henri IV looks forward, but here he regards the visitor. In the Thévenin drawing, Ingres unites the main figures by shifting the queen to the left. A tracing (fig. 1) is midway between the Alba and Thévenin drawings in its presentation of the characters. All three drawings include in the foreground toys absent in the 1817 painting.

The painting Ingres did for Coutan (W. 204; Paris, Private Collection. Oil on canvas, 39.5 x 49 cm. Inscribed: Ingres, 1828) reverses the Petit Palais composition. The queen is right of center. The boy's gaze is directed forward. The girl standing by her father looks at the viewer rather than at either parent or at Don Pedro. The result is an unfocused composition. The canopied throne has been replaced by a curtained entryway.

During his second stay in Rome, Ingres did a completely revised version (fig. 3). He limited the figures to the king, a son, and Don Pedro. He raised the ceiling, altered the decor, and subsituted a fireplace for the earlier throne or entryway.

In a final version (W. 115; Paris, Private Collection. Oil on canvas, 40 x 47 cm), the Ambassador enters from the right. The curtained doorway of the Coutan version is in the center. The servant now stands behind the queen.

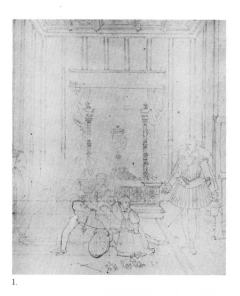

1.

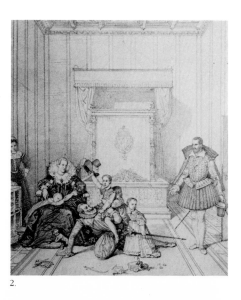

2.

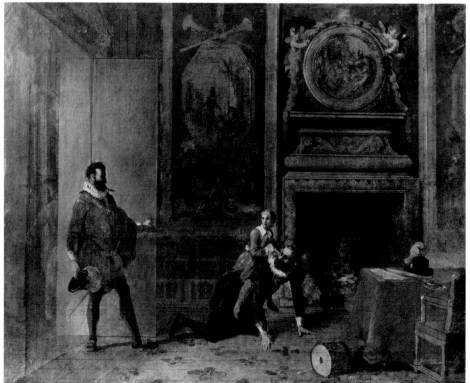

3.

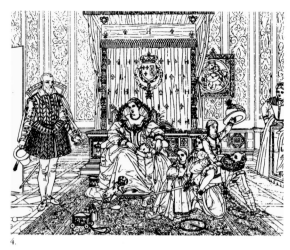

4.

1. Montauban, Musée Ingres, 867.1402. Graphite on tracing paper, 20.1 x 17.3 cm, 1814-17.

2. New York City, Private Collection, cat. 27.

3. London, Victoria and Albert. Oil on canvas, 50 x 62 cm, c. 1815. Inscribed: Ingres. (W. 114)

4. Réveil, 1851.

5. Paris, Petit Palais, cat. 78.

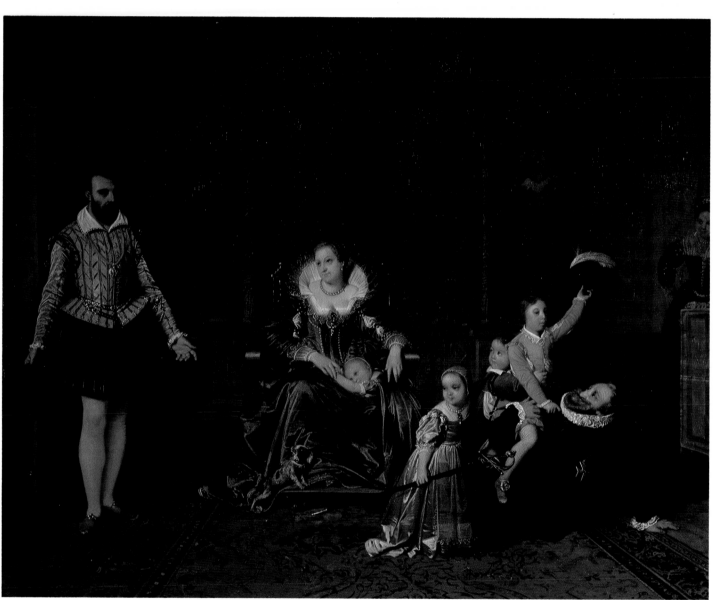

5.

a slightly expanded foreground and additional width on the left, which allows space for the extra figure and the *Mona Lisa.*

In 1852 Ingres gave an oil of *Leonardo* to Alexander von Humboldt, a German naturalist and explorer (W. 267; England, Private Collection, 50 x 48 cm). Its major change is in the figure gesturing toward the dying artist. No longer dressed as a cardinal, he sports a full beard and has bushy, dark hair. This painting may be the one to which Ingres referred in Notebook X as among works underway in the late 1840s or early 1850s (Lapauze, 1901, p. 242).

That reference could also be to another version of the painting (fig. 3, cat. 31), usually dated c. 1818 but never completed. Like the painting given to Humboldt, this canvas reverses the 1818 version (fig. 2). The painting of the *Mona Lisa* is barely visible in the background of the Smith College version, suggesting a date closer to the 1851 print than to the 1818 painting.

Ingres cites in his Notebook X two drawings of the *Death of Leonardo* (Lapauze, 1901, p. 250). One is listed by him just above the 1856 watercolor of the *Birth of the Muses,* the other just before the 1858 *Martyrdom* drawing. One is the wash drawing from Brussels (fig. 6, cat. 32); the other must be the drawing formerly owned by Haro (Del. p. 281, no. 214; location unknown. Pen and brown ink, with black ink. Inscribed: Ingres in. et pin. 1818). Ingres later dated each drawing according to his earliest work on the compositional cycle.

The Brussels work has a layer upon layer technique that never occurs in Ingres' early wash drawings. In fact, the most suitable comparison is the 1864 *Baigneuse* from Bayonne. In both, the washes are like veiled pools of color, placed with great control and finesse to model the form and create the contours. Ingres worked over this surface with white chalk. For the first time, the man at the foot of the bed (now with long, dark hair and no beard) faces Leonardo rather than his companions.

3.

4.

92

5.

3. Northampton, Mass., Smith College Museum
of Art, cat. 31.

4. New York City, Private Collection, cat. 28.

5. Réveil, 1851.

6. Brussels, Musées Royaux, cat. 32.

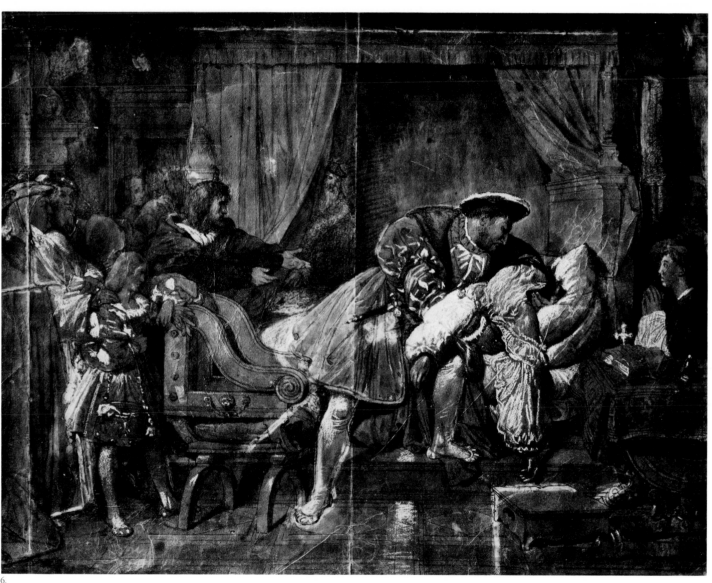

6.

Roger Freeing Angelica

This tale of chivalric ideals and sensual allure captured Ingres' imagination with particular force, judging by the number of times he repeated it. Of the many versions, only the first, the 1819 oil (fig. 1) commissioned through the Comte de Blacas for Louis XVIII, was apparently executed for a patron. This large canvas, which was to hang over the door in the Throne Room at Versailles, was intended to complement a Bergeret painting of a similar theme from Tasso's poem *Rinaldo and Armida.*

The broad horizontal format was thus dictated by the intended placement. An early compositional sketch (fig. 3) shows the artist's initial response to the project. A massive rock fills the central space. Before it stands Angelica, whose arms are bound low and to her left. The artist has positioned her head twice, once facing forward and once turned toward the hero. A few quick strokes indicate the monster, who approaches from the lower left. Roger's lance cuts diagonally in front of the heroine. The contours of Roger's form and that of his charging steed merge with the side of the rock.

Another early sketch (fig. 2) is more detailed. Roger and the hippogriffe benefit from Ingres' many studies of armour, bird plumage, and equine anatomy. More space has been inserted between Roger and the rock, which allows the lance to pass below Angelica rather than directly in front of her. The monster's head has taken a more precise shape. As is often true in his earliest versions, Ingres has confined himself to the facts as given in the literary source.

The Louvre painting (fig. 1) is wider than either of the sketches. To the left, Ingres had space to introduce the horizon line of the sea. He has placed on it a miniscule sailboat. On the right, he added a rocky shoreline with the light of a distant fortress at its summit. To offset the increased horizontality, Ingres returned to the closely intertwined central unit and has the lance again cross in front of Angelica's leg. Angelica still stands directly in front of the huge rock. Her hands are now tied above her left shoulder, a pose that emphasizes the sensuous curves of her nude form. Her head is tipped so far back that as she swoons in terror, she can see the arrival of her deliverer. In the earlier drawings, such as the Fogg Art Museum's oil study for her (W. 126, pl.17), no connection had been established between the two protagonists.

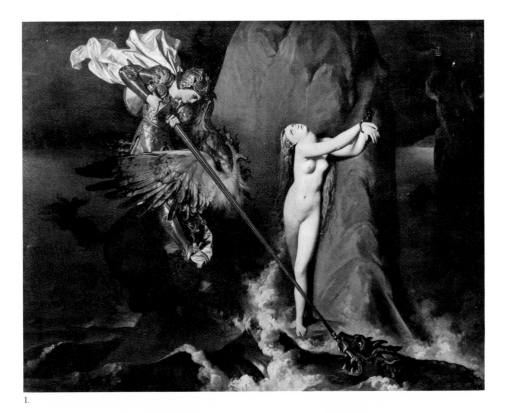

1.

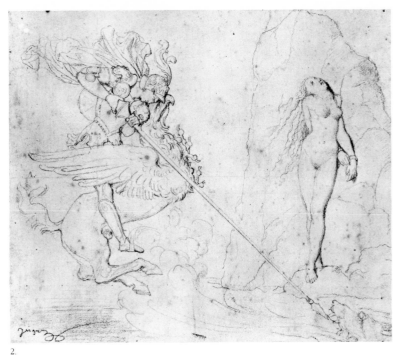

2.

3.

1. Paris, Musée du Louvre, Inv. 5419. Oil on canvas, 147 x 199 cm. Inscribed: J. A. Ingres P.it. Roma, 1819. (W. 124)

2. Cambridge, Mass., Fogg Art Museum, 1943.859. Graphite on wove paper, 17.1 x 19.7 cm, 1818.

3. Montauban, Musée Ingres, 867.2103. Graphite on wove paper, 8.8 x 10.5 cm, c. 1818.

4. London, Harari & Johns, cat. 33.

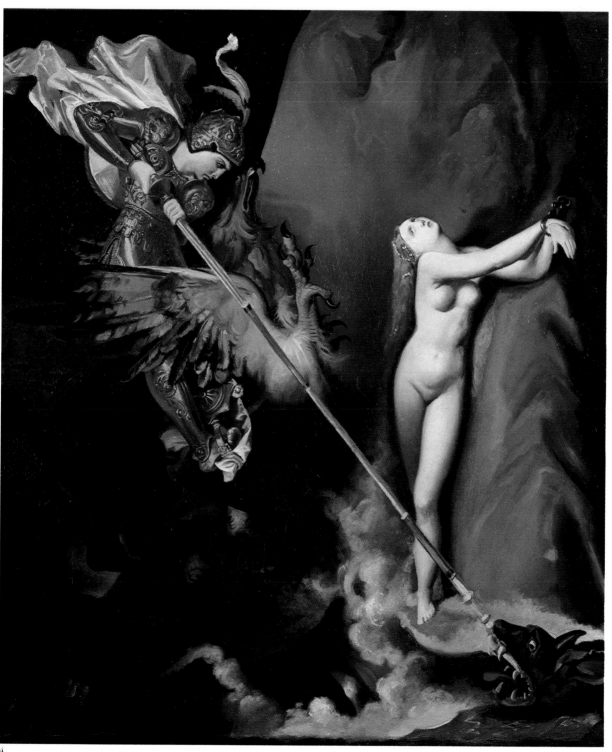

4.

canvas at the 1819 Salon, he was severely criticized. One of the criticisms he most detested referred to the *Angelica* as an *Andromeda.* Yet his own early figure of Angelica is in fact derived from a fresco representation of Andromeda (Fogg, 1980, p. 75, no. 23). In addition, this figure, standing demurely with her hands tied low and her head lowered, was taken up again in a small oil sketch of unknown date (fig. 5), which, given the hero's winged heel, surely depicts the rescue of Andromeda by Perseus. The sketch may date from the late 1820s as one of three canvases designed to assimilate the freer manner of the Romantic school (the London *Oedipus and the Sphinx* and the Phillips Collection *Bather,* cat. 48, are the other two. Fogg, 1980, p. 75, no. 23). Although the authenticity of the painting has been questioned (Ternois and Camesasca, 1971, p. 99, under 100b), its presence in the Coutan collection alone should validate it. Moreover, the many replicas Ingres created for Coutan in the late 1820s had different degrees of finish. Some were carefully rendered and some were loosely done; some were completely new in concept, but most combined old and new ideas.

The final version focuses even more closely than the Detroit oil on the central figure. In this work (fig. 10, cat. 35), the artist eliminated Roger altogether and let the spotlight rest entirely on the damsel in distress. The monster is a more seaworthy creature, and on the right is a gleaming shield more suited to Perseus than to Roger. The two tales seem ultimately to have merged for Ingres.

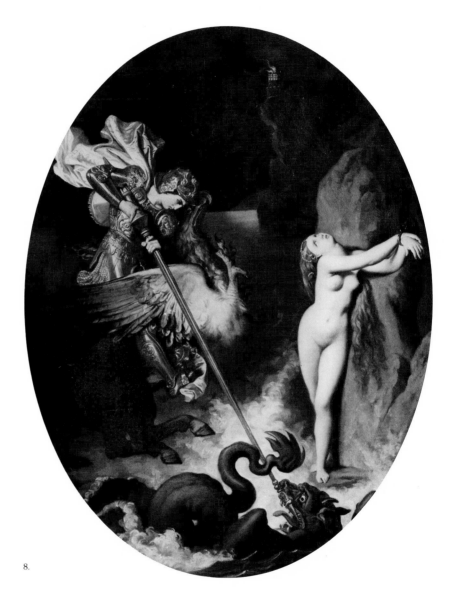

8.

8. Montauban, Musée Ingres. Oil on canvas, 54 x 46 cm. Inscribed: Ingres, 1841. (W. 233)

9. Réveil, 1851.

10. Sao Paulo, Brazil, Museu de Arte. Oil on canvas, 97 x 75 cm. Inscribed: J. Ingres, 1859. (W. 287)

9.

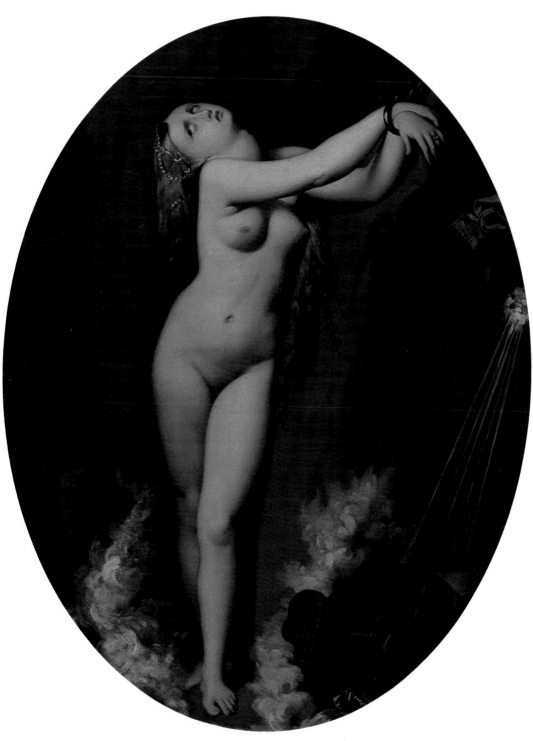

10.

The Tomb of the Lady Jane Montague

Ingres at times felt that the compositional importance of his "unpainted" works warranted their inclusion in the 1851 Réveil publication as the equal of his paintings. His flexible conception of the hierarchy of both media and subject allowed him to include such works as the 1806 *Philémon and Baucis* and his drawing for *The Tomb of the Lady Jane Montague*.

The first version is a delicate brown wash and yellow watercolor drawing (fig. 3, cat. 36) done in 1816. It was never intended as a model for a real tomb (as indicated in A.P. Oppé, "Ingres," *Old Master Drawings,* 1926, pp. 20-21), but was to be instead the memorial itself.

Ingres received the commission during his leanest years, when financial necessity forced him to accept far more work as a portraitist than he wished. In Notebook X, he dismissed these endeavors as "an immeasurable quantity of drawn portraits of English, French and all other nations" before citing two drawings related to the memorial to Lady Montague (Lapauze, 1901, p. 248). Although the works were physically small, their conception, linked to Classical and Renaissance traditions of artistic memorials, removed them from the ranks of the small works Ingres felt forced to do. The drawings exhibit a conscientious regard for detail (cf. fig. 1) that testifies to their importance to Ingres.

The horizontal format, tight cropping of the scene around the figure, and two-dimensional layout of the Melbourne drawing are revised in later works. The 1851 Réveil print (fig. 2) and the Montauban watercolor (fig. 4) are vertical compositions that include the full architectural frame of the sculpted monument. Ingres' conception of the work is here much cooler and less personal. In the early drawing, the gaze of the beautiful woman engages us directly. Ingres breaks that bond by closing her eyes in the Réveil print and by distancing her from the viewer in the late watercolor.

In the late years, Ingres also elaborated the narrative details. There is no hint of death in the early version other than the inscribed verse by Malherbe. The Réveil print and later watercolor include two putti, who pull the curtain closed, symbolizing death.

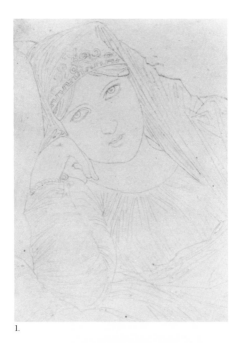

1.

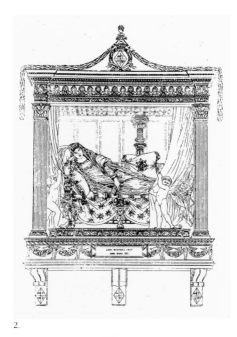

2.

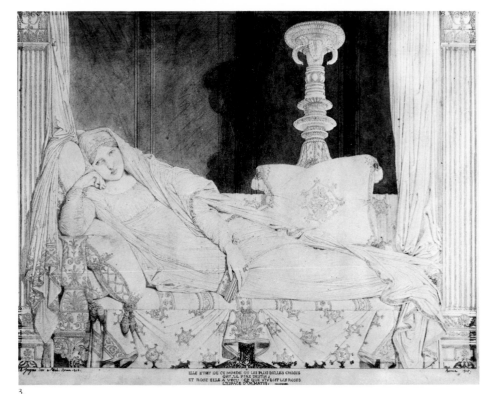

3.

1. Montauban, Musée Ingres, 867.333, detail. Graphite on tracing paper, 27.7 x 42.7 cm.

2. Réveil, 1851.

3. Melbourne, Australia, National Gallery of Victoria, cat. 36.

4. Montauban, Musée Ingres, Deposit from Musée du Louvre, D.54.4.1. Graphite and watercolor on tracing paper, 35.5 x 26.5 cm. Inscribed: J. Ingres In(it) et Del(it) et fecit Roma—1860. Inscribed in the cartouche: Lady Jane Montague, obut anno aetatis. (Del. 220).

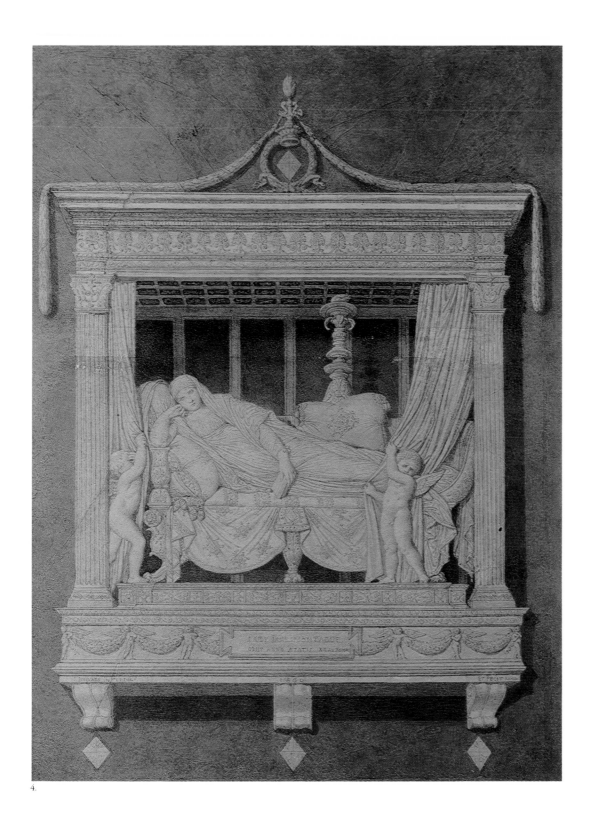

4.

Joan of Arc at the Coronation of Charles VII

In 1851 Guisard, the government's Director of Fine Arts, asked Ingres to do a painting for the State for the price of 20,000 francs. The artist could choose the subject. The only stipulation was that Ingres submit a drawing for the approval of the government. Ingres rejected this offer, proposing instead to finish for 10,000 francs each two works already on his easel. The two paintings, *Virgin with the Host* and *Joan of Arc,* were both repetitions of subjects first done by him in the early 1840s. Guisard agreed to this proposal, and both paintings were delivered by the artist in 1854. Ingres asked in 1855 that his fee for *Joan of Arc* (fig. 4, cat. 38) be increased to 15,000 francs. In a letter supporting this unusual demand, M. de Mercy explained what had happened: "M. Ingres, in executing the *Joan of Arc,* abandoned himself to his inspiration and instead of limiting himself to reproducing the figure of the heroine alone, which was all he had promised to do, has composed a picture showing her surrounded by her pages and followers witnessing the Coronation of King Charles VII in the Church of Reims" (Philadelphia Museum of Art, *The Second Empire: Art in France under Napoléon III,* 1978, p. 319). Among the witnesses, Ingres included a self-portrait.

Ingres had first undertaken the subject for the second edition of E. Mannechet's *Le Plutarque français, Vies des hommes et femmes illustres de la France* (Paris, 1844-47). Engraved by Pollet (fig. 1), this design shows the heroine alone, standing beside an altar. She is outfitted in a gleaming suit of armour and holds her battalion flag in her right hand. Her helmet lies on the floor. A wash drawing (Location unknown; repr. J. Williams, *Jeanne d'Arc,* Paris, 1964, p. 149) may have been Ingres' model for this engraving. The altar and the retable above it are less finished than in the Pollet engraving, but otherwise the works are the same. The 1851 Réveil print (fig. 3) is identical to the Pollet engraving.

When he turned to the large-scale painting, Ingres decided that more color and texture were needed. He devised a beautiful patterned skirt for St. Joan's armour. A study in Montauban (fig. 2) records this revision as sanguine additions on the surface of an earlier graphite drawing.

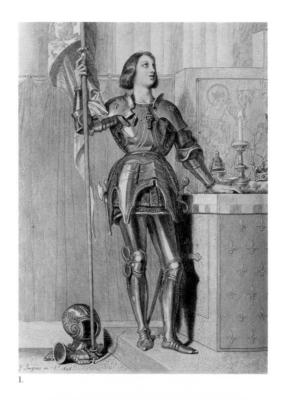

1.

2.

1. Pollet engraving, 1846.

2. Montauban, Musée Ingres, 867.1578. Graphite and sanguine on wove paper, 47.5 x 37 cm, c. 1852.

3. Réveil, 1851.

4. Paris, Musée du Louvre, cat. 38.

3.

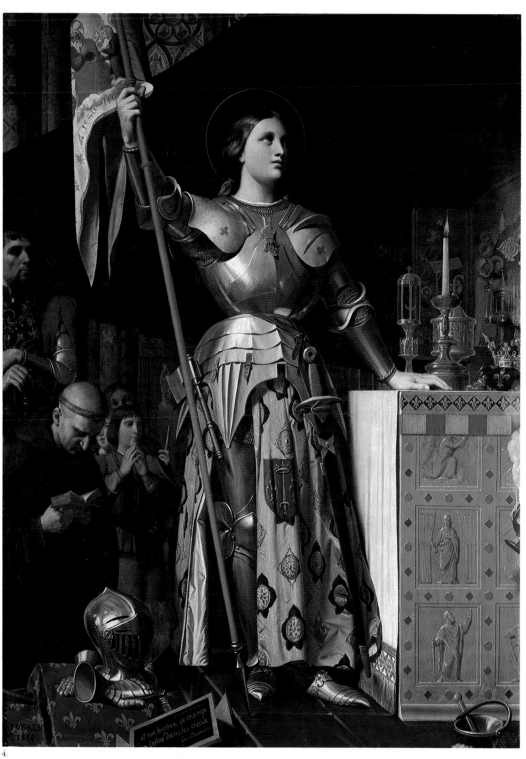

4.

J.-A.-D. Ingres, "Peintre d'Histoire"
Allegorical Subjects

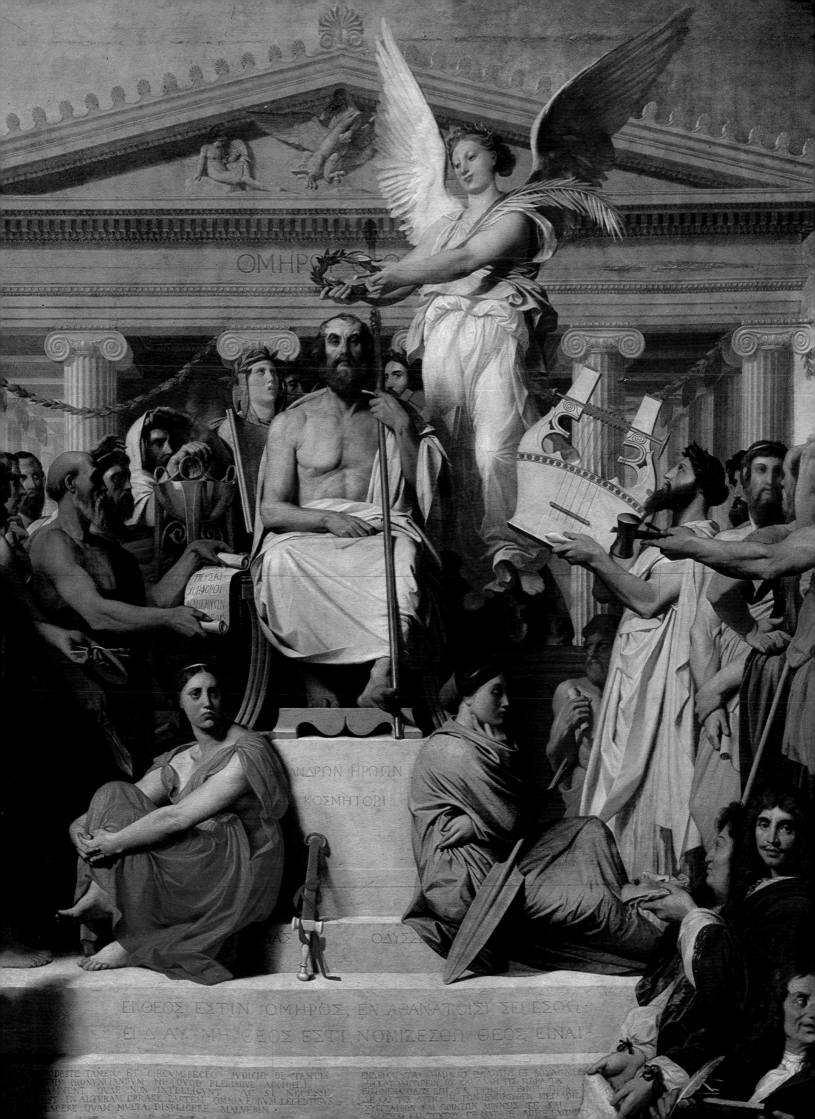

Napoleon on the Pont of Kehl

The handsome drawing of *Napoleon on the Pont of Kehl* (fig. 1, cat. 40) was done as a model for an engraving published before Ingres' departure for Rome in 1806. That print (fig. 2), cited as anonymous by Delaborde (1870, p. 283, no. 221), is usually credited today to Potrelle. Susan Siegfried (*Ingres and His Critics, 1806 to 1824,* Diss. Harvard, 1980) notes, however, that the engraving is signed not by Potrelle but by Pierre-Charles Coqueret, who sold it through the shop of Potrelle.

Subtitled *Allégorie du Passage du Rhin,* the engraving recalls the first act in Napoleon's campaign against the Austrians in 1805. Under a sky lit by a lightning bolt, Napoleon stands on the steps of a regal throne beside the battlefield. In flight behind him is a figure of Victory. She holds in one hand the regal scepters, palms, and wreaths and in the other a shield bearing the French imperial eagle with the eagle of Austria in its talons.

Ingres gave Napoleon the same attributes here and in the commissioned portrait of *Napoleon on His Imperial Throne* (fig. 5). In both the Emperor wears his coronation robes and carries the scepter of Charles V, the hand of justice, and the sword said to be Charlemagne's. The thunderbolt refers to the one held by Jupiter in images showing him enthroned. These images of Napoleon as triumphal leader are far removed from Ingres' first portrait of him as First Consul (fig. 4), done in 1804 for the city of Liège.

The delicate linearity of the drawing's original design (fig. 1, cat. 40) shows the pattern followed by Coqueret. Preparing for the Réveil print (fig. 3), Ingres revised the earlier drawing with tentative brown ink revisions. Most significant was the change in the position of Napoleon's left arm. In the 1806 engraving, it was extended behind him and held the scepter. In the revised drawing, Ingres sketched a second arm holding the shaft of the sword. In the 1851 print, Napoleon has both hands on his sword and the scepter leans against the throne on the right, which now bears Napoleon's insignia. Also lightly sketched on the drawing is the figure who holds Napoleon's horse at the lower left in the Réveil print. A second drawing (Montauban, Musée Ingres, 867.2772) incorporates all these changes and was executed as a model for Réveil.

1.

2.

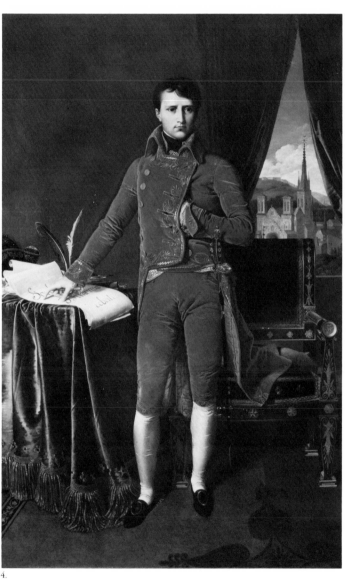

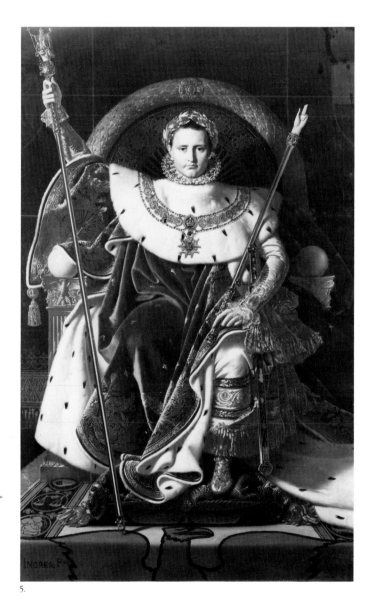

1. Montauban, Musée Ingres, cat. 40.

2. Coqueret engraving.

3. Réveil, 1851.

4. *Napoleon First Consul*, Liège, Musée des Beaux-Arts, No. 1. Oil on canvas, 227 × 147 cm, 1804. Inscribed: Ingres, an XII. (W. 14)

5. *Napoleon on the Imperial Throne*, Paris, Musée de l'Armée. Oil on canvas, 260 × 163 cm. Inscribed: Ingres Pxit anno 1806. (W. 27)

3.

4.

5.

The Apotheosis of Homer

Commissioned in 1826 for the ceiling of one of the nine new rooms dedicated to Egyptian and Etruscan antiquities in the Louvre (known as the Musée Charles X), Ingres' monumental painting *The Apotheosis of Homer* (fig. 2) was executed as required within a year's time. The area surrounding it was decorated with personifications of the seven cities that claimed to be Homer's birthplace. These were executed by Ingres' students Cambon and Debia from his designs.

The composition is arranged around the figure of the enthroned Homer seated in front of an Ionic temple. Sitting below and to either side of the Greek poet are personifications of his epic poems *The Iliad* (left) and *The Odyssey* (right). Famous men from the antique and modern world pay homage to the poet. The figures so honored reflect Ingres' estimate of history's most celebrated artists, writers, and philosophers.

The evolution of this composition is an extreme example of the artist's penchant for elaboration. He began with a cast of forty-six characters (Ternois and Camesasca, 1971, p. 103, no. 121, lists the figures from the 1827 painting) and ended with eighty-five (Delaborde, 1870, pp. 359-364, gives the figures included in the 1865 drawing). Momméja's 1905 catalogue of the Musée Ingres cites 204 drawings related to the 1827 painting of *The Apotheosis of Homer* (nos. 663-865) and another 123 drawings (nos. 2209-2331) related to the 1865 *Homer Deified* (fig. 3). Wildenstein catalogued thirty-seven paintings related to this subject (W. 168-200, 294, 298, 299, 323, 324). Some of these were oil studies for the painting (fig. 11 and cat. 46), others (figs. 8-10) were repetitions.

Ingres was especially proud that his idea came to him within an hour after receiving the commission. That speed is more than made up for by the eleven years the final drawing was in the works. The early pen and ink sketches (cf. cat. 42) exhibit a tremendous vitality. As a group, they are the work of an artist still high from his triumphant return to Paris and moving with confidence into the years of his artistic maturity. All the essentials are noted in a few quick strokes. Opposed to these sketches are the many careful studies Ingres did of individual figures, groups, and later of the whole, such as the drawing (cat. 44) that may well have served as the model for the painting.

A wash drawing (fig. 1) that

1.

1. Paris, Musée du Louvre, RF 1447. Graphite, white gouache, grey wash on laid paper, 21.8 × 31.3 cm. Inscribed: Ingres inv. et Pinxit. (Del. 176)

2. Paris, Musée du Louvre, Inv. 5417. Oil on canvas, 386 × 515 cm. Inscribed: Ingres Ping (Bat)/Anno 1827. (W. 168)

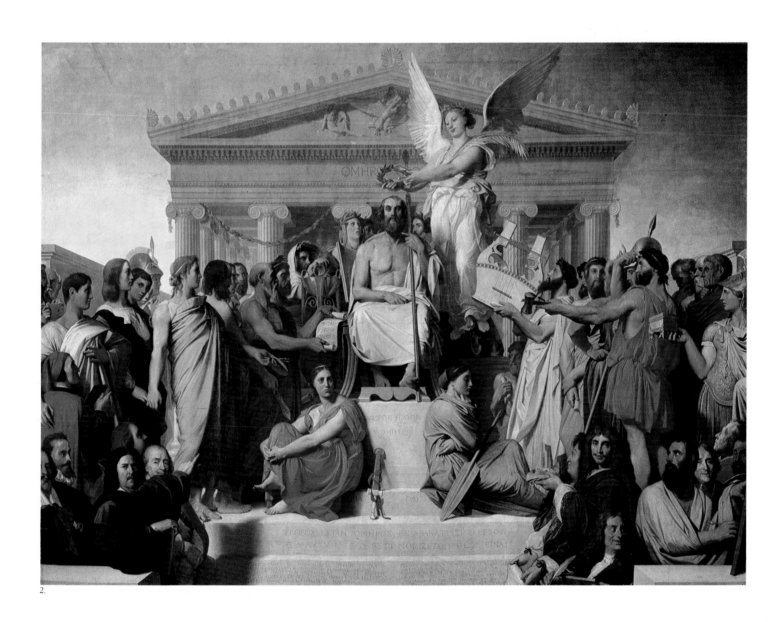

2.

Delaborde (1870, p. 269, no. 176) cites as earlier than the painting differs in several ways from the painting. Homer holds his staff out to his side rather than close to his shoulder. The Victory (or Renown) crowning him has a torch in her left hand, whereas in the painting, she uses both hands to hold the laurel crown. The Iliad holds her sword in her hand rather than letting it lean on the steps beside her. The Odyssey looks over her shoulder at Homer; in the painting, she rests her chin on her hand. In the painting, the Odyssey has an oar in her lap, which symbolizes the sea journey of Odysseus. The lyre and staff on the ground here are not in the painting. On the left in this drawing, Virgil is turned full-face to look down at Dante; in the painting, he is in profile and looks toward Homer.

A watercolor of the subject (fig. 6, cat. 43) has the same internal dimensions as the wash drawing and appears to have been traced from it. Ingres' Notebook X citations of works done in 1857 include a "Dessin d'un Homère" immediately below the "Dessin du Tombeau de lady Russell," which is the late watercolor version of that subject. Since all other references he made to the 1865 drawing refer to it as the "Grand dessin de l'Homère," the reference is probably to the Lille watercolor. Moreover, all of Ingres' dated watercolors on tracing paper were done after 1850 (cf. Appendix, Index by Media). The collaged framework, which includes the figures of the seven cities from the voussoirs of the original location, exhibits the many revisions characteristic of his late works.

Given the artist's conviction that this subject was of preeminent importance in his oeuvre, he welcomed the chance to "amplify and complete" his original conception when Calamatta decided to engrave the Musée Charles X paintings. Ingres' drawing (fig. 3) for that project was not begun until 1854; he finished and signed it in 1865. The aggrandized architectural background was designed by Ingres' friend Hittorff. Sculpted friezes derived from Flaxman's illustrations to Homer's poems line high walls on either side of a tall Ionic temple. There are thirty-seven new figures. Some figures from the original work remain unchanged; others are dropped altogether or changed in appearance. The best indication of how much the artist agonized over the choice of figures and how important the drawing was to him is the fact that he sent Marville photographs of it (fig. 4) to forty-nine of his friends when he thought it

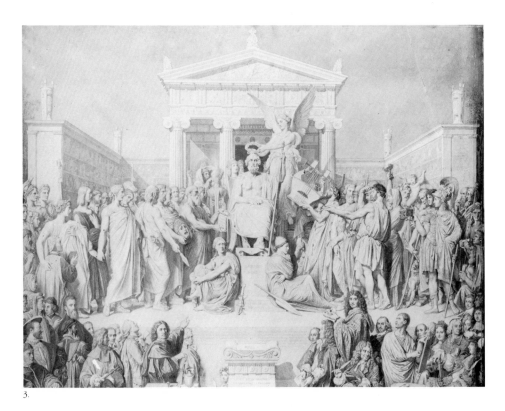

3.

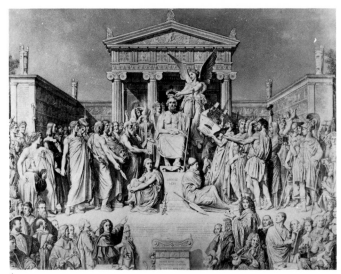

4.

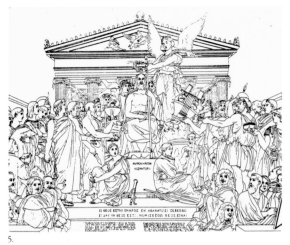

5.

3. Paris, Musée du Louvre, RF 5273. Graphite and grey wash on laid paper, 76 × 85.5 cm, 1865. Inscribed: J.A.D. Ingres inv. Pinxit Delineavit. (Del. 180)

4. Marville photograph, Paris, Bibliothèque Nationale.

5. Réveil, 1851.

6. Lille, Musée des Beaux-Arts, cat. 42.

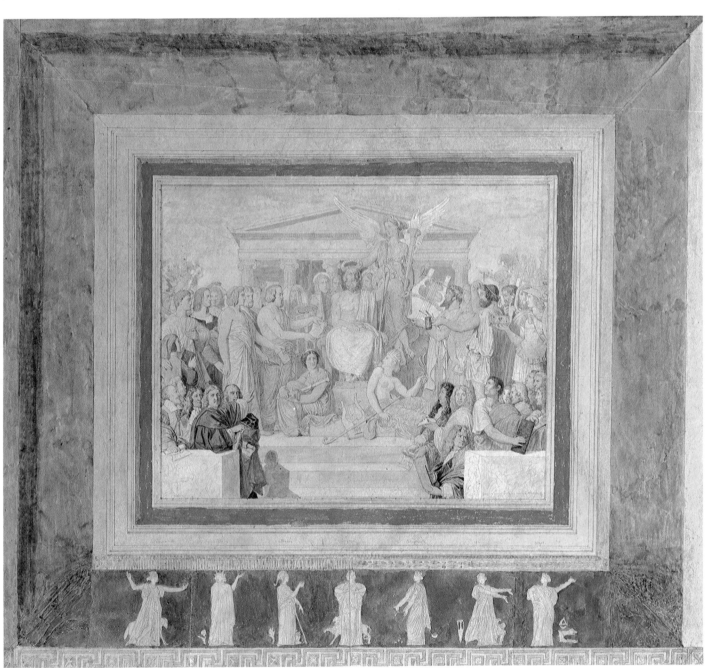

6.

complete (the names of those to whom it was sent are cited by Schlenoff, 1956, pp. 304-305). He then added still more figures.

In a letter to Pauline Gilibert dated February 26, 1856 (Schlenoff, 1956, p. 176), Ingres underscored the value of this work to him: "I am preparing it myself for the engraver. The drawing is very large; it is the same composition but augmented by the addition of new figures and all the perfections of which I am capable. I would wish that this composition would be the most beautiful and important work of my life. For that I assure you is what accounts for my loss of sleep and my total absorption in it."

Of the many paintings related to this project, Ingres cited only a few in his notebooks. From the works done in the early 1850s, he mentions one of *The Iliad* (W. 175, fig. 104; Neuilly, Collection David-Weill. Oil on canvas, 59.5 × 53.5 cm. Inscribed l.l.: Ingres) and one of *The Odyssey* (fig. 8). A further reduction of this latter work (fig. 7, cat. 44) also shows a new pose for the figure. No other version, not even the Réveil print (fig. 5), depicts the figure with forehead in hand.

In December 1859, Ingres cited another repetition, *Homer and His Guide* (fig. 9, cat. 46). He combined the central figure of *The Apotheosis* (cf. cat. 46) with a figure from its contemporary work, the *Martyrdom of St. Symphorian,* in a composition with new narrative intent. An old and blind Homer is led by the young boy.

One of the last works to be listed by the artist (Notebook X; Lapauze, 1901, p. 250) is the Angers painting *The Three Great Tragedians of Greece, Aeschylus, Sophocles and Euripedes* (fig. 10). The artist added a new background and also rearranged the poses from those of any earlier version.

The canvas of *Pindar* (fig. 11) is typical of many studies for the 1827 painting which were touched up by the artist, signed, and sold to his dealer Haro to provide an estate for his wife.

7.

8.

7. Glens Falls, New York, The Hyde Collection, cat. 44.

8. Lyon, Musée des Beaux-Arts. Oil on canvas, 61 × 55 cm. (W. 182)

9. Brussels, The Royal Collection, cat. 46.

10. Angers, Musée des Beaux-Arts. Oil on canvas, 40 × 46 cm, 1866. (W. 324)

11. London, The National Gallery. Oil on canvas affixed to panel, 24.1 × 17.1 cm. (W. 187)

9.

10.

11.

The Apotheosis of Napoleon I

On March 2, 1853, Ingres accepted a commission from the government of Napoleon III for a ceiling painting for the Salon Napoléon in the Hôtel de Ville in Paris. The work had to be completed by the end of the same year. It was delivered on schedule, but was later destroyed by fire in the Commune of 1871. All that remain of the composition today are several graphite studies (cf. cat. 41); a wash drawing (fig. 1); two oil sketches, one at the Musée Carnavalet (W. 271, pl. 100), the other on deposit from the Louvre at Châteauroux (fig. 2); and a watercolor (fig. 3).

The basic composition shows Napoleon rising from the rock of St. Helena in a quadriga of gold, guided by an imperial eagle. The figure of Victory, carrying a palm branch and a laurel wreath, directs his chariot to the heavens. He is crowned by Fame. France stands in mourning at the lower left. Behind a deserted throne is Nemesis, shown in pursuit of Crime and Anarchy. Around the central composition in the Salon Napoléon were personifications of the eight cities conquered by Napoleon: Rome, Vienna, Milan, Naples, Moscow, Cairo, Berlin, and Madrid. These were painted by Ingres' students.

In 1859 Ingres was commissioned by Napoleon III to design a cameo of this subject. It was intended to rival the most famous of the antique cameos. The drawing for it (fig. 1) has an irregular shape like that of the sardonyx on which the sculptor, Adolphe David, executed the design. The format of the piece and the figure types are those of the two extant oil sketches.

The watercolor version of the subject (fig. 3) stands apart from the other works in the almost miniaturist approach it takes to the figures and the background. In the other versions of the subject, the figures are robust and muscular and have heavy jowls. Their stoniness signals the origin of the composition in antique relief sculpture. By contrast, the figures in the watercolor are more sprightly. The colors are more precious and delicate and give the work a lively air. This watercolor is a late replica of the composition rather than a presentation drawing done on receipt of the commission. There is a study for it in the Musée Ingres (867.1094, graphite on tracing paper, 39 × 47.4 cm).

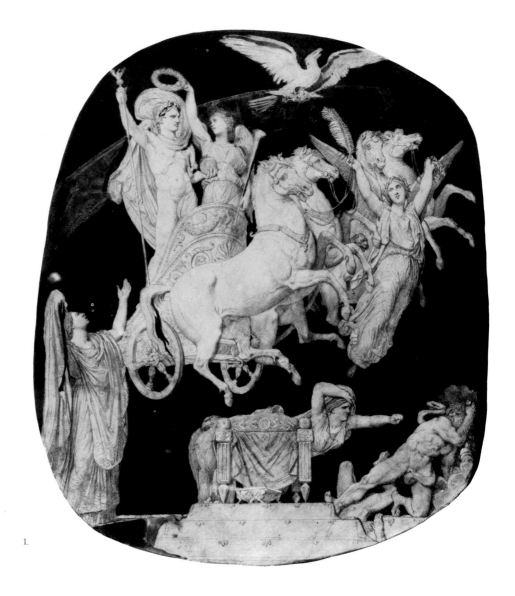

1.

1. London, British Museum, 1949-2-12-6. Graphite and grey wash on paper, 43 × 38 cm. Inscribed: J. Ingres 1821 [the date of Napoleon's death], 1861. (Del. 222)

2. Châteauroux, Musée de Châteauroux, Deposit from Musée du Louvre. Oil on canvas, 50 × 50 cm, c. 1853. (T. 152c)

3. Paris, Musée du Louvre, RF 3608. Graphite, watercolor, white gouache on laid paper, 33 × 31 cm, c. 1856.

2.

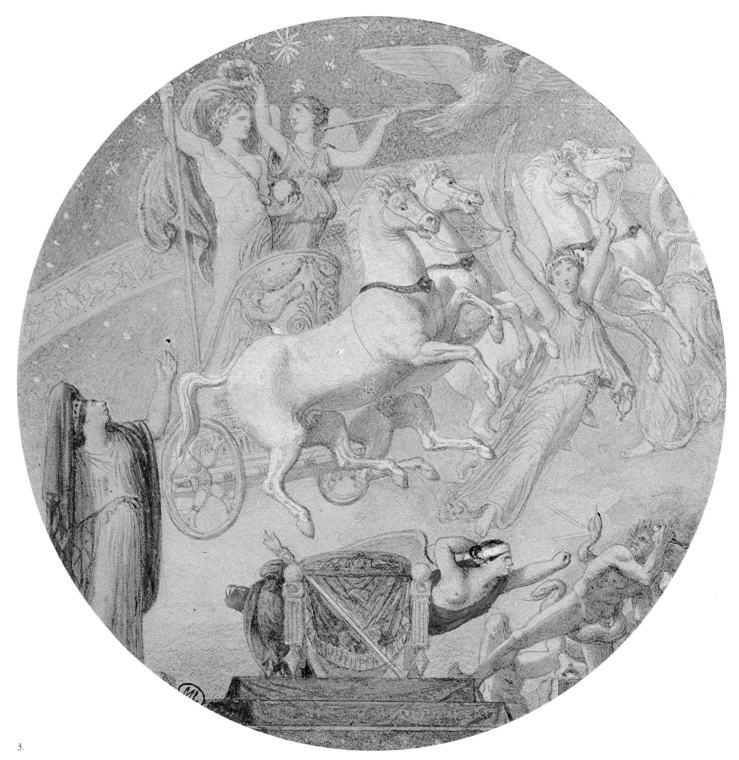

3.

J.-A.-D. Ingres, "Peintre d'Histoire"
Harem Subjects

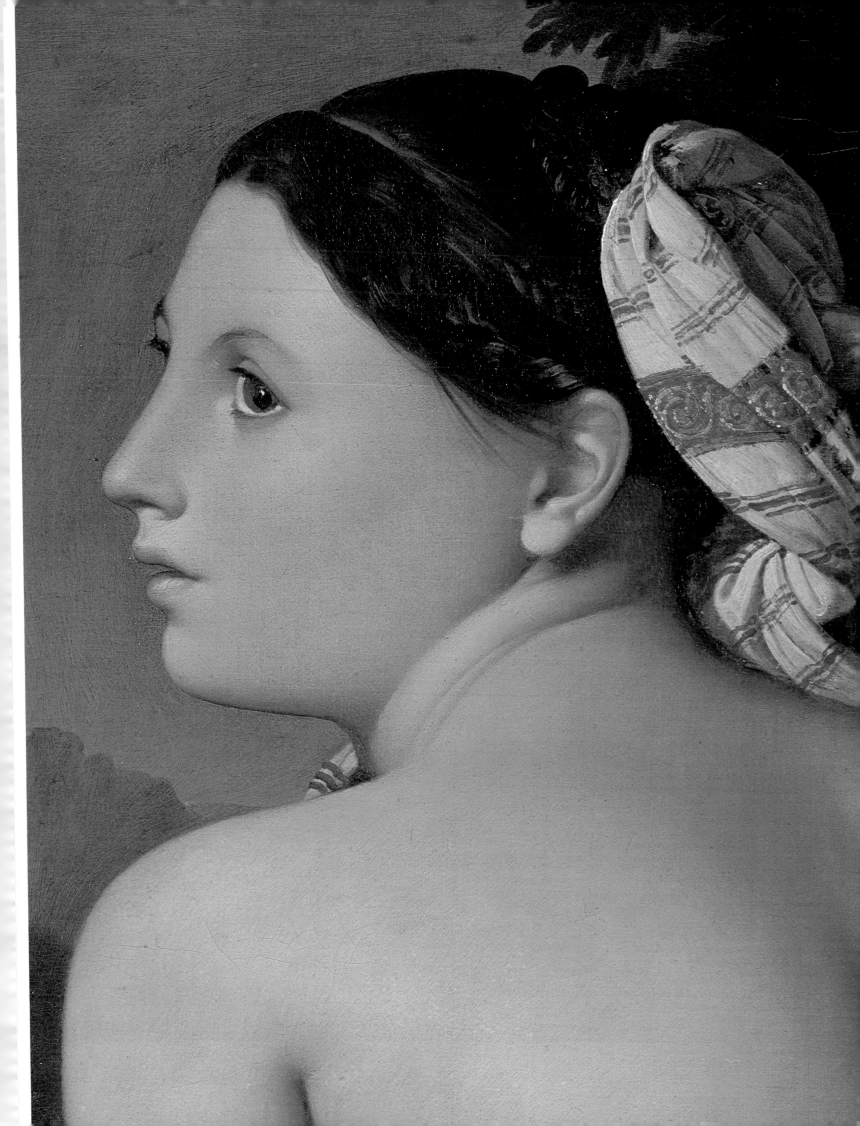

The Grand Odalisque

Queen Caroline Murat of Naples ordered the *Grand Odalisque* (fig. 1) in 1813 as a pendant to a painting of a sleeping female nude Ingres had done several years earlier for the king. The 1815 fall of the Napoleonic empire meant that Ingres' patron was no longer in a position to purchase the *Grand Odalisque*; it was sold in 1816 to M. de Pourtalés. In the chaos attending the political events, the early *Sleeper of Naples* was lost, much to the artist's regret.

In 1819 Ingres' *Grand Odalisque* was shown in the Salon with little success. The critics and public alike found the arbitrariness of the Odalisque's anatomical structure shocking. Modern viewers, conditioned by the art of Picasso and Matisse, read in the cool elegance of her serpentine form confirmation of Ingres' extraordinary vision and find it difficult to understand that early viewers did not succumb to the powerful spell cast by her glance. It may well be that she has three too many vertebrae in her long back, that her arms would never match if they were extended, and that the position of her legs is structurally impossible. But none of that really matters given the suppleness of her curves and the detached and serene purity which pervades the work. In a shockingly modern way, the reality of flesh and blood, bone and muscle give way here to intellectual, formal values.

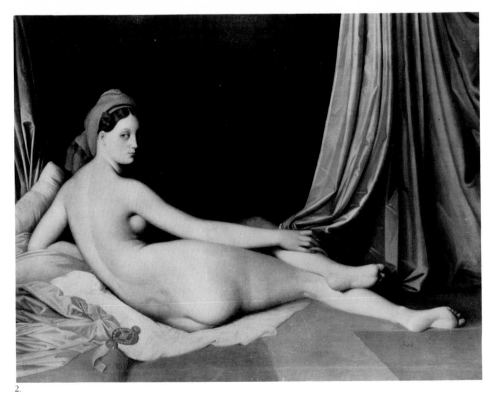

1.

The work is the sister not only to Ingres' Bathers, but also to the *Venus* of Titian and to David's *Portrait of Mme. Récamier*. The elongation of her proportions has roots in the Italian Mannerist paintings of Bronzino and Pontormo. The flatness of the form against the patterned background is a harbinger of the mid-century passion for Japanese prints.

Notebook X cites "plusieurs petites répetitions" immediately after the entry "L'Odalisque, la grande" (Lapauze, 1901, p. 248). The earliest of the replicas may have been the two miniature versions of the subject, one of which Ingres gave to his friend Gilibert (W. 95; France, Private Collection. Oil on canvas affixed to panel, 6 × 10.7 cm. Inscribed on verso: Ingres Pinxit) and the other of which was formerly in the collection of the painter Turpin de Crissé (cat. 50). Strangely, the artist never seems to have done any drawn or watercolor repetitions of this subject.

Among the works completed in Paris between 1824 and 1834, the artist lists a "petite *Odalisque* en grisaille"

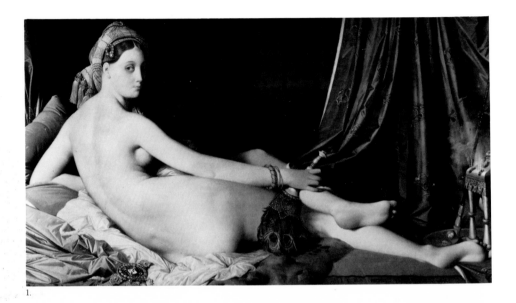

2.

1. Paris, Musée du Louvre. Oil on canvas, 91 ×
162 cm. Inscribed: J. A. Ingres Pat 1814. Rom.
(W. 93)

2. New York City, Metropolitan Museum of Art,
cat. 51.

3. Montauban, Musée Ingres, cat. 80.

4. Réveil, 1851.

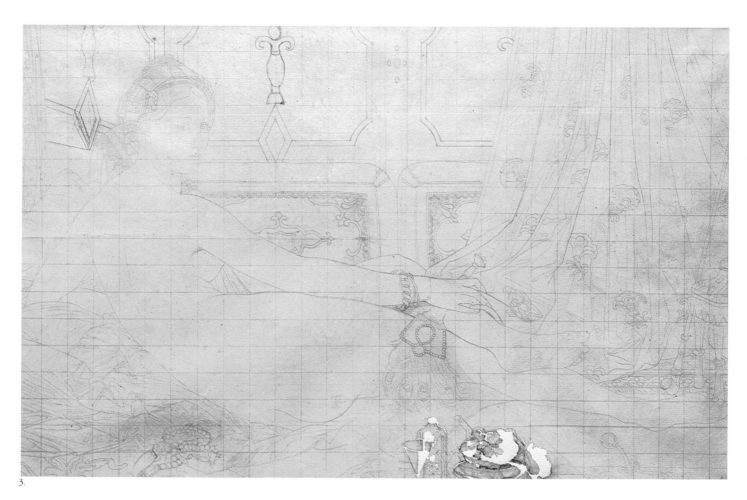

3.

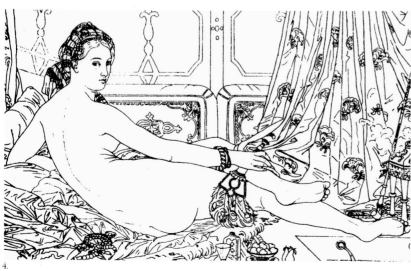

4.

J.-A.-D. Ingres, "Peintre d'Histoire"
Religious Subjects

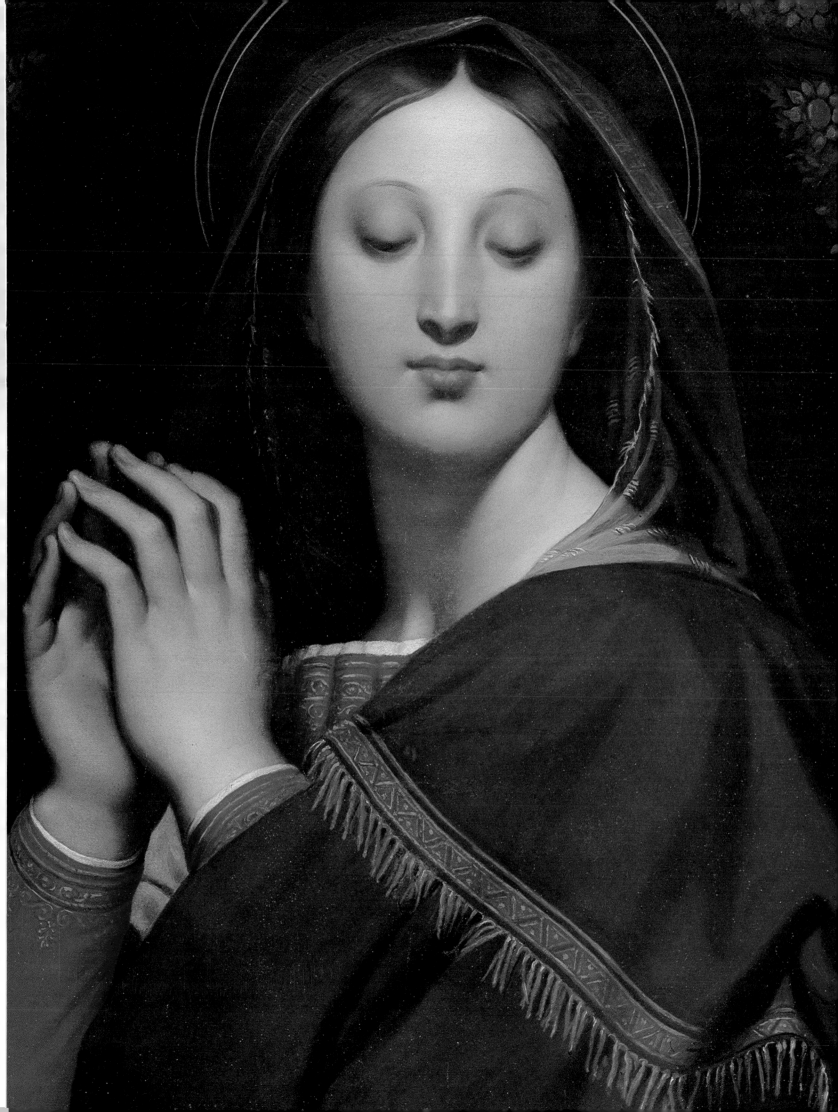

J.-A.-D. Ingres,
Portraitist

by Agnes Mongan

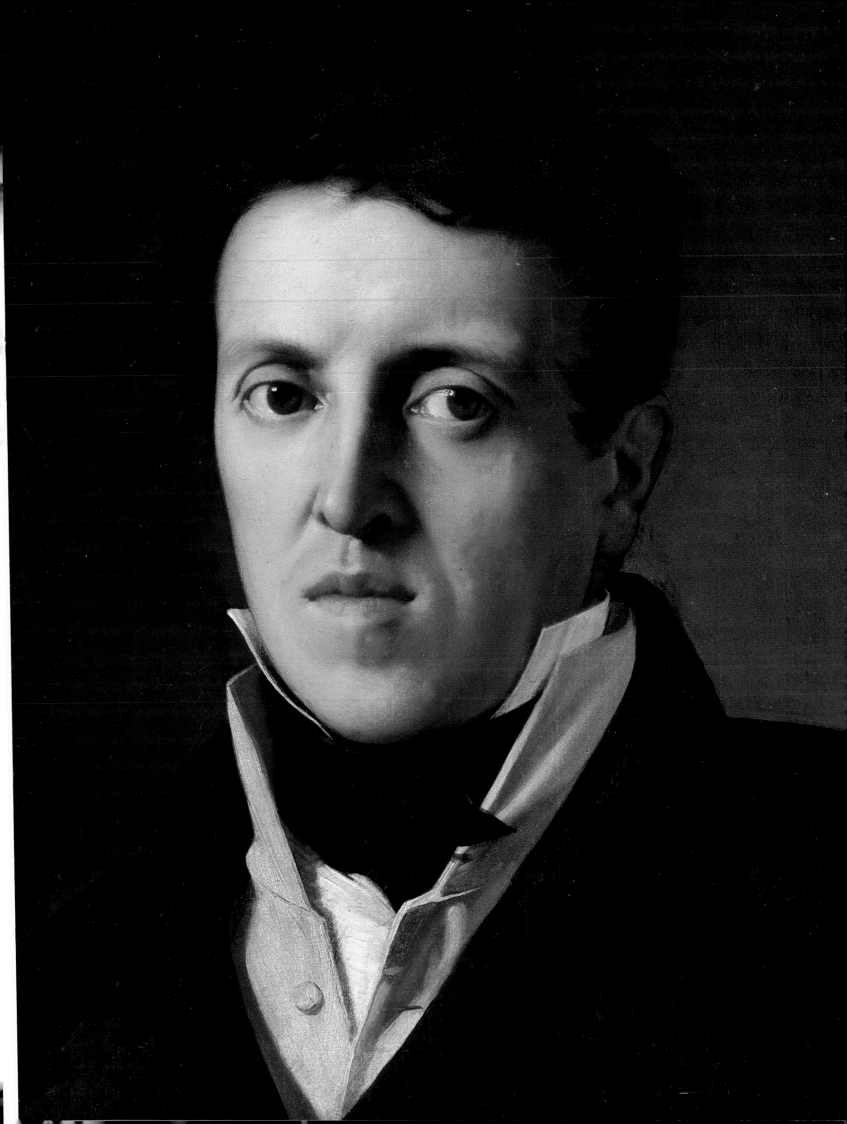

later to a subject that still challenged him.

Ingres also turned his well-trained eye to his circle of family and friends, recording with great affection their personalities and the fashions and tastes of the time. The graceful three-quarter-length portrait of *Mlle. Joséphine Nicaise-Lacroix* (cat. 69) is the earliest portrait drawing in the exhibition. Within a lightly indicated oval, Joséphine stands with her hand supporting her inclined head. Her expression is that of a person lost in dreams, which were probably suggested by the small book she casually holds in her right hand. The drawing, which remained in the sitter's family for over a century, is dated 1813, the year before Ingres married Joséphine's cousin.

The artist's pregnant wife is the subject of a work done the following year. The well-known portrait of *Madeleine Ingres, née Chapelle* (cat. 70) has been shown widely in the United States and Europe. It remains one of the most treasured of Ingres' works, for it clearly reflects his affection for the sitter as well as her lively response to his presence. The peace and happiness reflected in the drawing were not, unfortunately, to last, as the infant was not born alive. The work is one of the few portrait drawings Ingres enriched with watercolor wash.

In 1815 Ingres made an oval portrait drawing of the son of his friend Guillon Lethière, Director of the French Academy in Rome. This portrait of the nineteen-year-old *Auguste Lethière*. (cat. 71) is the tenth known drawing by Ingres of members of Guillon Lethière's family. The drawing has no history prior to its appearance on the art market in 1971, but its existence had been surmised as early as 1963 by Hans Naef ("Ingres und die Familie Guillon Lethière," *Du,* December 1963, p. 75). In the heavy-lidded eyes and the mobile mouth is a strong resemblance to the other family members Ingres portrayed. The sadness in Auguste's eyes perhaps foretold his unhappy life, which ended miserably, apparently in an asylum in Turin in 1865.

It was in Florence that Ingres painted in 1821 one of the simplest, most direct, and most charming of all his female portraits, that of *Mademoiselle Jeanne Gonin* (cat. 72). Jeanne was the sister of a Swiss merchant who had become one of Ingres' good friends. she is presented a little more than half length against a completely neutral background. There is no hint of a setting. Her crisp hair ribbon is as dark and simple as her dress. Her gold chain and small rings are of restrained design. Her wide-set, observing eyes contemplate the viewer with calm and candor, and her charm is made more alluring by the hint of a smile brightening her face. In 1822 Jeanne Gonin married the Geneva-born clergyman Pyramé Thomeguex, of whom there is a pencil portrait (Basil, Edmund Levy Collection; repr. Naef, V, p. 22) and a counter-proof by Ingres of the same year (Geneva, Musée d'Art et d'Histoire; repr. Naef, V, p. 259). Jeanne became a close friend of Madame Ingres, who, about 1829, sent her from Paris a portrait drawing of herself by her husband dedicated "à ma bonne amie/Madame Thomequex" (Santa Barbara, Collection of Mrs. Hugh Kirkland).

In 1830 Ingres drew the portrait of *Madame Désiré Raoul Rochette* (cat. 73). Antoinette Claude Houdon, daughter of the famous sculptor, had become in 1810 the wife of Ingres' friend, the distinguished archaeologist Désiré Raoul-Rochette. At the time of this drawing, Raoul-Rochette was Secretaire perpétuel de l'Academie des Beaux-Arts. At about the same time, 1830, Ingres quickly drew Monsieur Raoul-Rochette's portrait (Vienna, Albertina; repr. Naef, V, p. 160). A comparison between Ingres' portrait of Claudine, as Madame Raoul-Rochette was known, and a terra cotta sculpture her father completed when she was only one year old (New York, Metropolitan Museum of Art) reveals that her nose, eyes, and mouth changed little over the years. If the father's portrait captures the child's enchanting charm, Ingres' portrait reflects her adult beauty, virtue, and merit. The elaborate coiffure and crisply handsome collar and coat only make more subtle and effective the artist's record of the sitter's calm and sympathetic face.

What a contrast is the next drawing, the portrait of *Madame Thiers* (cat. 74). The drawing is inscribed "offert à Monsieur/Thiers. ministre d/l'intérieur-/Ingres Del/1834" and was apparently a gift to Thiers, although the two were not close. Ingres did not count Thiers among his favorites and Thiers in turn found Ingres' writing on art both inadequate and pretentious. As Thiers became Minister of the Interior in April 1834 and Ingres left Paris for Rome in December 1834, the drawing must have been made in the intervening months. Thiers' marriage to the fifteen-year-old daughter of his friend Madame Dosne took place in the autumn of 1833, so we are presented with a youthful bride of less than a year

Madeleine Chapelle (the artist's first wife) Gueret, Musée de Gueret. Graphite on cream wove paper, 19 x 13.5 cm, 1830. (Naef 327)

Mme. Delphine Ingres (the artist's second wife)
Cambridge, Mass., Fogg Art Museum. Graphite on
white wove paper, 35 x 27.2 cm, 1855. (Naef 436)

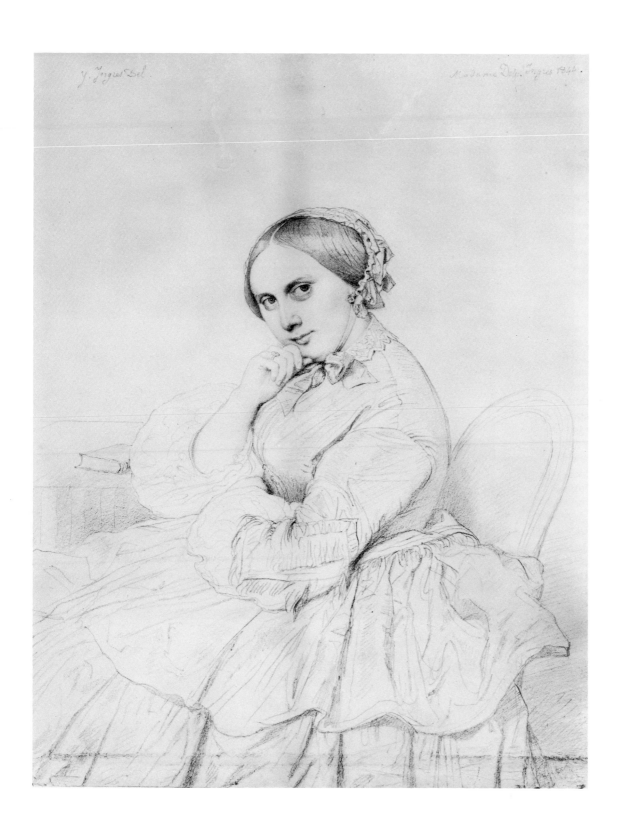

Exhibition Checklist

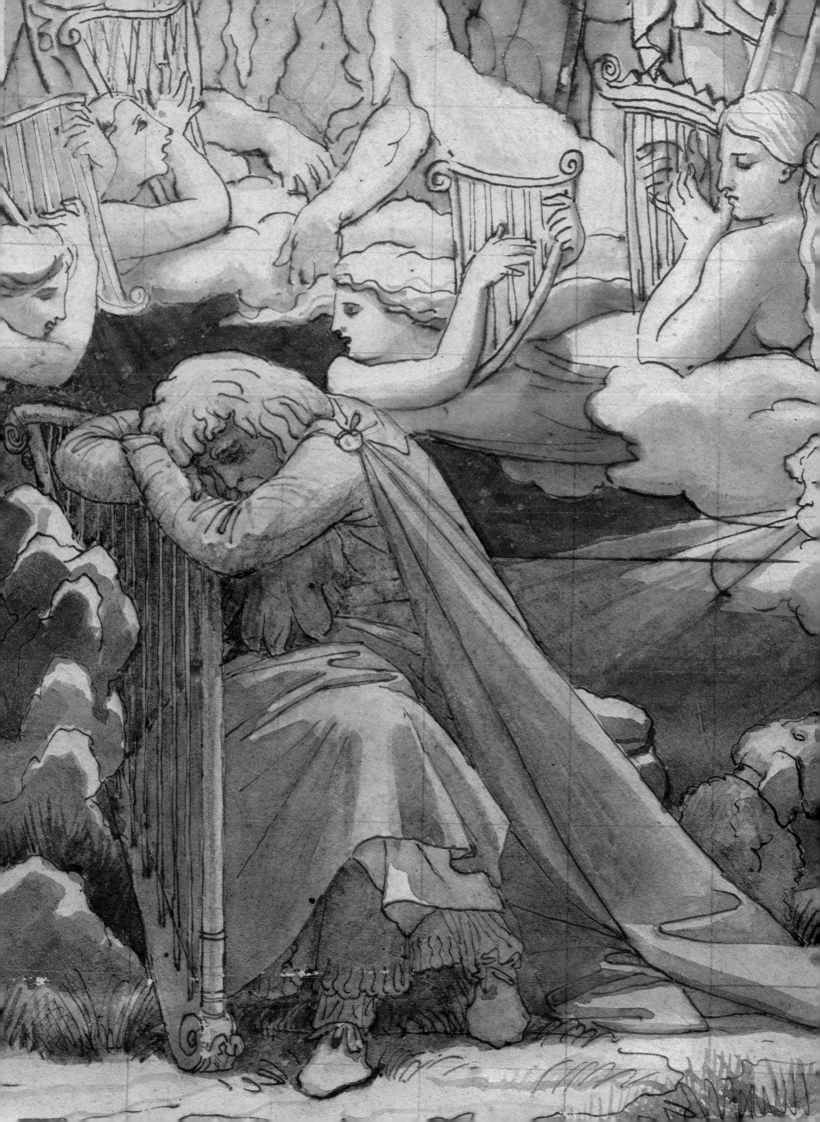

1. Philémon and Baucis Giving Hospitality to Jupiter and Mercury, n.d. (before 1833)
Le Puy, Musée Crozatier, 833-20
Graphite, pen and black ink, grey wash with changes in sepia on white wove paper
30 x 39 cm
Inscribed in black ink l.r.: J. Ingres inv. et de.

Provenance
Gift to the Société d'Agriculture du Puy, 1833

Exhibition History
Paris, 1900, no. 1065
Toulouse-Montauban, 1955, no. 86
London, Victoria and Albert, 1972, no. 650, pp. 368-369
Paris, Grand Palais, 1974-75, no. 84, repr.

Selected References
Becdelièvre, *Annales de la Société d'Agriculture du Puy*, VI, 1832-33, p. 249
Delaborde, 1870, p. 273, no. 182
L. Clément de Ris, "Musée du Puy," *Gazette des Beaux-Arts*, March 1878, p. 270
M. Vibert, mus. cat., Le Puy, 1872, pp. 70-71
Terrasse, mus. cat., Le Puy, 1904, no. 480
Lapauze, 1911, repr. p. 36
V. Rouchon, mus. cat., Le Puy, 1926, p. 27
V. Rouchon, mus. cat., Le Puy, 1931, p. 10; repr. p. 48

E.S. King, "Ingres as a classicist," *Journal of The Walters Art Gallery*, 1942, p. 105, no. 41
R. Gounot, mus. cat., Le Puy, 1949, p. 38
Schlenoff, 1956, p. 38
N. Schlenoff, "Un souvenir d'Ingres: un dessin inédit," *Bulletin du Musée Ingres*, December 1957, p. 12, fig. 1
F.-X. Amprimoz, *Guide du Musée Crozatier*, 1979, p. 73, fig. 87

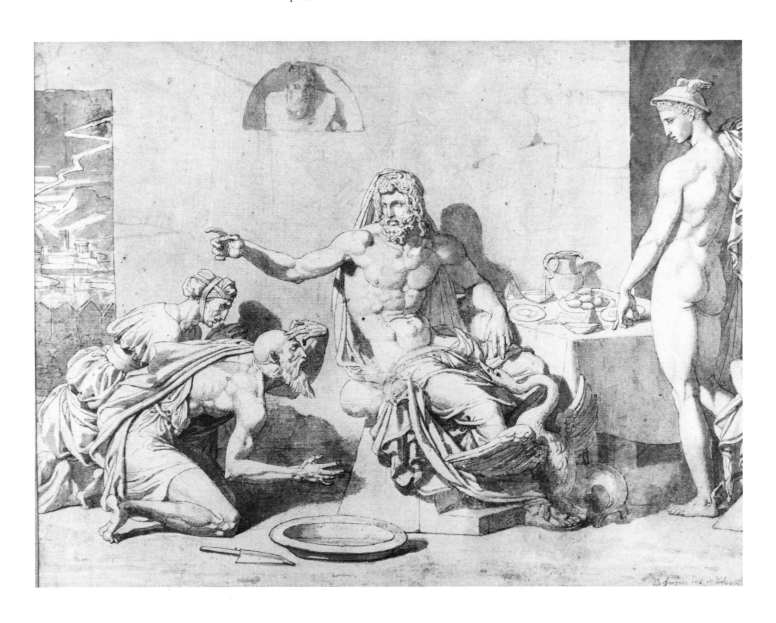

2. Philémon and Baucis, 1864
New York City, Mrs. Althea Schlenoff, Courtesy of
 Shepherd Gallery
Graphite and grey wash with lead white
 heightening on tan laid paper
29.4 x 27.6 cm
Inscribed in graphite l.l.: J. Ingres inv.
Inscribed in graphite l.r.: 20 sept. 1864
Inscribed in graphite l.c.: PHILEMON ET BAUCIS
Inscribed in graphite below title: Souvenir de
 L'Haÿ/à Monsieur et Madame Haché/leur bien
 affectionné/J. Ingres

Provenance
M. et Mme. Haché, Paris
André Haché, Paris

Exhibition History
New York, Shepherd Gallery, *French Nineteenth-
 Century Drawings, Pastels, Watercolors*, 1977-
 78, no. 55, repr.

Selected References
Schlenoff, 1956, pl. II, opp. p. 35; p. 38
N. Schlenoff, "Un souvenir d'Ingres: un dessin
 inédit," *Bulletin du Musée Ingres*, December
 1957, pp. 8-13, fig. 2

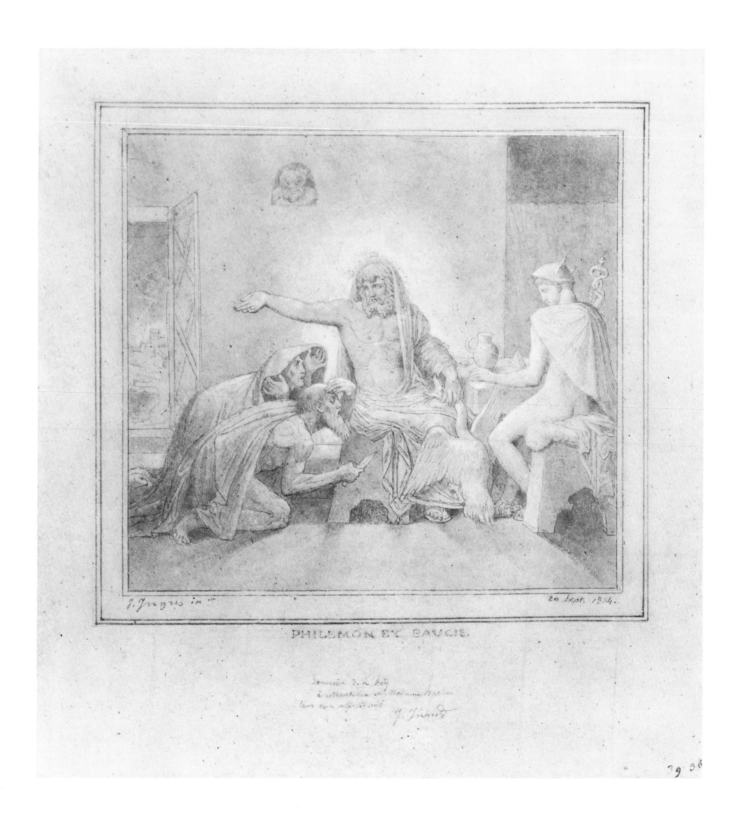

3. Oedipus and the Sphinx, 1864
Baltimore, The Walters Art Gallery, 37.9
Oil on canvas
105.5 x 87 cm
Inscribed l.c.: J. Ingres fbat/etatis/LXXXIII/1864

Provenance
Painted for M. Emile Pereire
Pereire Sale, Paris, March 6-9, 1872, no. 26
Secrétan Sale, Paris, July 1-7, 1889, no. 37
P.-A. Chéramy Sale, Paris, May 5-7, 1908, no. 208

Exhibition History
Paris, 1867, no. 24
Baltimore Museum of Art, *From Ingres to
 Gauguin*, 1951, no. 8
Dayton Art Institute and Columbus Institute of
 Fine Arts, *Flight: Fantasy, Faith, Fact*, 1953-54,
 no. 58
New York, 1961, no. 72
Seattle World's Fair, *Masterpieces of Art*, 1962,
 no. 38
San Francisco, California Palace of the Legion of
 Honor, *Man: The Glory, Jest, and Riddle*, 1964-
 65, no. 194
Cleveland Museum of Art, *Neo-Classicism: Style
 and Motif*, 1964, no. 131
Baltimore Museum of Art, *From El Greco to
 Pollack*, 1968, no. 72

Selected References
Delaborde, 1870, p. 212, no. 36
J. Gigoux, *Causeries sur les artistes de mon temps*,
 Paris, 1885, p. 92
Lapauze, 1911, p. 90
E.S. King, "Ingres as a classicist," *Journal of The
 Walters Art Gallery*, 1942, pp. 70-76, fig. 1
Alazard, 1950, p. 42, pl. XII
P.H. Polak, "de invloed van enige monumenten
 der oudheid op het classicism van David,
 Ingres en Delacroix," *Nederlandsch
 Kunsthistorisch jaarboek*, 1948-49, p. 301
Wildenstein, 1954, p. 231, no. 315, fig. 32
Schlenoff, 1956, repr. cover; pl. XIII
Paris, 1967-68, p. 60
Ternois and Camesasca, 1971, p. 91, no. 51c, repr.
W. Johnston, *The Nineteenth-Century Paintings in
 The Walters Art Gallery*, 1982, p. 38, repr.

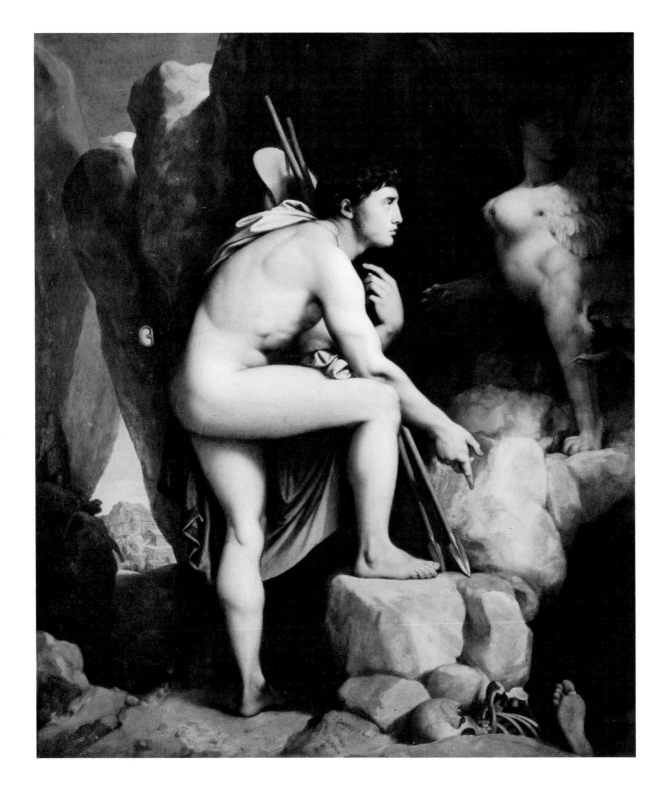

4. Profile of a Bearded Man, 1808
Aix-en-Provence, Musée Granet
Oil on canvas
33 × 24 cm

Provenance
Granet estate, 1849

Exhibition History
Unavailable

Selected References
H. Pontier, *Le Musée d'Aix,* II, 1900, no. 362
Wildenstein, 1954, p. 172, no. 63, fig. 30
Ternois and Camesasca, 1971, p. 91, no. 53a, repr.

5. Head of Jupiter, 1810
Montauban, Musée Ingres, Deposit from Musée
 du Louvre, D.54.1.2
Oil on canvas affixed to wood
48 × 40 cm
Inscribed l.l.: J. Ingres, Roma 1810

Provenance
Sold by Ingres, c. 1866
Eugène Lecomte Sale, Paris, June 11-13, 1906,
 no. 48

Exhibition History
Paris, 1867, no. 17
Montauban, 1980, no. 25

Selected References
Delaborde, 1870, p. 241, no. 84
Lapauze, 1911, pp. 100-102
Wildenstein, 1954, p. 174, no. 73, fig. 38
Ternois, *Guide du Musée Ingres*, 1959, p. 19
Montauban, 1967, no. 156, repr.
Ternois and Camesasca, 1971, p. 92, no. 67b; repr.
 p. 93

6. Romulus Victorious Over Acron, n.d.
USA, Private Collection
Graphite and grey wash on tracing paper
26 x 51.2 cm
Inscribed l.r.: Ingres à M. Haro

Provenance
Painted for Etienne-François Haro, Paris
Haro Sale, Paris, April 2-3, 1897, lot 175, to Henri
 Haro, Paris
Henri Haro Sale, Paris, February 3, 1912, lot 147,
 to Henry Lapauze, Paris
Henry Lapauze Sale, Paris, June 21, 1929, lot 46

Exhibition History
Paris, 1911, no. 190
Paris, Palais des Beaux-Arts, *David et ses élèves,*
 1913, no. 337
London, Wildenstein & Co., Inc., *French
 Drawings from Clouet to Ingres*, 1934, no. 49

New York, Wildenstein & Co., Inc., *French XIX
 Century Drawings*, 1947-48, no. 34
New York, Wildenstein & Co., Inc., *French
 Neoclassicism*, 1976, no. 27
Ithaca, New York, Herbert F. Johnson Museum of
 Art, Cornell University, *The Linear Tradition:
 Selected Drawings from the Eighteenth to the
 Twentieth Century*, 1978
London, Wildenstein & Co., Inc., *Consulat,
 Empire, Restauration: Art in Early XIX Century
 France*, 1981, repr. p. 9
New York, Wildenstein & Co., Inc., *Consulat,
 Empire, Restauration: Art in Early XIX Century
 France*, 1982, p. 113; repr. p. 11

Selected References
Delaborde, 1870, p. 275, no. 190
Fogg, 1967, under no. 12
Rome, Villa Medici, *Ingres in Italia,*1968, under
 no. 34

7. Romulus Victorious Over Acron, Study
for the Central Portion, n.d.
Montauban, Musée Ingres, 867.2129
Graphite, squared for transfer, on cream wove
paper
33.4 × 33.5 cm

Provenance
Ingres estate, 1867

Exhibition History
None

Selected References
Unpublished

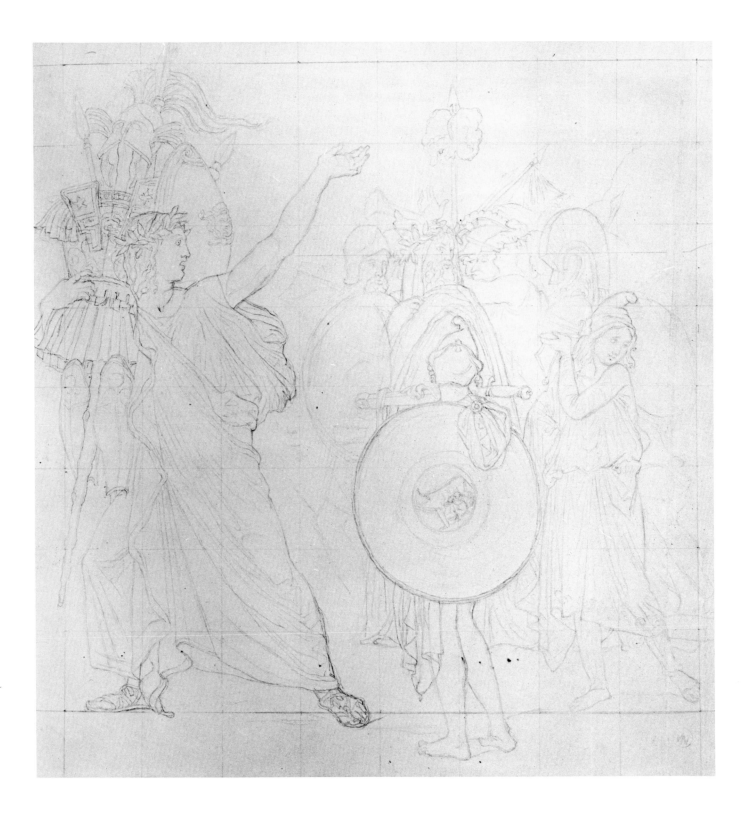

158

8. The Dream of Ossian, n.d. (c. 1811-13)
Montauban, Private Collection
Graphite, watercolor, pen and brown ink on
 white wove paper
28.2 × 23.8 cm

Provenance
Gift to Jean-François Gilibert
Mme. Montet-Noganets (his daughter), 1850
Mme. Fournier, 1937

Exhibition History
Montauban, 1862, no. 561
Paris, 1867, no. 220
Montauban, 1877, no. 374
Paris, 1911, no. 193
Paris, 1967-68, no. 62, repr.
Toulouse-Montauban, 1955, no. 211
Montauban, 1967, no. 44
Hamburg, Kunsthalle, *Ossian und die Kunst um
 1800*, 1974, p. 129, no. 110; repr. color p. 131

Selected References
Delaborde, 1870, p. 278, no. 200
Schlenoff, 1956, p. 79
Ternois, 1959, pp. 126-127, fig. 6
Ternois, 1965, *Inventaire*, p. 189, fig. 4; pl. 43
Ternois and Camesasca, 1971, p. 95, no. 76, repr.;
 pl. XXII

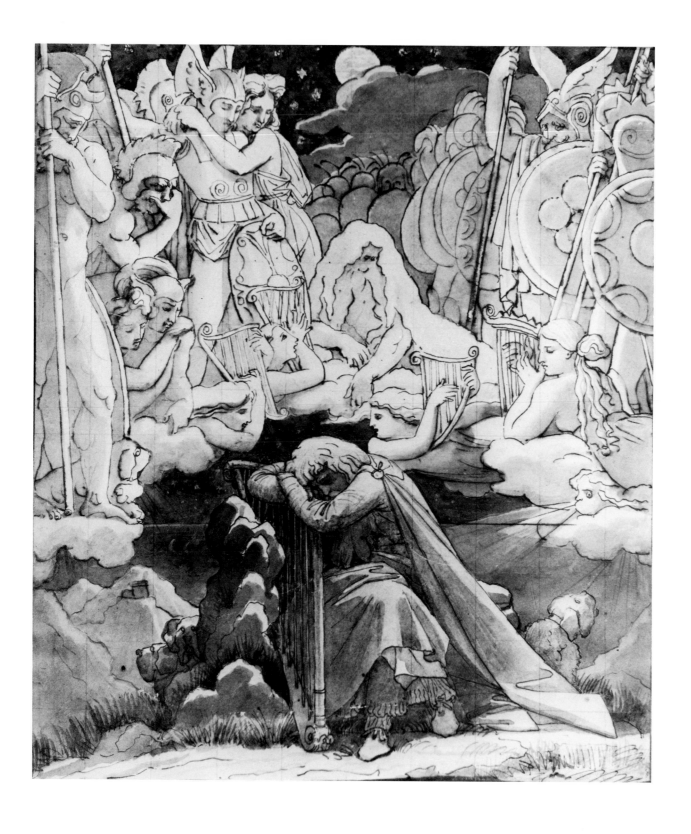

9. Virgil Reading from the Aeneid to Augustus, Octavia, and Livia, Study, n.d.
Ottawa, National Gallery of Canada, 17134
Graphite on cream wove paper
39.8 × 32.1 cm
Inscribed in graphite l.r.: Ing.

Provenance
Ingres Sale, Paris
Emile Bernard
E. Joseph Rignault, Paris, 1874
Jaccottet Collection
Private Collection, Switzerland, 1930s
Fritz Nathan, Zurich

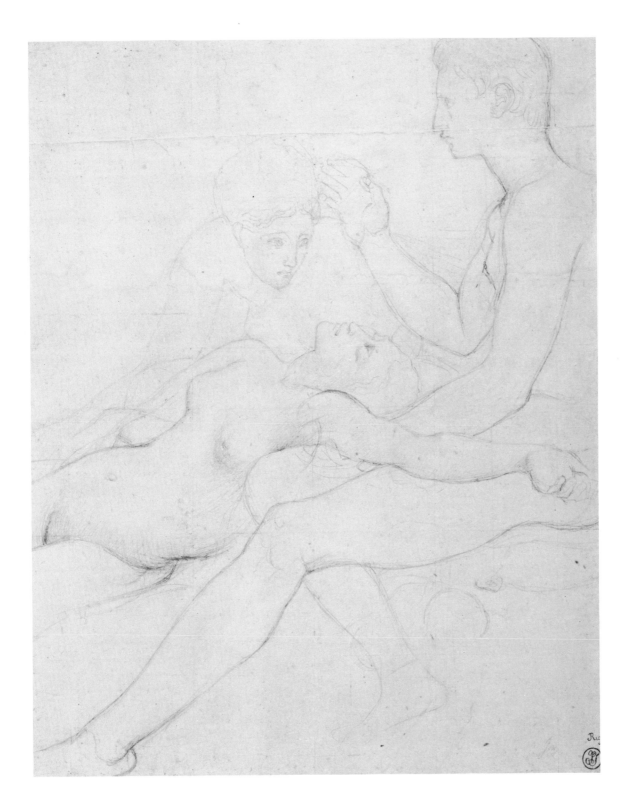

160

10. Virgil Reading the Aeneid Before Augustus, Octavia, and Livia, n.d. (c. 1819)
Brussels, Musées Royaux des Beaux-Arts de Belgique, 1836
Oil on canvas
138 × 142 cm

Provenance
Ingres estate sale, Paris, Hôtel Drouot, April 22, 1867, lot 4

Exhibition History
Paris, 1867, no. 427
Paris, Palais des Beaux-Arts, *David et ses élèves*, 1913, no. 186
Paris, 1921, no. 21
Brussels, Musées Royaux des Beaux-Arts de Belgique, *David et son temps*, 1925, no. 45
London, Royal Academy, *French Art, 1200-1900*, 1932, no. 372

Paris, Musée des Arts décoratifs, *Les artistes français en Italie*, 1934, no. 215
Paris, Palais National des Arts, *Chefs- d'oeuvre de l'art français*, 1937, no. 350
Recklinghausen and Amsterdam, *Polarité, le coté apollineen et le coté dyonisiaque dan les beaux-arts*, 1961
Brussels, *Art français de David à Matisse*, 1963, 1966
Montauban, 1967, no. 58; pl. 7
Paris, 1967-68, no. 111
Rome, Villa Medici, *Ingres in Italia*, 1968, no. 39
London, Victoria and Albert, 1972, no. 149

Selected References
Magimel, 1851, pl. 23
T. Silvestre, *L'apothéose de M. Ingres*, Paris, 1862
O. Merson and E. Bellier, *Ingres, sa vie et ses oeuvres*, Paris, 1867, pp. 106-107
Delaborde, 1870, p. 29; p. 223, no. 47; p. 333

Blanc, 1870, pp. 52-54, 232
Amaury-Duval, Paris, 1878, p. 87; 1924, p. 59
Lapauze, 1901, p. 125
Lapauze, 1911, p. 126; repr. p. 185
A. Mongan and P. Sachs, *Drawings in the Fogg Museum of Art*, Cambridge, Mass., 1940, cited in no. 700
A. Mongan, "Ingres and the Antique," *Journal of the Warburg and Courtauld Institute*, X, 1947, pp. 9-10
Alazard, 1950, p. 53; pl. XLII
Wildenstein, 1954, p. 188, no. 128; pl. 53
Schlenoff, 1956, p. 105
D. Ternois, "Ingres et le Songe d'Ossian," *Walter Friedlaender zum 90. Geburtstag*, Berlin, 1965, p. 187
Ternois and Camesasca, 1971, p. 94, no. 70b; pl. XIX

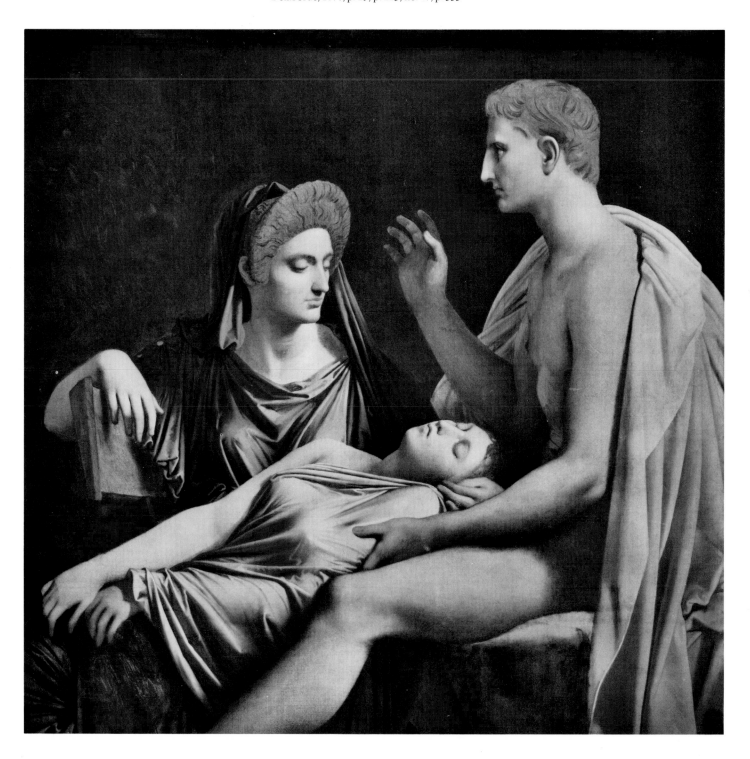

11. Virgil Reading the Aeneid, Study, n.d.
Montauban, Musée Ingres, 867.2463a
Graphite, pen and black ink, grey wash, with
changes in brown ink on tracing paper with
pieces of wove paper
23.6 x 36.5 cm

Provenance
Ingres estate, 1867

Exhibition History
None

Selected References
A. Cambon, *Catalogue du Musée de Montauban*,
1885, no. 1960, fasc. 8SP.
Momméja, 1905, no. 926

12. Virgil Reading the Aeneid, Study, n.d.
Montauban, Musée Ingres, 867.2463b
Graphite, pen and black ink, grey wash, with
 changes in brown ink on tracing paper with
 pieces of cream wove paper
14.7 x 34.6 cm

Provenance
Ingres estate, 1867

Exhibition History
None

Selected References
A. Cambon, *Catalogue du Musée de Montauban*,
 1885, no. 1960, fasc. 8SP.
Momméja, 1905, no. 926

13. Virgil Reading the Aeneid, 1832
Paris, Bibliothèque Nationale, A.A.5res
Engraving by Pradier, retouched by Ingres, on
cream laid paper
63 × 47.5 cm
Inscribed in graphite l.l. margin: Epreuve
retouchée par l'auteur

Provenance
Gift of the artist to Cabinet des Etampes, 1859

Exhibition History
None

Selected References
L. Hourticq, *Ingres, l'oeuvre du maître,* Paris,
1928, p. 32, repr.

Louisville Only

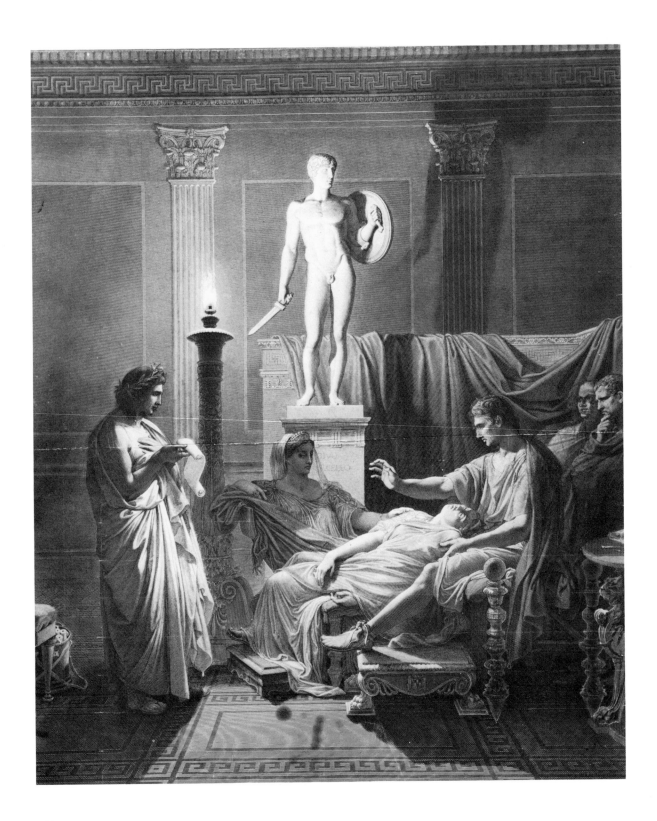

164

14. Virgil Reading the Aeneid to Augustus,
1812
Toulouse, Musée des Augustins, Inv. 124
Oil on canvas
304 x 323 cm

Provenance
Commissioned by Général Miollis, 1811
Repurchased by Ingres, c. 1835
Ingres estate, 1867

Exhibition History
Montauban, 1980, no. 27

Selected References
Ingres, Notebook IX, X
Magimel, 1851, pl. 23
Delaborde, 1870, p. 221, no. 46
Blanc, 1870, pp. 52-53, 227
Boyer d'Agen, 1909, pp. 117, 459
Lapauze, 1911, pp. 118, 124-128, 226, 246, 474;
 repr. p. 119
W. Deonna, "Ingres et l'imitation de l'antique,"
 Pages d'Art, Geneva, October 1921, p. 321, and
 December 1921, p. 373
R. Longa, *Ingres inconnu,* Paris, n.d., p. 34
Wildenstein, 1954, p. 175, no. 83, fig. 50
Ternois and Camesasca, 1971, p. 93, no. 70a; repr.
 p. 94

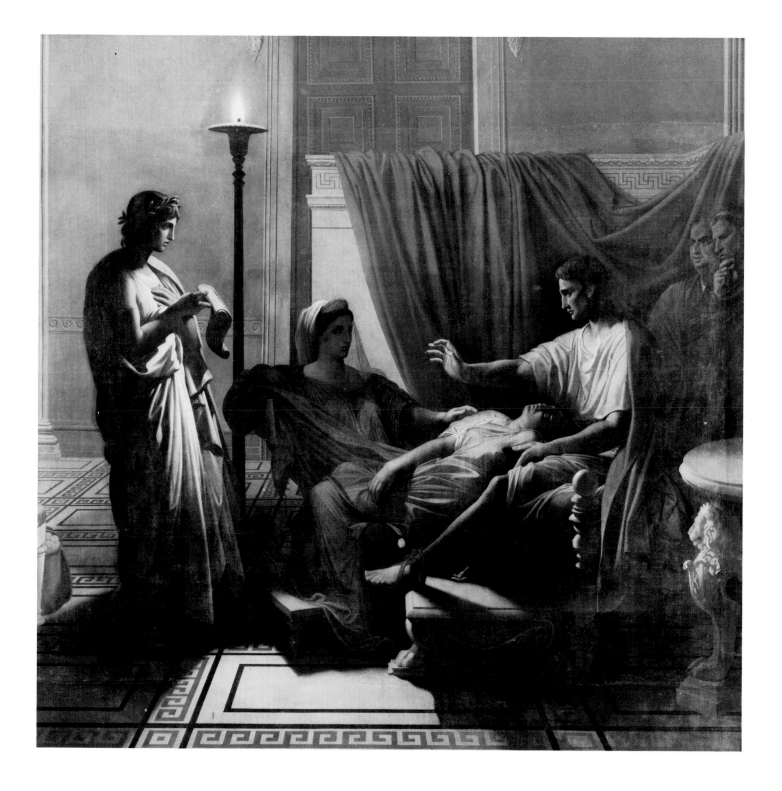

15. Virgil Reading the Aeneid to Augustus,
1865
Philadelphia, La Salle College Art Museum,
69-P-53
Painted in oil by Ingres over an 1832 Pradier
engraving on paper affixed to wood
58 x 46.9 cm

Provenance
Ingres studio
Mme. Delphine Ingres
M. et Mme. Ramel
M. Emmanuel Riant
Marquis de Salverte
Anonymous Sale, December 24, 1952, lot 101
Purchased from Wildenstein & Co., Inc., New
York, 1969

Exhibition History
Toulouse-Montauban, 1955, no. 154, p. 95

Selected References
Ingres, Notebook X
Delaborde, 1870, p. 223, no. 48
Lapauze, 1911, p. 380
Wildenstein, 1954, p. 232, no. 320, fig. 49
Ternois and Camesasca, 1971, p. 94, no. 70c, repr.
Fogg, 1980, under no. 35

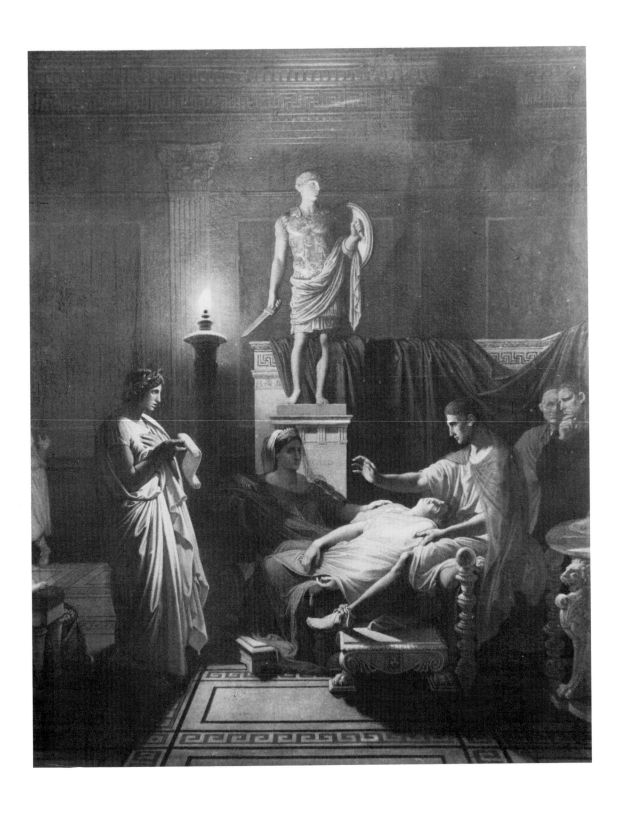

16. Antiochus and Stratonice, 1866
Montpellier, Musée Fabre, 844.1.1
Oil, graphite, watercolor, varnish on paper
 affixed to canvas
61 × 92 cm
Inscribed l.l.: J. Ingres, 1866

Provenance

Mme. Delphine Ingres
Purchased from the artist's widow, 1884

Exhibition History

Paris, 1867, no. 58
London, Royal Academy, *French Art, 1200- 1900*,
 1932, no. 294; cat. no. 418
Paris, *Chefs-d'oeuvre du Musée de Montpellier*,
 1939, no. 69
Buenos Aires, Museo Nacional de Bella Artes, *La
 pintura francesa de David a nuestros dias*,
 1939 (also Montevideo, Rio de Janeiro, San
 Francisco, Washington, Chicago, New York,
 1939- 45)
Montauban, 1967, no. 150
Montauban, 1980, no. 116; repr. pp. 82, 83

Selected References

Ingres, Notebook X
Delaborde, 1870, p. 220, no. 43
Blanc, 1870, pp. 115-118
Lapauze, 1901, p. 144

Lapauze, 1911, p. 550
Boyer d'Agen, 1909, pp. 27, 53, 72, 253, 261, 286,
 291
Joubin, *Catalogue du Musée Fabre de
 Montpellier*, n.d., no. 615; pl. LXIV
L. Venturi, *Peintres modernes*, Paris, 1942, p. 96
A. Mongan, "Ingres and the Antique," *Journal of
 the Warburg and Courtauld Institute*, X, 1947,
 pp. 11, 12, repr.
Alazard, 1950, pp. 95-96
Wildenstein, 1954, p. 232, no. 322, fig. 182
Ternois and Camesasca, 1971, p. 108, no. 131a,
 repr.

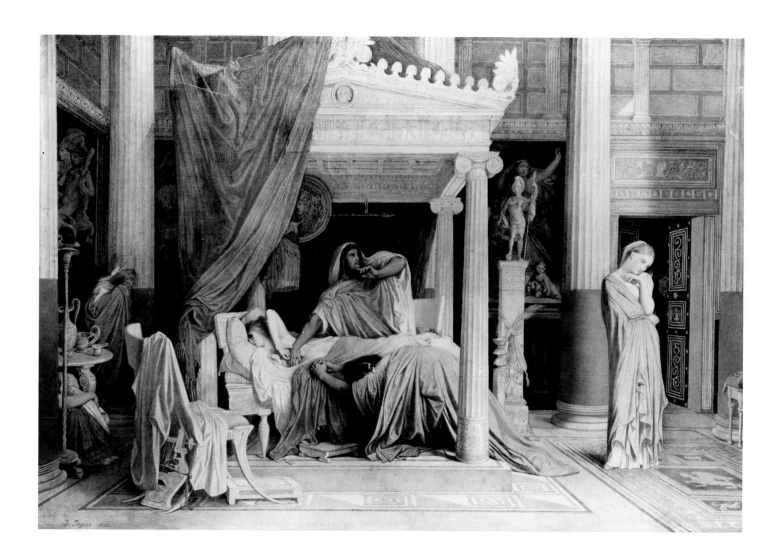

17. **Antiochus and Stratonice,** Study for
 Stratonice, 1834
Lexington, Kentucky, John R. Gaines Collection
Graphite on paper
39.4 × 28 cm

Provenance
Private Collection, Paris
Paul Rosenberg & Co., New York City

Exhibition History
None

Selected References
Unpublished

18. Eros, n.d. (c. 1864)
New York City, Ian Woodner Family Collection,
 41
Oil on canvas
32 cm (diam.)
Inscribed in oil l.r.: I.G.

Provenance
Estate of Jacques Ignace Hittorf
Wallraf-Richartz Museum, Cologne, sold 1938

Exhibition History
Paris, 1867, no. 417

Selected References
*Verziechnis der Gëmalde des Wallraf-Richartz
 Museum des Stadt.,* Köln, 1910, no. 95
Wildenstein, 1954, p. 219, no. 261, fig. 165
Ternois and Camesasca, 1971, p. 119, no. 171c;
 repr. p. 11

19. Paolo and Francesca, n.d.
Birmingham, England, Barber Institute
Oil on canvas
35 × 28 cm
Inscribed: J. Ingres

Provenance
Jean-Alexandre Coraboeuf, Paris
Henry Lapauze, Paris, February 27, 1911
Lapauze Sale, June 21, 1929, lot 55, to Guarnati
Anonymous Sale, May 30, 1949, lot 27

Exhibition History
Unavailable

Selected References
Wildenstein, 1954, p. 186, no. 123, fig. 69
Ternois and Camesasca, 1971, p. 96, no. 80c, repr.

Louisville Only

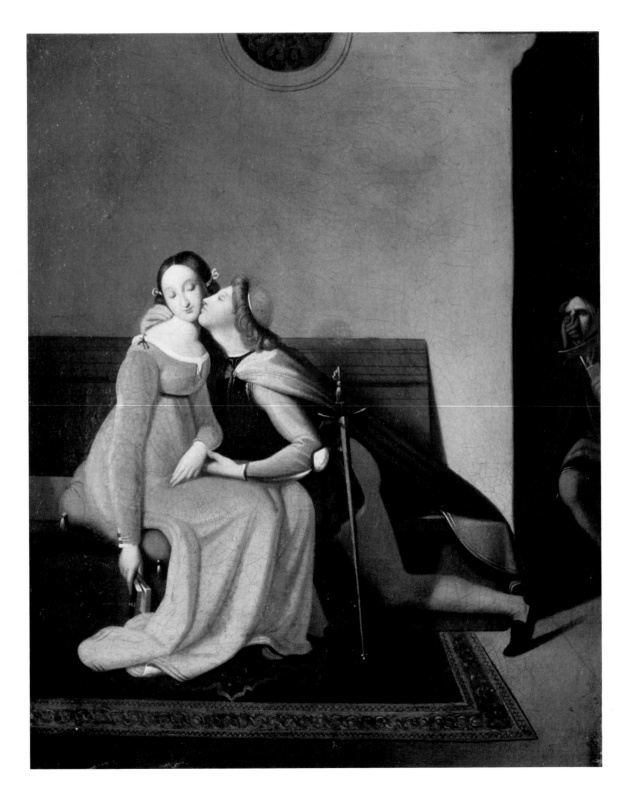

20. Paolo Malatesta and Francesca da Rimini, 1820
Amsterdam, Amsterdams Historisch Museum,
A10970
Graphite on white wove paper
19.4 × 13 cm
Inscribed in graphite l.l.: Ingres (three words
illegible) /8/20 (?)
Inscribed in graphite l.c.: Francesca da Rimini e
Paölo
Inscribed in graphite l.r.: Ingres inv (?) à
madame Taurel
Inscribed in graphite l.r.: roma 1820

Provenance
A.B.B. Taurel
Taurel Sale, Amsterdam, April 12, 1859, no. 2, to
Lamme
C.J. Fodor, Amsterdam
Musée Fodor, Amsterdam
Musée Municipal, Amsterdam

Exhibition History
Amsterdam, *Exposition rétrospective d'art
français*, 1926, no. 174 bis.
Amsterdam, *Fodor 100 jaar*, 1963, no. 78
Paris, Institut Néerlandais, *Le dessin français dans
les collections hollandaises*, 1964, no. 144

Selected References
C.E. Taurel, *Douze eaux-fortes d'aprés des dessins
originaux et inédites de Jean Alaux, Léon
Cogniet, Coutan, Henrique Dupont, Ingres,
Léopold Robert et Etna Michalon. Avec texte
explicatif et biographique enrichi de lettres
inédites*, Amsterdam-La Haye, 1885, pp. 2, 37-38,
repr.
H. Naef, "Ingres und die Familien Thévenin und
Taurel," *Nederlands Kunsthistorisch Jaarboek*,
16, 1965, pp. 119-157, esp. p. 149
Paris, 1967-68, p. 110, no. 156
Naef, 1980, II, p. 222
M.-C. Chaudonneret, "Ingres: Paolo et Francesca,"
Bayonne, n.d., p. 3, repr.

21. Paolo and Francesca, 1857
Switzerland, Private Collection
Graphite and grey wash heightened with white
 gouache on laid paper
23 × 17 cm
Inscribed l.l.: J. Ingres, 1857

Provenance
Blocque, Paris
Eugène Lecomte, Paris
de Maisonneuve Collection, Paris

Exhibition History
Paris, 1911, no. 219
Paris, Galerie Schmit, 1979, no. 97, p. 101
Paris, Grand Palais, *Bieniale des Antiquaries*,
 1980, no. 57

Selected References
Delaborde, 1870, p. 279, no. 205

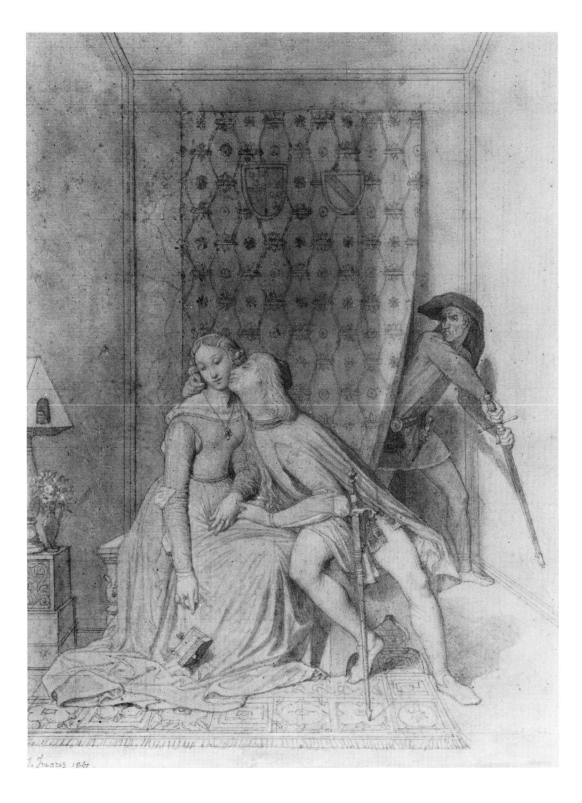

172

22. Paolo and Francesca, c. 1855-60
Glens Falls, New York, Hyde Collection, 1971.24
Oil on canvas
28.3 x 22.2 cm

Provenance
Vicomte du Tallis Sale, May 2, 1865, no. 7
Mrs. Louis F. Hyde, Glens Falls, New York, c. 1930

Exhibition History
Paris, *Exposition des tableaux de l'école moderne*,
 1860, no. 230
Springfield (Mass.) Museum of Fine Arts, *David
 and Ingres, Paintings and Drawings*, 1939, no.
 20 (also New York, Cincinnati, Rochester)
College Park, University of Maryland Art Gallery,
 *Search for Innocence, Primitive and
 Primitivistic Art of the 19th Century*, 1975, no.
 13, fig. 10

Selected References

E. Galichon, "Dessins de M. Ingres," *Gazette des
 Beaux-Arts*, 2, 1861, p. 42
Delaborde, 1870, p. 224, no. 50
Wildenstein, 1954, p. 186, no. 122, fig. 70
Rome, Villa Medici, *Ingres in Italia*, 1968, p. 86
W. Hartmann, "Dante's Paolo und Francesca als
 Liebspar," *Beiträge zu Kunst des 19. und 20.
 Jahrhunderts: Jahrbuch 1968/69*, Zurich, 1970,
 p. 15
Ternois and Camesasca, 1971, p. 112, no. 140a,
 repr.

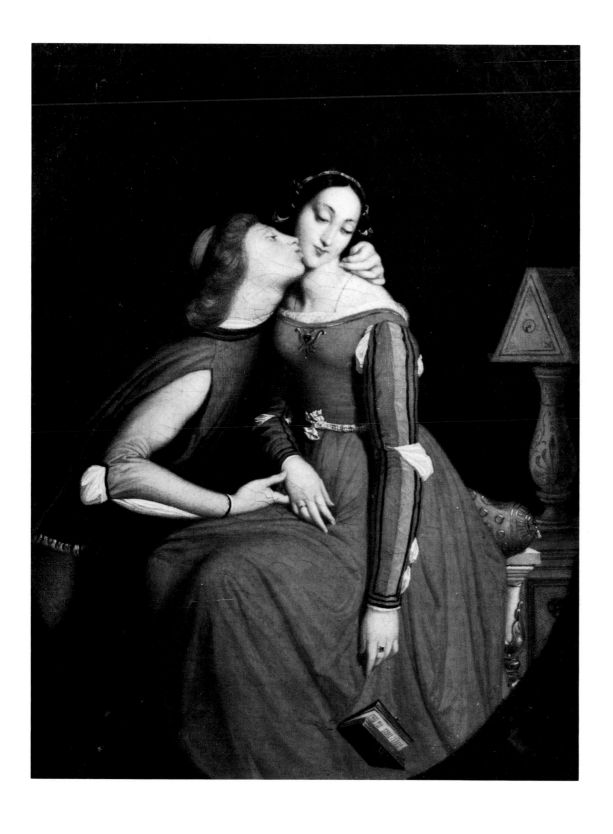

23. Paolo and Francesca, n.d. (c. 1856-57)
New York City, Private Collection
Oil on canvas
30.5 × 25.7 cm
Inscribed: J. Ingres

Provenance
Mme. Ingres, Paris
Henri Fare, Paris
Mme. de L. . ., Paris
Galerie Charpentier Sale, Paris, June 24, 1937, lot
 29, repr., to Private Collection, Paris
Sotheby & Co. Sale, London, November 30, 1966,
 lot 24, repr. (withdrawn)
M. Knoedler & Co., New York
Private Collection, USA
Robert M. Leylan, New York

Exhibition History
None

Selected References
E. Saglio, "Un nouveau tableau de M. Ingres, liste
 complète de ses oeuvres," *La Correspondance
 littéraire,* February 5, 1857, p. 79
Wildenstein, 1954, p. 222, no. 282, fig. 71
Ternois and Camesasca, 1971, p. 112, no. 140b,
 repr.

Louisville Only

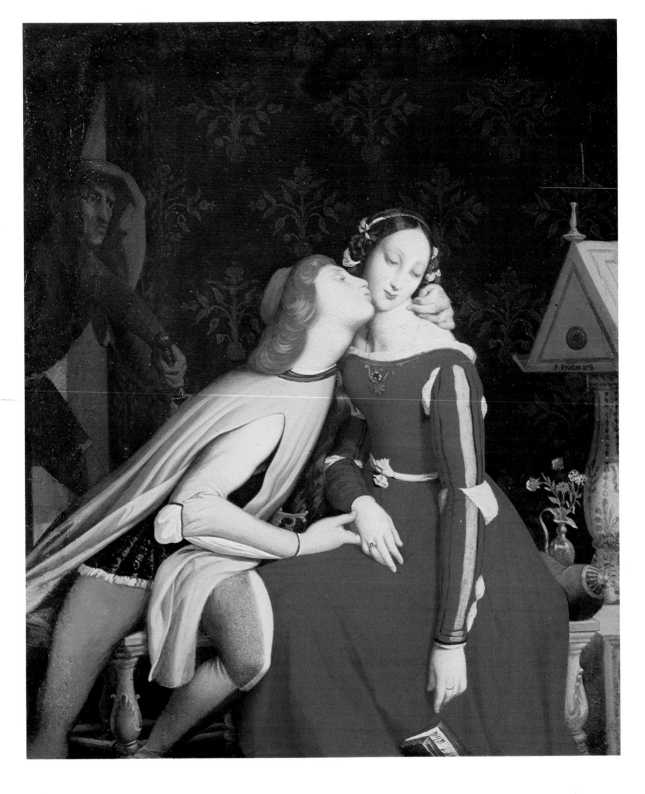

24. Paolo and Francesca, n.d.
London, Roland, Browse & Delbanco
Oil on canvas
26 x 21.5 cm

Provenance
Professor Halliday, Great Britain

Exhibition History
Manchester (England) City Art Gallery, *Works of
Art from Private Collections in the North West
and North Wales*, 1960, no. 179

Selected References
H. Naef, "Paolo und Francesca: Zum Problem der
 Schöpferischen Nachahmung bei Ingres,"
 Zeitschrift für Kunstwissenschaft, Berlin, 1956,
 p. 101, no. 10
Schlenoff, 1956, pl. X
Ternois and Camesasca, 1971, p. 112, no. 140c,
 repr.

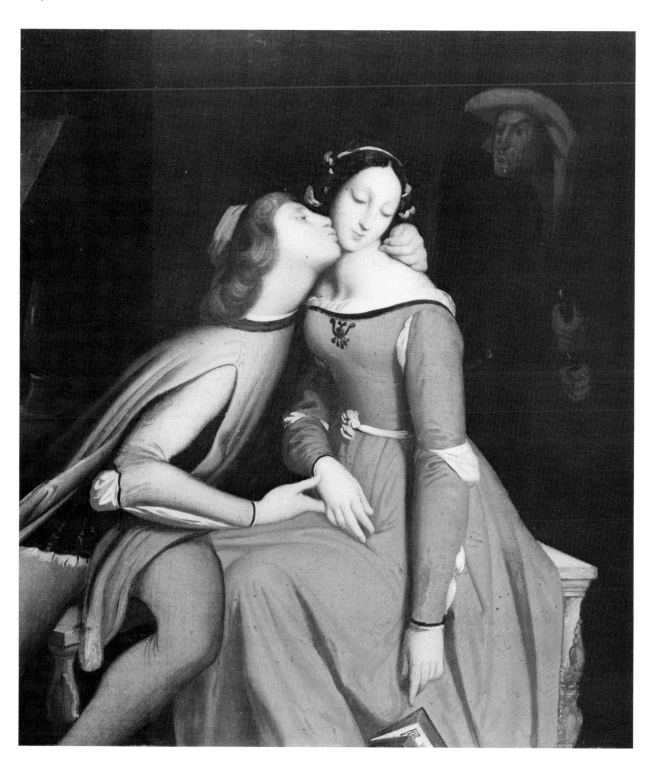

**25. Don Pedro of Toledo Kissing the
 Sword of Henry IV**, 1816
Montauban, Musée Ingres, 867.1367
Graphite, pen and brown ink, black crayon on
 blue wove paper mounted on white laid paper
17 x 11.6 cm
Inscribed l.l.: Ingres

Provenance
Ingres estate, 1867

Exhibition History
None

Selected References
Lapauze, 1901, p. 126

26. The Duke of Alba at St. Gudule, 1815

New York City, Paul Rosenberg & Co.

Graphite, white gouache, grey wash, pen and
 brown ink, red chalk on laid paper mounted
 on Japan paper

43 × 52.8 cm

Inscribed l.l.: J. Ingres 1815

Inscribed in graphite l.r.: (?)...des Diables un ange
emporte l'Eucharistie et l'eau bénite

Provenance

Etienne-François Haro, Paris

M. d'Esprémesnil, Paris, before 1860

Baron Maurice de Rothschild, Paris, before 1934

George Wildenstein, Paris, before 1936

Wildenstein & Co., Inc., London, 1952

Rothschild Collection, London

Exhibition History

Paris, *Tableaux tirés de collections d'amateurs et
exposés au profit de la caisse de secours des
artistes peintres, sculpteurs, architects et
dessinateurs*, 1860, no. 332

Paris, Salon des Arts-Unis, *Dessins d'Ingres tiré
collections d'amateurs*, 1861, no. 21

Brussels, Palais des Beaux-Arts, *Ingres- Delacroix,
dessins, pastels et aquarelles*, 1936, no. 43

Selected References

E. Galichon, "Description des dessins de M.
 Ingres exposés au Salon des Arts- Unis,"
 Gazette des Beaux-Arts, March 1861, pp. 349-
 350

Delaborde, 1870, p. 281, no. 216

Lapauze, 1911, p. 186

J. Cassou, "Ingres et ses contradictions," *Gazette
 des Beaux- Arts*, March 1934, p. 155, pl. 13

Alazard, 1950, p. 54

H. Naef, "Un tableau inachevé d'Ingres:
 Le Duc d'Albe à Sainte-Gudule," *Bulletin du
 Musée Ingres*, 7, July 1960, p. 4, fig. 3; p. 6, note
 9

D. Ternois, "Notes sur le Duc d'Albe à Sainte-
 Gudule," *Bulletin du Musée Ingres*, 7, July
 1960, pp. 7-8

Ternois, 1965, *Inventaire*, under no. 158

27. Henri IV, His Children, and the Spanish Ambassador, 1819
New York City, Private Collection
Graphite on paper
19 x 16.5 cm
Inscribed l.c.: Ingres inv. & pinxit a Monsieur
 Thevenin. roma 1819

Provenance
J.C. Thévenin
Thévenin Sale, Paris, November 1869, to M.
 Clément
Eugène Lecomte, Paris
Lecomte Sale, Paris, Hôtel Drouot, June 11-13,
 1906, no. 11, p. 9

Exhibition History
New York, 1961, no. 30, p. 36

Selected References
Delaborde, 1870, p. 281, no. 217

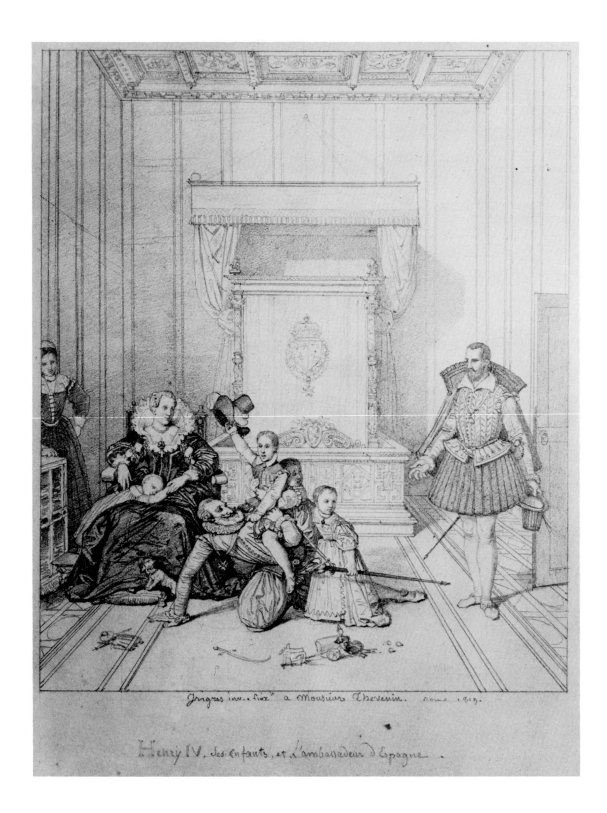

28. Leonardo da Vinci Dying in the Arms of François I, in 1518, n.d.
New York City, Private Collection
Graphite on paper
19 × 16.5 cm
Inscribed in graphite l.c.: Ingres inv. et Pinxit a Monsieur Thevenin.

Provenance
J.-C. Thévenin
Thévenin Sale, Paris, November 1869 to M. Clement
Eugène Lecomte, Paris
Lecomte Sale, Paris, Hôtel Drouot, June 11-13, 1906, no. 12, p. 9

Exhibition History
New York, 1961, no. 29, p. 36, repr.

Selected References
Delaborde, 1870, pp. 280-281, no. 213
Lapauze, 1911, p. 190, note 1

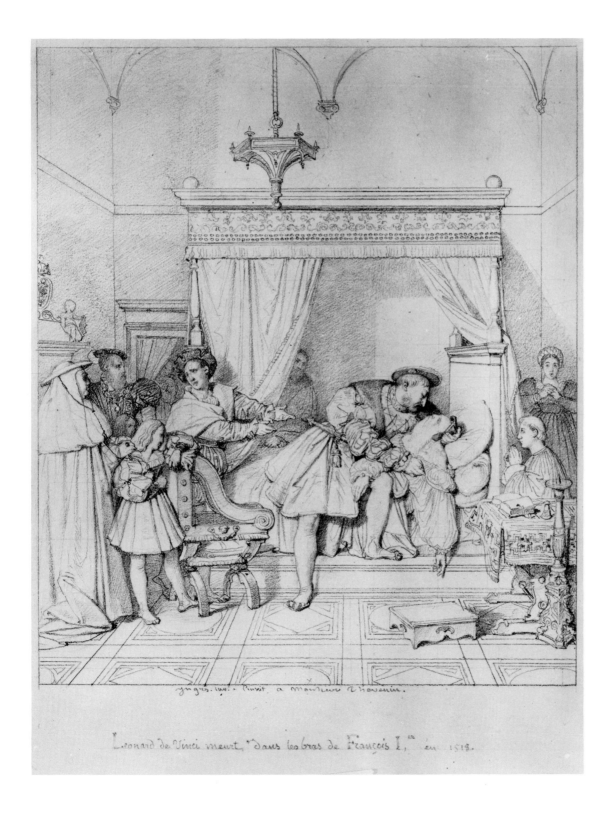

29. Leonardo da Vinci Dying in the Arms of François I, n.d.

Paris, Musée du Louvre, RF 1442
Graphite, pen and black ink, brown wash, grey wash on cream wove paper, collaged
38 × 48.2 cm
Inscribed in black chalk l.r.: première Pensée du Tableau/Ingres inv. à Monsieur Coutan

Provenance

Gift to Coutan, 1825 (?)
Gift of Hauguet, Schubert, and Milliet to the Louvre, 1883

Exhibition History

Paris, Musée du Louvre, Cabinet des Dessins, *Revoir Ingres,* 1980, no. 32

Selected References

Delaborde, 1870, p. 280, no. 211
Blanc, 1870, p. 243
P. de Chennevières, "Les donations et acquisitions du Louvre depuis 1880/Peintures et Dessins," *Gazette des Beaux-Arts,* n.s. 28, 1883, p. 359
J. Guiffrey and P. Marcel, *Inventaire général des Dessins du Louvre et du Musée de Versailles,* VII, 1911, p. 123, no. 5027
J. Klein, "An Unpublished Painting from the Studio of Ingres," *The Burlington Magazine,* September 1930, p. 136, pl. IIB
Rome, Villa Medici, *Ingres in Italia,* 1968, p. 108, under no. 76; p. 176, under no. 133
B. Lossky, "Léonard de Vinci mourant dans les bras de François Ier," *Bulletin de l'Association Léonard de Vinci,* 9, December 1970, p. 15, fig. 1
Paris, Grand Palais, 1974-75, p. 498, under no. 106
H. Toussaint, *French Paintings: The Revolutionary Decades 1760-1830,* Sydney-Melbourne, 1980, p. 163, under no. 84

Louisville Only

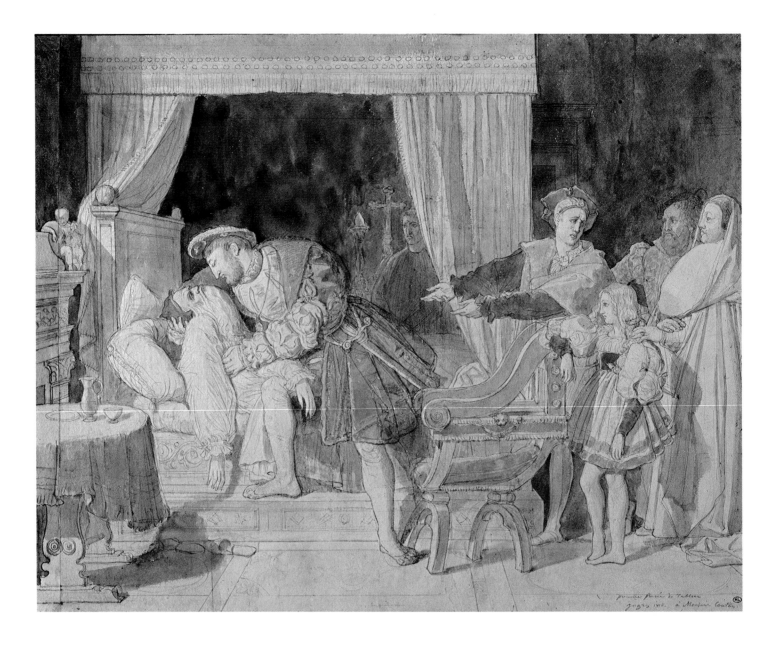

30. The Death of Leonardo da Vinci, n.d.
 (c. 1819)
Montauban, Musée Ingres, 867.1992
Graphite on tracing paper
20.5 × 17.5 cm

Provenance
Ingres estate, 1867

Exhibition History
None

Selected References
Lapauze, 1901, p. 131
Lapauze, 1911, p. 190
F. Bouisset, *Le Musée Ingres,* Montauban, 1926,
 cited p. 60

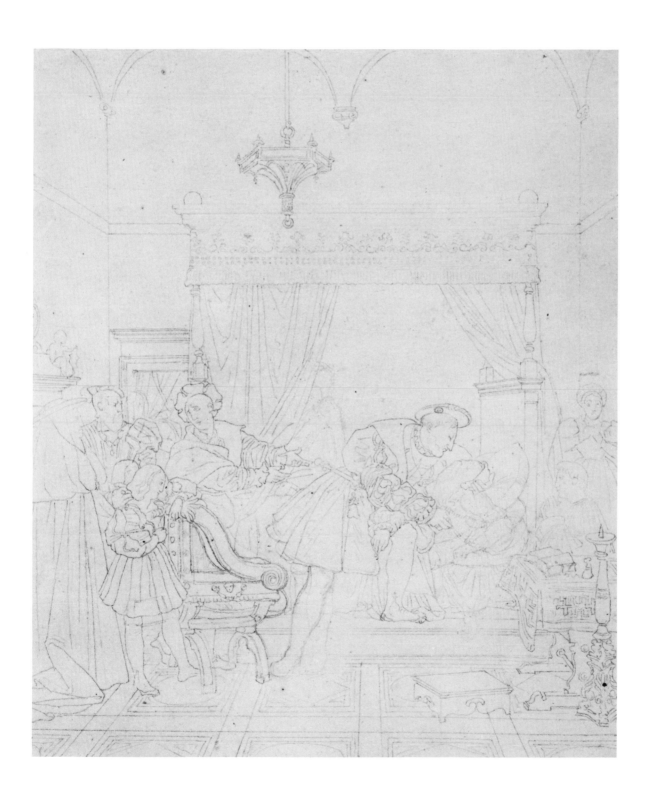

31. The Death of Leonardo da Vinci, c. 1818
Northampton, Mass., Smith College Museum of
Art, 1950.98
Oil on canvas
41.2 × 48.9 cm

Provenance
Ingres estate Sale, Paris, Hôtel Drouot, April 27,
1867, no. 10, to Goldber
Mme. Ingres Sale, Paris, Hôtel Drouot, April 10,
1894, no. 59
Baron Vitta Sale, Paris, Hôtel Drouot, June 27-28,
1924, no. 57, repr., to Vaudoyer
Anonymous Sale, June 23, 1925, no. 42, to Sholing
J.B. Neumann Sale, New York, Rains Auction
Room, January 24, 1936, no. 61, repr., to Julius
H. Weitzner, New York
E. and A. Silberman Galleries, New York, 1936-50

Exhibition History
Paris, 1921, no. 221
Hartford, Conn., Wadsworth Atheneum, *An
Exhibition of Literature and Poetry in Painting
since 1850,* 1933, no. 31
Dallas Museum of Fine Arts, *Exhibition of
Paintings, Sculpture, and Graphic Arts (Texas
Centennial Exposition),* 1936, no. 10, p. 29
Flint (Mich.) Institute of Art, *Six Centuries of
Painting,* 1941, no. 16, repr.
Shreveport, Louisiana State Exhibition, *Five
Centuries of Art,* 1949
Poughkeepsie, New York, Vassar College Art
Gallery, *French Paintings,* 1952
New York, M. Knoedler & Co., *Paintings and
Drawings from the Smith College Collection,*
1953, no. 20

Andover, Mass., Addison Gallery of American Art,
Variations, Three Centuries of Painting, 1954,
no. 4
New York, E. and A. Silberman Galleries, *Art
Unites Nations,* 1957, no. 14, repr.
London, The Tate Gallery, *The Romantic
Movement,* 1959, no. 221
Northampton, Mass., Smith College Museum of
Art, *An Exhibition in Honor of Henry-Russell
Hitchcock,* 1968, no. 12
Northampton, Mass., Smith College Museum of
Art, *19th and 20th Century Paintings from the
Collection of the Smith College Museum of Art,*
no. 30, repr.
College Park, University of Maryland Art Gallery,
*Search for Innocence, Primitive and
Primitivistic Art of the 19th Century,* 1975, no.
18, fig. 23; repr. cover

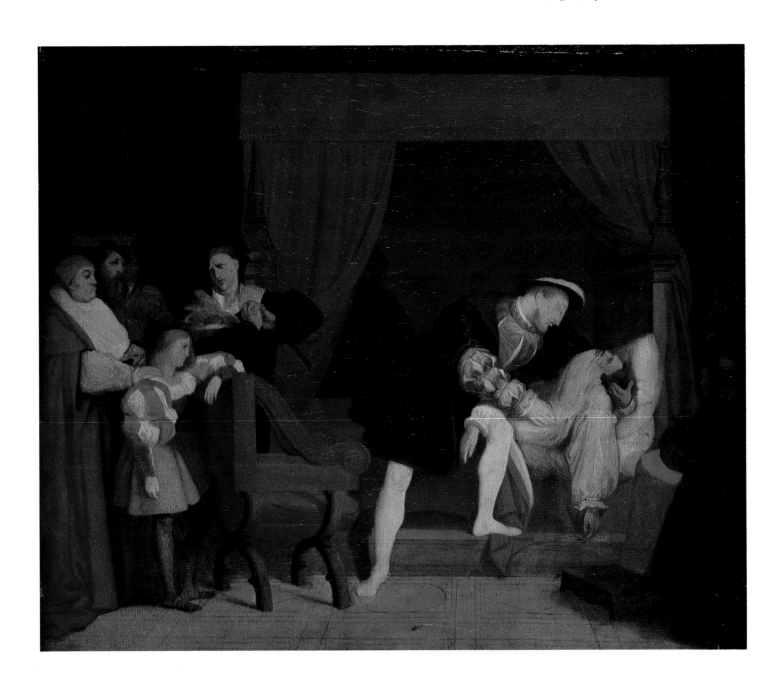

32. The Death of Leonardo da Vinci, 1819
Brussels, Musées Royaux des Beaux-Arts de
 Belgique, 1837
Graphite, grey wash, white goauche, pen and
 brown ink on tracing paper mounted on cream
 laid paper, varnished
42.8 × 53.4 cm, irregular
Inscribed in graphite l.r.: J Ingres in e pxit 1819
 Ro

Provenance
Acquired by the State in 1867

Exhibition History
Paris, 1867, no. 203
Brussels, 1923-24, no. 135

Selected References
Delaborde, 1870, p. 280, no. 212

33. Roger Freeing Angelica, n.d. (c. 1819)
London, Harari & Johns, Ltd.
Oil on canvas
65 × 54.5 cm

Provenance
Unknown

Exhibition History
None

Selected References
Unpublished

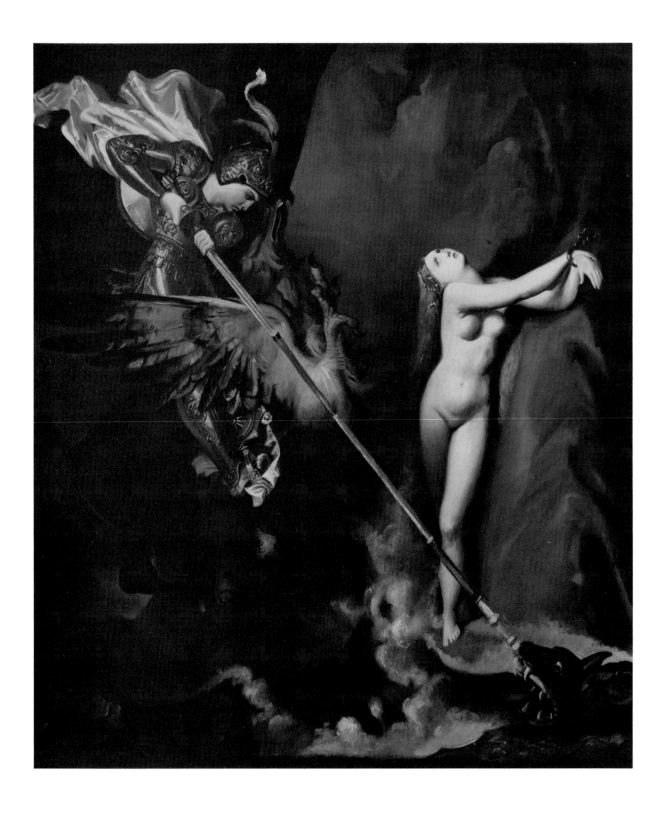

34. Roger Freeing Angelica, n.d. (c. 1851)
New York City, Private Collection
Graphite on paper
48.3 × 38.1 cm

Provenance
Louis Galichon, Paris
Galichon Sale, Paris, March 4-9, 1895, no. 87
Puvis de Chavannes
Collection Rénaud
Malborough Fine Art, Ltd., London
Richard S. Davis, Minneapolis, 1962
M. Knoedler & Co., New York, 1962
Miss Barbara Wilcox, Ithan, Pennsylvania
Mr. and Mrs. Sylvan Schendler
Parke-Bernet Sale, October 21, 1976, no. 102

Exhibition History
London, Marlborough Fine Art, Ltd., *French
 Masters of the XIXth and XXth Centuries,* 1951,
 no. 28, repr.

Selected References
Unpublished

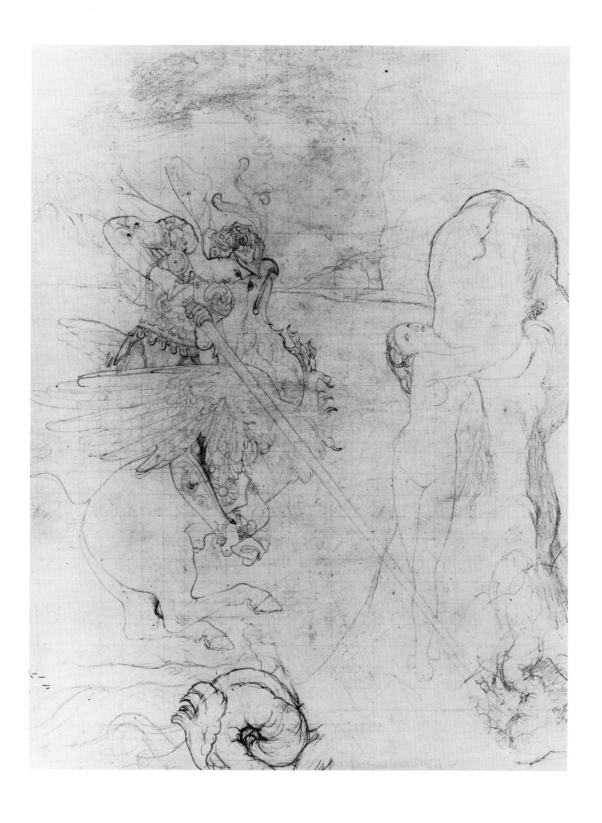

35. Angelica, 1859
Sao Paulo, Brazil, Museu de Arte
Oil on canvas
97 × 75 cm
Inscribed: J. Ingres, 1859

Provenance
Ingres estate Sale, Paris, Hôtel Drouot, April 1867
Haro Collection
Carlen Sale, 1872
Carlos Gonzalès de Candoma Sale, 1933
Mattei Collection, Marseilles
Wildenstein & Co., Inc., New York

Exhibition History
Paris, 1867, no. 20

Selected References
Ingres, Notebook X
L. Lagrange, "Ingres," *Le Correspondant,* May
 1867, p. 53
Delaborde, 1870, p. 209, no. 33
L. Mabilleau, "Les dessins d'Ingres au Musée de
 Montauban," *Gazette des Beaux-Arts,* II, 1894,
 pp. 195-196
Lapauze, 1911, p. 198
Wildenstein, 1954, p. 223, no. 287, pl. 16
Ternois and Camesasca, 1971, pp. 99-100, no.100e

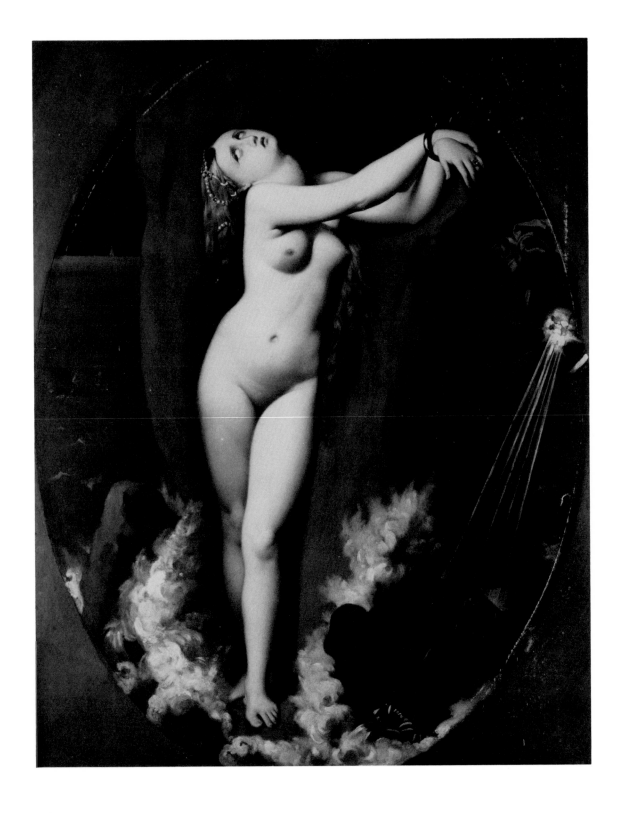

36. The Tomb of the Lady Jane Montagu,
 1816
Melbourne, Australia, National Gallery of Victoria,
 1066/3
Graphite with ochre wash, pen and brown ink on
 paper
Inscribed l.l.: J.A. Ingres inv. e del. Roma 1816
Inscribed l.r.: Roma 1815
Inscribed l.c.: Elle était de ce monde où les plus
 belles choses/Ont le pire destin;/Et rose elle a
 vécu ce que vivent les roses/L`espace d`un
 matin. Malherbe.

Provenance
Sold by Ingres in Rome (?)
Anonymous Sale, London, Christie`s, March 30,
 1920, no. 122, to National Gallery of Victoria,
 Felton Bequest

Exhibition History
London, Victoria and Albert, 1972, no. 666
Sydney, Art Gallery of South Wales and
 Melbourne, National Gallery of Victoria, *French
 Paintings: The Revolutionary Decades 1760-
 1830,* 1980-81, no. 83, p. 161, repr.

Selected References
E. Saglio, "Un nouveau tableau de M. Ingres, liste
 complète de ses oeuvres," *La Correspondance
 littéraire,* February 5, 1857, p. 77
Blanc, 1870, p. 144
A.P. Oppé, "Ingres," *Old Master drawings,*
 September 1926, pp. 20-21; pl. 29
Ternois, 1959, nos. 134-137

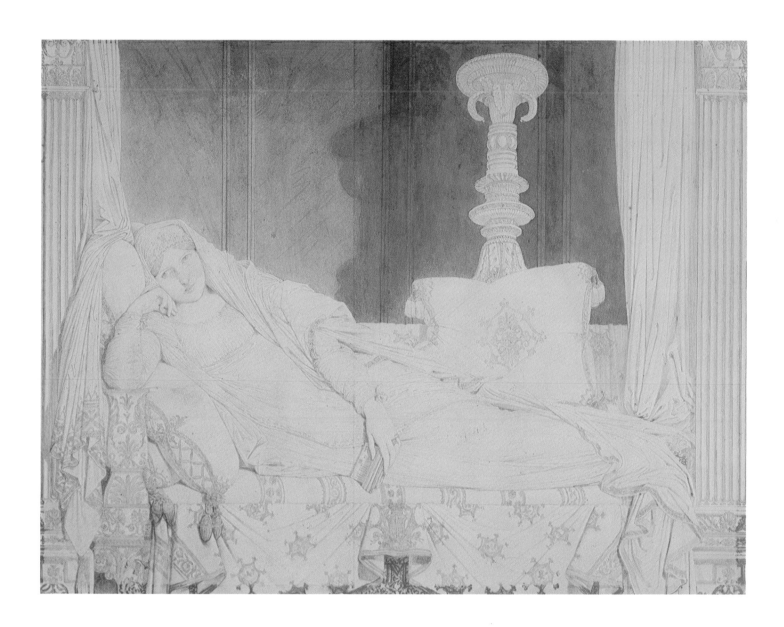

37. The Entry into Paris of the Future Charles V, 1821
Hartford, Wadsworth Atheneum, Gift of Paul Rosenberg & Co.
Oil on panel
47 × 56 cm
Inscribed l.l.: J. Ingres 1821.

Provenance
Commissioned by Comte de Pastoret; delivered 1824
Marquise du Plessis-Bellière (his daughter) Sale, Paris, May 10-11, 1897, no. 86, to M. Haro
Frappier Collection, Paris
Bessonneau d'Angers Sale, Paris, June 15, 1954
Paul Rosenberg & Co. to Wadsworth Atheneum, 1959

Exhibition History
Paris, Salon of 1822, no. 719; in cat., but not exhibited
Paris, Salon of 1824
Paris, 1846, no. 51
Paris, 1855, no. 3355
Paris, 1867, no. 428
Paris, 1911, no. 29
New York, 1961, no. 32, repr.
San Francisco, California Palace of the Legion of Honor, *Man: The Glory, Jest, and Riddle,* 1964-65, no. 193
Paris, 1967-68, no. 121, p. 174

Selected References
Ingres, Notebook IX, X
P.A., *Revue encyclopédique,* XXIV, December 1824, p. 589
T. Thoré, *Salon de 1846,* Paris, 1846

Magimel, 1851, pl. 41
T. Silvestre, *Histoire des artistes vivants. Etudes d'après nature,* Paris, 1855, pp. 17, 36
O. Merson and E. Bellier, *Ingres, sa vie et ses oeuvres,* Paris, 1867, p. 110
Delaborde, 1870, p. 225, no. 51
Lapauze, 1911, pp. 212, 220-222, 238; repr. p. 215
Alazard, 1950, p. 71
Wildenstein, 1954, p. 192, no. 146, fig. 87
E.A. Bryant, "L'entrée du futur Charles V à Paris," *Bulletin of the Wadsworth Atheneum,* Winter 1959, p. 16, repr.
K. Andrews, *The Nazarenes: A Brotherhood of German Painters in Rome,* Oxford, 1964, repr.
Rosenblum, 1967, pl. 29
Ternois and Camesasca, 1971, p. 101, no. 108a, repr.

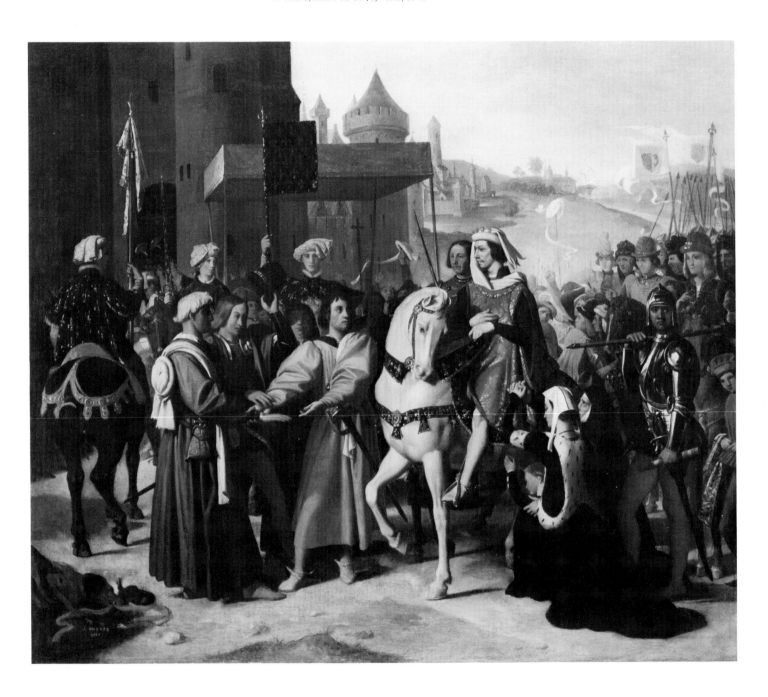

**38. Joan of Arc at the Coronation of
Charles VII,** 1854
Paris, Musée du Louvre, Inv. M1667
Oil on canvas
240 × 178 cm
Inscribed l.l.: I. Ingres P. II 1854
Inscribed on cartouche l.l.: et son boucher se
change en trône dans les cieux. Em.
Deschamps

Provenance
Work in progress when commissioned by the
State, 1851
Musée du Luxembourg, March 1856-December
26, 1862
Musée du Louvre, December 26, 1862-January 28,
1863
Versailles, January 28-August 1863
Musée du Louvre, August 1863-December 1865

Galerie du Corps Législatif, December 1865-April
1867
Musée du Louvre, April 1867
Musée du Luxembourg, 1867-November 1874
Musée du Louvre, November 1874

Exhibition History
Orléans, 1854
Paris, Atelier Ingres, 1854
Paris, 1855, no. 3356
Paris, 1867, no. 59
Paris, Petit Palais, 1968-69, no. 264
Philadelphia Museum of Art, *The Second Empire:
Art in France under Napoléon III,* 1978, no. VI-
70, p. 319, repr. (biblio.)

Selected References
E. About, *Voyage à travers l'exposition des
Beaux-Arts,* Paris, 1855, p. 129

M. du Camp, *Les Beaux-Arts à l'exposition
universelle de 1855,* Paris, 1855, pp. 54, 72-73
T. Gautier, *Le Moniteur Universel,* October 11,
1855, pp. 155-156
C. Vignon, "Exposition universelle de 1855,"
Beaux-Arts, Paris, 1855, pp. 191-192
Wildenstein, 1954, p. 221, no. 273; pl. 111
Schlenoff, 1956, pp. 271, 275-277
C. Sterling and H. Adhémar, *Musée du Louvre,
peintures, école française. XIXe siècle,* IV, Paris,
1960, no. 1117; pl. 408
Rosenblum, 1967, pp. 160-163; pl. 45
P. Angrand, *Monsieur Ingres et son époque,*
Lausanne, 1967, pp. 318-346
Ternois and Camesasca, 1971, p. 115, no. 153a;
repr. p. 114
Mus. cat., *Paintings,* Paris, Musée du Louvre, I,
1972, p. 210

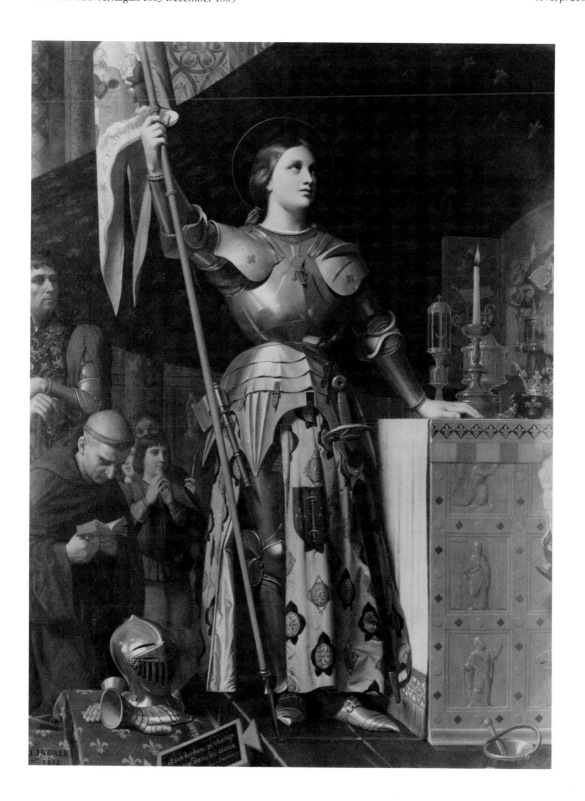

39. Louis XIV and Molière, 1860
USA, Private Collection
Oil on canvas
54.5 × 70.5 cm
Inscribed l.l.: J. Ingres 1860

Provenance
Commissioned by the Empress Eugénie
Collection of the French State, Palais des
 Tuileries, Paris, 1861-1879
Empress Eugénie, Farnborough Hall, Hampshire,
 England, 1881
Empress Eugénie Sale, London, Christie's, July 1,
 1927, lot 58

Exhibition History
New York, Wildenstein & Co., Inc., *The Great
 Tradition of French Painting,* 1939, no. 27
New York, Wildenstein & Co., Inc., *The Painter as
 Historian,* 1962, no. 34; repr. p. 61
Caracas, Museo de Bellas Artes, *Cinco siglos de
 arte francés,* 1977, no. 42, repr.

Selected References
Ingres, Notebook X
Delaborde, 1870, p. 234, no. 70
R. Delorme, *Le Musée de la Comédie-Française,*
 Paris, 1878, pp. 63-64
Lapauze, 1901, p. 250
Lapauze, 1911, pp. 504, 512
Wildenstein, 1954, p. 225, no. 293, fig. 184
Ternois and Camesasca, 1971, p. 116, no. 159b,
 repr.
Philadelphia Museum of Art, *The Second Empire:
 Art in France under Napoléon III,* 1978, cited
 p. 321, under no. VI-72
Tokyo-Osaka, *Ingres,* 1981, p. 126, no. 57, repr.
 color

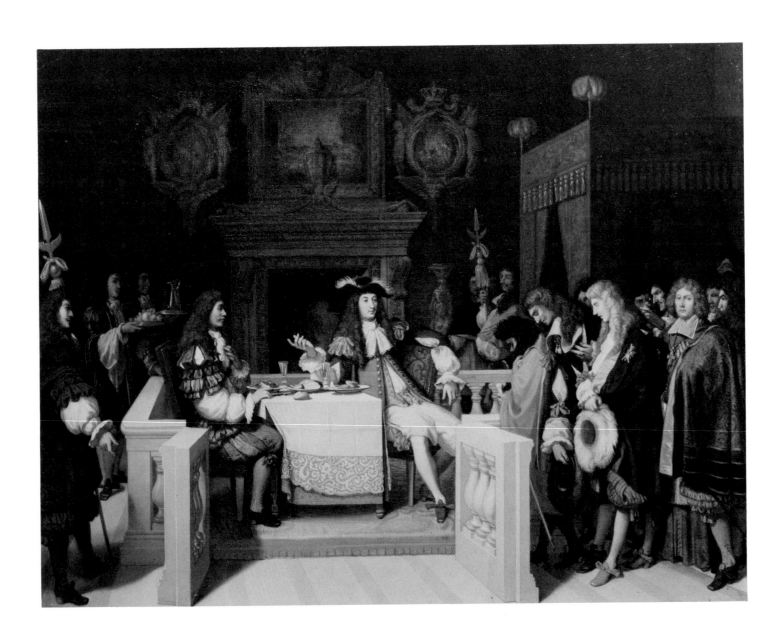

40. Napoleon at the Pont of Kehl, n.d.
Montauban, Musée Ingres, 867.2773
Graphite, pen and black ink on white wove paper
28.4 × 37.7 cm
Inscribed in graphite l.r.: Ing

Provenance
Ingres estate, 1867

Exhibition History
Paris, 1921, no. 173

Selected References
Delaborde, 1870, p. 283, no. 221
Lapauze, 1901, p. 150
M. Malingue, *Ingres,* Monaco, 1943, pl. 115
S. Siegfried, *Ingres and His Critics, 1806 to 1824,*
 Diss. Harvard University, 1980, pp. 109-110,
 note 57

41. Apotheosis of Napoleon I, Study, n.d.
(c. 1853)
USA, Private Collection
Graphite on tracing paper
42.9 cm (diam.)

Provenance
de Maisonneuve Collection, Paris

Exhibition History
New York, Wildenstein & Co., Inc., *French
 Neoclassicism,* 1976, no. 25
London, Wildenstein & Co., Inc., *Consulat,
 Empire, Restauration: Art in Early XIX Century
 France,* 1981, repr. p. 31

Selected References
Unpublished

42. The Apotheosis of Homer, n.d. (c. 1827)
Montauban, Musée Ingres, 867.872
Pen and black ink on paper
18 × 19 cm
Inscribed on verso: list of the colors for the
 drapery of each figure

Provenance

Ingres estate, 1867

Exhibition History
None

Selected References
A. Cambon, *Catalogue du Musée de Montauban*,
 1885, no. 5, fasc. 2SP
Momméja, 1905, no. 669
Lapauze, 1911, p. 264
D. Ternois, "Les sources iconographiques de
 l'Apothéose d'Homère," *Bulletin de la Société
 Archéologique de Tarn-et-Garonne*, LXXXI,
 1954-55, p. 44, note 6

43. Apotheosis of Homer, n.d.
Lille, Musée des Beaux-Arts, PL 1480
Graphite, watercolor, white goauche on tracing
 paper mounted on white laid paper
54.6 × 62 cm
Inscribed: Ingres inv. et pinx. Musee Charles X

Provenance
Benvignat Collection
Acquired from M. Petit, 1867

Exhibition History
Paris, 1867, no. 583
Paris, 1900, no. 1066
Paris, 1967-68, no. 142
Paris, Grand Palais, 1974-75, no. 85, repr.

Selected References
Delaborde, 1870, p. 269, no. 178
H. Pluchart, mus. cat., Lille, 1889, no. 1480
Boyer d'Agen, 1909, p. 191

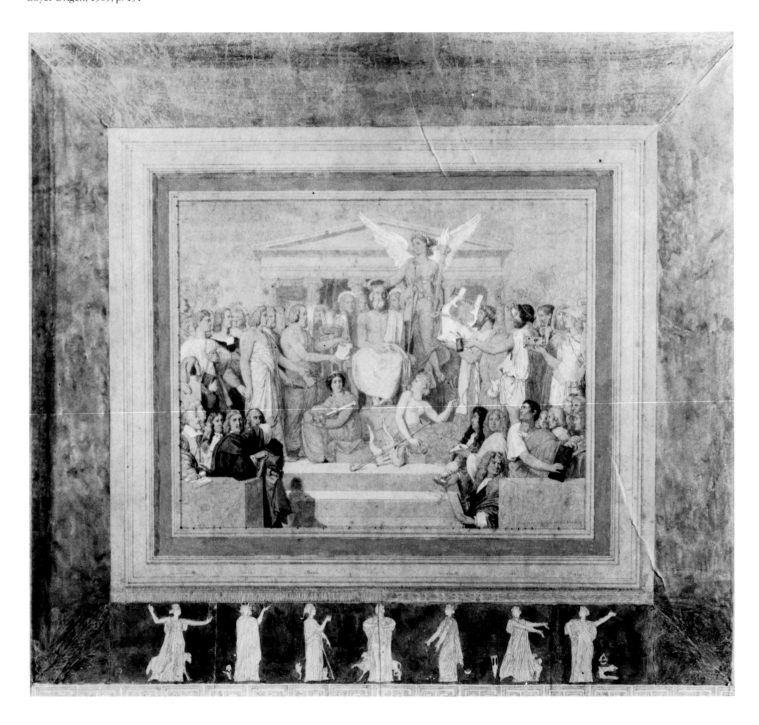

44. The Apotheosis of Homer, n.d.
Montauban, Musée Ingres, 867.885
Graphite on tracing paper
46.2 × 61.3 cm

Provenance
Gustave Cambon estate, 1916

Exhibition History
Toulouse-Montauban, 1955, no. 134

Selected References
Lapauze, 1911, pp. 261, 277
W. Deonna, "Ingres et l'imitation de l'antique,"
 Pages d'Art, Geneva, October 1921 and
 December 1921

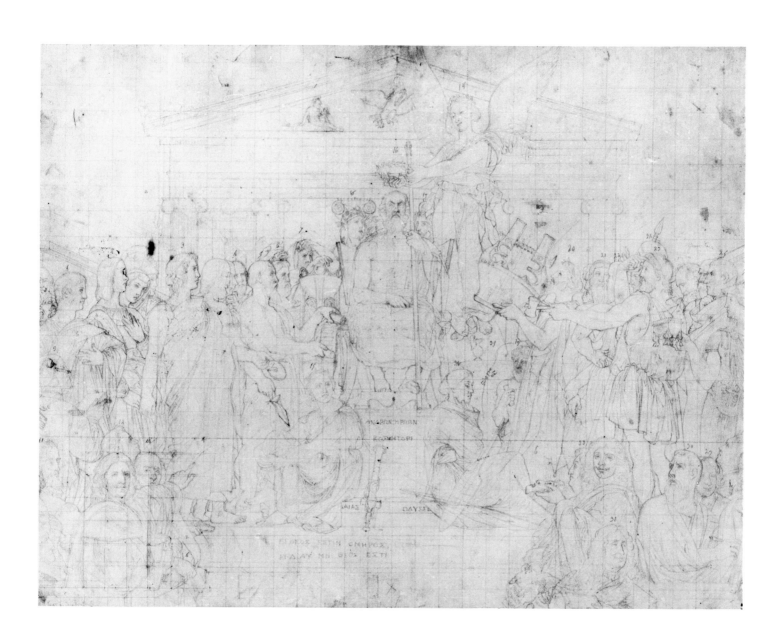

45. The Odyssey, Head, Study for *The Odyssey*, n.d. (c. 1826-27 and 1866)
Glens Falls, New York, The Hyde Collection, 1971.25
Oil on canvas affixed to panel
24 × 18 cm
Inscribed: Ingres

Provenance

Anonymous Sale, March 21, 1866
Haro Sale, Paris, May 30-31, 1892, lot 108
G.-H. Edgar Degas Sale, Paris, March 26-27, 1918, lot 67, p. 130
Henri Lapauze Sale, Paris, June 21, 1929, lot 57, p. 38 (as *Iliad*), to Baron Fukushima
Purchased from E. and A. Milch Co., Inc., New York, 1929

Exhibition History

Paris, 1867, no. 36
New York, Kraushaar, 1929
New York, M. Knoedler & Co., *David and Ingres, Paintings and Drawings*, 1939 (also Springfield, Mass.; Cincinnati; Rochester)

Selected References

Lapauze, 1911, p. 552, no. 6 (as *Iliad*)
Alazard, 1950, pl. LVIII
Wildenstein, 1954, p. 202, no. 183, fig. 108
Ternois and Camesasca, 1971, p. 105, no. 121dd; repr. p. 104

46. Homer, n.d.
Montauban, Musée Ingres, 16.1.1
Oil on canvas
53 × 44 cm

Provenance
Armand Cambon, Montauban
Gustave Cambon (his son) estate, 1916

Exhibition History
Paris, 1921, no. 30
Toulouse-Montauban, 1955, no. 135
Montauban, 1967, no. 96
Montauban, 1980, no. 52

Selected References
W. Deonna, "Ingres et l'imitation de l'antique,"
 Pages d'Art, Geneva, December 1921
F. Bouisset, *Le Musée Ingres*, Montauban, 1926,
 p. 55; repr. p. 53
A. Mongan, "Ingres and the Antique," *Journal of
 the Warburg and Courtald Institute*, X, 1947
Wildenstein, 1954, p. 198, no. 173, fig. 102
D. Ternois, "Les sources iconographiques de
 l'Apothéose d'Homère," *Bulletin de la Société
 Archéologique de Tarn-et-Garonne*, LXXXI,
 1954-55, pp. 26-45
Ternois, 1959, p. 16
Ternois, 1965, *Inventaire*, no. 167
P. Barousse, *Catalogue du Musée Ingres*, 1975,
 p. 21

47. Homer and His Guide, 1861
Brussels, The Royal Collection
Oil on canvas affixed to panel
70 × 59 cm
Inscribed l.c.: 1861. Ingres 1862 (infra-red reveals
 1862)

Provenance
Collection of Leopold I, King of the Belgians

Exhibition History
None

Selected References
Ingres, Notebook X
Delaborde, 1870, p. 214, no. 39
Lapauze, 1911, pp. 512-513
Wildenstein, 1954, p. 226, no. 298, fig. 199
Ternois and Camesasca, 1971, p. 116, no. 165a;
 repr. p. 117

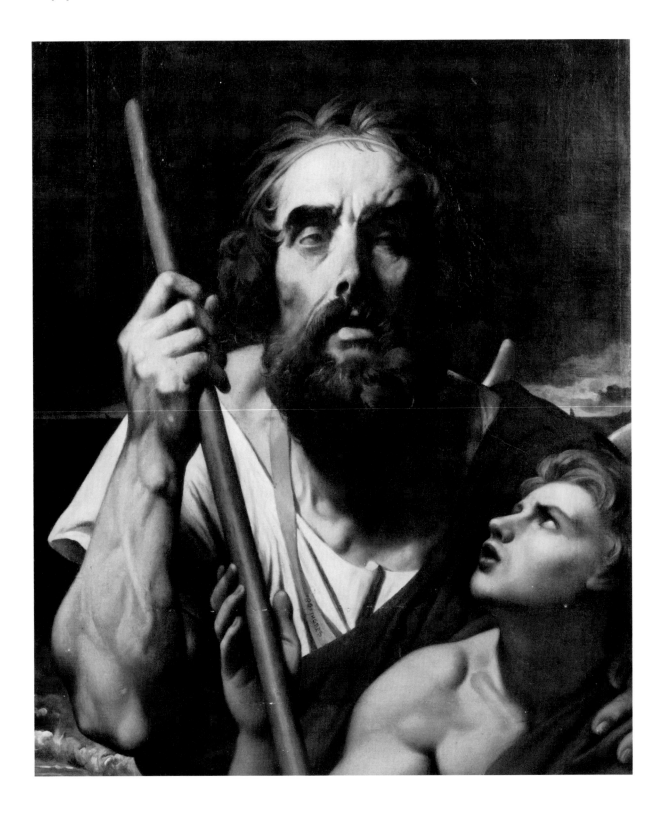

48. The Small Bather, 1826
Washington, D.C., The Phillips Collection
Oil on canvas
32.7 × 25.1 cm
Inscribed l.r.: Ingres 1826

Provenance
E. Blanc Sale, April 7, 1862
Mme. Blanc
Baron Mourre Sale, March 28, 1892, lot 24, p. 11, repr.
Paul Rosenberg & Co., Paris, to Baron François de Hatvany, Budapest, c. 1911
Paul Rosenberg & Co., Paris, 1947, to The Phillips Collection, 1948

Exhibition History
Paris, 1867, no. 422
Paris, 1911, no. 32
Budapest, *Oeuvres d'art socialisées*, 1919, no. IV, 16
Paris, Paul Rosenberg & Co., *Oeuvres importantes de grands maîtres du XIX siècle*, 1931, no. 47, repr.
Amsterdam, Stedlijk Museum, *Honderd Jaar Fransche Kunst*, 1938, no. 136
New York, Paul Rosenberg & Co., *Benefit Exhibition: Retrospective for a Dealer*, 1957
New York, 1961, no. 34, repr.

Selected References
Blanc, 1870, p. 232
Delaborde, 1870, p. 235, no. 73
The Phillips Collection Catalogue, Washington, D.C., 1952, p. 50; pl. 14
Wildenstein, 1954, p. 196, no. 165, fig. 88
E. Gerlötei, "L'Ancienne collection François de Hatvany," *Gazette des Beaux-Arts*, May-June 1966, p. 359, repr.
Ternois and Camesasca, 1971, p. 106, no. 122b; repr. p. 105
E. Green, *Museums Discovered: The Phillips Collection*, New Jersey, 1981, p. 24; repr. color, p. 25

Fort Worth Only

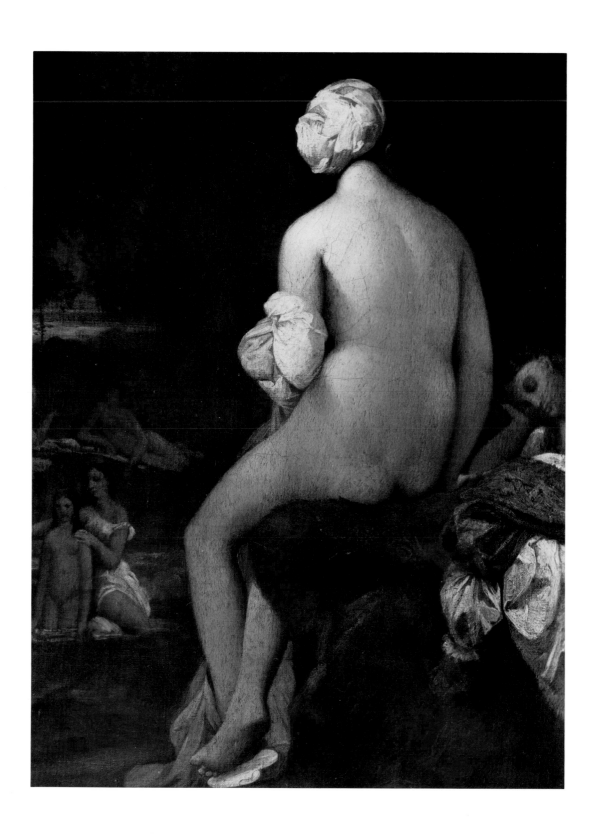

49. The Turkish Bath, 1864

Cambridge, Mass., Fogg Art Museum, Harvard
 University, Gift of Charles E. Dunlap, 1956.244
Graphite and watercolor over brown ink Réveil
 engraving on white wove paper
16.7 × 12.6 cm
Inscribed in graphite l.c.: à Madame Beulé/1864
 Ingres, over an erased inscription: Ingres Pinxit
 Delit/1864

Provenance

Mme. Charles-Ernest Beulé
Karl-Victor Beulé (her son)
Wildenstein & Co., Inc., to Charles E. Dunlap,
 March 1950

Exhibition History

Fogg, 1980, no. 61, p. 164, repr.

Selected References

Magimel, 1851, no. 18
Delaborde, 1870, p. 284, no. 229
Mus. cat., Montauban, 1899, pp. 294-296
Lapauze, 1901, pp. 120-122
H. Lapauze, "Le 'Bain Turc' d'Ingres," *Revue de
 l'art ancien et moderne*, XVIII, 1905, p. 385
Lapauze, 1911, p. 508
Paris, 1967-68, under no. 34
H. Toussaint, *Le bain turc d'Ingres*, Paris, Musée
 du Louvre, 1971, pp. 6, 7
M. B. Cohn and R. Rosenfeld, *Wash and Gouache,
 a Study of the Development of the Materials of
 Watercolor*, Cambridge, Mass., Fogg Art
 Museum, 1977, no. 28

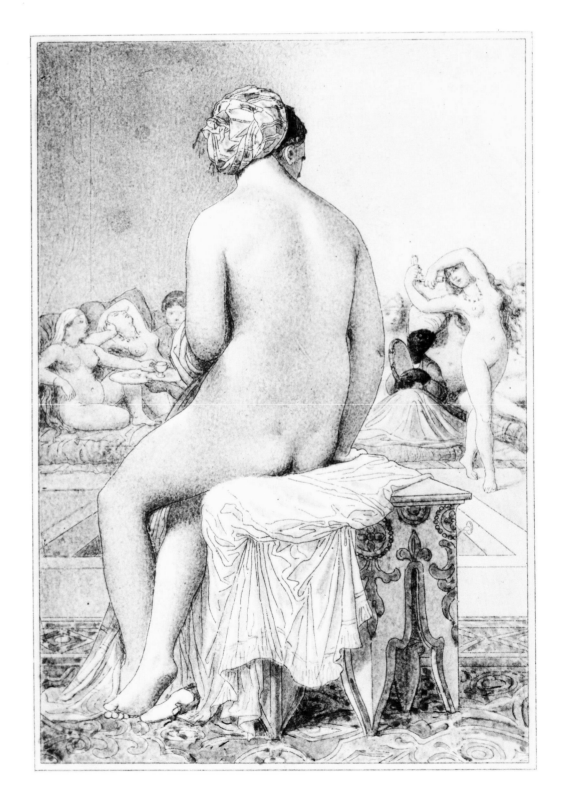

50. The Grand Odalisque, n.d. (c. 1820s or
early 1830s)
Angers, Musée d'Angers, MTC 18
Oil on canvas
10 × 19 cm
Inscribed in oil l.r.: Ingres

Provenance
Turpin de Crissé

Exhibition History
None

Selected References
Mus. cat., Angers, 1934, p. 155, no. 264
Ternois and Camesasca, 1971, p. 97, no. 83c, repr.

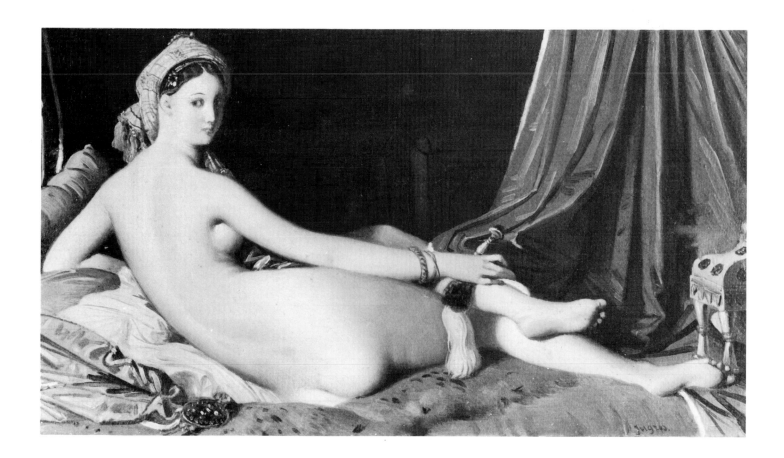

51. Odalisque in Grisaille, n.d. (c. 1824-34)
New York City, Metropolitan Museum of Art,
 Catharine Lorillard Wolfe Collection, 38.65
Grisaille on canvas
83.2 × 109.2 cm

Provenance
Ingres estate Sale, Paris, Hôtel Drouot, April 27,
 1867, no. 7
Mme. Ingres, Paris
Albert Ramel (her brother), Paris
Mme. Albert Ramel, Paris
Mme. Emmanuel Riant (her daughter), Paris, to
 1937
Jacques Seligmann, Paris and New York, 1937-38

Exhibition History
Paris, 1921, no. 24
New York World's Fair, *Masterpieces of Art*, 1940,
 no. 236

Toronto Art Gallery, *The Classical Contribution
 to Western Civilization*, 1949
Birmingham (Alabama) Museum, 1953
New York, Wildenstein & Co., Inc., *The Nude in
 Painting*, 1956, no. 20
Los Angeles, The UCLA Art Galleries, *Paintings,
 Drawings, and Prints, French Masters, Rococo
 to Romanticism*, 1961
Houston, Rice University Museum, *Gray is the
 Color*, 1973-74, no. 62, repr. p. 97
Athens, Greece, National Pinakothiki, Alexander
 Soutzos Museum, *Treasures from the
 Metropolitan Museum of Art, New York,
 Memories and Revivals of the Classical Spirit*,
 1979, no. 85
Rochester, New York, Memorial Art Gallery of the
 University of Rochester, *Orientalism: The Near
 East in French Painting 1800-1880*, 1982, no.
 54, fig. 49 (also Purchase, New York)

Selected References
Delaborde, 1870, p. 236, no. 75
L. Burroughs, *Metropolitan Museum of Art
 Bulletin*, XXXIII, 1938, pp. 222-225, repr.
W. Pach, *Ingres*, New York, 1939, p. 49; repr. opp.
 p. 67
Wildenstein, 1954, p. 210, no. 226, fig. 56
C. Sterling and M. Salinger, *French Paintings, a
 Catalogue of the Collection of the Metropolitan
 Museum of Art*, II, New York, 1966, p. 7f, repr.
Paris, 1967-68, p. 104
Ternois and Camesasca, 1971, p. 97, no. 83d, repr.
J. L. Connolly, Jr., "Ingres and the Erotic Intellect,"
 *Woman as Sex Object: Studies in Erotic Art,
 1730-1970, Art News Annual*, XXXVIII, 1972,
 pp. 19-23
Fogg, 1980, pp. 14, 148
D. Ternois, *Ingres*, Paris, 1980, p. 177, no. 109,
 repr.

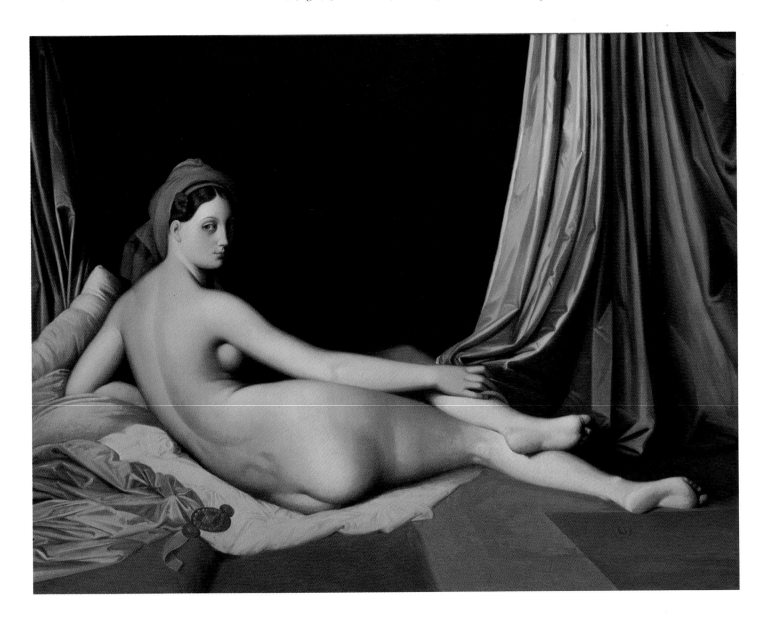

52. Christ, Half-Length, 1834
Sao Paulo, Brazil, Museu de Arte
Oil on canvas
80 × 66 cm
Inscribed l.r.: J. Ingres, 1834

Provenance
Painted for the Marquis de Pastoret
Marquise du Plessis-Bellière (his daughter) Sale,
 Paris, May 10-11, 1897, lot 87
M. de Catalan
Wildenstein & Co., Inc.

Exhibition History
Paris, 1867, no. 403

Selected References
Ingres, Notebook IX, X
Delaborde, 1870, p. 180, no. 4
Wildenstein, 1954, p. 208, no. 211, fig. 130
Ternois and Camesasca, 1971, p. 106, no. 127,
 repr.

53. Christ Giving the Keys to St. Peter, 1846
Paris, Bibliothèque Nationale, AA51846347
Pradier engraving on white laid paper
72 × 60.5 cm
Inscribed l.l: Peint par Ingres
Inscribed l.r.: Gravé par C. S. Pradier
Inscribed l.c.: TIBI DABO GRAVES REGNI
 COELORUM

Provenance
Deposited in the Cabinet des Estampes, 1846

Exhibition History
None

Selected References
E. Hardouin-Fugier, "Jesus remettant les clefs à
 Saint-Pierre," *Bulletin du Musée Ingres*, 41,
 1978, p. 9, pl. v

Louisville Only

54. The Vow of Louis XIII, Study, n.d.
 (c. 1820-24)
Montauban, Musée Ingres, 885.11.21
Oil on canvas
36 × 23 cm
Inscribed l.r.: Ingres Flor. 18 (last two letters
 illegible)

Provenance
Gift to Armand Cambon, 1849
Cambon estate, 1885

Exhibition History
Paris, 1867, no. 432
Paris, 1900
Paris, 1911, no. 27
Paris, 1921, no. 23
New York, 1952, no. 8
Montauban, 1970, no. 86
Montauban, 1980, no. 42, pp. 51-52

Selected References
Ingres, Notebook IX
Delaborde, 1870, p. 179, no. 3
Boyer d'Agen, 1909, p. 409
Lapauze, 1911, p. 218
F. Bouisset, *Le Musée Ingres*, Montauban, 1926,
 p. 56
L. Hourticq, *Ingres, l'oeuvre du maître*, Paris,
 1928, pl. 55
Wildenstein, 1954, p. 195, no. 156, fig. 91

Schlenoff, 1956, p. 145
M.-J. Ternois, "Ingres et le voeu de Louis XIII,"
 *Bulletin de la Société Archeólogique de Tarn-
 et-Garonne*, 1958, pp. 23-28
D. Ternois, *Ingres et son Temps*, Montauban,
 1967, no. 164, repr.
P. Barousse, *Catalogue du Musée Ingres*, 1975,
 p. 20, repr.
Ternois and Camesasca, 1971, p. 102, no. 116b,
 repr.

55. The Virgin with the Blue Veil, n.d.
 (c. 1827)
Sao Paulo, Brazil, Museu de Arte
Oil on canvas
77 × 65 cm
Inscribed on the collar: INGRES P.

Provenance
Comte de Pastoret
Marquise du Plessis-Bellière (his daughter) Sale,
 Paris, May 10-11, 1897, lot 88
Mgr. Charmatant Sale, May 22-23, 1908, lot 70
Anonymous Sale, April 20, 1910, lot 7, to M.
 Letellier
Anonymous Sale, March 20, 1944, lot 102
Private Collection, Paris
Wildenstein & Co., Inc.

Exhibition History
Paris, 1867, no. 404

Selected References
Ingres, Notebook IX, X
Delaborde, 1870, p. 180, no. 5
Manuscript catalogue of the Pastoret Collection,
 Bibliothèque d'Art et d'Archéologie, University
 of Paris, p. 186
E. Delignières, "Notice sur des tableaux au château
 de Moreuil," *Réunion des Sociétés des Beaux-
 Arts des Départements*, 1890, pp. 494-495
Lapauze, 1911, p. 280
"Lettres inédit d'Ingres à son ami Marcotte," *Le
 Correspondant*, September 25, 1913, pp. 1073,
 1083, 1085
Wildenstein, 1954, p. 205, no. 203, pl. 65
Ternois and Camesasca, 1971, p. 103, no. 120;
 repr. p. 102

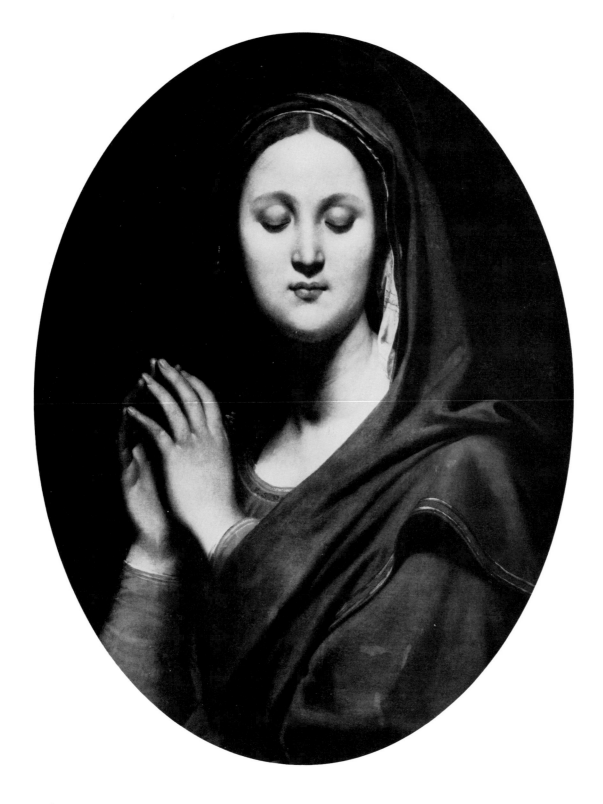

56. The Virgin with the Host, Study, 1863
Ottawa, National Gallery of Canada, 6144
Graphite and white chalk on tracing paper
 mounted on wove paper
47.6 × 37.4 cm
Inscribed in graphite l.l: Ingres delineavit 1863
Inscribed in graphite l.c.: ombre
Inscribed in graphite on the mount l.l.: J. Ingres
 in^it et Delvit
Inscribed in graphite l.r.: Meung 6 Octobre

Provenance

Purchased from Edouard Jonas, Paris, 1952

Exhibition History

Montréal, Musée des Beaux-Arts, *Cinq siècle de
 dessins*, 1953, no. 183, repr.
Manitoba-Winnepeg, Art Gallery Association,
 French Pre-impressionist Painters, 1954, no. 14,
 p. 12
Toronto, 1968, no. 53
Bloomington, Indiana University Art Museum, *The
 Academic Tradition*, 1968, no. 67, repr.
Colnaghi, *European Drawings from the National
 Gallery of Canada, Ottawa*, 1969, no. 49, repr.
Paris, Musée du Louvre, *De Raphael à Picasso,
 Dessins de la galerie national du Canada,
 Ottawa*, 1970
London-Ontario, 1980

Selected References

Art Quarterly, XVI, 1953, p. 253; repr. p. 256, fig. 3
A. E. Popham and K. M. Fenwick, *European
 Drawings (and two Asian drawings) in the
 Collection of the National Gallery of Canada*,
 Toronto, 1965, p. 166, no. 238; repr. p. 167

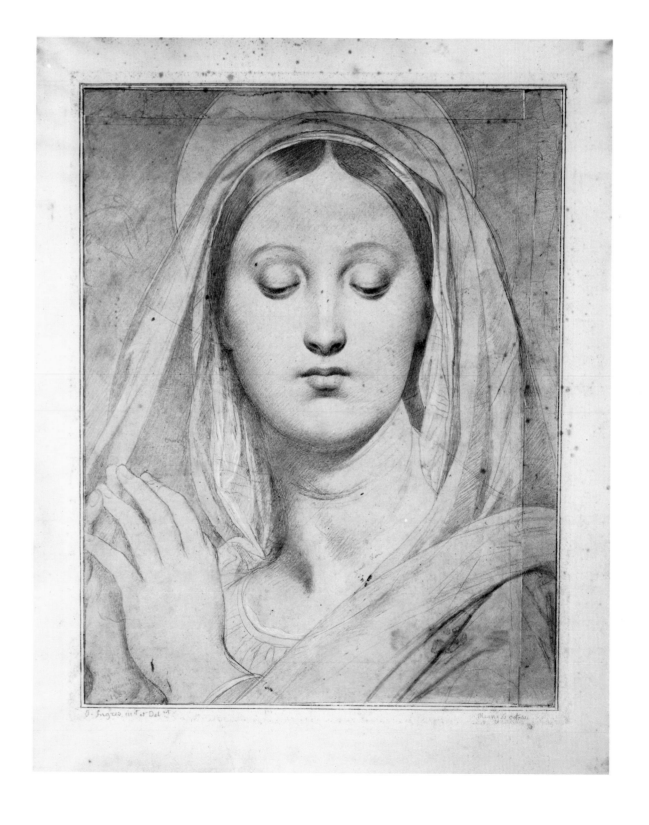

57. Jean-François Marius Granet, n.d.
 (c. 1807)
Aix-en-Provence, Musée Granet
Oil on canvas
72 × 61 cm
Inscribed l.r.: J. A. Ingres

Provenance
Granet Collection
Granet estate, 1849

Exhibition History
Paris, 1900, no. 14, repr.
Montauban, 1967, no. 23, pl. 1
Paris, 1967-68, no. 26

Selected References
Ingres, Notebook IX, X
Magimel, 1851, pl. 14
P. Sibert, *Notice historique sur la vie et l'oeuvre de Granet*, Aix, 1862
H. Gibert, *Catalogue du musée d'Aix*, 1862, no. 620
O. Merson and E. Bellier, *Ingres, sa vie et ses oeuvres*, Paris, 1867, p. 103
Delaborde, 1870, p. 250, no. 125
Blanc, 1870, p. 231
H. Pontier, *Le musée d'Aix*, II, 1900, no. 360
Lapauze, 1901, p. 109
Lapauze, 1911, pp. 88-89; repr. p. 79
L. Hourticq, *Ingres, l'oeuvre du maître*, Paris, 1928, repr. p. 19
L. Fröhlich-Bum, *Ingres, sein Leben und sein Stil*, Vienna-Leipzig, 1924, pl. 10
W. Pach, *Ingres*, New York, 1939, repr. opp. p. 35

P. Courthion, *Ingres raconté par lui-même et par ses amis*, I, Vésenaz-Geneva, 1947, pp. 153-154
Alazard, 1950, p. 37, pl. IX
Wildenstein, 1954, p. 169, no. 51, pl. 18, 23
Schlenoff, 1956, p. 94, note 3
P. Vigué, "L'amitié d'Ingres et de Granet," *Actes du 38e congrès national des sociétés savantes*, Aix-Marseille, 1958, pp. 565, 568
Rosenblum, 1967, pl. 11

58. Jean-Baptiste Desdéban, 1810
Besançon, Musée des Beaux-Arts et
 d'Archéologie, 896.1.166
Oil on canvas
63 × 49 cm

Provenance
Gift to Paul Lemoyne
Sold by Lemoyne to Jean-François Gigaux
Gigaux estate, 1894

Exhibition History
Paris, 1867, no. 437
Paris, 1883
Paris, 1911, no. 13, p. 19
Bâle, *Les principaux maîtres de la peinture*, 1921
London, *French Art, 1200-1900*, 1932, no. 339;
 cat. no. 410, pl. 90
Paris, Musée Carnavalet, *Chefs d'oeuvres des
 Musées de province*, 1933, no. 49

Paris, 1937, no. 348
Amsterdam, Stedlijk Museum, *Honderd Jaar
 Fransche Kunst*, no. 133, repr. cover
Buenos-Aires, Museo Nacional de Bellas Artes,
 Siete siglos de pintura francesa, 1939, no. 75
Brussels, *De David à Cézanne*, 1947, no. 21, pl. 71
Paris, Galerie Charpentier, *Cent portraits
 d'hommes*, 1952, no. 44a, repr. p. 17
Toulouse-Montauban, 1955, no. 115
Paris, Musée des Arts décoratifs, *Besançon, le plus
 ancien musée de France*, 1957, no. 71, pp. 32-
 33
Munich, *De David à Cézanne*, 1964
Montauban, 1967, no. 21, p. 30
Paris, 1967-68, no. 41, p. 68, repr. p. 69
Montreal, *Trésors du Musée de Besançon*, 1968
Rome, Villa Medici, *Ingres in Italia*, 1968, no. 21,
 p. 30, repr. p. 31

Fribourg-en-Brisgau, Augustinermuseum,
 *Présentation des collections du Musée de
 Besançon*, 1979
Montauban, 1980

Selected References
Ingres, Notebook IX, X
Blanc, 1870, p. 234
Delaborde, 1870, p. 248, no. 117
Lapauze, 1911, pp. 102, 163; repr. p. 99
J. Magnin, *La peinture et le dessin au Musée de
 Besançon-Dijon*, 1919, p. 61; repr. p. 59, pl. 26
A. Chudont, *Catalogue des peintures et des
 dessins: collections Jean Gigoux, P.-A. Pâris,
 écoles anciennes, Besançon*, 1929, p. 37, no. 154
Alazard, 1950, p. 45
Wildenstein, 1954, p. 176, no. 70, fig. 44
Fogg, 1967, under no. 48
Ternois and Camesasca, 1971, p. 92, no. 61, repr.;
 pl. XVII

59. The Sculptor Paul Lemoyne, 1819
Kansas City, Missouri, The Nelson-Atkins Museum
 of Art, Nelson Fund, 32.54
Oil on canvas
46 × 35 cm

Provenance
Paul Lemoyne, Paris
Jean-François Gigoux, Paris, to May 6, 1861
P. A. Chéramy Sale, Paris, May 5-7, 1908, lot 212, to
 Henri Haro
Henri Haro Sale, Paris, December 12-13, 1911, no.
 217, to M. Fauchier Magnan
Henri Lapauze, Paris, 1914; Sale, Paris, June 21,
 1929, no. 54, p. 36

Exhibition History
Paris, 1867, no. 439
Paris, 1911, no. 24

Copenhagen, Musée Royal, *Exhibition of French
 Art of the Nineteenth Century*, 1914, no. 118
Paris, *Cent ans de peinture française*, 1922, repr.
 cover
Pittsburgh, Carnegie Institute, *Old Masters
 Exhibition*, 1930, no. 23
Kansas City Art Institute, 1930, no. 27
San Francisco, California Palace of the Legion of
 Honor, *French Painting from the Fifteenth
 Century to the Present Day*, 1934, no. 114, p. 53
Springfield (Mass.) Museum of Fine Arts, *David
 and Ingres, Paintings and Drawings*, 1939, no.
 24 (also New York, Cincinnati, Rochester)
Cincinnati, The Taft Museum, *Fashion for the
 Greco-Roman Taste of the Continent and the
 New Republic*, 1947
Manitoba-Winnepeg, Art Gallery Association,
 French Pre-impressionist Painters, 1954, no. 9,
 repr. p. 11

Omaha, Nebraska, Joslyn Art Museum, *Twenty-
 Fifth Anniversary Exhibition*, 1956
Atlanta (Georgia) Art Museum, *Collectors' Firsts*,
 1959
New York, 1961, p. 35
Fogg, 1967, no. 48, repr.
Chapel Hill, Ackland Memorial Art Center,
 University of North Carolina, *French Nineteenth
 Century Oil Sketches: David to Degas*, no. 43,
 p. 91, repr.

Selected References
Ingres, Notebook IX, X
Delaborde, 1870, p. 254, no. 136
Lapauze, 1911, pp. 162-164
C. Burrows, "Portrait of the Sculptor Paul
 Lemoyne," *Apollo*, April 1931, pp. 237-238
Ternois and Camesasca, 1971, p. 100, no. 101, repr.

Fort Worth Only

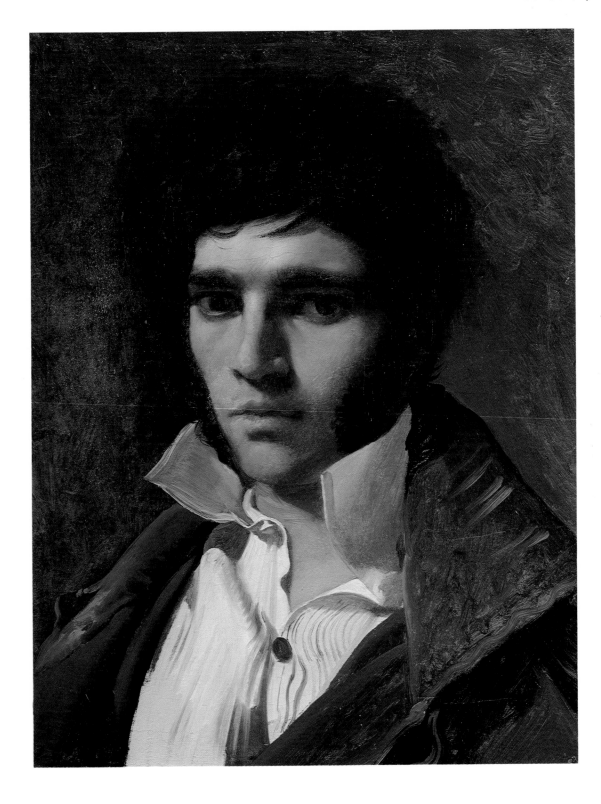

60. The Sculptor Paul Lemoyne, 1841
Marseille, Musée Grobet-Labadié, G. L. 308
Graphite on white paper
23.6 × 17.8 cm
Inscribed in graphite l.r.: Ingres/à Son ami/
 Lemoyne/Rome/1841

Provenance

Paul Lemoyne, until 1873
Louis Grobet, Marseille, until 1919
Mme. Louis Grobet (born Labadié), to the city of
 Marseille, 1920

Exhibition History

Rome, Villa Medici, *Ingres in Italia*, 1968, no. 126,
 repr. p. 162
Marseille, Musée Cantini, *Dessins des Musées de
 Marseille*, 1971, no. 122
Toulon, Musée des Beaux-Arts, *De Poussin à
 Corot*, 1981, no. 63

Selected References

J. A. Givert and P. Gonzalés, *Le Musée Grobet-
 Labadié à Marseille*, Paris, 1930, p. 21
H. Naef, "Notes on Ingres' Drawings, II," *The Art
 Quarterly*, Autumn 1957, pp. 299-301; repr. p.
 298
Fogg, 1967, under no. 48
Revue de l'Art, 14, 1971, repr. p. 100, fig. 9
Naef, 1980, V, p. 246, no. 379

Louisville Only

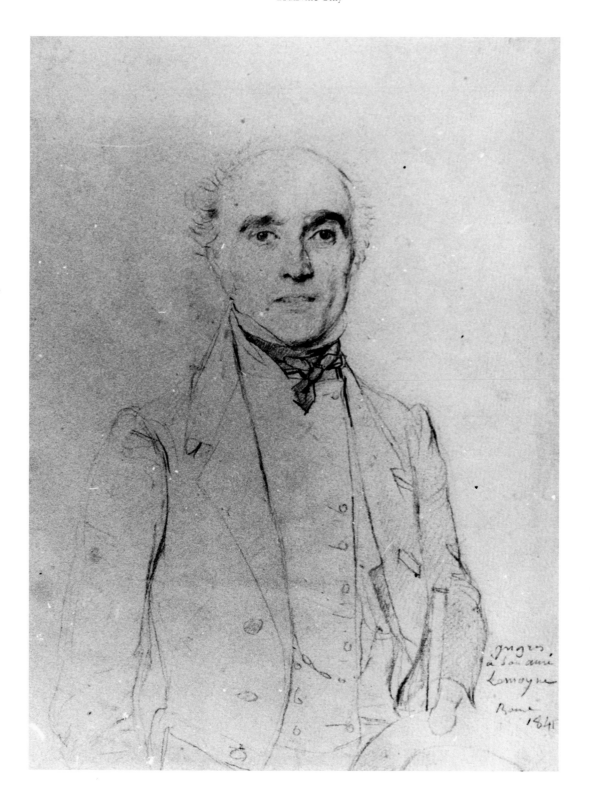

61. Luigi Cherubini, A Composer, 1841
Cincinnati, The Cincinnati Art Museum, Bequest
of Mary M. Emery, 1927.386
Oil on canvas
82 × 71.1 cm
Inscribed l.l.: J. Ingres pinx. 1841.
Inscribed u.r.: L. CHERUBINI COMP.EUR NÉ À
FLOR. 14 SEPT. 1760. M.BRE DE L'INST. D.EUR
DU CONS.E DE LA LEG. D'HON. CHEV.R DE ST
MIC.L ET DE DARMSTADT.

Provenance
Mme. Cherubini
M. Havemeyer
Mary M. Emery
Mrs. Thomas J. Emery

Exhibition History
Springfield (Mass.) Museum of Fine Arts, *David
and Ingres, Paintings and Drawings*, 1939, no.
19 (also New York, Cincinnati, Rochester)
New York World's Fair, *Masterpieces of Art*, 1940,
no. 237, pp. 162, 165
Detroit Institute of Arts, *French Painting from
David to Courbet*, 1950, no. 22
Toledo (Ohio) Museum of Art, *Composer
Portraits and Autograph Scores*, 1954, no. 10a
Columbus (Ohio) Gallery of Fine Arts,
International Masterpieces, 1956
New York, 1961, no. 49
Cleveland Museum of Art, *Style, Truth, and the
Portrait*, 1963, no. 78, repr.

Selected References
Blanc, 1870, p. 130
Delaborde, 1870, p. 248, under no. 114

Lapauze, 1911, pp. 370, 380, 385
"L'exposition Ingres," *La Renaissance*, May 1921
H. Lapauze, "Sur un portrait inédit d'Ingres," *La
Renaissance*, August 1923, p. 446
W. H. Siple, "Two Portraits by Ingres," *Cincinnati
Art Museum Bulletin*, 1, 2, April 1930, pp. 33-41
"Thirty-five Portraits from American Collections,"
Art News, XXIX, May 16, 1931, no. 35
W. Pach, *Ingres*, New York, 1939, p. 95; repr. opp.
p. 190
New York, 1952, under no. 36
Wildenstein, 1954, p. 312, no. 235, fig. 147
*Guide to the Collections of the Cincinnati Art
Museum*, 1956, p. 61
M. S. Young, "French Painting of the XIX and
XXth Centuries," *Apollo*, April 1971, p. 68, fig. 4
M. F. Rogers, Jr., *Favorite Paintings from the
Cincinnati Art Museum*, New York, 1980, p. 64;
repr. p. 65

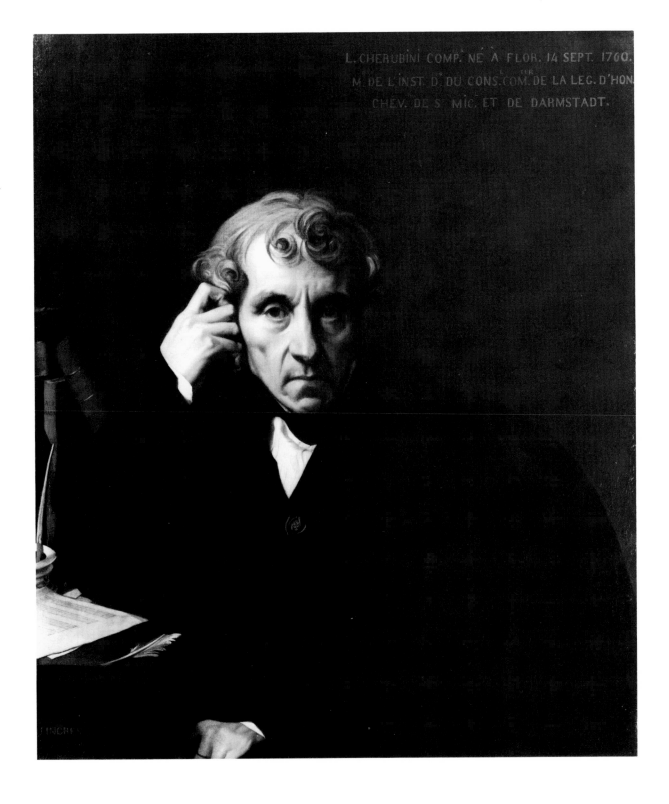

62. Alphonse-Pierre Hennet, 1846

Fort Worth, Kimbell Art Museum, AP77.2
Graphite on wove paper
32 × 24.2 cm
Inscribed in graphite l.l.: Ingres Del./à Sa très
Excellente/ amie Madame/hennet./Paris 1846

Provenance

Mme. Albert-Joseph-Boniface Hennet de Goutel,
until 1856
Alphonse Hennet, until 1887
Mme. Gustave-Louis Tanquerie de la Panissais
Lesseigneur Collection
Wildenstein & Co., Inc., 1949, to Sidney N.
Shoenberg, St. Louis, 1955
Eugene V. Thaw Company, New York
Merril C. Rueppel, sold to the Kimbell Art
Museum, 1977

Exhibition History

Paris, 1861
Paris, 1867, no. 354
Paris, 1911, no. 159
Paris, 1921, no. 113

Selected References

E. Galichon, "[Descriptions des] dessins de M.
Ingres [exposés au Salon des Arts-Unis],
deuxième série," *Gazette des Beaux-Arts*, July
1861, p. 46
Blanc, 1870, p. 237
Delaborde, 1870, p. 300, no. 324
Lapauze, 1911, repr. p. 399
Naef, 1980, V, p. 296, no. 405

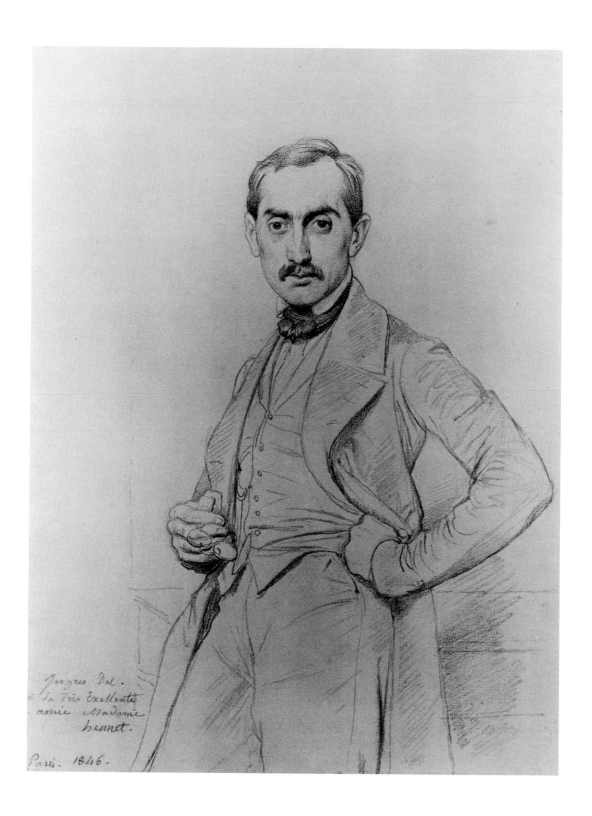

63. Monsieur Marcotte, 1810
Washington, D.C., National Gallery of Art, Samuel
 H. Kress Collection, 1107
Oil on canvas
93.5 × 69.3 cm
Inscribed l.r.: Ingres. Pinx. Rom./1810

Provenance
M. Marcotte d'Argenteuil
Mme. Joseph Marcotte (his daughter-in-law)
Mme. Pougin de la Maisonneuve
Private Collection, London

Exhibition History

Paris, 1867, no. 440
Paris, 1911, no. 14
Paris, 1967-68, no. 54

Selected References
Ingres, Notebook IX, X
O. Merson and E. Bellier, *Ingres, sa vie et ses
 oeuvres*, Paris, 1867, pp. 17, 103-104
Delaborde, 1870, p. 254, no. 139
Blanc, 1870, p. 33, note 1; pp. 38, 231
H. Lapauze, *Les portraits dessinés de J.-A.-D.
 Ingres*, Paris, 1903, pp. 63-64
Lapauze, 1911, pp. 102, 106-111
L. Fröhlich-Bum, *Ingres, sein Leben und sein Stil*,
 Vienna-Leipzig, 1924, p. 9
W. Pach, *Ingres*, New York, 1939, pp. 42-43
Wildenstein, 1954, p. 172, no. 69, pl. 21
H. Naef, "Ingres' Portraits of the Marcotte Family,"
 Art Bulletin, 40, 1958, pp. 336-346

Ternois and Camesasca, 1971, p. 92, no. 60, repr.
C. Eisler, *Paintings from the Samuel H. Kress
 Collection: European Schools excluding
 Italian*, Oxford, 1977, pp. 364-366, no. k 1650,
 fig. 336

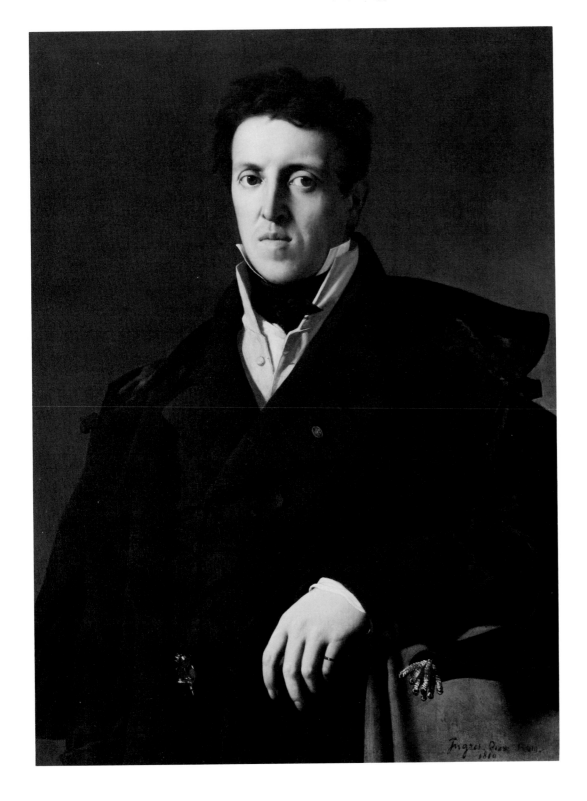

64. John Russell, Sixth Duke of Bedford,
1815
St. Louis, The St. Louis Art Museum, 345.1952
Graphite on white wove paper
37.8 × 28.5 cm
Inscribed in graphite l.l.: Ingres. fec. Roma 1815.

Provenance
John Russell, Sixth Duke of Bedford, Woburn
 Abbey
Family of the sitter, until 1952
Edward Speelman, London, June 1952
Dr. Otto Wertheimer, Paris, June 1952
Gift to the St. Louis Art Museum, December 1952

Exhibition History
Rotterdam, etc., Museum Boymans, *De Clouet à
 Matisse*, 1958-59, no. 130, repr.
Newark (New Jersey) Museum, *Old Master
 Drawings*, 1960, no. 61, repr.

Los Angeles, The UCLA Art Galleries, *Paintings,
 Drawings, and Prints, French Masters, Rococo
 to Romanticism*, 1961, no. 68; repr. p. 63
Fogg, 1967, no. 35, repr.
Paris, 1967-68, no. 86, repr.

Selected References
F. O'Donoghue, *Catalogue of Engraved British
 Portraits preserved in the Department of Prints
 and Drawings in the British Museum*, I,
 London, 1908, p. 157
H. Naef, "A Recently Discovered Drawing by
 Ingres," *Graphis*, VIII, 43, 1952, pp. 438-440;
 repr. p. 439
W. M. Eisendrath, "A Drawing by Ingres," *Bulletin
 of the City Art Museum of St. Louis*, XXXVIII, 2,
 1953, pp. 13-16; repr. p. 13
H. Comstock, "An English Portrait by Ingres," *The
 Connoisseur*, August 1953, p. 69, repr.

"Art News of the Year," *Art News Annual*, 1954,
 repr. p. 184
H. Naef, "Ingres' Portrait Drawings of English
 Sitters in Rome," *The Burlington Magazine*,
 December 1956, p. 428; repr. p. 433, fig. 10
J. Bouchot-Saupique, "Dessins français des
 collections américaines," *Art et Style*, 47, 1958,
 p. 7
Fogg, 1967, no. 35, repr.
A. Mongan, "Ingres as a Great Portrait
 Draughtsman," *Colloque Ingres*, Montauban,
 1969, p. 146; repr. p. 154, fig. 10
G. Blakiston, *Lord William Russel and his Wife*,
 London, 1972, repr. opp. p. 79
E. Pansu, *Ingres: Dessins*, Paris, 1977, no. 35, repr.
Naef, 1980, III, p. 280, no. 152

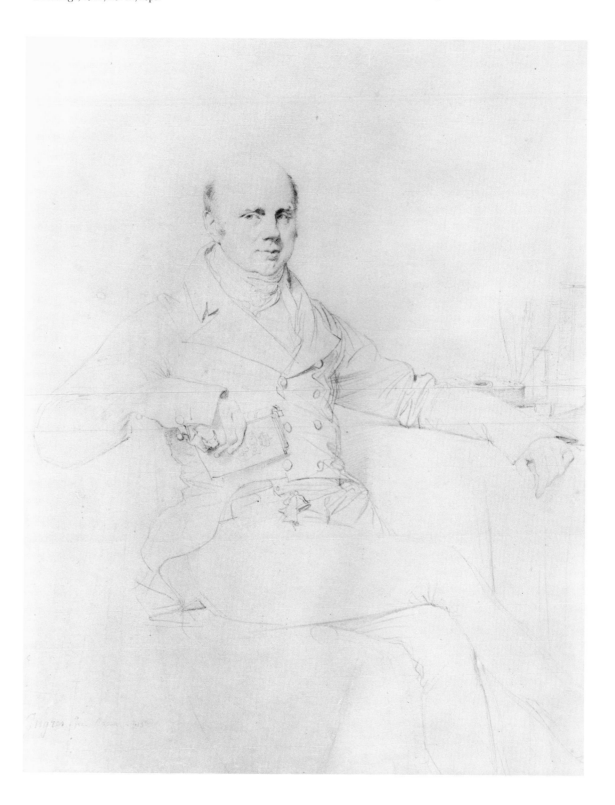

65. Portrait of Dr. Thomas Church, 1816
Los Angeles, Los Angeles County Museum of Art,
 M.67.62
Graphite on wove paper
20.4 × 16 cm
Inscribed in graphite l.l.: Ingres Del/rom. 1816

Provenance
Dr. Thomas Church, until 1821
Joseph Church (his brother), until 1830
John Longe, Spixworth
Rev. Robert Longe (his brother), Spixworth
Robert Bacon Longe (his son), Spixworth
Longe Sale, Spixworth Park, Norfolk, March 19-22,
 1912, no. 198, to Adele Emily Anna Hamilton
 (later Mrs. Clement Eustace Macro Wilson),
 Dalzell, Motherwell, Lanarkshire
David C. Wilson, Sheffield, and Rev. Michael
 Wilson, Ndola, Northern Rhodesia (her sons)

Tate Gallery, London, on loan, 1939-48
Sotheby's, London, December 1, 1966, no. 74,
 repr., to Feilchenfeldt Company, Zurich
Purchased by the Los Angeles County Museum of
 Art, Loula D. Lasker Fund, 1967

Exhibition History
Los Angeles County Museum of Art, *A Decade of
 Collecting, 1965-1975*, no. 85, repr.

Selected References
F. D. Singh, *Portraits in Norfolk Houses*, II,
 Norwich, 1928, p. 307, no. 14
B. Ford, "Ingres' Portrait Drawings of English
 People at Rome, 1806-1820," *The Burlington
 Magazine*, July 1939, p. 9; repr. p. 11
Critica d'arte, Florence, September 1966, p. 20,
 fig. 61
"International Saleroom," *The Connoisseur*,
 February 1967, p. 122, fig. 6

H. Naef, "L'Ingrisme dans le monde," *Bulletin du
 Musée Ingres*, 22, December 1967, p. 31
"Report of the President and Director, Permanent
 Collection, Annual Report 1967-1968," *Bulletin
 of the Los Angeles County Museum of Art*, XVIII,
 3-4, 1969, p. 13; repr. p. 14
E. Feinblatt, "An Ingres Drawing for Los Angeles,"
 The Connoisseur, April 1969, pp. 262, 265;
 p. 263, fig. 2
"Accessions of American and Canadian Museums,
 October-December, 1968," *The Art Quarterly*,
 Summer 1969, p. 215; repr. p. 231
Antiques, November 1969, repr. p. 684
M. Feilchenfeldt, *25 Jahre Feilchenfeldt in Zürich,
 1948-1973*, Zurich, 1972, no. 1, repr.
M. S. Young, "A Decade of Collecting, Los Angeles
 County Museum of Art," *Apollo*, March 1975,
 p. 221; p. 224, fig. 15
Naef, 1980, IV, p. 338, no. 183

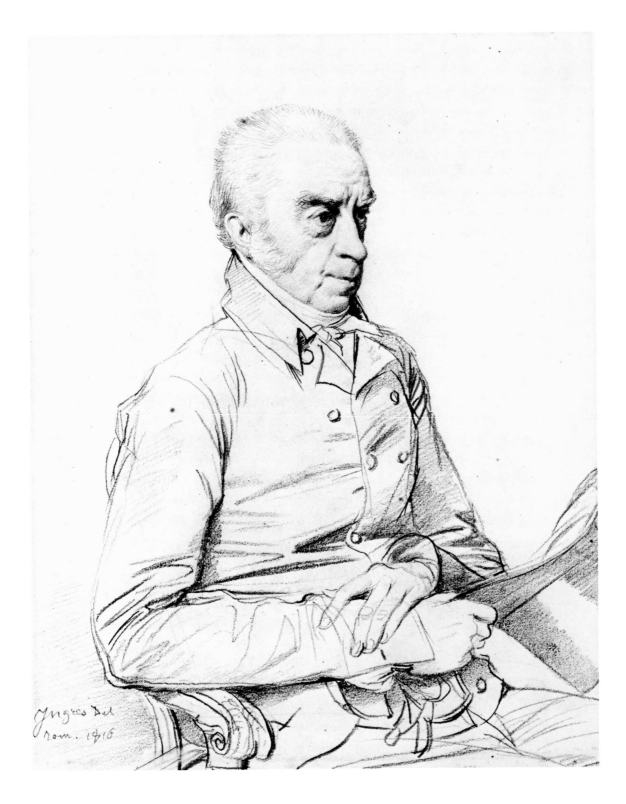

66. Amédée-David, Marquis de Pastoret,
1826
Chicago, The Art Institute of Chicago, AIC 71.452
Oil on canvas
103 × 83.5 cm
Inscribed l.l.: Ingres 1826
Inscribed u.l.: A. M. ^{is} DE PASTORET/AETAT. 32

Provenance
Amédée-David, Marquis de Pastoret
Louise Alphonsine de Pastoret (his wife)
Marquise du Plessis-Bellière (their daughter),
Sale, Paris, Hôtel Drouot, May 10-11, 1897, no.
85, to Edgar Degas
Degas Sale, Paris, Galerie Georges Petit, March
26-27, 1918, no. 52, to David-Weill Collection,
Neuilly
Wildenstein & Co., Inc., New York, to The Art
Institute of Chicago, June 21, 1971

Exhibition History
Paris, Salon of 1827, no. 575
Paris, 1846, no. 00
Paris, 1855, no. 3371
Paris, 1921, no. 25, repr. p. 15
Paris, 1931, no. 46, repr.
Paris, MM. Jacques Seligmann et fils, *Exposition
de portraits par Ingres et ses élèves*, 1934, no. 4,
repr.
Paris, 1967-68, no. 140, repr.
Paris, Grand Palais, 1974-75, no. 111, repr. pl. 288
Chicago, The Art Institute of Chicago, *European
Portraits 1600-1900 in The Art Institute of
Chicago*, 1978, no. 15, repr.

Selected References
Magimel, 1851, pl. 49
Delaborde, 1870, p. 259, no. 150
Lapauze, 1901, p. 112

Lapauze, 1911, pp. 212, 280-281; repr. p. 257
G. Henriot, *Collection David Weill*, I, Paris, 1926,
pp. 205-208; repr. p. 209
Alazard, 1950, pp. 84-85; p. 149, note 33; pl. 56
H. Naef, "Portrait Drawings by Ingres in The Art
Institute of Chicago," *The Museum Studies, The
Art Institute of Chicago*, 1, 1966, pp. 67, 79,
note 12
Rosenblum, 1967, p. 36, fig. 48
Ternois and Camesasca, 1971, p. 103, no. 119;
repr. p. 102
C. Cunningham, "Ingres — Portrait of the
Marquis de Pastoret," *The Bulletin of The Art
Institute of Chicago*, 66, 3, May-August 1972,
repr. pp. 1, 3
J. Maxon, *The Art Institute of Chicago*, London,
1977, p. 69, repr.

Fort Worth Only

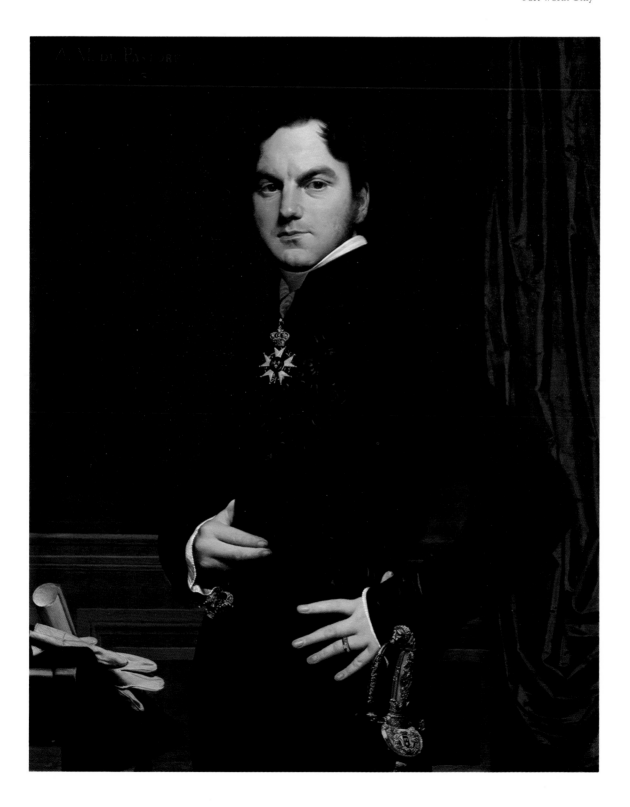

67. Ferdinand-Philippe, Duc d'Orléans,
 1843
Perpignan, Musée Hyacinthe-Rigaud, 863.1.1
Oil on canvas
154 × 119 cm
Inscribed l.r.: Ingres, 1863

Provenance
Commissioned by the city of Perpignan and
 purchased through public subscription

Exhibition History
Gérona, Spain, *Esposición de obras maestras de
 la pintura francesa (Siglos XVII-XIX)
 procedentes del Museo Hyacinthe-Rigaud de la
 ciudad de Perpignan. Campaña internacional
 des museos. X anniversario de la UNESCO*,
 1957, no. 19
Montauban, 1980, no. 95

Selected References
Catalogue du musée de Perpignan, 1862, p. 19,
 no. 67
Wildenstein, 1954, p. 214, no. 243, fig. 155
Ternois and Camesasca, 1971, p. 110, no. 134e;
 repr. p. 109
Valaison, *Guide du Musée Hyacinthe-Rigaud*, n.d.,
 p. 29; repr. p. 30

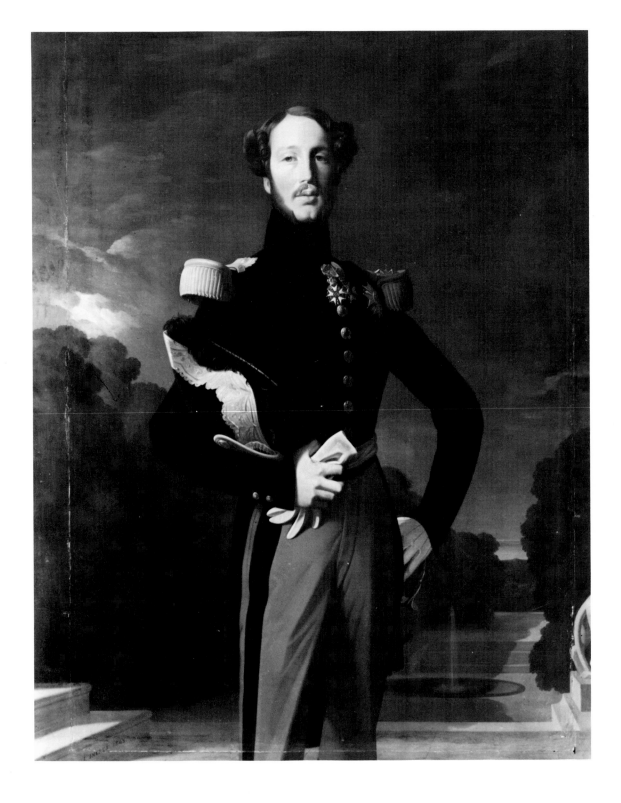

68. Charles X in Coronation Robes, n.d.
Chicago, The Art Institute of Chicago, The
 Worcester Sketch Fund, 1960.352
Watercolor, graphite, and red chalk, squared for
 transfer, on white laid paper
26 × 19.7 cm
Inscribed in graphite l.l.: Ingres

Provenance
M. P. Rosenberg

Exhibition History
Paris, 1911, no. 182
St. Petersburg, *Exposition centennale de l'art
 français à St. Petersbourg*, 1912, no. 182
New York, Wildenstein & Co., Inc., *Master
 Drawings from The Art Institute of Chicago*,
 1963, no. 78
Fogg, 1967, no. 63, repr.

Selected References
Ingres, Notebook X
Lapauze, 1901, p. 250
Ternois, 1959, under no. 22
Ternois and Camesasca, 1971, p. 106, under no.
 123

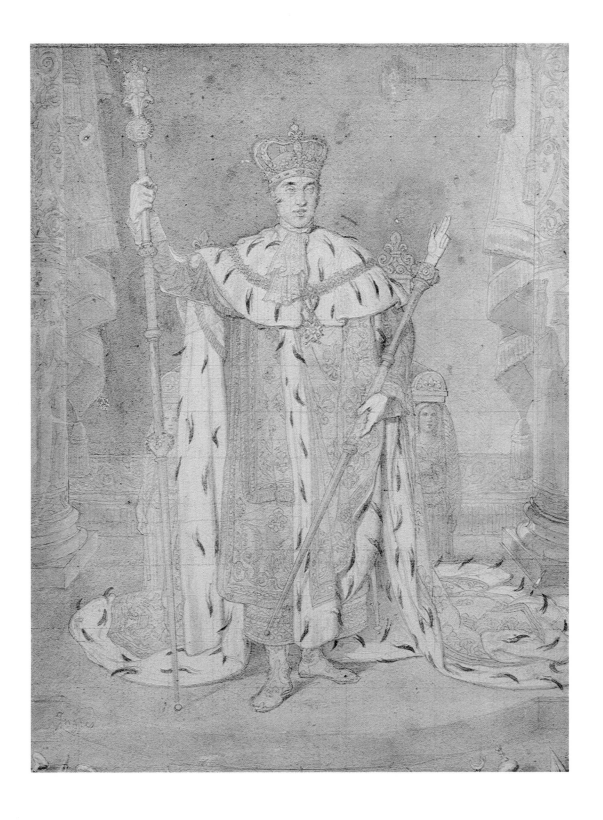

69. Mlle. Joséphine Nicaise-Lacroix, 1813
New York City, The Pierpont Morgan Library,
 III.124b
Graphite on white paper
25.8 × 19.9 cm
Inscribed in graphite l.l.: Ingres. 1813/roma.

Provenance
Joséphine Nicaise-Lacroix, until 1865
Maxime Maillard (her nephew), until 1871
Ossian Maillard (his son), until 1920
Mme. Germaine Etienne, Poitiers
Anonymous Sale, Paris, Galerie Georges Petit,
 May 22, 1930, no. 1 (withdrawn)
Mme. Germaine Etienne, Poitiers, to Mme. de la
 Chapelle, Paris, 1933
Z. G. Simmons
Durlacher Brothers Gallery, New York, to The
 Pierpont Morgan Library, 1943

Exhibition History
Paris, 1911, no. 85
New York, 1961, no. 12, repr.
Oberlin, Allen Memorial Art Museum, *Ingres and
 His Circle*, 1967, no. 1, p. 148, repr.

Selected References
Naef, 1980, IV, p. 184, no. 100

70. Madeleine Ingres (Born Chapelle), n.d.
(c. 1814)
Montauban, Musée Ingres, 867.277
Graphite and watercolor on wove paper
21.5 × 14.8 cm

Provenance
Ingres estate, 1867

Exhibition History
Paris, 1867, no. 360
Paris, 1878, no. 856
Paris, 1900, no. 1092
Paris, 1911, no. 87
Paris, 1921, no. 68
Paris, 1949, no. 5
Montauban, Musée Ingres, *Les dessins d'Ingres du Musée de Montauban*, 1951, no. 4, repr.
Montauban, Musée Ingres, *Ingres aquarelliste*, 1954, no. 1
Chicago, The Art Institute of Chicago, *French Drawings, Masterpieces from Seven Centuries*, 1955-56, no. 104, repr. (also Minneapolis, Detroit, San Francisco)
London, The Arts Council of Great Britain, *Ingres: Drawings from the Musée Ingres, Montauban*, 1957, no. 9, pl. I
Hamburg, Hamburger Kunsthalle, *Französische Zeichnungen von den Anfängen bis zum Ende des 19. Jahrhunderts*, 1958, no. 125, repr.
Lausanne, Musée cantonal des Beaux-Arts, *150 dessins des musées de France*, 1963, no. 58
Malmö (Sweden) Museum, *Ingres, en utställning fran Musée Ingres*, 1965, no. 9, repr.
Copenhagen, Thorvaldsens Museum, *Ingres i Rom, Tegningar fra Musée Ingres i Montauban*, 1967, no. 85, repr. p. 23
Montauban, 1967, no. 49
Paris, 1967-68, no. 73, repr.

Rome, Villa Medici, *Ingres in Italia*, 1968, no. 48, repr.
Florence, Orsanmichele, *Ingres e Firenze*, 1968, no. 23, repr.
Montauban, 1970, no. 4
London, Victoria and Albert, 1972, no. 661
Montauban, 1980, no. 30
Tokyo-Osaka, *Ingres*, 1981, no. 74, repr.
Dijon, 1981, no. 13, repr.

Selected References
Magimel, 1851, no. 24
Blanc, 1870, p. 237
Delaborde, 1870, p. 302, no. 334
Amaury-Duval, 1878, p. 121
Lapauze, 1901, pp. 95, 106, pl. 165
Lapauze, 1911, p. 169; repr. p. 132
Ternois, 1959, no. 83, repr.
Naef, 1980, IV, pp. 178-180, no. 97 (biblio.)

71. Auguste Lethière, n.d. (c. 1851)
Pittsburgh, Museum of Art, Carnegie Institute;
 Museum Purchase, Leisser Art Fund, 71.56
Graphite on paper
21.2 × 15.6 cm
Inscribed in graphite l.c.: Ingres fecit, à Monsieur
 Lethière.

Provenance

Guillaume Guillon Lethière, Paris, until 1832
Auguste Lethière, until 1865
Mme. Charles Lescot (his daughter), until 1902
Marcel Lescot (her son), until 1909
Daniel Lescot (his son), until 1970
Emmanuel Lescot (his son), Avignon, sold to Jean-
 Pierre Selz, Seiferheld & Co., New York, 1971

Exhibition History
None

Selected References

H. Naef, "Ingres und die Familie Guillon
 Lethière," *Du,* December 1963, p. 75
The Art Quarterly, XXXV, 2, Summer 1972, p. 190;
 repr. p. 202
H. Naef, "Auguste Lethière Portrayed by Ingres, a
 Drawing at the Carnegie Institute," *Master
 Drawings,* XI, 3, Autumn 1973, pp. 277-279;
 repr. pl. 29, cover
Naef, 1980, IV, p. 256, no. 141

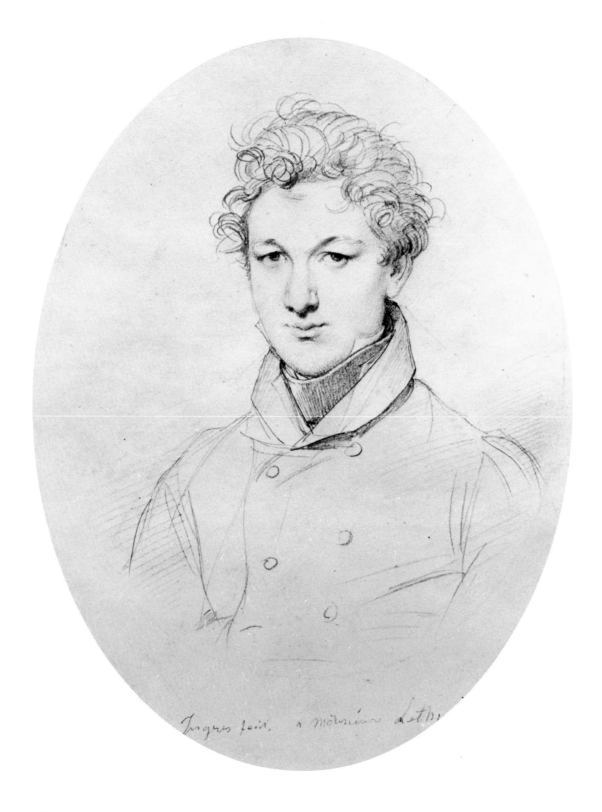

72. Mademoiselle Jeanne Gonin, 1821
Cincinnati, The Taft Museum, 1931.414
Oil on canvas
76 × 60.7 cm
Inscribed l.l.: D. Ingres, pint. flor, 1821

Provenance
Pyrame Thomeguex, until 1844
Antoine Thomeguex (his son), until 1899
Albert Thomeguex (his son), until 1918
Mme. Paul-Gaston Pictet (his sister), until 1923
Gallery Scott & Fowles, New York, to Charles
　Phelps Taft, 1924

Exhibition History
Paris, 1867, no. 442
Chicago, The Art Institute of Chicago, *A Century
　of Progress, Exhibition of Paintings and
　Sculpture,* 1933, no. 217

San Francisco, California Palace of the Legion of
　Honor, *French Painting from the Fifteenth
　Century to the Present Day,* 1934, no. 112, repr.
Toronto, Art Gallery of Toronto, *English and
　French Nineteenth Century Paintings,* 1935,
　no. 112
Springfield (Mass.) Museum of Fine Arts, *David
　and Ingres, Paintings and Drawings,* 1939,
　no. 25, repr. (also New York, Cincinnati,
　Rochester)
New York, M. Knoedler & Co., *Centenary
　Exhibition,* 1946
Detroit Institute of Arts, *French Painting from
　David to Clouet,* 1950, no. 20, repr.
Omaha, Joslyn Art Museum, *Twentieth
　Anniversary Exhibition, The Beginnings of
　Modern Painting, France, 1810-1910,* 1951
Cincinnati Art Museum, *Paintings and Drawings
　by Ingres,* 1953

New Orleans, Isaac Delgado Museum of Art,
　French Masterpieces through Five Centuries,
　1954
Chicago, The Art Institute of Chicago, *Great
　French Paintings,* 1955, no. 22, repr.
Richmond, Virginia Museum of Fine Arts,
　Treasures in America, 1961, no. 74, repr.
New York, 1961, no. 31, repr.
Indianapolis, Herron Museum of Art, *The
　Romantic Era: Birth and Flowering, 1750-
　1850,* no. 28, repr.
Paris, 1967-68, no. 122, repr. (biblio.)
Minneapolis Institute of Arts, *French XIX Century
　Painting,* 1969

Selected References
Wildenstein, 1954, pp. 192-193, no. 147, pl. 54

Louisville Only

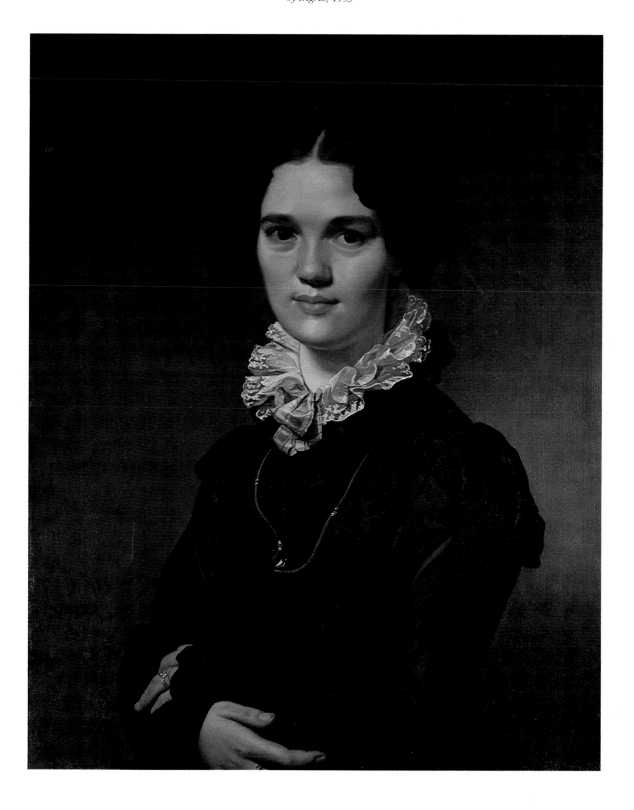

73. Madame Désiré Raoul-Rochette, 1830
Cleveland, The Cleveland Museum of Art,
 Purchase from the J.H. Wade Fund, 27.437
Graphite on cream wove paper
32.2 × 24.1 cm
Inscribed in graphite l.l.: Ingres à Son ami et/
 confrere Monsieur/Raoul Rochette/1830

Provenance
Désiré Raoul-Rochette, Paris, until 1854
Mme. Raoul-Rochette, Paris, until 1878
Raoul Perrin (her grandson), until 1910
Mme. Raoul Perrin (his wife), until 1910
Edmond Perrin (her son), sold before World War I
Wildenstein & Co., Inc., New York, to The
 Cleveland Museum of Art, 1927

Exhibition History
Paris, 1867, no. 573
Paris, 1911, no. 138

The Cleveland Museum of Art, *Drawings by Old
 and Modern Masters,* 1927
The Cleveland Museum of Art, *French Art Since
 Eighteen Hundred,* 1929, p. 159
The Cleveland Museum of Art, *Drawings from
 1630 to 1830,* 1932-33
San Francisco, California Palace of the Legion of
 Honor, *19th Century French Drawings,* 1947,
 no. 12, repr.
New York, 1961, no. 39, repr.
Fogg, 1967, no. 66, repr.
Paris, 1967-68, no. 155, repr.

Selected References
Delaborde, 1870, p. 310, no. 398
Blanc, 1870, p. 239
Lapauze, 1911, p. 286; repr. p. 281
H.S. Francis, "A Portrait Drawing by Ingres," *The
 Bulletin of The Cleveland Museum of Art,*
 February 1929, pp. 27-29; repr. p. 21

H.S. Francis, "Two Graphic Portraits by Ingres,"
 The Bulletin of The Cleveland Museum of Art,
 March 1948, p. 36
Alazard, 1950, p. 84, note 31; pl. LXI
H. Naef, "Ingres et le famille Raoul-Rochette,"
 Bulletin du Musée Ingres, 14, December 1963,
 pp. 13-23
J. G. Moore, *The Many Ways of Seeing, An
 Introduction to the Pleasure of Art,* Cleveland,
 1968, p. 91, fig. 1
A. Mongan, "Ingres as a Great Portrait
 Draughtsman," *Colloque Ingres,* Montauban,
 1969, p. 148; repr. p. 158, fig. 28
M. Delpierre, "Ingres et la mode de son temps
 (d'après ses portraits dessinés)," *Bulletin du
 Musée Ingres,* 37, July 1975, p. 23
E. Pansu, *Ingres: Dessins,* Paris, 1977, no. 62, repr.
Naef, 1980, V, p. 162, no. 334

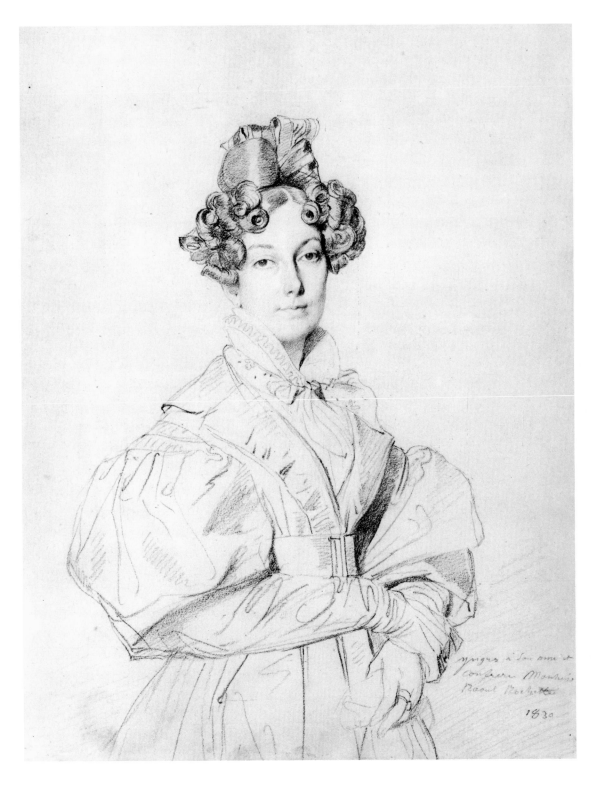

74. Portrait of Madame Thiers, 1834
Oberlin, The Allen Memorial Art Museum,
 Oberlin College, R.T. Miller, Jr. Fund, 48.27
Graphite on off-white wove paper
31.9 × 23.9 cm
Inscribed in graphite l.r.: offert à Monsieur/
 Thiers. ministre de/l'intérieur—/Ingres Del/
 1834

Provenance
Adolphe Thiers, Paris, until 1877
Mme. Aldophe Thiers, Paris, until 1880
Mlle. Félicie Dosne (her sister), Paris, until 1906
J.A. Heseltine Sale, Fountainebleu, April 23, 1933,
 no. 80, repr.
According to M. Knoedler & Co., New York:
 Stanislas de Castellone
 Andre Weil, Paris
 Vitale Bloch
 Langton Douglas
Paul Rosenberg & Co., to Justin K.
 Thannhauser, via M. Helmut Ripperger
According to The Allen Memorial Art Museum:
 Mme. Zak
 Langton Douglas
 Mme. Douglas, 1938
 Paul Rosenberg, 1942
According to Paul Rosenberg & Co.:
 Sold to Vladimir Golschmann, 1946
Justin K. Thannhauser to M. Knoedler & Co., New
 York, 1946
M. Knoedler & Co., New York, to The Allen
 Memorial Art Museum, 1948

Exhibition History
San Francisco, California Palace of the Legion of
 Honor, *19th Century French Drawings,* 1947,
 no. 14
New York, M. Knoedler & Co., *Paintings and
 Drawings from Five Centuries (Oberlin
 Collection),* 1954, no. 55, repr.
Ann Arbor, Museum of Art, University of
 Michigan, *Drawings and Watercolors from the
 Oberlin Collection,* 1956
New York, 1961, no. 44, repr.
Oberlin, The Allen Memorial Art Museum, *Ingres
 and His Circle,* 1967, no. 3, pp. 154-155, repr.
 p. 168
Paris, 1967-68, no. 170, repr.
College Park, University of Maryland, *Hommage
 à Baudelaire,* 1968, p. 33, repr. p. 66

Selected References
H. Naef, "Madame Thiers and Her Portrait by
 Ingres," *Allen Memorial Art Museum Bulletin,*
 Winter 1966, pp. 73-89, repr. p. 72
Naef, 1980, V, p. 178, no. 344

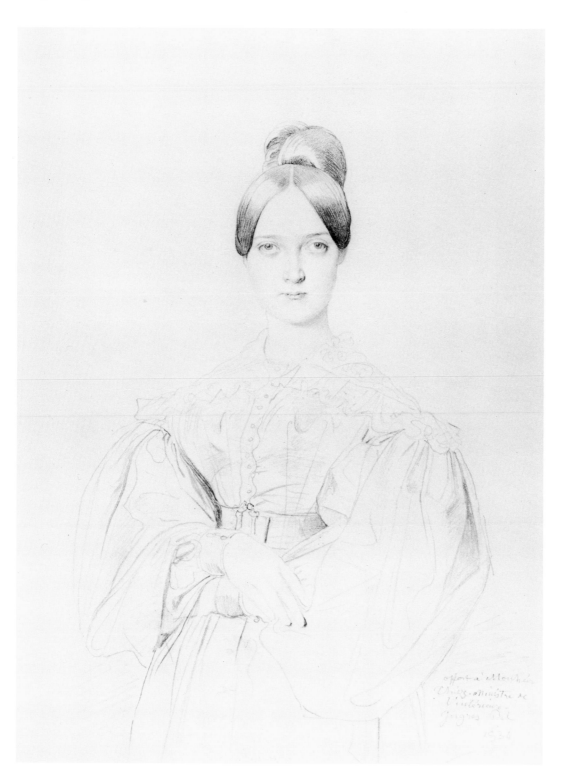

75. The Family Gatteaux, 1850
Baltimore, Douglas H. Gordon Collection
Graphite and printer's ink on paper
43.7 × 60.7 cm
Inscribed l.r.: Ingres à Son/Excellent ami/
 Gatteaux. 1850

Provenance
Edouard Gatteaux, Paris, until 1881
Edouard Brame (husband of his niece), Paris,
 until 1888
Paul Brame (his son), until 1908
Mme. Paul Brame
Henri Brame (her son)
Galerie Hector Brame, Paris, by 1931
Galerie Paul Cassirer, 1931
M. Knoedler & Co., New York, 1931, to Douglas
 H. Gordon, Annapolis, Maryland, 1932

Exhibition History
Versailles, *Exposition d'art rétrospectif,* 1881, no.
 190
Paris, 1900, no. 1088
Paris, 1911, no. 165
Paris, 1921, no. 120
Munich, Ludwigs-Galerie, *Romantische Malerei in
 Deutschland und Frankreich,* 1931, no. 43, repr.
Springfield (Mass.) Museum of Art, *David and
 Ingres, Paintings and Drawings,* 1939, no. 33,
 repr. (also New York, Cincinnati, Rochester)
Cincinnati Art Museum, *The Place of David and
 Ingres in a Century of French Painting,* 1940
San Francisco, California Palace of the Legion of
 Honor, *19th Century French Drawings,* 1947,
 no. 18, repr.
Baltimore Museum of Art, *From Ingres to
 Gauguin, French Nineteenth Century Paintings
 Owned in Maryland,* 1951, no. 7, repr. p. 17

New York, 1961, no. 64, repr.
College Park, University of Maryland, *Hommage
 à Baudelaire,* 1968, p. 33; repr. p. 66

Selected References
Magimel, 1851, no. 58
Delaborde, 1870, p. 297, no. 308
Lapauze, 1901, p. 266
H. Lapauze, *Le portraits dessinés de J.-A.-D. Ingres,*
 Paris, 1903, p. 12, no. 26, repr.
Lapauze, 1911, p. 286; repr. p. 429
H. Brame, *Ingres et ses amis Gatteaux,* Paris, 1911,
 p. 16-17; repr. p. 16
J. Mathey, "Ingres portraitiste des Gatteaux et de
 M. de Norvins," *Gazette des Beaux-Arts,* August
 1933, p. 118, note 2; repr. p. 121, fig. 7
Ternois, 1959, no. 57, repr.
Naef, 1980, V, p. 318, no. 417 (biblio).

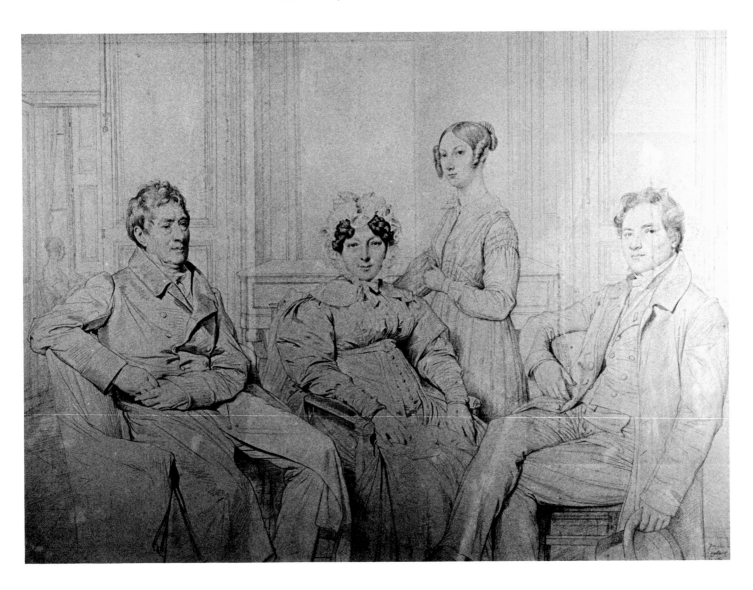

76. Madame Henri Gonse, n.d. (c. 1845-52)
Montauban, Musée Ingres, 28.2.1
Oil on canvas
73 × 62
Inscribed: Mme Car^ne^ Gonse 1852/J. Ingres
 Pinxit.

Provenance
Gonse Family
Henry Lapauze, Paris
Lapauze estate, 1928

Exhibition History
Paris, 1855, no. 3369
Paris, 1867, no. 92
Paris, 1911, no. 51
Belgrade, Musée du Prince Paul, *La peinture
 française au XIXe siècle,* 1939
Buenos Aires, Museo Nacional de Bellas Artes,
 Siete siglos de pintura francesca, 1939

New York, 1952, no. 13, repr.
Bordeaux, *La femme et l'artiste, de Bellini à
 Picasso,* 1964, no. 122, pl. 39
Montauban, 1967, no. 133
Paris, 1967-68, no. 248, repr.
Montauban, 1970, no. 21
Montauban, 1980, no. 99

Selected References
Ingres, Notebook IX, X
Delaborde, 1870, p. 249, no. 122
H. Lapauze, *Le roman d'amour de M. Ingres,*
 Paris, 1910, pp. 308-309, 313
Lapauze, 1911, pp. 440, 452-460; repr. p. 449
L. Hourticq, *Ingres, l'oeuvre du maître,* Paris,
 1928, pl. 101
Alazard, 1950, p. 106
Wildenstein, 1954, p. 220, no. 269, pl. 97

D. Ternois, *Ingres et son Temps,* Montauban,
 1967, no. 172
Rosenblum, 1967, p. 32, repr.
Ternois and Camesasca, 1971, p. 114, no. 150,
 repr.; pl. LI, color
P. Barousse, *Catalogue du Musée Ingres,* 1975,
 p. 23, repr.

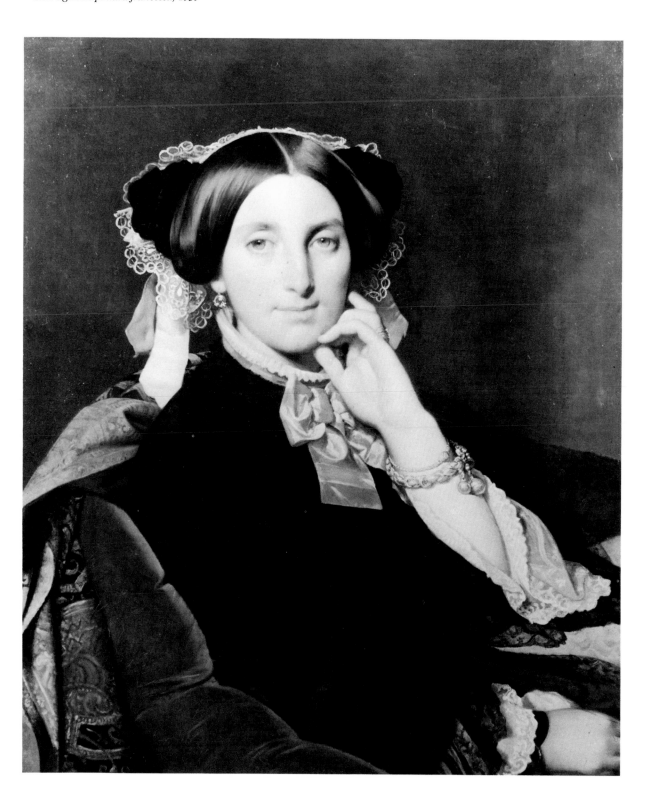

227

77. Philip V and The Marshal of Berwick,
1864
Paris, Petit Palais, 1282
Watercolor over graphite on tracing paper
37.5 x 49 cm
Inscribed in graphite l.c.: J.A.D Ingres f(at) 1864

Provenance
Ingres Sale, 1857, no. 13
Mme. Ingres Sale, Paris, Hôtel Drouot, 1894, no. 95
Gift of Sir Joseph Duveen, December 1921

Exhibition History
Paris, 1867, no. 501
London, Grosvenor Gallery, *Winter Exhibition of Drawings by the Old Masters*, 1878-79, no. 688
Paris, 1889, no. 352
Brussels, Palais des Beaux-Arts, *Ingres-Delacroix, dessins, pastels et aquarelles*, 1936, no. 44
Zurich, Kunsthaus, *Zeichnungen französischer Meister von David zu Millet*, 1937, no. 223
Tokyo-Osaka, *Ingres*, 1981, no. 9, repr.

Selected References
Ingres, Notebook X
Delaborde, 1870, pp. 281-282, no. 218
Lapauze, 1901, pp. 131, 250
Lapauze, 1911, p. 188
Paris, 1967-68, p. 142, under no. 101
Ternois and Camesasca, 1971, p. 99, under no. 98

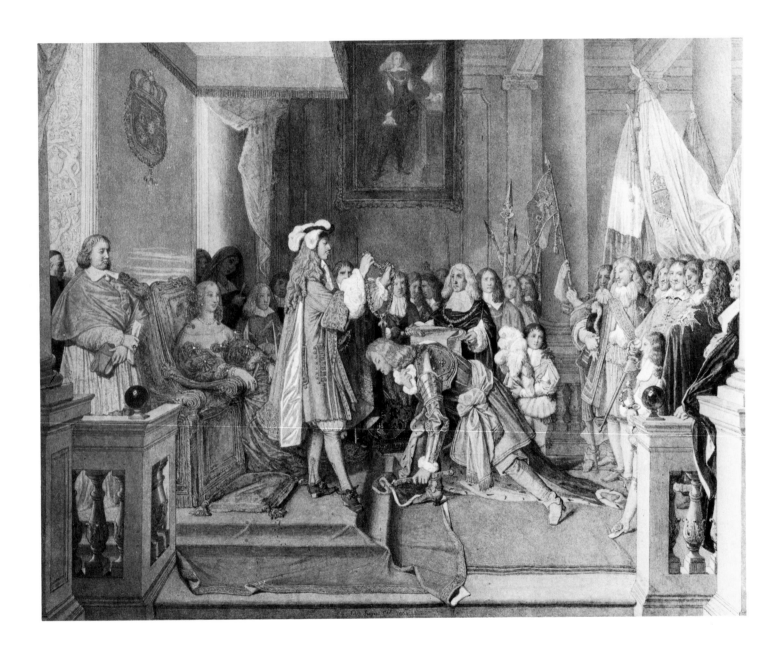

78. Henri IV Playing with His Children,
1817
Paris, Petit Palais, Dut 116
Oil on canvas
39 x 49 cm
Inscribed: Ingres Pinxit Roma 1817

Provenance
Commissioned by Comte de Blacas
Mme. la Marchesa di Vireu

Exhibition History
Paris, Salon of 1824, no. 923
Paris, 1855
Paris, 1867, no. 431

Selected References
Ingres, Notebook IX, X
Stendhal, Review of the Salon of 1824, *Mélange
 d'Art*, Paris, 1932, p. 194
Delaborde, 1870, p. 230, no. 63
Lapauze, 1911, pp. 189-190
Amaury-Duval, 1924, pp. 58-59
Wildenstein, 1954, p. 182, no. 113, fig. 61
Ternois and Camesasca, 1971, p. 98, no. 94a, repr.

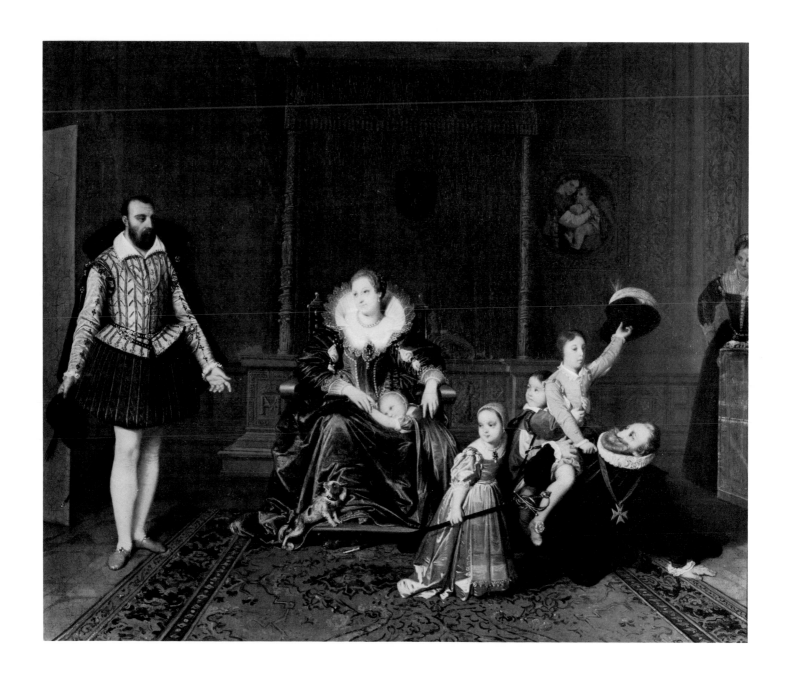

79. Paolo and Francesca, n.d.
Montauban, Musée Ingres, 867.1399
Graphite on tracing paper
17.3 x 13.5 cm
Inscribed: Ingres

Provenance
Ingres estate, 1867

Exhibition History
Hamburg, Kunsthalle, *John Flaxman*, 1979, no.
 221a, repr.

Selected References
Unpublished

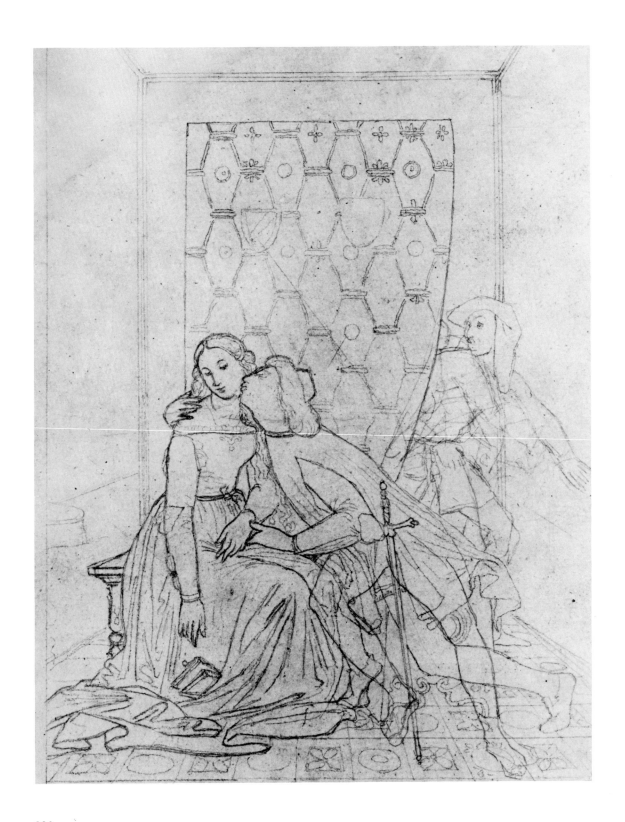

80. Grand Odalisque, c. 1826
Montauban, Musée Ingres, 867.1197
Graphite, pen and brown ink, with sanguine,
 squared for transfer, on tracing paper
32.5 × 49.5 cm

Provenance
Ingres estate, 1867

Exhibition History
None

Selected References
Lapauze, 1901, pp. 120, 122
Lapauze, 1911, p. 508

Appendix

Select Bibliography

The Bibliography cites all major reference books about Ingres, as well as articles and books of a more specific nature about him and his artistic mileau which were used by the authors in the preparation of their texts. General monographs devoted to Ingres and books about the period of a less scholarly nature that might be more readily available in the libraries and bookstores are also cited. Finally, a major ingredient in the Ingres' bibliography is the rich corpus of exhibition catalogues. These are cited by the city in which the exhibition occured rather than by author, as frequently several authors are involved in the project or authorship is uncited. The abbreviation used for works or exhibitions cited frequently in the text follows the full bibliographic entry.

Alaux, J. *L'Academie de France à Rome*, 2 vols., Paris, 1933.

Alazard, J. "Ce que J.-D. Ingres doit aux Primitifs Italiens," *Gazette des Beaux-Arts*, 2, 1936, pp. 167-175.

Alazard, J. *Ingres et l'Ingrisme*, Paris, 1950. (Alazard, 1950)

Amaury-Duval, E. *L'Atelier d'Ingres*, Paris, 1878; 2nd ed., 1924. (Amaury-Duval, 1924)

Angrand, P. *Monsieur Ingres et son époque*, Lausanne, 1967.

Angrand, P. and Naef, H. "Ingres et la famille de Pastoret: Correspondance inédite," *Bulletin du Musée Ingres*, 28, 1970, pp. 7-22.

Baudelaire, C. *Art in Paris, 1845-1862; Salons and Other Exhibitions*, trans. and ed. by J. Mayne, Oxford, 1965.

"Bibliographie des Revues d'art en France (1746-1914)," *Gazette des Beaux-Arts*, XXXVIII, 1951.

Blanc, C. *Ingres, sa vie et ses ouvrages*, Paris, 1870. (Blanc, 1870)

Boime, A. *The Academy and French Painting in the Nineteenth Century*, London, 1971.

Boyer d'Agen, A. *Ingres d'apres une correspondance inédite*, Paris, 1909. (Boyer d'Agen, 1909)

Brion, M. *Art of the Romantic Era: Romanticism, Classicism, Realism*, New York, 1966.

Bryant, E. "Notes on J.A.D. Ingres' *Entry into Paris of the Dauphin, Future Charles V*," *Wadsworth Atheneum Bulletin*, 5th ser., 3, 1959.

Cambon, A. *Catalogue du Musée de Montauban*, Montauban, 1885.

Cambridge, Cohn, M. and Siegfried, S. *Works by J.-A.-D. Ingres in the collection of the Fogg Art Museum*, Fogg Art Museum Handbooks, III, 1980. (Fogg, 1980)

Cambridge. Mongan, A. and Naef, H. *Ingres Centennial Exhibition, 1867-1967: Drawings, Watercolors and Oil Sketches from American Collections*, Fogg Art Museum, 1967. (Fogg, 1967)

Chaudonneret, M.-C. "Ingres: Paolo et Francesca," *Galerie d'Essai*, Bayonne, Musée Bonnat, c. 1982.

Cogniat, R., ed. *Ingres écrits sur l'art; textes recueillis dans les carnets et dans la correspondance de Ingres*, Paris, 1947.

Courthion, P. *Ingres raconté par lui-même et par ses amis: Pensées et écrits du peintre*, I, Vésenaz-Geneva, 1947.

Courthion, P. *Ingres raconté par lui-même et par ses amis: Ses contemporains, sa posterité*, II, Vésenaz-Geneva, 1948.

Delaborde, H. *Ingres, sa vie, ses travaux, sa doctrine, d'après les notes manuscrites et les lettres du maître*, Paris, 1870. (Delaborde, 1870)

Delaborde, H. "Les dessins de M. Ingres au Salon des Arts-Unis," *Gazette des Beaux-Arts*, IX, 1861, I, pp. 257-69.

Delacroix, E. *The Journal of Eugene Delacroix*, trans. by L. Norton, New York, 1979.

Delécluze, E. *David, son école & son temps (souvenirs de soixante années)*, Paris, 1862.

de Montaiglon, A. *Essai de bibliographie des livres et des critiques des Salons depuis 1673 jusqu'en 1851*, Paris, 1852.

de Montaiglon, A. and Guiffrey, J. *Correspondance des directeurs de l'Académie de France à Rome*, 18 vols., Paris, 1887-1912.

Detroit. *The Age of the Revolution: French Painting, 1774-1830*, Detroit Institute of Arts; New York, Metropolitan Museum of Art; Paris, Réunion des Musées Nationaux, 1975.

Durbé, D. *Maestri del Colore: Ingres*, Milan, 1965.

Eitner, L. *Neoclassicism and Romanticism, 1750-1850*, 2 vols., Englewood Cliffs, N.J., 1970.

Ewals, L.J.L. "Ary Sheffer, entre Ingres et Delacroix," *Colloque Ingres et son influence*, Montauban, 1980, pp. 17-32.

Florence, *Ingres e Firenze*, Or San Michele, 1968.

Friedlander, W. *David to Delacroix*, trans. by R. Goldwater, Cambridge, MA., 1952.

Fröhlich-Bum, L. *Ingres: sein Leben und sein Stil*, Vienna, 1924.

Galichon, E. "Descriptions des dessins de M. Ingres," *Gazette des Beaux-Arts*, IX, XI, 1861, pp. 341-362, 38-48.

Gatteaux, E. *Collection des 120 dessins, croquis et peintures de M. Ingres classés et mis en ordre par son ami Edouard Gatteaux*, 2 vols., Paris, 1875.

Gatteaux, E. *Dessins, croquis et peintures de M. Ingres de la Collection de Edouard Gatteaux, du Musée National du Louvre et l'Ecole Nationale des Beaux-Arts*, 2nd ser., edited by A. Guerinet, 2 vols., Paris, n.d.

Gross, R. "Ingres' Celtic Fantasy *The Dream of Ossian*," *Rutgers Art Review*, 2, 1981, pp. 43-58.

Hamburg. *Ossian und die Kunst um 1800*, Hamburg, Kunsthalle; Paris, Grand Palais, 1974.

Hardouin-Fugier, E. "Jésus remettant les clefs à Saint-Pierre," *Bulletin du Musée Ingres*, 41, 1978, pp. 1-13.

Honour, H. *Neo-classicism*, New York, 1977.

Honour, H. *Romanticism*, New York, 1979.

Hourticq, L. *Ingres, l'oeuvre de maitre, ouvrage illustré de 160 gravures*, Paris, 1928.

King, E. "Ingres as Classicist," *Journal of the Walters Art Gallery*, V, 1942, pp. 69-113.

Lapauze, H. *Les dessins de J.-A.-D. Ingres du Musée de Montauban*, Paris, 1901. (Lapauze, 1901)

Lapauze, H. *Le roman d'amour de M. Ingres*, Paris, 1910.

Lapauze, H. *Ingres, sa vie & son oeuvre*, Paris, 1911. (Lapauze, 1911)

Lapauze, H. "Lettres inédit à M. Marcotte," *Le Correspondant*, CCLII, CCLIII, 1913, pp. 1069-1090, 88-107.

Lapauze, H. *Histoire de l'Académie de France à Rome*, 2 vols., Paris, 1924.

Leymarie, H. *French Painting, the Nineteenth Century*, trans. by J. Emmons, Cleveland, 1962.

London. *Ingres: drawings from the Musée Ingres, Montauban*, Arts Council of Great Britain, 1957.

London. *The Age of Neo-Classicism*, Royal Academy and Victoria and Albert Museum, 1972. (London, Victoria and Albert, 1972)

Lugt, F. *Les marques de collections de dessins et d'estampes*, Amsterdam, 1921; suppl., The Hague, 1956.

Lugt, F. *Répertoire des catalogues de ventes publiques*, 3 vols., The Hague, 1938-64.

Mabilleau, L. "Les dessins d'Ingres au Musée de Montauban," *Gazette des Beaux-Arts*, XII, 1894, pp. 177-201, 371-390.

Magimel, A. *Oeuvres de J.A. Ingres, gravées au trait sur acier par A. Réveil, 1800-1851*, Paris, 1851. (Referred to in text as Réveil, 1851; in checklist as Magimel, 1851)

Manessa. Naef, H., *Ingres Rom*, Manessa, 1962.

Mesuret, R. "Si Qua Fata Aspera Rumpas," *Colloque Ingres*, Montauban, 1969, pp. 125-132.

Mireur, H. *Dictionnaire des ventes d'art faites en France et à l'etranger pendant les XVIII et XIXeme siècles*, 7 vols., Paris, 1911-12.

Momméja, J. "Collection Ingres au Musée de Montauban," *Inventaire général des richesses d'art de la France. Province, Monuments civils VII*, Paris, 1905, pp. 29-256. (Momméja, 1905)

Mongan, A. "Drawings by Ingres in the Winthrop Collection," *Gazette des Beaux-Arts*, XXVI, 1944, pp. 387-412.

Mongan, A. "Ingres and the Antique," *Journal of The Warburg and Courtauld Institute*, X, 1947, pp. 1-13.

Montauban. *Exposition des Beaux-Arts*, Montauban, Hôtel de Ville, 1862. (Montauban, 1862)

Montauban. *Ingres et Son Temps, Exposition organisé pour le centenaire de la mort d'Ingres*, Musée Ingres, 1967. (Montauban, 1967)

Montauban. Naef, H. *Rome vue par Ingres*, Musée Ingres, 1973.

Montauban. *Ingres et sa Postérité: jusqu'à Matisse et à Picasso*, Musée Ingres, 1980. (Montauban, 1980)

Naef, H. *Die Bildniszeichnungen von J.-A.-D. Ingres*, 5 vols., Bern, 1977-81. (Naef, 1980, I-V)

Naef, H. "Paolo und Francesca zum Problem der Schöpferischen Nachahmung bei Ingres," *Zeitschrift fur Kunstwissenschaft*, X, 1/2, 1956.

Naef, H. "Un Tableau d'Ingres Inachevé: Le Duc d'Albe à Sainte-Gudule," *Bulletin du Musée Ingres*, 7, 1960, pp. 3-6.

New York. *A Loan Exhibition of Paintings and drawings from the Ingres Museum at Montauban*, M. Knoedler & Co., 1952. (New York, 1952)

New York. *Ingres in American Collections*, Paul Rosenberg & Co., 1961. (New York, 1961)

New York. *The Non-Dissenters*, Shepherd Gallery, 1968.

New York. *Christian Imagery in French Nineteenth Century Art 1789-1906*, Shepherd Gallery, 1980.

Novotny, F. *Painting and Sculpture in Europe 1780-1880*, New York, 1978.

Oppé, A.P. "J. A. D. Ingres: Design for a Monument to Lady Jane Montague, 1816, Felton Bequest, National Gallery of Victoria, Melbourne." *Old Master Drawings*, September 1926, pp. 20-21.

Pach, W. *Ingres*, New York, 1939.

Pansu, E. *Ingres dessins*, Paris, 1977.

Paris. *Explication des Ouvrages de Peinture exposés dans la Galerie des Beaux-Arts Boulevard Bonne-nouvelle, 22 au Profit de la Caisse de Sécours et Pensions de la Société des Artistes*, Galerie Bonne-Nouvelle, 1846. (Paris, 1846)

Paris. *Exposition universelle de 1855 . . . Explication des ouvrages de peinture, sculpture . . .*, 1855. (Paris, 1855)

Paris. *Exposition au profit de la caisse de sécours des peintres*, Galerie Georges Petit, 1860. (Paris, 1860)

Paris. *Ingres*, Galerie Martinet, 1861. (Paris, 1861)

Paris. *Catalogue des tableaux, études peintes, dessins et croquis de J.-A.-D. Ingres . . . exposé dans les galeries du l'Ecole des Beaux-Arts* and *Supplement au catalogue*, Ecole des Beaux-Arts, 1867. (Paris, 1867)

Paris. *Cent chefs-d'oeuvre des collections parisiennes*, Galerie Georges Petit, 1883. (Paris, 1883)

Paris. *Oeuvres d'Ingres*, Grand Palais, Salon d'automne, 1905. (Paris, 1905)

Paris. *Ingres*, Galerie Georges Petit, 1911. (Paris, 1911)

Paris. *David et ses élèves*, Petit Palais, 1913. (Paris, 1913)

Paris. *Ingres*, Chambre syndicale de la Curiosité et des Beaux-Arts and Galerie Georges Petit, 1921. (Paris, 1921)

Paris. *David, Ingres, Géricault et leur temps*, Ecole des Beaux-Arts, 1934.

Paris. *Exposition de portraits par Ingres et ses élèves*, Jacques Seligmann et Fils, 1934.

Paris. *Ingres*, Petit Palais, 1967-68. (Paris, 1967-68)

Paris. *"Equivoques" Peintures françaises du XIXe siécle*, Musée des Arts Décoratifs, 1973.

Paris. *Le Neo-Classicisme français: Dessins des Musées de Province*, Grand Palais, 1974. (Paris, Grand Palais, 1974-75)

Paris. *Cinquante dessins de nus par Ingres*, Musée Bourdelle, 1976. (Paris, 1976)

Philadelphia. *The Second Empire: Art in France under Napoléon III*, Philadelphia Museum of Art; Detroit Institute of Arts; Paris, Grand Palais, 1978-79.

Picon, G. *Ingres*, Geneva, 1967.

Picon, G. *Jean-Auguste-Dominique Ingres*, New York, 1980.

Potts, A. "Winckelmann's Construction of History," *Art History*, 4, December 1982, pp. 337-407.

Quatremêre de Quincy, A.-C. *The Destination of Works of Art and the Use to Which They Are Applied*, trans. by H. Thomson, London, 1821.

Réveil, A. *Museum of Painting and Sculpture . . . in the . . . Galleries of Europe*, I, London, 1828.

Radius, E. and Camesasca, E. *L'Opera completa di Ingres*, Milan, 1968.

La Renaissance de l'art français, IV, 1921, pp. 190-276 (issue devoted to Ingres).

Rome. *Vedute di Roma di Ingres; disegni appartenti al Museo di Montauban esposti nel Palazzo Braschi*, Amici Dei Musei Di Roma, 1958.

Rome. *Ingres in Italia, 1806-1824, 1835-1841*, Villa Medici, 1968. (Rome, Villa Medici, 1968)

Rosen, C. and Zerner, H. "The Permanent Revolution," *New York Review of Books*, XXVI, 22 November 1979.

Rosenblum, R. *Jean-Auguste-Dominique Ingres*, New York, 1967. (Rosenblum, 1967)

Rosenblum, R. *Transformations in Late Eighteenth Century Art*, Princeton, 1967.

Rosenblum, R. *The International Style of 1800*, New York, 1976.

Rosenthal, L. *La peinture romantique. Essai sur l'évolution de la peinture française de 1815 à 1830*, Paris, 1900.

Rosenthal, L. "Les conditions sociales de la peinture sous la Monarchie de Julliet," *Gazette des Beaux-Arts*, III, 1910, pp. 93-114, 217-241.

Rosenthal, L. *Du Romanticism au Realisme: Essai sur l'évolution de la peinture en France de 1830 à 1848*, Paris, 1914.

Schlenoff, N. *Ingres, ses sources littéraires*, Paris, 1956. (Schlenoff, 1956)

Schlenoff, N. "Un souvenir d'Ingres, un dessin inédit," *Bulletin du Musée Ingres*, 3, 1957, pp. 8-13.

Siegfried, S. *Ingres and His Critics, 1806-1824* Diss., Harvard University, 1980.

Ternois, D. "Les sources iconographiques de l'Apothéose d'Homère," *Bulletin de la Société Archéologique de Tarn-et-Garonne*, 1954-55.

Ternois, D. *Inventaire général des dessins des Musées de province, III, les dessins d'Ingres au Musée de Montauban, les portraits*, Paris, 1959. (Ternois, 1959)

Ternois, D. "Notes sur le *Duc d'Albe à Sainte-Gudule*," *Bulletin du Musée Ingres*, 7, 1960, pp. 7-10.

Ternois, D. *Inventaire des collections publiques françaises, 11, Montauban-Musée Ingres, peintures, Ingres et son temps*, Paris, 1965. (Ternois, 1965, *Inventaire*)

Ternois, D. "Ingres et le Songe d'Ossian," *Walter Friedlaender zum 90. Geburtstag*, Berlin, 1965, pp. 185-192.

Ternois, D. "Ingres et sa Méthode," *Revue du Louvre*, 4, 5, 1967, pp. 195-208.

Ternois, D. "Ossian et les peintres," *Colloque Ingres*, Montauban, 1969, pp. 165-213.

Ternois, D. "Napoléon et la decoration du palais impériel de Monte Cavallo en 1811-13," *Revue de l'Art*, 7, 1970, pp. 68-89.

Ternois, D. "Lettres d'Ingres à Calamatta," *Colloque Ingres et son influence*, Montauban, 1980, pp. 61-110.

Ternois, D. and Camesasca, E. *Tout l'oeuvre peint d'Ingres*, Paris, 1971. (Ternois and Camesasca, 1971)

Ternois, M. J. "Les oeuvres d'Ingres dans la collection Gilibert," *Revue d'Art*, 3, 1959, pp. 120-30.

Thoré, T. (pseud. of W. Burger). *Salons de T. Thoré, 1844, 1845, 1846, 1847, 1848*, Paris, 1868.

Toulouse-Montauban. *Ingres et ses maîtres de Roque à David*, Musée des Augustins, Musée Ingres, 1955. (Toulouse-Montauban, 1955)

Tourneux, M. *Salons et expositions d'art à Paris, 1801-70*, Paris, 1919.

Tokyo. *Ingres*, Tokyo, Musée National d'Art Occidental; Osaka, Musée National d'Art, 1981. (Tokyo-Osaka, 1981)

Van Lière, E. "Ingres' *Raphael and the Fornarina*: Reverence and Testimony," *Arts Magazine*, LVI, 4, December 1981, pp. 108-115.

Whiteley, J. *Ingres*, London, 1977.

Wildenstein, G. *The Paintings of J.-A.-D. Ingres*, London, 1954. (Wildenstein, 1954)

Ziff, N. "Jeanne d'Arc and French Restoration Art," *Gazette des Beaux-Arts*, 93, 1979.

Zurich. *Rome vue par Ingres, die italienischen Landschaften und Ansichten aus dem Musée Ingres in Montauban. Portraitzeichnungen von Ingres aus schweizerischen Privatbesitz*, Kunsthaus, 1958.

Ancient Subjects

Philémon and Baucis

This story is taken from Book VIII of Ovid's *Metamorphoses*. Jupiter, traveling in human form in the company of his winged messenger Mercury, visited the land of Phrygia. The hour was late as they went from door to door presenting themselves as weary travelers. Hospitality was denied until they reached the cottage of the pious old Baucis and her husband Philémon. Laying cloths and soft pillows to cushion the hard table stools for their guests, the couple brought water for them to wash and cool themselves. They served a simple but abundant meal of cooked eggs, olives, bread, cheese, and stew. At the moment the wine pitcher replenished itself, the identity of the heavenly guests was revealed. Falling to their knees, Philémon and Baucis pleaded forgiveness for the humbleness of the meal. Anxious to give a more appropriate offering, they then chased the family goose. The bird wisely sought refuge at the foot of Jupiter, who declared a sacrifice unnecessary.

As a reward for the gracious reception, Jupiter led the pair from their home to a temple on a distant hillside. There they passed their remaining years as its priests. To the inhospitable community Jupiter was not so kind; he destroyed it with a flood.

Oedipus and the Sphinx

Oedipus as an infant had been condemned to death by his father, who feared a prophecy that he would die by the hand of his son. A peasant rescued the baby from a tree, where a herdsman who could not bear to kill him outright had left him hanging by his ankles. Many years later, Laius, Oedipus' father and King of Thebes, quarrelled on the highway with a young stranger and was killed. The man, who was Oedipus, travelled on to Thebes. Neither he nor the city realized he had murdered their king, his father.

The city was in the demonic grasp of a Sphinx. This beast had evolved in late Greek mythology into an almost intellectual monster whose power over humans was a combination of superior wisdom and terrifying form (the upper body a woman, the lower body a crouching lion). She was poised along the road to the city and confronted all who passed with the riddle: "What animal is that which in the morning goes on four feet, at noon on two, and in the evening upon three?" For their failure to answer correctly, all were slain. Oedipus, however, challenged her and responded, "Man, who in childhood creeps on hands and knees, in manhood walks erect, and in old age with the aid of a staff." The Sphinx, hearing the correct response, cast herself to death on the rocks below.

In an early version of the myth, Oedipus destroyed the Sphinx in physical combat. The remarkable characteristic of the developed myth is that Oedipus overcame the Sphinx not by force but by his superior intelligence.

As a reward for this, the city of Thebes made him king. Thus, he unwittingly became the husband of his mother, the tragedy which is the point of departure for Sophocle's *Oedipus*.

Jupiter and Thetis

The story is taken from the first book of *The Iliad* by Homer. The episode is marked in crayon in Ingres' French edition of it. Wronged by his commander Agamemnon, Achilles—the greatest of the Greek warriors in the Trojan War—seeks revenge through his mother, the sea goddess Thetis. He asks her to plead with Jupiter (her former suitor) to assure a Trojan victory to spite Agamemnon. His wish is no less than treason.

His mother waited twelve days for the formidable Jupiter to return to Olympus and then (quoting from the Fitzgerald translation), "rising like a dawn mist from the sea . . . she soared aloft." Kneeling before him, she placed her left hand on his knees and with her right hand caressed his chin as she pleaded with him: "O Father [Jupiter], if ever amid the immortals I by word or deed served you, grant my wish and see to my son's honor!"

Although he readily acceded to her request, Jupiter was disturbed by this threat to his domestic peace with his wife Juno. "Here is trouble. You drive me into open war with [Juno] sooner or later: she will be at me scolding all day long. Even as matters stand she never rests from badgering me before the gods. . . . Go home before you are seen. But you can trust me to put my mind on this; I shall arrange it. Here, let me bow my head, then be content to see me bound by the most solemn act before the gods." Their interview concluded when he "bent his ponderous black brows down" and Olympus trembled. After this they parted: "misty Thetis from glittering Olympus leapt away into the deep sea. [Jupiter] to his hall retired." But Jupiter's instincts were correct: Juno "knew he had new interests; she had seen the goddess Thetis, silvery-footed daughter of the Old One of the Sea."

Romulus Conqueror of Acron

Ingres' source for this subject is Plutarch's *Life of Romulus*, which details many triumphs in the life of Rome's founder and king. Unable by conventional means to remedy the shortage of women to marry his soldiers and mother future generations of Romans, Romulus condoned an outrageous solution. At the inter-tribal festival honoring the god Neptune, the Roman soldiers kidnapped, raped, and took as their wives the finest of the young Sabine women. To retaliate for this breach of honor, Acron, king of a neighboring tribe, declared war on the Romans. Romulus in turn prayed to Jupiter for a victory, promising that if he won he would build a temple to honor the god and would deliver up to him the arms of the vanquished enemy.

As he willed it, it was done. Acron was killed; the battle was a rout. To ensure that his offering would be acceptable to both the god and the citizens of Rome, Romulus spared no trouble in his preparations for the triumphal procession. He cut himself a huge, straight oak and decked it out with his trophies—the arms of Acron. He put on his finest robe, added a wreath of laurel, threw the oak over his shoulder, and marched victoriously from the battlefield toward the city, where he was greated by the celebratory chants of his people.

Dream of Ossian

The Gaelic Ossian poems were "discovered" and "assembled" by the Scottish poet James MacPherson in 1760-63. Ossian's (The Homer of the North) story of a third century Nordic world of nocturnal visions, epic adventures, warriors, lovers, and bards who chant songs of the heroes of the past was instantly popular throughout Europe. Napoleon considered Ossian "his poet" and carried the poems on campaign with him, just as Alexander the Great had carried the *The Iliad*. Ingres was so devoted to the story that he persisted with versions of it long after the poems themselves were revealed as a literary hoax.

Ingres recorded the details of the subject: "Ossian the bard was the son of Fingal and Roscrana. He accompanied his father on all his expeditions. Ireland was the theatre. On the last of Fingal's exploits, he solemnly consigned to Ossian his lance which had served him for the defense of the weak and oppressed. Then, deprived of his father and of his son Oscar, [who was] slain treacherously, blind and sick, he [Ossian] charmed his unhappiness and his misery by chanting of the exploits of

his friends. He often crawled along to the tomb of his son and father and there plucked his harp with his trembling fingertips. The wife of his dear Oscar, Malvina, never abandoned him; it was to her that he addressed the majority of his poems about the valiant Oscar. . . . Malvina learned the poems of Ossian by heart and accompanied him on the harp: dear Oscar, you live in the heart of Malvina. Your ghost rarely comes . . . but your death like a violent wind came to wither my youth." (Schlenoff, 1956, p. 78).

Beneath this Ingres added some notes for his composition: "victory of Fingal over Caracalla/ Noise of the torrential storm/ ground, heather and deserted lands/ Brilliant stars/ the baying of hounds." At least two other manuscript entries contain additional details of the scene recorded by the artist at various stages of his life.

Virgil Reading the Aeneid

Virgil (70-19 BC) was the Roman answer to the Greek Homer. The twelve books of his poem *The Aeneid* contain all that made the history of Rome heroic legend.

Ingres' patron for his first version of this subject was an ardent Virgilian. The incident Ingres chose is characteristic of the Neo-Classical approach to subject matter: action is stopped, emotion is held in check, the gestures tell all, the psychological import is of far more value than the actual event.

Virgil reads *The Aeneid* to the Emperor Augustus, his wife Livia, and his sister Octavia. He has just read the lines detailing Aeneas' encounter in the underworld with the ghost of the young military hero Marcellus, whose life had been cut short by a treacherous plot (VI, 860-886). At this moving tribute to her dead son, Octavia faints. Augustus signals to the poet to stop reading. Livia sits coolly, unmoved. She had been responsible for Marcellus' death, since his heroic exploits endangered the chances for the succession of her own son Tiberus.

Antiochus and Stratonice

This romantic tale was copied by Ingres into his Notebook X from the *Life of Demetrius* by Plutarch. Antiochus, young prince and son of Seleucus (Syria, third-century, BC) fell hopelessly in love with his father's second wife. The young and beautiful Stratonice was unaware of Antiochus' passion. Despite his attempts to deny his feelings, they did not abate. Ashamed of his weakness, he saw death as the only escape from his incurable passion. He

resolved to abandon life, and little by little he came nearer to that moment as he turned away all food and water. Not wanting to confess the real cause of his malady, he claimed to be suffering from a physical distress. No one could identify it until the doctor Erastratus suspected that the ailment was love. He then began to spectulate as to the object of Antiochus' passion. He passed the day in the sick room, and each time a beautiful young woman from the court entered, he carefully watched Antiochus' face and body movements for signs of a secret affection. Antiochus' pulse and face remained unchanged. But when Stratonice entered, whether alone or in the company of her husband, the doctor perceived the signs of love described by Sappho: Antiochus' words and voice failed when Stratonice was near, he blushed, and his expression changed. He threw himself into the pillow, and then, breaking into a sweat, his pulse rose. When he regained control, he was like a person transported—ravished, spiritless, and pale.

Ingres' copy of the story ends at that point. In fact, there is yet another part. The doctor told the father what he had seen. Out of love for his son, the father gave Stratonice to him so that he might live.

Venus Anadyomene

The birth of Venus is an allegory of the birth of beauty in the mind of man. Venus sprang from the foam of the sea, which had been fertilized by the severed genitals of Saturn. She stood on a cockle shell, her long golden hair swept about her, and she had roses at her head and feet. The wind gods (zephyrs) bore her on the waves to the isle of Cyprus, where she was received by an assembly of the gods.

The sister to the *Venus*, *The Source*, is a water nymph, or a Naiad. These lovely creatures presided over brooks and fountains. Urns, rocks, and water are their traditional attributes.

Modern Subjects

Paolo and Francesca

In his *Divine Comedy* (*Inferno*, Canto V), Dante was the first to tell this story of tragic love. In about 1275 the aristocratic Francesca, daughter of a lord from Ravenna, was married for political reasons to Giovanni Malatesta of Rimini, a physically deformed and hot-headed soldier much older than she. After her marriage, Francesca often passed her time in the company of Giovanni's younger brother Paolo, who

was as handsome, elegant, and given to diversions of idleness as his older brother was ugly and given to pursuits of war. In the long hours spent together, their love flourished innocently.

Dante encountered the lovers in the Second Circle of Hell (reserved for the Carnal, whose sin was sexual excess). They were whirled and buffeted endlessly through murky air (symbolic of the clouding of their reason by passion) by a great gale (symbolic of their lust). Dante asked Francesca what had caused their fall. Responding that there was no greater pain than to remember in present grief past happiness, she answered, "If your great desire is to learn the very root of such a love as ours, I shall tell you, but in words of flowing tears. One day we read, to pass the time away, of Lancelot, how he had fallen in love; we were alone, innocent of suspicion. Time and again our eyes were brought together by the book we read; our faces flushed and paled. To the moment of one line alone we yielded: it was when we read about those longed-for lips now being kissed by such a famous lover, that this one (who shall never leave my side) then kissed my mouth and trembled as he did" (trans. M. Musa, 1971, lines 121-136).

What Francesca does not tell Dante is that at the instant of the kiss, her husband burst into the room and murdered both the lovers.

Don Pedro of Toledo Kissing the Sword of Henri IV

Henri IV was one of Ingres' favorite historical figures. In his Notebook he copied out passages of *l'Histoire de Henri Grand* by Hardouin de Beaumont de Péréfixe. He made a list of fifteen possible subjects; only this and *Henri IV Playing with His Children* were ever painted. Both are typical of the "petite histoire" or anecdotal/troubadour paintings that became popular in the early nineteenth century. The stories favored intimate scenes from the lives of famous historical figures. The scale of the works was always small, "cabinet" size made for the private homes of the new bourgeois collectors.

Ingres described this incident in Notebook IX (Lapauze, 1901, p. 220-221): "One day Don Pedro of Toledo, the Ambassador of Spain to the court of Henri IV, saw in the Louvre the sword of the King in the hands of a young page. Advancing, he knelt on the ground and kissed it, rendering honor, he said, to the most glorious sword in Christendom."

Philip V and the Marshal of Berwick

Jacques Fitz-James, the Duke of Berwick (Moulins, 1670-Philipsbourg, 1734), entered the service of Louis XIV and in 1706 was named Field Marshal. He commanded the French troops during the War of Succession in Spain and won a major victory in the Battle of Almanza. This win assured the succession of the Spanish throne to the grandson of Louis XIV, Philip V. For his victory, the Marshal was presented the Order of the Golden Fleece by Philip V.

The Duke of Alba at St. Gudule

The Duke of Alba's successful campaign against the Protestant Reformation resulted in the expulsion of the Prince of Orange from the Low Countries and the Duke's being appointed governor by King Philip II of Spain. Upon his triumphant entry into Brussels, the Duke immediately sent news of the Catholic victory to Rome. To honor the Duke for his service to the Church, Pope Pius V sent the Archbishop of Malines to Brussels to present the Duke with a hat and sword that had been blessed by the Pope on Christmas night in the Sistine Chapel. The presentation of these honors in the Cathedral of St. Gudule in 1568 mandated the repression of the Reformation in the Netherlands and implicitly condoned the Duke's burning to death of 10,000 Protestants.

Henri IV Playing with His Children

This subject, like many of those chosen by painters and their patrons in the years after the fall of the Napoleonic empire, had a political aim as well as a pictorial one. The story celebrates the idea of an approachable monarch and is expressly tailored to the political world of democratic idealism introduced by the French Revolution. Of the French kings, the most popular figure in art was Henri IV. The annals of the Salon from 1814 to 1827 record sixty-seven paintings depicting scenes from his life.

Ingres cited the subject of the king playing with his children in the list of contemplated topics in Notebook IX (Lapauze, 1901, p. 221). He described the king as "making the tour around the room with his children on his back when Don Pedro, the Spanish Ambassador, entered." The king asked his visitor if he was also a father, and when Don Pedro replied that he was, Henri IV said "then surely you will understand if I complete my tour before we talk."

The Death of Leonardo da Vinci

Among the most popular subjects in troubadour painting were deathbed scenes of famous personages. Also of great appeal in the early nineteenth century were scenes from the lives of famous artists of the past. Both lent themselves to the historicism and sentimentality the new bourgeois patrons loved. *The Death of Leonardo*, a motif combining the two subjects, was one of many Salon paintings that used these elements, but Ingres added the motif of the king venerating the dying artist. The combination reinforced two important ideas: the humanization of the monarch and the elevated position of the artist in society.

François I witnesses the death of Leonardo, the celebrated Italian Renaissance artist, who was in the employ of the French king when he died at the Chateau du Clos-Lusé on May 2, 1519. Vasari included this famous deathbed scene in his *Lives of the Artists* in 1551. The accuracy of Vasari's account was questioned in the nineteenth century by Stendhal, who pointed out that Melzi, one of Leonardo's disciples, indicated in a letter to his brother in Florence that "François I shed tears upon learning of the death of Leonardo da Vinci" ("Léonard de Vinci mourant dans les bras de François Ier. Peinture de François-Guillaume Ménageot au Musée de l'Hôtel de Ville de Ambroise," *Bulletin de l'Association Léonard de Vinci*, 6, June 1967, p. 17). Though Vasari's story was touching, it may have been a fabrication.

Roger Freeing Angelica

This literary theme, from the 1532 *Orlando Furioso* by the Renaissance poet Ariosto, has its parallels in both the ancient myth of Perseus and Andromeda and the Christian story of St. George and the Dragon. The focus of all three is a virtuous and valiant man's rescue of a beautiful lady from the grasp of a monster.

Ingres summarized the tale in Notebook IX. Passing near the coast of Brittany, Roger saw Angelica chained to a rock on the Isle of Tears. The island's barbarian inhabitants travelled the seas and abducted the beautiful women they encountered. They brought the women back to the rocks of their shoreline and left them for a monster who feasted on the flesh of the unfortunate victims. After being stripped of her clothes that morning, Angelica had been tied up and abandoned. Roger thought her so beautiful that she might have been carved of alabaster had it not been for the tears on her cheeks and the slight blowing of her long tresses in the light wind. Moved by love and compassion,

he halted the flight of his charger (a hippogriffe—half horse, half eagle) and descended toward her. At that moment, a great tumult engulfed the shore as the monster charged toward his victim. His head was a shapeless mass, of which only the eyes and enormous teeth, like those of a wild boar, could be seen. Roger struck him between the eyes with his lance. The monster struggled and slid into the sea.

The Tomb of the Lady Jane Montague

According to Lapauze (1911, p. 170), Lady Jane Montague had come from England to Rome knowing that she was about to die. The year was 1815, and she was twenty years old. It is not known whether her father, the Duke of Manchester, or her aunt, the Dowager Duchess of Bedford, commissioned this drawing to commemorate her death. In any event, the use of the Renaissance tomb equates this monument with the grand memorials of the past.

The Entry into Paris of the Dauphin, the Future Charles V

The future Charles V returned to Paris on August 2, 1358 after the victory of the loyalists over Etienne Marcel. The moment is a significant one in French history, as it marks the transition within the period of the Hundred Years War with England (begun in 1328) from a time of disorganization in France to one of prosperity and solidarity. In 1356, after the Battle of Poitiers, King John II was captured by the English; his son Charles, the Dauphin and the Duke of Normandy, became regent of France. The States-General, headed by Etienne Marcel and supported by a pretender to the French throne, tried to overthrow the government. In March 1358, the Dauphin had to flee Paris. After a series of confrontations, the revolutionary movement was crushed and the Dauphin was able to re-enter Paris.

Louis XIV and Molière

This incident is recorded in Madame Campin's 1822 *Mémoires sur la vie privée de Marie-Antoinette*. In order to make clear the importance of the playwright Molière (1622-1673) to the members of the Royal court at Versailles, Louis XIV invited him to breakfast. The king then announced to his courtiers, "You find me attending to Molière's meal; my footmen do not consider him good enough company for them." The need for the king to assert the importance of this man to anyone seems a little strange, as now he is universally regarded as the greatest name in French comic theater.

Joan of Arc at the Coronation of Charles VII

Joan of Arc, France's best known and most cherished national herione, was a peasant girl of sixteen when divine voices told her she was destined to save France. After a century of ceaseless warfare, the grip of the English on Northern France seemed unshakeable. Joan's native city of Orléans would have opened the way to the south. At the beginning of 1429, she presented herself to the Dauphin (the future Charles VII) and convinced him that he was indeed the legitimate heir to the kingdom and that she was the appointed instrument of the French victory. When an army was placed in her hands, she quickly ended the siege of Orléans. Thereafter victory was with the French. In July of 1429, Charles VII was consecrated king in the Cathedral at Rheims. In the next year, Joan was captured by the Burgundians, who sold her to the English. She was put on trial for heresy and burned at the stake in Rouen in 1430.

W097 *Head of the Grand Odalisque*, n.d., Cambrai, Musée de Cambrai, deposit of Musée du Louvre. Oil on canvas, 42 x 42 cm, 16.5 x 16.5 inches. Repr. p. 129 (color)

W098 *Head of the Grand Odalisque*, c. 1824-34, Grenoble, Musée de Grenoble, deposit of Musée du Louvre. Oil on canvas, 34 x 34 cm, 13.3 x 13.3 inches. Repr. p. 128

W226 *Odalisque in Grisaille*, c. 1824-34, New York City, Metropolitan Museum of Art, 38.65. Grisaille on canvas, 83.2 x 109.2 cm, 32.7 x 42.9 inches. Cat. 51, repr. p. 126, 202 (color)

C031 *The Grand Odalisque*, c. 1826, Montauban, Musée Ingres, 867.1197. Graphite, sanguine, pen and brown ink on paper, 32.5 x 49.5 cm, 12.7 x 19.4 inches. Cat. 80, repr. p. 127 (color), 128 (detail)

Henri IV Playing with His Children (HIV)

W113 *Henri IV Playing with His Children*, 1817, Paris, Petit Palais. Oil on canvas, 39 x 49 cm, 15.3 x 19.2 inches. Cat. 78, repr. p. 68 (color detail), 89 (color)

W114 *Henri IV Playing with His Children*, c. 1835, London, Victoria and Albert. Oil on canvas, 50 x 62 cm, 19.6 x 24.4 inches. Repr. p. 88

W115 *Henri IV Playing with His Children*, n.d., Paris, Private Collection (1971). Oil on canvas, 40 x 47 cm, 15.7 x 18.5 inches.

W204 *Henri IV Playing with His Children*, 1828, location unknown. Oil on canvas.

D217 *Henri IV Playing with His Children*, 1819, New York City, Private Collection. Graphite on paper, 19 x 16.5 cm, 7.48 x 6.49 inches. Cat. 27, repr. p. 88, 178

C032 *Henri IV Playing with His Children*, n.d., location unknown. Graphite and brown wash on paper, 23 x 17.5 cm, 9.05 x 6.88 inches. Ref.: Sale Hôtel Drouot, February 13, 1939, no. 44.

C033 *Henri IV Playing with His Children*, 1814-17, Montauban, Musée Ingres, 867.1402. Graphite on tracing paper, 20.1 x 17.3 cm, 7.91 x 6.81 inches. Repr. p. 88

Jesus Among the Doctors (JAD)

W302 *Jesus Among the Doctors*, c. 1842-62, Montauban, Musée Ingres, 867.71. Oil on canvas, 26.5 x 32 cm, 10.4 x 12.5 inches. Repr. p. 27

W303 *Jesus Between Two Doctors*, c. 1866, Montauban, Musée Ingres. Oil on canvas affixed to panel, 59 x 49 cm, 23.2 x 19.2 inches.

C034 *Jesus Among the Doctors*, c. 1842-62, Montauban, Musée Ingres, 867.1607. Graphite on tracing paper, 35.4 x 42.3 cm, 13.9 x 16.65 inches.

Joan of Arc at the Coronation of Charles VII (J/A)

W273 *Joan of Arc at the Coronation of Charles VII*, 1854, Paris, Musée du Louvre, Inv. MI 667. Oil on canvas, 240 x 178 cm, 94.4 x 70 inches. Cat. 38, repr. p. 105, (color), 189

W274 *The Head of Joan of Arc*, c. 1851-54, Paris, Private Collection (1954). Oil on canvas, 46.9 x 13.6 cm, 18.5 x 5.37 inches.

W275 *Head of Joan of Arc, In the Background a Landscape With a Church*, n.d., location unknown. Oil on unknown support.

C035 *Joan of Arc*, 1865, Orléans, Musée Historic. Graphite on paper, 11 x 8.5 cm, 4.33 x 3.34 inches.

C036 *Joan of Arc*, before 1846 drawing for the engraving by Pollet in E. Mennechet, location unknown. Grey wash, pen and black ink on paper. Ref.: Jay Williams, *Jeanne d'Arc*, New York, 1963, repr. p. 149.

C037 *Joan of Arc*, Study for 1840 engraving by Pollet, New York City, Curtis Baer. Graphite, pen and black ink on tracing paper mounted on wove paper, 30.2 x 39.2 cm, 11.8 x 15.4 inches.

C038 *Joan of Arc at the Coronation of Charles VII*, c. 1854, Montauban, Musée Ingres, 867.1578. Graphite and sanguine on wove paper, 47.5 x 37 cm, 18.7 x 14.5 inches. Repr. p. 104

Jupiter and Thetis (J&T)

W062 *Head of a Bearded Man*, n.d., Paris, Private Collection (1971). Oil on canvas, 34.9 x 26 cm, 13.75 x 10.25 inches.

W063 *Profile of a Bearded Man*, c. 1808, Aix-en-Provence, Musée Granet. Oil on canvas, 33 x 24 cm, 12.9 x 9.44 inches. Cat. 4, repr. p. 155

W072 *Jupiter and Thetis*, 1811, Aix-en-Provence, Musée Granet, 835.1.1. Oil on canvas, 327 x 260 cm, 128 x 102 inches. Repr. p. 41

W073 *Head of Jupiter*, 1810, retouched and enlarged 1866, Montauban, Musée Ingres, deposit of Musée du Louvre, D.54.1.2. Oil on canvas affixed to panel, 48 x 40 cm, 18.8 x 15.7 inches. Cat. 5, repr. p. 156 (color)

W074 *Head of Jupiter*, 1864, USA, Private Collection (1971). Oil on canvas, 32 x 32 cm, 12.5 x 12.5 inches.

W075 *Head of Jupiter in Profile*, n.d., Paris, Private Collection (1971). Oil on canvas affixed to panel, 48.3 x 40.5 cm, 19 x 15.9 inches.

C039 *Jupiter and Thetis*, n.d., location unknown. Graphite on paper, 18.5 x 13.8 cm, 7.28 x 5.43 inches. Ref.: Sale Hôtel Drouot, June 2, 1981, no. 42, repr.

C040 *Jupiter and Thetis*, c. 1851, Montauban, Musée Ingres, 867.1795. Graphite on tracing paper, 40.2 x 30 cm, 15.8 x 11.8 inches. Repr. p. 40

C041 *Jupiter and Thetis*, 1810, Montauban, Musée Ingres, 867.1786. Graphite on laid paper, 18.3 x 16.9 cm, 7.2 x 6.65 inches.

C042 *Jupiter and Thetis*, c. 1810, Montauban, Musée Ingres, 867.1796. Graphite on tracing paper, 32.5 x 24.2 cm, 12.7 x 9.52 inches. Repr. p. 40

C043 *Jupiter and Thetis*, c. 1851, Montauban, Musée Ingres, 867.1797. Graphite on tracing paper, 34.4 x 28.5 cm, 13.5 x 11.2 inches.

C124 *Jupiter and Thetis*, 1848, location unknown, Private Collection. Pen and ink (?), wash/watercolor (?) on paper. Ref.: Schlenoff, 1956, pl. XV.

Louis XIV and Molière (LXIV)

W281 *Louis XIV and Molière*, 1857, Paris, Musée de la Comédie-Française. Oil on canvas, 50.5 x 69 cm, 19.8 x 27.1 inches. Repr. p. 103

W293 *Louis XIV and Molière*, 1860, USA, Private Collection. Oil on canvas, 54.5 x 70.5 cm, 21.4 x 27.7 inches. Cat. 39, repr. p. 103 (color), 190

The Martyrdom of St. Symphorian (M/SS)

W202 *The Martyrdom of St. Symphorian*, 1827, USA, Private Collection. Oil on canvas, 55 x 30 cm, 21.6 x 11.8 inches.

W212 *The Martyrdom of St. Symphorian*, 1834, Autun, Cathedral. Oil on canvas, 407 x 339 cm, 160 x 133 inches. Repr. p. 19

W214 *Lictor on right, Man Picking Up Stones, and Centurion on Horseback*, c. 1834, Cambridge, Fogg Art Museum. Oil on canvas affixed to panel, 61.8 x 50.1 cm, 24.37 x 19.75 inches.

W220 *The Martyrdom of St. Symphorian*, n.d., Bayonne, Musée Bonnat. Oil on canvas affixed to panel, 21 x 18 cm, 8.26 x 7.08 inches.

W319 *The Martyrdom of St. Symphorian*, 1865, Philadelphia, Philadelphia Museum of Art. Oil on paper affixed to canvas, 36.2 x 30.8 cm, 14.2 x 12.1 inches.

D171 *The Martyrdom of St. Symphorian*, 1858, Cambridge, Fogg Art Museum, 1943.845. Graphite, white gouache and grey wash on laid paper, 47.9 x 40.5 cm, 18.8 x 15.9 inches. Repr. p. 25

C044 *The Martyrdom of St. Symphorian*, 1834, Bayonne, Musée Bonnat, Inv. 250 NI 943. White gouache, black chalk, pen and brown ink on tracing paper, 68 x 59.5 cm, 26.7 x 23.4 inches.

C045 *The Martyrdom of St. Symphorian*, n.d., location unknown. Litho ink with crayon on paper. Ref.: Delaborde, 1870, p. 183, under no. 171.

Napoleon (Nap)

W014 *Napoleon Bonaparte as First Consul*, 1804, Liège, Musée des Beaux-Arts, No. 1. Oil on canvas, 227 x 147 cm, 89.3 x 57.8 inches. Repr. p. 109

W027 *Napoleon I on the Imperial Throne*, 1806, Paris, Musée de l'Armée. Oil on canvas, 260 x 163 cm, 102 x 64.1 inches. Repr. p. 109

D221 *Napoleon at Kehl*, c. 1806, lost. Unknown media on paper.

C046 *Napoleon on the Pont of Kehl*, c. 1851, Montauban, Musée Ingres 867.2772. Graphite on tracing paper, 30.3 x 37.6 cm, 11.99x 14.8 inches.

C047 *Napoleon at the Pont of Kehl*, c. 1806, Reworked c. 1851, Montauban, Musée Ingres, 867.2773. Graphite, pen and black ink on wove paper, 28.4 x 37.7 cm, 11.1 x 14.8 inches. Cat. 40, repr. p. 108, 191

Odalisque with the Slave (Ow/S)

W228 *Odalisque with the Slave*, 1840, Cambridge, Fogg Art Museum, 1943.251. Oil on canvas, 72 x 100 cm, 28.3 x 39.3 inches. Repr. p. 25

W237 *Odalisque with the Slave*, 1842, Baltimore, Walters Art Gallery. Oil on canvas, 76 x 125 cm, 29.9 x 49.2 inches.

D228 *Odalisque with the Slave*, 1858, Paris, Musée du Louvre, RF 4622. Graphite, white gouache, grey wash, pen and brown ink on tracing paper, 34.5 x 47.5 cm, 13.5 x 18.7 inches.

C048 *Odalisque with the Slave*, 1839, USA, Private Collection. Graphite, white gouache, brown wash, grey wash and black chalk on wove paper, 33.3 x 46.4 cm, 13.1 x 18.2 inches. Ref.: Fogg, 1980, p. 118, under no. 41.

Oedipus and the Sphinx (O&S)

W060 *Oedipus and the Sphinx*, 1808-25, Paris, Musée du Louvre. Oil on canvas, 189 x 144 cm, 74.4 x 56.6 inches. Repr. p. 38

W061 *Oedipus and the Sphinx*, c. 1828, London, National Gallery of Art. Oil on canvas, 17.8 x 13.7 cm, 7 x 5.39 inches. Repr. p. 38

W315 *Oedipus and the Sphinx*, 1864, Baltimore, Walters Art Gallery, 37.9. Oil on canvas, 105.5 x 87 cm, 41.5 x 34.2. Cat. 3, repr. p. 39 (color), 154

Paolo and Francesca (P&F)

W100 *Paolo and Francesca*, c. 1814, Chantilly, Musée Condé. Oil on panel, 35 x 28 cm, 13.7 x 11 inches. Repr. p. 71

W121 *Paolo and Francesca*, 1819, Angers, Musée d'Angers. Oil on canvas, 48 x 39 cm, 18.8 x 15.3 inches. Repr. p. 13, 72 (color)

W122 *Paolo and Francesca*, c. 1845, Glens Falls, New York, The Hyde Collection, 1971.24. Oil on canvas, 28.3 x 22.2 cm, 11.1 x 8.74 inches. Cat. 22, repr. cover, p. 77 (color), 173

W123 *Paolo and Francesca*, n.d., Birmingham, England, Barber Institute. Oil on canvas, 35 x 28 cm, 13.7 x 11 inches. Cat. 19, repr. p. 71, 170

W249 *Paolo and Francesca*, c. 1850, Bayonne, Musée Bonnat. Oil on canvas, 22.8 x 15.8 cm, 8.97 x 6.22 inches. Repr. p. 75

W282 *Paolo and Francesca*, c. 1856-57, New York City, Private Collection. Oil on canvas, 30.5 x 25.7 cm, 12 x 10.1 inches. Cat. 23, repr. p. 77, 174 (color)

T140 *Paolo and Francesca*, c. 1856, London, Roland, Browse & Delbanco. Oil on canvas, 26 x 21.5 cm, 10.25 x 8.5 inches. Cat. 24, repr. p. 175

D204 *Paolo and Francesca*, c. 1820, Montauban, Private Collection. Graphite on laid paper, 17.2 x 13 cm, 6.77 x 5.11 inches. Repr. p. 73

D205 *Paolo and Francesca*, 1857, Switzerland, Private Collection. Graphite, white gouache, grey wash on laid paper, 23 x 17 cm, 9.05 x 6.69 inches. Cat. 21, repr. p. 74, 172

D206 *Paolo and Francesca*, 1816, location unknown. Graphite on paper. Repr. p. 70

C049 *Paolo and Francesca*, c. 1810, Paris, Musée du Louvre, RF 23.328. Graphite, brown wash on laid paper, 25 x 18.7 cm, 9.84 x 7.36 inches. Repr. p. 70

C050 *Paolo and Francesca*, 1820, Amsterdam, Amsterdams Historisch Museum, A10970. Graphite on wove paper, 19.4 x 13 cm, 7.63 x 5.11 inches. Cat. 20, repr. p. 73, 171

C051 *Paolo and Francesca*, n.d., Bayonne, Musée Bonnat, Inv. 2234 NI 974. Graphite on paper, 23.5 x 17.4 cm, 9.25 x 6.85 inches. Repr. p. 75

C052 *Paolo and Francesca*, 1816, location unknown, graphite on paper. Ref.: Naef, "Paolo and Francesca," *Zeitschrift fur Kunstwissenschaft*, X, 1/2, 1956, p. 104, fig. 3.

C053 *Paolo and Francesca*, c. 1820, Winterthur, Hahnloser Collection. Graphite on paper. Ref.: Alazard, 1950, pl. XLIV.

C054 *Paolo and Francesca*, c. 1819, Indianapolis, Indianapolis Museum of Art, 47.19. Graphite on tracing paper, 50.6 x 40 cm, 19.93 x 15.75 inches. Repr. p. 72

C055 *Paolo and Francesca*, c. 1819, Montauban, Musée Ingres, 867.1391. Graphite on wove paper, 50 x 39.5 cm, 19.6 x 15.5 inches. Repr. p. 73

C056 *Paolo and Francesca*, before 1857, Montauban, Musée Ingres, 867.1399. Graphite on tracing paper, 17.3 x 13.5 cm, 6.81 x 5.31 inches. Cat. 79, repr. p. 74

Philémon and Baucis Giving Hospitality to Jupiter and Mercury (P&B)
D182 *Philémon and Baucis Giving Hospitality to Jupiter and Mercury*, before 1833, Le Puy, Musée Crozatier, 833-20. Graphite, grey wash, pen and black ink with changes in sepia on wove paper, 30 x 39 cm, 11.8 x 15.3 inches. Cat. 1, repr. p. 36, 152

D183 *Philémon and Baucis Giving Hospitality to Jupiter and Mercury*, 1851, location unknown. Watercolor on paper.

D184 *Philémon and Baucis Giving Hospitality to Jupiter and Mercury*, 1856, Bayonne, Musée Bonnat, Inv. 2258 NI 998. Graphite, white gouache, pen and brown ink, pen and black ink on wove paper, 29.4 x 44.3 cm, 11.5 x 17.4 inches. Repr. p. 36

C059 *Philémon and Baucis Giving Hospitality to Jupiter and Mercury*, 1864, New York City, Private Collection. Graphite, white gouache, brown wash, grey wash on laid paper, 29.4 x 27.6 cm, 11.5 x 10.6 inches. Cat. 2, repr. p. 37, (color), 153

C060 *Philémon and Baucis*, 1800-1806, Montauban, Musée Ingres, 867.2775. Graphite on tracing paper, 30.2 x 41.7 cm, 11.8 x 16.4 inches.

Philip V and the Marshal of Berwick (PVMB)
W120 *Philip V and the Marshal of Berwick*, 1818, Madrid, Alba Collection. Oil on canvas, 88 x 109 cm, 34.6 x 42.9 inches. Repr. p. 83

D218 *Philip V and the Marshal of Berwick*, 1864, Paris, Petit Palais, 1282. Graphite, watercolor, white gouache, gold heightening on tracing paper, 37.5 x 49 cm, 14.7 x 19.2 inches. Cat. 77, repr. p. 85 (color)

C057 *Philip V and the Marshal of Berwick*, 1817, Madrid, Alba Collection. Graphite, white gouache, pen and black ink, unspecified wash on wove paper, squared for transfer, 47 x 57 cm, 18.5 x 22.44 inches. Repr. p. 84

C058 *Philip V and the Marshal of Berwick*, 1816-17, Bayonne, Musée Bonnat, Inv. 248 NI 941. Graphite, grey wash, pen and brown ink, 38.9 x 50 cm, 15.3 x 19.6 inches. Repr. p. 82

Raphael and the Fornarina (R&F)
W086 *Raphael and the Fornarina*, 1813, destroyed. Oil on unknown support.

W088 *Raphael and the Fornarina*, 1814, Cambridge, Fogg Art Museum, 1943.252. Oil on canvas, 68 x 55 cm, 26.7 x 21.6 inches. Repr. p. 24

W089 *Raphael and the Fornarina*, n.d., USA, Kettaneh Collection (1971). Oil on canvas, 32 x 27 cm, 12.5 x 10.6 inches.

W231 *Raphael and the Fornarina*, 1840, Columbus, Ohio, Gallery of Fine Arts. Oil on canvas, 35 x 27 cm, 13.7 x 10.6 inches.

W297 *Raphael and the Fornarina*, begun before 1850, continued 1860-65, Norfolk, Virginia, Chrysler Museum. Oil on canvas, 70 x 54 cm, 27.5 x 21.2 inches. Repr. p. 24

D209 *Raphael and the Fornarina*, 1825, Paris, Musée du Louvre, RF 1448. Graphite, white gouache on tracing paper, 20 x 16.7 cm, 7.87 x 6.57 inches.

C061 *Raphael and the Fornarina*, 1818, London, British Museum, 1922-10-17-11. Graphite, grey wash, pen and brown ink on paper.

C062 *Raphael and the Fornarina*, 1813, Montauban, Musée Ingres, 867.2071. Graphite on laid paper, 20.2 x 14.3 cm, 7.95 x 5.62 inches.

C063 *Raphael and the Fornarina*, 1816, Montauban, Musée Ingres, 867.2074. Graphite on laid paper, 26.1 x 18.6 cm, 10.2 x 7.32 inches.

C064 *Raphael and the Fornarina*, 1814, Montauban, Musée Ingres, 867.2076. Graphite on tracing paper, 20 x 16.1 cm, 7.87 x 6.33 inches.

C065 *Raphael and the Fornarina*, 1814, Montauban, Musée Ingres, 867.2084. Graphite on wove paper, 15.6 x 13.5 cm, 6.14 x 5.31 inches.

Roger Freeing Angelica (R&A)
W124 *Roger Freeing Angelica*, 1819, begun in 1818, Paris, Musée du Louvre, Inv. 5419. Oil on canvas, 147 x 199 cm, 57.8 x 78.3 inches. Repr. p. 94

W125 *Roger Freeing Angelica*, c. 1825-30, Detroit, Detroit Institute of Arts. Oil on canvas, 18.2 x 15 cm, 7.16 x 5.9 inches. Repr. p. 96 (color)

W126 *Angelica*, n.d., Cambridge, Fogg Art Museum. Oil on canvas, 45.8 x 37 cm, 18.3 x 14.56 inches.

W127 *Angelica*, n.d., Paris, Musée du Louvre. Oil on canvas, 84.5 x 42.5 cm, 33.2 x 16.7 inches.

W227 *Roger Freeing Angelica*, 1830, London, National Gallery of Art. Oil on canvas, 47.5 x 39.5 cm, 18.7 x 15.5 inches. Repr. p. 97

W233 *Roger Freeing Angelica*, 1841, Montauban, Musée Ingres. Oil on canvas, 54 x 46 cm, 21.2 x 18.1 inches. Repr. p. 97

W287 *Angelica*, 1859, Sao Paulo, Brazil, Museu de Arte. Oil on canvas, 97 x 75 cm, 38.1 x 29.5 inches. Cat. 35, repr. p. 99 (color), 186

T100d *Angelica*, n.d., Montauban, Musée Ingres, deposit of Musée du Louvre. Oil on canvas, 92 x 73 cm, 36.22 x 38.74 inches.

C066 *Roger Freeing Angelica*, c. 1819, London, Harari & Johns. Oil on canvas, 80 x 45 cm, 31.4 x 17.7 inches. Cat. 33, repr. p. 95 (color), 184, 232 (color detail)

C067 *Roger Freeing Angelica*, 1818, Cambridge, Fogg Art Museum, 1943.859. Graphite on wove paper, squared for transfer, 17.1 x 19.7 cm, 6.73 x 7.75 inches. Repr. p. 94

C068 *Roger Freeing Angelica*, 1867, location unknown. Graphite on paper. Ref.: Delaborde, 1870, p. 209, under no. 32.

C069 *Roger Freeing Angelica*, c. 1851, New York City, Private Collection. Graphite on paper, 48.3 x 38.1 cm, 19 x 15 inches. Cat. 34, repr. p. 185

C070 *Roger Freeing Angelica*, c. 1818, Montauban, Musée Ingres, 867.2103. Graphite on wove paper, 8.8 x 10.5 cm, 3.46 x 4.13 inches. Repr. p. 95

Romulus Conqueror of Acron (RCA)
W082 *Romulus Victorious Over Acron*, 1812, Paris, Ecole des Beaux-Arts. Tempera on canvas, 276 x 530 cm, 108 x 208 inches. Repr. p. 43 (color)

D189 *Romulus Victorious Over Acron*, n.d., location unknown. Graphite, watercolor, grey wash, pen and black ink on paper.

D190 *Romulus Victorious Over Acron*, n.d., USA, Private Collection. Graphite, grey wash on tracing paper, 26 x 51.2 cm, 10.2 x 20.1 inches. Cat. 6, repr. p. 42, 157

D191 *Romulus Victorious Over Acron*, 1812-25, Paris, Musée du Louvre, RF 1441. Graphite, watercolor, pen and brown ink on laid paper, 31 x 50.7 cm, 12.2 x 19.9 inches. Repr. p. 42

D192 *Romulus Victorious Over Acron*, n.d., Paris, Musée du Louvre, RF 4623. Graphite, white gouache, grey wash, pen and black ink on tracing paper, 33.5 x 53 cm, 13.1 x 20.8 inches. Repr. p. 45

D193 *Self Portrait of the Artist at Work on Romulus Victorious Over Acron*, 1812, Bayonne, Musée Bonnat, Inv. 2224 NI 964. Graphite, watercolor, pen and brown ink on paper, 46.4 x 56.6 cm, 18.2 x 22.2 inches.

C071 *Romulus Conqueror of Acron, Study for the Central Portion*, n.d., Montauban, Musée Ingres, 867.2129. Graphite on wove paper, 33.4 x 22.5 cm, 13.1 x 13.1 inches. Cat. 7, repr. p. 158

C072 *Romulus Conqueror of Acron, Study for the Central Portion*, n.d., Montauban, Musée Ingres, 867.2130. Graphite on wove paper, 34.2 x 52 cm, 13.4 x 20.4 inches. Repr. p. 44

C126 *Romulus Conqueror of Acron*, before 1812, location unknown. Graphite on paper. Ref.: Montauban, 1967, under no. 42.

The Sacre Album for the Coronation of Charles X (SA)
C076 *Study for The Alliance of Royalty and Religion*, 1828, Cambridge, Fogg Art Museum, 1948.19. Graphite, turquoise wash on tracing paper, 15.7 x 17 cm, 6.18 x 6.69 inches.

C077 *The Alliance of Royalty and Religion*, 1828, Paris, Musée du Louvre, 27.203. Graphite, brown wash, pen and brown ink on laid paper, 57.2 x 47.1 cm, 22.5 x 18.5 inches.

C078 *Frontispiece for the Sacre of Charles X*, 1828, Montauban, Musée Ingres, 867.2654. Pen and black ink on paper, 10.3 x 6.5 cm, 4.05 x 2.55 inches. Repr. p. 10

C079 *Frontispiece for the Sacre of Charles X*, 1828, Montauban, Musée Ingres, 867.2676. Graphite on tracing paper, 14.1 x 12.2 cm, 5.55 x 4.8 inches.

W206 *King Charles X in Coronation Robes*, 1829, Bayonne, Musée Bonnat. Oil on canvas, 129 x 90 cm, 50.7 x 35.4 inches.

D269 *Portrait of Charles X*, c. 1829, Montauban, Musée Ingres. Graphite on paper.

C073 *Portrait of Charles X*, c. 1829, Bayonne, Musée Bonnat, Graphite, grey wash on unknown support.

C074 *Portrait of Charles X in Coronation Robes*, c. 1829, Paris, Musée du Louvre, 27.204. Brown wash, pen and brown ink on laid paper, 66 x 46.3 cm, 25.9 x 18.2 inches.

C075 *Charles X in Coronation Robes*, n.d., Chicago, The Art Institute, 1960.352. Graphite, watercolor, red chalk on laid paper, 26 x 19.7 cm, 10.2 x 7.75 inches. Cat. 68

D342 *Portrait of the Cardinal de Latil, Archbishop of Reims*, c. 1829, Paris, Musée du Louvre, 27.205. Graphite, brown wash on laid paper, 66.3 x 46.3 cm, 26.1 x 18.2 inches.

The Sistine Chapel (SC)
W091 *The Sistine Chapel*, 1814, Washington, National Gallery of Art, 1106. Oil on canvas, 74.5 x 92.7 cm, 29.3 x 36.4 inches.

W131 *The Sistine Chapel*, begun in Rome, completed in Florence 1820, Paris, Musée du Louvre, RF 360. Oil on canvas, 69.5 x 55.4 cm, 27.3 x 21.8 inches.

W254 *Investiture of a Prefect of Rome, Nephew of Pope Urban VIII, in the Sistine Chapel*, 1848, Montauban, Musée Ingres. Oil on canvas, 81 x 98 cm, 31.8 x 38.5 inches.

W255 *The Tribuna Dei Cantori in the Sistine Chapel*, 1848, Montauban, Musée Ingres. Oil on canvas, 81 x 98 cm, 31.8 x 38.5 inches.

W256 *Investiture of Taddeo Barberini by Urban VIII*, n.d., Montauban, Musée Ingres, 35.1. Oil, graphite, black crayon on tracing paper on canvas, 132 x 163 cm, 51.9 x 64.1 inches.

C080 *Investiture of Taddeo Barberini by Urban VIII*, c. 1865, location unknown. Pen and black ink on unknown support. Ref.: Sale Hôtel Drouot, April 21, 1954.

C081 *Investiture of Taddeo Barberini by Urban VIII*, n.d., Montauban, Musée Ingres, 867.1250. Black crayon on paper, 26.9 x 22.2 cm, 10.5 x 8.74 inches.

The Source (S)
W279 *The Source*, 1820-56, Paris, Musée du Louvre, RF 219. Oil on canvas, 164 x 82 cm, 64.5 x 32.2 inches. Repr. p. 67

W286 *The Source*, 1859, Paris, Musée du Louvre. Oil on canvas affixed to panel, 24 x 12.5 cm, 9.44 x 4.92 inches.

C082 *The Source*, 1807, Montauban, Musée Ingres, 867.2316. Graphite on tracing paper, 27.5 x 12.1 cm, 10.8 x 4.76 inches.

The Tomb of the Lady Jane Montague (TLJM)
D220 *The Tomb of the Lady Jane Montague*, 1860, Montauban, Musée Ingres, Inv. MID 54.4.1. Graphite, watercolor on tracing paper, 35.5 x 26.5 cm, 13.9 x 10.4 inches. Repr. p. 101 (color)

C083 *The Tomb of the Lady Jane Montagu*, 1816, Melbourne, Australia, National Gallery of Victoria, 1066/3. Graphite, brown wash, pen and brown ink on paper, 44 x 56 cm, 17.3 x 22 inches. Cat. 36, repr. p. 100, 187 (color)

C084 *The Tomb of the Lady Jane Montague*, c. 1850, Montauban, Musée Ingres, 867.331. Graphite on tracing paper, 17.5 x 22.3 cm, 6.88 x 8.77 inches.

C085 *The Tomb of the Lady Jane Montague*, Study, c. 1850, Montauban, Musée Ingres, 867.332. Graphite on tracing paper, 18.2 x 18.4 cm, 7.16 x 7.24 inches.

C086 *The Tomb of the Lady Jane Montague*, c. 1816, Montauban, Musée Ingres, 867.333. Graphite on tracing paper, 27.7 x 42.7 cm, 10.9 x 16.8 inches. Repr. p. 100 (detail)

C087 *The Tomb of the Lady Jane Montague*, c. 1816, Montauban, Musée Ingres, 867.334. Graphite on tracing paper, 42.7 x 56.30 cm, 16.8 x 22.1 inches.

Venus Anadyomene (VA)
W257 *Venus Anadyomene*, 1808-48, Chantilly, Musée Condé. Oil on canvas, 163 x 92 cm, 64.1 x 36.2 inches. Repr. p. 65

W258 *Venus Anadyomene*, c. 1864, location unknown, Private Collection (1971). Oil on canvas, 32 x 32 cm, 12.5 x 12.5 inches.

W259 *Venus Anadyomene*, c. 1858, Paris, Musée du Louvre. Oil on paper, 31.5 x 20 cm, 12.4 x 7.87 inches. Repr. p. 66

W261 *Eros*, c. 1864, New York City, Ian Woodner Family Collection, 41. Oil on canvas, 32 x 32 cm, 12.5 x 12.5 inches. Cat. 18, repr. p. 65, 169

C088 *Venus Anadyomene*, c. 1851-67, location unknown. Watercolor and graphite on paper. Ref.: Wildenstein, 1954, pl. 78.

C089 *Venus Anadyomene*, c. 1851, Paris, Private Collection. Graphite on tracing paper. Ref.: Photo in Louvre painting documentation files.

C090 *Venus Anadyomene, Study with Manuscript Notes*, c.1806, Montauban, Musée Ingres, 867.2301. Graphite on wove paper, 26.6 x 15.2 cm, 10.4 x 5.98 inches.

C091 *Venus Anadyomene*, c. 1807, Montauban, Musée Ingres, 867.2302. Graphite, pen and brown ink on tracing paper, 19 x 9.4 cm, 7.48 x 3.7 inches. Repr. p. 64

C092 *Venus Anadyomene, Study*, c. 1807, Montauban, Musée Ingres, 867.2303. Graphite, pen and brown ink on tracing paper, 18 x 12.3 cm, 7.08 x 4.84 inches. Repr. p. 64

C093 *Venus Anadyomene*, c. 1807, Montauban, Musée Ingres, 867.2304. Graphite on wove paper, 17.7 x 20.9 cm, 6.96 x 8.22 inches.

C094 *Venus Anadyomene*, c. 1820, Montauban, Musée Ingres, 867.2305. Black chalk on laid paper, 38.3 x 28.5 cm, 15 x 11.2 inches. Repr. p. 67

Virgil Reading the Aeneid to Augustus (VRA)
W083 *Virgil Reading the Aeneid to Augustus*, 1812, reworked 1835-67, Toulouse, Musée des Augustins, Inv. 124. Oil on canvas, 302 x 325 cm, 118 x 127 inches. Cat. 13, repr. p. 56 (color), 165

W128 *Virgil Reading the Aeneid to Augustus*, c. 1819, Brussels, Musées Royaux des Beaux-Arts de Belgique, 1836. Oil on canvas, 138 x 142 cm, 54.3 x 55.9 inches. Cat. 14, repr. p. 28, 34 (color detail), 53 (color), 161

W320 *Virgil Reading the Aeneid to Augustus*, 1865, Philadelphia, La Salle College Art Museum, 69-P-53. Painted in oil by Ingres over an 1832 Pradier engraving on paper affixed to panel, 58 x 46.9 cm, 22.8 x 18.4 inches. Cat. 15, repr. p. 29 (color), 57, 166

D194 *Virgil Reading the Aeneid to Augustus*, 1850, Cambridge, Fogg Art Museum, 1943.373. Graphite, watercolor, white gouache, black crayon on tracing paper, 38.5 x 33 cm, 15.1 x 12.9 inches. Repr. p. 59

D195 *Virgil Reading the Aeneid to Augustus*, 1815, location unknown. White gouache, ink washed with bistre on paper.

D196 *Virgil Reading the Aeneid to Augustus*, 1822, Paris, Private Collection (1975). Graphite, white gouache on unknown support.

D197 *Virgil Reading the Aeneid to Augustus*, 1830, Paris, Musée du Louvre, RF 1444. Graphite, white gouache, brown wash on laid paper, 52.5 x 40.5 cm, 20.6 x 15.9 inches.

D198 *Virgil Reading the Aeneid to Augustus*, n.d., location unknown. Black crayon on paper.

C099 *Virgil Reading the Aeneid to Augustus*, c. 1812-15, Cambridge, Fogg Art Museum, 1965.299. Graphite, grey wash on wove paper, 29.1 x 42.2 cm, 11.4 x 16.6 inches. Repr. p. 52

C100 *Virgil Reading the Aeneid to Augustus*, c. 1812-19, Ottawa, National Gallery of Canada, 17134. Graphite on paper, 45.7 x 30.5 cm, 17.9 x 12 inches. Cat. 11, repr. p. 53, 160

C101 *Virgil Reading the Aeneid to Augustus*, 1815, Bayonne, Musée Bonnat, Inv. 2232 NI 972. Pen lightly washed with bistre on paper. Repr. p. 52

C102 *Virgil Reading the Aeneid: Statue of Marcellus*, c. 1865, Montauban, Musée Ingres, 867.2466. Graphite, pen and brown ink on tracing paper, 23.9 x 15 cm, 9.4 x 5.9 inches. Repr. p. 58

C103 *Virgil Reading the Aeneid to Augustus*, c. 1812, Montauban, Musée Ingres, 867.2398. Graphite on paper, 14.8 x 20.2 cm, 5.82 x 7.95 inches. Repr. p. 52

C104 *Virgil Reading the Aeneid to Augustus*, c. 1825, Montauban, Musée Ingres, 867.2453. Black chalk, and stump on paper, 26.1 x 21.3 cm, 10.2 x 8.38 inches. Repr. p. 54

C105 *Virgil Reading the Aeneid to Augustus*, c. 1825, Montauban, Musée Ingres, 867.2454. Graphite on tracing paper, 40 x 49.2 cm, 15.7 x 19.3 inches.

C106 *Virgil Reading the Aeneid to Augustus*, c. 1832, Montauban, Musée Ingres, 867.2455. Graphite on paper, 50.7 x 37.9 cm, 19.9 x 14.9 inches.

C107 *Virgil Reading the Aeneid to Augustus*, c. 1825-32, Montauban, Musée Ingres, 867.2456. Graphite on tracing paper, 15.5 x 11.6 cm, 6.1 x 4.56 inches.

C108 *Virgil Reading the Aeneid to Augustus*, c. 1825-32, Montauban, Musée Ingres, 867.2457. Graphite on tracing paper, 22.5 x 33.5 cm, 8.85 x 13.1 inches.

C109 *Virgil Reading the Aeneid to Augustus*, c. 1825, Montauban, Musée Ingres, 867.2461. Graphite on tracing paper, 29 x 18.4 cm, 11.4 x 7.24 inches. Repr. p. 59

C110 *Virgil Reading the Aeneid, Study*, c. 1825, Montauban, Musée Ingres, 867.2463a. Graphite, grey wash, pen and brown ink, pen and black ink on tracing paper with wove paper, 29 x 18.4 cm, 11.4 x 7.24 inches. Cat. 9, repr. p. 162

C111 *Virgil Reading the Aeneid, Study*, c. 1825, Montauban, Musée Ingres, 867.2463b. Graphite, grey wash, pen and brown ink, pen and black ink on tracing paper with wove paper, 14.7 x 34.6 cm, 5.78 x 13.6 inches. Cat. 10, repr. p. 163

C112 *Virgil Reading the Aeneid*, c. 1825, Montauban, Musée Ingres, 867.2469. Graphite, brown wash on tracing paper, 49.7 x 44.7 cm, 19.5 x 17.5 inches. Repr. p. 54

C122 *Virgil Reading the Aeneid*, 1832, Paris, Bibliothèque Nationale, A.A.5res. Engraving by Pradier, retouched by Ingres on paper, 63 x 47.5 cm, 24.8 x 18.7 inches. Cat. 12, repr. p. 54, 164

C125 *Virgil Reading the Aeneid: Mécène and Agrippa*, c. 1825-32, Montauban, Musée Ingres, 867.2480. Graphite, pen and brown ink on tracing paper with wove paper, 20.1 x 13.2 cm, 7.91 x 5.19 inches. Repr. p. 56

The Virgins (V)

W203 *Virgin with the Blue Veil*, c. 1827, Sao Paulo, Museu de Arte. Oil on canvas, 77 x 65 cm, 30.3 x 25.5 inches. Cat. 55, repr. p. 136, 206

W229 *Virgin and Sleeping Child*, n.d., lost. Oil on canvas, 119 x 86 cm, 46.8 x 33.8 inches.

W283 *Virgin of Adoption*, 1858, location unknown. Oil on unknown support.

W284 *The Virgin*, n.d., location unknown. Oil on canvas.

W288 *The Virgin with the Crown*, 1859, Paris, Private Collection. Oil on canvas, 69 x 50 cm, 27.1 x 19.6 inches.

The Virgin with the Host (V/H)

W234 *Virgin with the Host*, 1841, Moscow, Pushkin Museum. Oil on canvas, 116 x 84 cm, 45.6 x 33 inches.

W268 *Virgin with the Host*, 1852, London, Private Collection. Oil on canvas, 40 x 33 cm, 15.7 x 12.99.

W276 *Virgin with the Host*, 1854, Paris, Musée du Louvre. Oil on canvas, 113 x 113 cm, 44.4 x 44.4 inches. Repr. p. 130 (color detail), 137 (color)

W289 *Virgin with the Host*, 1859, lost. Oil on canvas.

W296 *Virgin with the Host*, 1860, USA, Private Collection. Oil on canvas, 60 x 46 cm, 23.6 x 18.1 inches.

W325 *Virgin with the Host*, 1866, Bayonne, Musée Bonnat. Oil on canvas, 78 x 67 cm, 30.7 x 26.3 inches. Repr. p. 136

C113 *Virgin with the Host*, after 1854, France, Private Collection. Watercolor on paper. Ref.: Photograph in Louvre painting documentation files.

C114 *Virgin with the Host*, 1840, Montauban, Musée Ingres, 867.2356. Graphite on tracing paper, 42 x 31 cm, 16.5 x 12.2 inches.

C115 *The Virgin with the Host in a Circular Medallion*, 1854-66, Montauban, Musée Ingres, 867.2368. Graphite on tracing paper, 15.9 x 14.2 cm, 6.25 x 5.59 inches.

C116 *The Virgin with the Host in a Circular Frame*, 1854-66, Montauban, Musée Ingres, 867.2369. Graphite on tracing paper, 14.7 x 14.5 cm, 5.78 x 5.7 inches.

C117 *The Virgin with the Host, in a Circular Frame*, 1854-66, Montauban, Musée Ingres, 867.2371. Graphite on paper, 29.3 x 29.5 cm, 11.5 x 11.6 inches.

C118 *Virgin with the Host*, 1863, Ottawa, National Gallery of Canada, 6144. Graphite on tracing paper, 47.6 x 37.5 cm, 18.7 x 14.7 inches. Cat. 56, repr. p. 207

C119 *Virgin with the Host*, 1866, location unknown. Graphite on paper, 32 x 24 cm, 12.59 x 9.44 inches.

The Vow of Louis XIII (VOW)

W155 *The Vow of Louis XIII*, 1824, Montauban, Cathedral. Oil on canvas, 421 x 262 cm, 165 x 103 inches. Repr. p. 14, 134

W156 *The Vow of Louis XIII (Oil Study)*, c. 1820-24, Montauban, Musée Ingres, 885.11.21. Oil on canvas, 36 x 23 cm, 14.1 x 9.05 inches. Cat. 54, repr. p. 134, 205 (color)

W160 *The Infant Jesus, Leg, Foot, and Hands*, c. 1824, Paris, Private Collection. Oil on canvas, 40 x 31.1 cm, 15.75 x 12.25 inches.

D166 *Virgin and Child Appearing to Sts. Anthony of Padua and Leopold*, 1855, Cambridge, Fogg Art Museum, 1943.375. Graphite, watercolor, pen and brown ink on tracing paper laid down, 26.4 x 18.7 cm, 10.3 x 7.36 inches. Repr. p. 135 (color)

C120 *Virgin of Mme. Ingres*, 1855, Montauban, Musée Ingres, 867.2389. Graphite on laid paper, 26.5 x 17.2 cm, 10.4 x 6.77 inches.

C121 *Virgin of Mme. Ingres*, 1855, Montauban, Musée Ingres, 867.2390. Graphite on tracing paper, 27.1 x 17.7 cm, 10.6 x 6.96 inches.

NYC, Paul Rosenberg & Co.
D216, DASG

NYC, Private Collection
W282, P&F
D213, D/L
D217, HIV
C069, R&A
C059, P&B

Norfolk, Chrysler Museum
W297, R&F

Northampton, Smith College Museum of Art
W119, D/L

Orléans, Musée Historic
C035, J/A

Oslo, Private Collection
W141, DPT

Ottawa, National Gallery of Canada
C100, VRA
C118, V/H

Paris, Ecole des Beaux-Arts
W007, A/A
W082, RCA

Paris, Musée du Louvre
W027, NAP
W053, B/V
W060, O&S
W093, GO
W124, R&A
W127, R&A
W131, SC
W168, A/H
W205, PB
W207, DPT
W259, VA
W271, A/N
W273, J/A
W276, V/H
W279, S
W281, LXIV
W286, S
W312, TB
D211, D/L
D228, Ow/S
D167, CKP
D176, A/H
D180, A/H
D188, A&S
D191, RCA
D192, RCA
D197, VRA
D199, D/O
D209, R&F
D210, B/R
D342, SA
C049, P&F
C074, SA
C077, SA

Paris, Petit Palais
W113, HIV
W118, D/L
D218, PVMB

Paris, Private Collection
W062, J&T
W075, J&T
W115, HIV
W129, DPT
W134, CKP
W160, VOW
W175, A/H
W179, A/H
W181, A/H
W188, A/H
W253, A&T
W274, J/A
W288, V/H
D196, VRA
C089, VA

Philadelphia, Collection R. de Schauensee
W295, A&S

Philadelphia, La Salle College Museum
W320, VRA

Philadelphia, Museum of Art
W319, M/S

San Diego, Fine Arts Gallery
W184, A/H

Sao Paulo, Museu de Arte
W203, V/H
W211, CKP
W287, R&A

Stockholm, Museum
W008, A/A

Switzerland, Private Collection
D205, P&F

Toulouse, Musée des Augustins
W083, VRA

USA, Kettaneh Collection
W089, R&F

USA, Private Collection
W074, J&T
W202, M/SS
W289, V/H
W293, LXIV
D190, RCA
C006, A/N
C048, Ow/S

Washington, D.C., National Gallery of Art
W091, SC

Washington, D.C., The Phillips Collection
W165, PB

Wintherthur, Hahnloser
C053, P&F

Location Unknown
W096, GO
W101, DPT
W139, CKP
W140, CKP
W164, A&S
W172, A/H
W180, A/H
W194, A/H
W204, HIV
W252, A&CV
W258, VA
W267, D/L
W275, J/A
W283, V/H
W284, V/H
T105, CKP
D181, A/A
D183, P&B
D189, RCA
D195, VRA
D198, VRA
D201, D/O
D206, P&F
D214, D/L
C016, B/R
C929, DPT
C021, DPT
C022, DPT
C032, HIV
C036, J/A
C039, J&T
C045, M/SS
C052, P&F
C068, R&A
C080, SC
C088, VA
C119, V/H
C124, J&T
C126, RCA

C125, VRA, Montauban, Musée Ingres
D166, VOW, Cambridge, Fogg Art Museum
D178, A/H, Lille, Musée des Beaux-Arts
D190, RCA, USA, Private Collection
D192, RCA, Paris, Musée du Louvre
D194, VRA, Cambridge, Fogg Art Museum
D199, D/O, Paris, Musée du Louvre
D202, D/O, Montauban, Musée Ingres
D209, R&F, Paris, Musée du Louvre
D212, D/L, Brussels, Musées Royaux
D218, PVMB, Paris, Petit Palais
D220, TLJM, Montauban, Musée Ingres
D228, Ow/S, Paris, Musée du Louvre

Any Media Except Oil on Unspecified Paper
C001, A&S, Boulogne-sur-Mer, Musée des Beaux-Arts
C007, A/N, Bayonne, Musée Bonnat
C016, B/R, Location Unknown
C017, B/R, Montauban, Musée Ingres
C019, DPT, Florence, Uffizi
C020, DPT, Location Unknown
C021, DPT, Location Unknown
C026, D/O, Basel, Private Collection
C032, HIV, Location Unknown
C035, J/A, Orléans, Musée Historic
C036, J/A, Location Unknown
C039, J&T, Location Unknown
C045, MSS, Location Unknown
C051, P&F, Bayonne, Musée Bonnat
C052, P&F, Location Unknown
C053, P&F, Winterthur, Hahnloser
C061, R&F, London, British Museum
C068, R&A, Location Unknown
C069, R&A, NYC, Private Collection
C073, SA, Bayonne, Musée Bonnat
C081, SC, Montauban, Musée Ingres
C083, TLJM, Melbourne, Natl. Gallery of Victoria
C088, VA, Location Unknown
C097, A/H, Montauban, Musée Ingres
C101, VRA, Bayonne, Musée Bonnat
C103, VRA, Montauban, Musée Ingres
C104, VRA, Montauban, Musée Ingres
C106, VRA, Montauban, Musée Ingres
C113, V/H, France, Private Collection
C117, V/H, Montauban, Musée Ingres
C124, J&T, Location Unknown
C126, RCA, Location Unknown
C167, ECV, Montauban, Musée Ingres
D181, A/A, Location Unknown
D183, P&B, Location Unknown
D189, RCA, Location Unknown
D193, RCA, Bayonne, Musée Bonnat
D195, VRA, Location Unknown
D198, VRA, Location Unknown
D201, D/O, Location Unknown
D206, P&F, Location Unknown
D213, D/L, NYC, Private Collection
D214, D/L, Location Unknown
D217, HIV, NYC, Private Collection
D221, NAP, Lost
D222, A/N, London, British Museum
D269, SA, Montauban, Musée Ingres

Graphite Only on Laid Paper
C008, A/N, Montauban, Musée Ingres
C041, J&T, Montauban, Musée Ingres
C062, R&F, Montauban, Musée Ingres
C063, R&F, Montauban, Musée Ingres
C120, VOW, Montauban, Musée Ingres
D204, P&F, Montauban, Private Collection

Graphite Only on Wove Paper
C050, P&F, Amsterdam, Historisch Museum
C055, P&F, Montauban, Musée Ingres
C065, R&F, Montauban, Musée Ingres
C067, R&A, Cambridge, Fogg Art Museum
C070, R&A, Montauban, Musée Ingres
C071, RCA, Montauban, Musée Ingres
C072, RCA, Montauban, Musée Ingres
C090, VA, Montauban, Musée Ingres
C093, VA, Montauban, Musée Ingres
C100, VRA, Ottawa, National Gallery of Canada

Graphite Only on Unspecified Paper
C019, DPT, Florence, Uffizi

C035, J/A, Orléans, Musée Historic
C039, J&T, Location Unknown
C051, P&F, Bayonne, Musée Bonnat
C052, P&F, Location Unknown
C053, P&F, Winterthur, Hahnloser
C068, R&A, Location Unknown
C069, R&A, NYC, Private Collection
C103, VRA, Montauban, Musée Ingres
C106, VRA, Montauban, Musée Ingres
C117, V/H, Montauban, Musée Ingres
C120, VOW, Montauban, Musée Ingres
C126, RCA, Location Unknown
D206, P&F, Location Unknown
D213, HIV, NYC, Private Collection
D269, SA, Montauban, Musée Ingres

Graphite Only on Tracing Paper
C002, A&S, Montauban, Musée Ingres
C003, A&S, Montauban, Musée Ingres
C004, A/H, Montauban, Musée Ingres
C006, A/N, USA, Private Collection
C008, A/N, Montauban, Musée Ingres
C012, B/V, Montauban, Musée Ingres
C018, D/L, Montauban, Musée Ingres
C022, DPT, Location Unknown
C028, D/O, Montauban, Musée Ingres
C030, DASG, Montauban, Musée Ingres
C033, HIV, Montauban, Musée Ingres
C034, JAD, Montauban, Musée Ingres
C040, J&T, Montauban, Musée Ingres
C042, J&T, Montauban, Musée Ingres
C043, J&T, Montauban, Musée Ingres
C046, NAP, Montauban, Musée Ingres
C054, P&F, Indianapolis, Museum of Art
C056, P&F, Montauban, Musée Ingres
C060, P&B, Montauban, Musée Ingres
C064, R&F, Montauban, Musée Ingres
C079, SA, Montauban, Musée Ingres
C082, S, Montauban, Musée Ingres
C084, TLJM, Montauban, Musée Ingres
C085, TLJM, Montauban, Musée Ingres
C086, TLJM, Montauban, Musée Ingres
C087, TLJM, Montauban, Musée Ingres
C089, VA, Paris, Private Collection
C105, VRA, Montauban, Musée Ingres
C107, VRA, Montauban, Musée Ingres
C108, VRA, Montauban, Musée Ingres
C109, VRA, Montauban, Musée Ingres
C114, V/H, Montauban, Musée Ingres
C115, V/H, Montauban, Musée Ingres
C116, V/H, Montauban, Musée Ingres
C118, V/H, Ottawa, National Gallery of Canada
C121, VOW, Montauban, Musée Ingres

Graphite and Pen and Brown Ink on Tracing Paper
C009, AECV, Montauban, Musée Ingres
C010, A&T, Montauban, Musée Ingres
C024, DPT, Montauban, Musée Ingres
C091, VA, Montauban, Musée Ingres
C092, VA, Montauban, Musée Ingres
C102, VRA, Montauban, Musée Ingres
C125, VRA, Montauban, Musée Ingres

Brown Wash + Any Media on Any Paper
C020, DPT, Location Unknown
C032, HIV, Location Unknown
C048, Ow/S, USA, Private Collection
C049, P&F, Paris, Musée du Louvre
C059, P&B, NYC, Private Collection
C074, SA, Paris, Musée du Louvre
C077, SA, Paris, Musée du Louvre
C085, TLJM, Melbourne, Natl. Gallery of Victoria
C112, VRA, Montauban, Musée Ingres
D188, A&S, Paris, Musée du Louvre
D197, VRA, Paris, Musée du Louvre
D202, D/O, Montauban, Musée Ingres
D211, D/L, Paris, Musée du Louvre
D214, D/L, Location Unknown
D342, SA, Paris, Musée du Louvre

Brown Wash + Any Media on Tracing Paper
C112, VRA, Montauban, Musée Ingres
D202, D/O, Montauban, Musée Ingres

Grey Wash + Any Media on Any Paper

C001, A&S, Boulogne-sur-Mer, Musée des Beaux-Arts
C007, A/N, Bayonne, Musée Bonnat
C027, D/O, France, Private Collection
C036, J/A, Location Unknown
C048, Ow/S, USA, Private Collection
C058, PVMB, Bayonne, Musée Bonnat
C059, P&B, NYC, Private Collection
C061, R&F, London, British Museum
C073, SA, Bayonne, Musée Bonnat
C099, VRA, Cambridge, Fogg Art Museum
C110, VRA, Montauban, Musée Ingres
C111, VRA, Montauban, Musée Ingres
D171, M/SS, Cambridge, Fogg Art Museum
D176, A/H, Paris, Musée du Louvre
D180, A/H, Paris, Musée du Louvre
D181, A/A, Location Unknown
D182, P&B, LePuy, Musée Crozatier
D189, RCA, Location Unknown
D190, RCA, USA, Private Collection
D192, RCA, Paris, Musée du Louvre
D199, D/O, Paris, Musée du Louvre
D202, D/O, Montauban, Musée Ingres
D205, P&F, Switzerland, Private Collection
D211, D/L, Paris, Musée du Louvre
D212, D/L, Brussels, Musées Royaux
D214, D/L, Location Unknown
D216, DASG, NYC, Paul Rosenberg & Co.
D222, A/N, London, British Museum

Grey Wash + Any Media on Tracing Paper
C110, VRA, Montauban, Musée Ingres
C111, VRA, Montauban, Musée Ingres
D190, RCA, USA, Private Collection
D192, RCA, Paris, Musée du Louvre
D199, D/O, Paris, Musée du Louvre
D202, D/O, Montauban, Musée Ingres
D212, D/L, Brussels, Musées Royaux
D228, Ow/S, Paris, Musée du Louvre

White Gouache on Laid, Wove, or Unspecified Paper
C005, A/N, Paris, Musée du Louvre
C011, B/V, Cambridge, Fogg Art Museum
C021, DPT, Location Unknown
C025, D/O, Cambridge, Fogg Art Museum
C048, Ow/S, USA, Private Collection
C057, PVMB, Madrid, Alba Collection
C059, P&B, NYC, Private Collection
D171, M/SS, Cambridge, Fogg Art Museum
D176, A/H, Paris, Musée du Louvre
D180, A/H, Paris, Musée du Louvre
D184, P&B, Bayonne, Musée Bonnat
D195, VRA, Location Unknown
D196, VRA, Paris, Private Collection
D197, VRA, Paris, Musée du Louvre
D205, P&F, Switzerland, Private Collection
D210, B/R, Paris, Musée du Louvre
D216, DASG, NYC, Paul Rosenberg & Co.

White Gouache on Tracing Paper
C015, B/R, Cambridge, Fogg Art Museum
C044, M/SS, Bayonne, Musée Bonnat
D178, A/H, Lille, Musée des Beaux-Arts
D192, RCA, Paris, Musée du Louvre
D194, VRA, Cambridge, Fogg Art Museum
D199, D/O, Paris, Musée du Louvre
D202, D/O, Montauban, Musée Ingres
D209, R&F, Paris, Musée du Louvre
D212, D/L, Brussels, Musées Royaux
D218, PVMB, Paris, Petit Palais
D228, Ow/S, Paris, Musée du Louvre

Watercolor + Any Media on Laid, Wove, or Unspecified Paper
C005, A/N, Paris, Musée du Louvre
C011, B, Cambridge, Fogg Art Museum
C014, TB, Cambridge, Fogg Art Museum
C025, D/O, Cambridge, Fogg Art Museum
C075, SA, Chicago, The Art Institute
C088, VA, Unknown
C113, V/H, France, Private Collection
D167, CKP, Paris, Musée du Louvre
D183, P&B, Unknown
D189, RCA, Unknown
D191, RCA, Paris, Musée du Louvre

D193, RCA, Bayonne, Musée Bonnat
D200, D/O, Montauban, Private Collection
D215, A&T, Bayonne, Musée Bonnat

Watercolor + Any Media on Wove Paper
C011, B, Cambridge, Fogg Art Museum
C014, TB, Cambridge, Fogg Art Museum
C025, D/O, Cambridge, Fogg Art Museum
D200, D/O, Montauban, Private Collection
D215, A&T, Bayonne, Musée Bonnat

Watercolor + Any Media on Laid Paper
C005, A/N, Paris, Musée du Louvre
C075, SA, Chicago, The Art Institute
D167, CKP, Paris, Musée du Louvre
D191, RCA, Paris, Musée du Louvre

Watercolor + Any Media on Unspecified Paper
C088, VA, Unknown
C113, V/H, France, Private Collection
D183, P&B, Unknown
D189, RCA, Unknown

Watercolor + Any Media on Tracing Paper
C013, TB, Bayonne, Musée Bonnat
C015, B/R, Cambridge, Fogg Art Museum
D166, VOW, Cambridge, Fogg Art Museum
D178, A/H, Lille, Musée des Beaux-Arts
D194, VRA, Cambridge, Fogg Art Museum
D218, PVMB, Paris, Petit Palais
D220, TLJM, Montauban, Musée Ingres

Watercolor + Brown Ink +/or Brown Wash
D167, CKP, Paris, Musée du Louvre
D191, RCA, Paris, Musée du Louvre
D193, RCA, Bayonne, Musée Bonnat
D200, D/O, Montauban, Private Collection

Watercolor + Black Ink +/or Grey Wash
D189, RCA, Location Unknown
D202, D/O, Montauban, Musée Ingres
D220, TLJM, Montauban, Musée Ingres

W257, VA, Chantilly, Musée Condé, c. 1807-48
W063, J&T, Aix-en-Provence, Musée Granet,
c. 1808
W060, O&S, Paris, Musée du Louvre, c. 1808-25
W087, D/O, Montauban, Musée Ingres,
c. 1812-35+
W093, GO, Paris, Musée du Louvre, c. 1814
W100, P&F, Chantilly, Musée Condé, c. 1814
W102, DASG, Montauban, Musée Ingres,
c. 1816-19
W128, VRA, Brussels, Musées Royaux, c. 1819+

1820-1824
C050, P&F, Amsterdam, Historisch Museum, 1820
W132, CKP, Montauban, Musée Ingres, 1820
W141, DPT, Oslo, Private Collection, 1820
C019, DPT, Florence, Uffizi, 1821
W146, ECV, Hartford, Wadsworth Atheneum, 1821
D196, VRA, Paris, Private Collection, 1822
W155, VOW, Montauban, Cathedral, 1824
C086, TLJM, Montauban, Musée Ingres, c. 1816
C087, TLJM, Montauban, Musée Ingres, c. 1816
C070, R&A, Montauban, Musée Ingres, c. 1818
C053, P&F, Winterthur, Hahnloser, c. 1820
C094, VA, Montauban, Musée Ingres, c. 1820
C023, DPT, Montauban, Musée Ingres, c. 1820-23
D215, A&T, Bayonne, Musée Bonnat, c. 1815
D211, D/L, Paris, Musée du Louvre, c. 1817
D167, CKP, Paris, Musée du Louvre, c. 1820
D168, CKP, Location Unknown, c. 1820
D204, P&F, Montauban, Private Collection, c. 1820
W156, VOW, Montauban, Musée Ingres, c. 1820-24
W094, GO, Angers, Musée d'Angers, c.1820-34
W279, S, Paris, Musée du Louvre, c. 1820-56

1825-1834
C021, DPT, Location Unknown, 1825
D209, R&F, Paris, Musée du Louvre, 1825
W164, A&S, Location Unknown, 1825
W165, PB, Washington, D.C., Phillips Collection,
1826
W168, A/H, Paris, Musée du Louvre, 1827
W202, M/SS, USA, Private Collection, 1827
W205, PB, Paris, Musée du Louvre, 1828
C077, SA, Paris, Musée du Louvre, 1828
W204, HIV, Location Unknown, 1828
C078, SA, Montauban, Musée Ingres, 1828
C076, SA, Cambridge, Fogg Art Museum, 1828
C079, SA, Montauban, Musée Ingres, 1828
W206, SA, Bayonne, Musée Bonnat, 1829
D197, VRA, Paris, Musée du Louvre, 1830
W227, R&A, London, National Gallery of Art, 1830
W207, DPT, Paris, Musée du Louvre, 1832
W212, M/SS, Autun, Cathedral, 1834
C044, M/SS, Bayonne, Musée Bonnat, 1834
W211, CKP, Sao Paulo, Museu de Arte, 1834
C026, D/O, Basel, Private Collection, c. 1825
C104, VRA, Montauban, Musée Ingres, c. 1825
C105, VRA, Montauban, Musée Ingres, c. 1825
C109, VRA, Montauban, Musée Ingres, c. 1825
C110, VRA, Montauban, Musée Ingres, c. 1825
C111, VRA, Montauban, Musée Ingres, c. 1825
C112, VRA, Montauban, Musée Ingres, c. 1825
C107, VRA, Montauban, Musée Ingres, c. 1825-32
C108, VRA, Montauban, Musée Ingres, c. 1825-32
C125, VRA, Montauban, Musée Ingres, c. 1825-32
C031, GO, Montauban, Musée Ingres, c. 1826
C004, A/H, Montauban, Musée Ingres, c. 1827
C097, A/H, Montauban, Musée Ingres, c. 1827
C073, SA, Bayonne, Musée Bonnat, c. 1829
C074, SA, Paris, Musée du Louvre, c. 1829
C024, DPT, Montauban, Musée Ingres, c. 1832
C106, VRA, Montauban, Musée Ingres, c. 1832
C025, D/O, Cambridge, Fogg Art Museum, c. 1833
D176, A/H, Paris, Musée du Louvre, c. 1827 (?)
D269, SA, Montauban, Musée Ingres, c. 1829
D342, SA, Paris, Musée du Louvre, c. 1829
D199, D/O, Paris, Musée du Louvre, c. 1830
D182, P&B, LePuy, Musée Crozatier, before 1833
W133, CKP, Montauban, Private Coll., c. 1820
W134, CKP, Paris, Private Collection, c. 1820+
W098, GO, Grenoble, Musée de Grenoble,
c. 1824-34
W095, GO, France, Private Coll., c. 1824-34
W226, GO, NYC, Metropolitan, c. 1824-34

W203, V, Sao Paolo, Museu de Arte, c. 1827
W061, O&S, London, Natl. Gallery of Art, c.1828
W125, R&A, Detroit, Institute of Arts, c. 1828
W224, A&S, Cleveland, Museum of Art, c. 1834

1835-1840
C048, Ow/S, USA, Private Collection, 1839
W231, R&F, Columbus, Gallery of Fine Arts, 1840
W228, Ow/S, Cambridge, Fogg Art Museum, 1840
W323, A&S, Chantilly, Musée Condé, 1840
C114, V/H, Montauban, Musée Ingres, 1840
W114, HIV, London, Victoria and Albert, c. 1835

1841-1849
W233, R&A, Montauban, Musée Ingres, 1841
W234, V/H, Moscow, Pushkin Museum, 1841
W237, Ow/S, Baltimore, Walters Art Gallery, 1842
W253, A&T, Paris, Private Collection, 1848
C124, J&T, Private Collection, 1848
W252, A&CV, Location Unknown, 1848
W255, SC, Montauban, Musée Ingres, 1848
W254, SC, Montauban, Musée Ingres, 1848
C036, J/A, Location Unknown, before 1846
C034, JAD, Montauban, Musée Ingres, 1842-62
W251, GA, Dampierre, Chateau, c. 1842-49
W302, JAD, Montauban, Musée Ingres, c. 1842-62
W122, P&F, Glens Falls, Hyde Collection, c. 1845

1850-1859
D194, VRA, Cambridge, Fogg Art Museum, 1850
D183, P&B, Location Unknown, 1851
W268, V/H, London, Private Collection, 1852
C004, A/N, Paris, Musée du Louvre, 1853
W270, A/N, Destroyed, 1853
W271, A/N, Paris, Musée Carnavalet, 1853
W276, V/H, Paris, Musée de Louvre, 1854
W273, J/A, Paris, Musée du Louvre, 1854
C121, VOW, Montauban, Musée Ingres, 1855
D166, VOW, Cambridge, Fogg Art Museum, 1855
C120, VOW, Montauban, Musée Ingres, 1855
C007, A/N, Bayonne, Musée Bonnat, 1856
D184, P&B, Bayonne, Musée Bonnat, 1856
W281, LXIV, Paris, Musée de la Comédie
Française, 1857
D205, P&F, Switzerland, Private Collection, 1857
D228, Ow/S, Paris, Musée du Louvre, 1858
D171, M/SS, Cambridge, Fogg Art Museum, 1858
W289, V/H, Lost, 1859
W287, R&A, Sao Paulo, Museu de Arte, 1859
W286, S, Paris, Musée du Louvre, 1859
W288, V/H, Paris, Private Collection, 1859
C017, B/R, Montauban, Musée Ingres, c. 1851
C022, DPT, Location Unknown, c. 1851
C040, J&T, Montauban, Musée Ingres, c. 1851
C043, J&T, Montauban, Musée Ingres, c. 1851
C046, NAP, Montauban, Musée Ingres, c. 1851
C069, R&A, NYC, Private Collection, c. 1851
C084, TLJM, Montauban, Musée Ingres, c. 1851
C085, TLJM, Montauban, Musée Ingres, c. 1851
C089, VA, Paris, Private Collection, 1851
C088, VA, Location Unknown, c. 1851-67
C006, A/N, USA, Private Collection, c. 1853
C008, A/N, Montauban, Musée Ingres, c. 1853
C038, A/N, Montauban, Musée Ingres, c. 1854
C056, P&F, Montauban, Musée Ingres, before
1857
C115, V/H, Montauban, Musée Ingres, c. 1854-66
C116, V/H, Montauban, Musée Ingres, c. 1854-66
C117, V/H, Montauban, Musée Ingres, c. 1854-66
D178, A/H, Lille, Musée des Beaux-Arts, c. 1857
D192, RCA, Paris, Musée du Louvre, c. 1857
T152, A/N, Musée de Châteauroux, c. 1853
T140, P&F, London, Roland, Browse ..., c. 1856
W175, A/H, Neuilly, Coll. David-Weill, c. 1850
W182, A/H, Lyon, Musée des Beaux-Arts, c. 1850
W183, A/H, Glens Falls, Hyde Collection, c. 1850
W249, P&F, Bayonne, Musée Bonnat, c. 1850+
W297, R&F, Norfolk, Chrysler Museum, c. 1850+
W274, J/A, Paris, Private Collection, c. 1851-54
W267, D/L, Northampton, Smith College,
c. 1852+
W282, P&F, NYC, Private Collection, c. 1856-57
W259, VA, Paris, Musée du Louvre, c. 1858

1860-1867
W293, LXIV, USA, Private Collection

W295, A&S, Philadelphia, R. de Schauensee, 1860
W296, V/H, London, Private Collection, 1860
D220, TLJM, Montauban, Musée Ingres, 1860
D222, A/N, London, British Museum, 1861
W298, A/H, Brussels, The Royal Collection, 1862
W301, GA, Cambridge, Fogg Art Museum, 1862
W312, TB, Paris, Musée du Louvre, 1862
C118, V/H, Ottawa, Nat. Gallery of Canada, 1863
W074, J&T, USA, Private Collection, 1864
C013, TB, Bayonne, Musée Bonnat, 1864
C014, TB, Cambridge, Fogg Art Museum, 1864
C059, P&B, NYC, Private Collection, 1864
W315, O&S, Baltimore, Walters Art Gallery, 1864
D218, PVMB, Paris, Petit Palais, 1864
C015, B/R, Cambridge, Fogg Art Museum, 1864
C035, J/A, Orléans, Musée Historic, 1865
D180, A/H, Paris, Musée du Louvre, 1865
W319, M/SS, Philadelphia, Museum of Art, 1865
W320, VRA, Philadelphia, La Salle College, 1865
W324, A/H, Angers, Musées d'Angers, 1866
C119, V/H, Location Unknown, 1866
D202, D/O, Montauban, Musée Ingres, 1866
W325, V/H, Bayonne, Musée Bonnat, 1866
W322, A&S, Montpellier, Musée Fabre, 1866
C068, R&A, Location Unknown, 1867
C003, A&S, Montauban, Musée Ingres, c. 1860
C080, SC, Location Unknown, c. 1865
C102, VRA, Montauban, Musée Ingres, c. 1865
W261, VA, NYC, Ian Woodner Family, c. 1864
W303, JAD, Montauban, Musée Ingres, c. 1866

New York, 1961, Paul Rosenberg & Co.
D213, D/L, NYC, Private Collection
D217, HIV, NYC, Private Collection
W085, B/R, Baltimore, Walters Art Gallery
W089, R&F, USA, Kettaneh Collection
W103, AECV, California, Private Collection
W104, A&T, California, Private Collection
W146, ECV, Hartford, Wadsworth Atheneum
W165, PB, Washington, D.C., Phillips Collection
W237, Ow/S, Baltimore, Walters Art Gallery
W297, R&F, Norfolk, Chrysler Museum
W315, O&S, Baltimore, Walters Art Gallery

Paris, 1967-68
D178, A/H, Lille, Musée des Beaux-Arts
D180, A/H, Paris, Musée du Louvre
D188, A&S, Paris, Musée du Louvre
D192, RCA, Paris, Musée du Louvre
D200, D/O, Montauban, Private Collection
D228, Ow/S, Paris, Musée du Louvre
W008, A/A, Stockholm, Nationalmuseum
W014, NAP, Liège, Musée des Beaux-Arts
W027, NAP, Paris, Musée de l'Armée
W053, B/V, Paris, Musée du Louvre
W060, O&S, Paris, Musée du Louvre
W072, J&T, Aix-en-Provence, Musée Granet
W082, RCA, Paris, Ecole des Beaux-Arts
W085, B/R, Baltimore, Walters Art Gallery
W087, D/O, Montauban, Musée Ingres
W093, GO, Paris, Musée du Louvre
W102, DASG, Montauban, Musée Ingres
W120, PVMB, Madrid, Alba Collection
W121, R&F, Angers, Musée d'Angers
W124, R&A, Paris, Musée du Louvre
W127, R&A, Paris, Musée du Louvre
W128, VRA, Brussels, Musées Royaux
W131, SC, Paris, Musée du Louvre
W141, DPT, Oslo, Private Collection
W146, ECV, Hartford, Wadsworth Atheneum
W155, VOW, Montauban, Cathedral
W168, A/H, Paris, Musée du Louvre
W175, A/H, Neuilly, Coll. D. David-Weill
W182, A/H, Lyons, Musée des Beaux-Art
W205, PB, Paris, Louvre
W212, M/SS, Autun, Cathedral
W231, R&F, Columbus, Ohio, Gallery of Fine Arts
W237, Ow/S, Baltimore, Walters Art Gallery
W276, V/H, Paris, Musée du Louvre
W279, S, Paris, Musée du Louvre
W295, A&S, Philadelphia, Coll. R. de Schauensee
W302, JAD, Montauban, Musée Ingres
W303, JAD, Montauban, Musée Ingres
W312, TB, Paris, Musée du Louvre

Montauban, 1967
C091, VA, Montauban, Musée Ingres
C094, VA, Montauban, Musée Ingres
C103, VRA, Montauban, Musée Ingres
C104, VRA, Montauban, Musée Ingres
D191, RCA, Paris, Musée du Louvre
D199, D/O, Paris, Musée du Louvre
D200, D/O, Montauban, Private Collection
D228, Ow/S, Paris, Musée du Louvre
W008, A/A, Stockholm, Museum
W087, D/O, Montauban, Musée Ingres
W102, DASG, Montauban, Musée Ingres
W121, P&F, Angers, Musée d'Angers
W128, VRA, Brussels, Musées Royaux
W132, CKP, Montauban, Musée Ingres
W133, CKP, Montauban, Private Collection
W256, SC, Montauban, Musée Ingres
W271, A/N, Paris, Musée Carnavalet
W281, LXIV, Paris, Musée de la Comédie Française

Cambridge, 1967
C011, B/V, Cambridge, Fogg Art Museum
C015, B/R, Cambridge, Fogg Art Museum
C025, D/O, Cambridge, Fogg Art Museum
C037, J/A, NYC, Curtis Baer
C067, R&A, Cambridge, Fogg Art Museum
C075, SA, Chicago, The Art Institute
C099, VRA, Cambridge, Fogg Art Museum
D166, VOW, Cambridge, Fogg Art Museum
W125, R&A, Detroit, Institute of Arts
W126, R&A, Cambridge, Fogg Art Museum

W224, A&S, Cleveland, Museum of Art

Rome, 1968´
C042, J&T, Montauban, Musée Ingres
C092, VA, Montauban, Musée Ingres
D167, CKP, Paris, Musée du Louvre
D191, RCA, Paris, Musée du Louvre
W087, D/O, Montauban, Musée Ingres
W102, DASG, Montauban, Musée Ingres
W118, D/L, Paris, Petit Palais
W124, R&A, Paris, Musée du Louvre
W128, VRA, Brussels, Musées Royaux

London, 1972
C083, TLJM, Melbourne, Nat. Gallery of Victoria
D182, P&B, Le Puy, Musée Crozatier
D188, A&S, Paris, Musée du Louvre
W007, A/A, Paris, Ecole des Beaux-Arts
W014, NAP, Liège, Musée des Beaux-Arts
W087, D/O, Montauban, Musée Ingres
W128, VRA, Brussels, Musées Royaux

Cambridge, 1980
C011, B/V, Cambridge, Fogg Art Museum
C014, TB, Cambridge, Fogg Art Museum
C015, B/R, Cambridge, Fogg Art Museum
C025, D/O, Cambridge, Fogg Art Museum
C067, R&A, Cambridge, Fogg Art Museum
C076, SA, Cambridge, Fogg Art Museum
C099, VRA, Cambridge, Fogg Art Museum
D166, VOW, Cambridge, Fogg Art Museum
D171, M/SS, Cambridge, Fogg Art Museum
D194, VRA, Cambridge, Fogg Art Museum
W088, R&F, Cambridge, Fogg Art Museum
W126, R&A, Cambridge, Fogg Art Museum
W228, Ow/S, Cambridge, Fogg Art Museum
W301, GA, Cambridge, Fogg Art Museum

Montauban, 1980
C019, B/V, Montauban, Musée Ingres
C092, V/A, Montauban, Musée Ingres
C094, V/A, Montauban, Musée Ingres
C104, VRA, Montauban, Musée Ingres
D199, D/O, Paris, Musée du Louvre
D202, D/O, Montauban, Musée Ingres
D228, Ow/S, Paris, Musée du Louvre
W007, A/A, Paris, Ecole des Beaux-Arts
W073, J&T, Montauban, Musée Ingres
W083, VRA, Toulouse, Musée des Augustins
W087, D/O, Montauban, Musée Ingres
W098, GO, Grenoble, Musée de Grenoble
W102, DASG, Montauban, Musée Ingres
W127, R&A, Montauban, Musée Ingres
W132, CKP, Montauban, Musée Ingres
W156, VOW, Montauban, Musée Ingres
W173, A/H, Montauban, Musée Ingres
W175, A/H, Neuilly, Coll. D. David-Weill
W233, R&A, Montauban, Musée Ingres
W271, A/N, Paris, Musée Carnavalet
W279, S, Paris, Musée du Louvre
W302, JAD, Montauban, Musée Ingres
W303, JAD, Montauban, Musée Ingres
W322, A&S, Montpellier, Musée Fabre

Tokyo-Osaka, 1981
C086, TLJM, Montauban, Musée Ingres
C091, VA, Montauban, Musée Ingres
C092, VA, Montauban, Musée Ingres
C094, VA, Montauban, Musée Ingres
C104, VRA, Montauban, Musée Ingres
D218, PVMB, Paris, Petit Palais
T100, R&A, Montauban, Musée Ingres
W014, NAP, Liège, Musée des Beaux-Arts
W087, D/O, Montauban, Musée Ingres
W097, GO, Cambrai, Musée de Cambrai
W113, HIV, Paris, Petit Palais
W131, SC, Paris, Musée du Louvre
W231, R&F, Columbus, Ohio, Gallery of Fine Art
W233, R&A, Montauban, Musée Ingres
W271, A/N, Paris, Musée Carnavalet
W279, S, Paris, Musée du Louvre

Overleaf

Self-Portrait at the Age of Seventy-Eight
Florence, Uffizi. Oil on canvas, 64 x 53cm, 1858. (W. 285)